Jacques-Laurent Agasse

JACQUES-LAURENT
AGASSE
1767-1849

The Tate Gallery London

The exhibition 'Jacques-Laurent Agasse (1767-1849)'
has been organised by the Tate Gallery
and the Musée d'Art et d'Histoire, Geneva.
It has received a generous measure of sponsorship from
the Pro Helvetia Foundation and the support of Swissair.

Executive Committee:
Renée Loche, Geneva
Colston Sanger, London

Entries by
Lucien Boissonnas:
Cat. 76-115
Renée Loche:
Cat. 1-13, 15-18, 21, 22, 24, 25, 27, 28, 30-39,
41-46, 53-56, 61, 62, 65 to 67, 70, 73
Colston Sanger:
Cat. 14, 19, 20, 23, 26, 29, 40, 47-52, 57-60, 63, 64,
68, 69, 71, 72, 74, 75

Translations by
Fabia Claris:
Cat. 1-13, 15-18, 21, 22, 24, 25, 27, 28, 30-39,
41-46, 53-56, 61, 62, 65-67, 70, 73

Published by order of the Trustees 1988
for the exhibition at the Tate Gallery
15 February-2 April 1989
first shown at the Musée d'Art et d'Histoire, Geneva,
from 10 November 1988 - 22 January 1989
© 1988 The Tate Gallery
Published by Tate Gallery Publications
Millbank, London SW1P 4RG
Printed in Switzerland by Benteli AG, Bern
ISBN 1-85437-003-0

Front cover:
Lord Rivers Coursing at Newmarket with his Friends. 1818 (Cat.no. 41)

Contents

Lenders

United States of America

Yale Center for British Art, Paul Mellon Collection
14, 23, 57, 58, 63, 64, 75

United Kingdom

Her Majesty The Queen 59, 60

Mr Tim Edwards 40

Harari & Johns, London 20

The Royal College of Surgeons of England, London
47, 48, 49, 50, 51, 52

Tate Gallery 19, 26

Zoological Society of London 71, 72

Private Collection by courtesy of Hildegard Fritz-Denneville Fine Arts, London 31, 68

Switzerland

Aargauer Kunsthaus Aarau 24

Öffentliche Kunstsammlung, Kunstmuseum, Basle 10

Kunstmuseum Berne 61

Musée d'Art et d'Histoire, Geneva 3, 4, 6, 11, 17, 18, 32, 36, 41, 43, 56, 62, 70, 76, 77, 81, 88, 89, 91, 92, 95, 100, 101, 103, 104, 108, 109, 110, 112, 113, 115

Musée d'Art et d'Histoire – Collection de la Société des Arts, Geneva 85, 98

Fondazione Thyssen-Bornemisza, Lugano 39

Museum Stiftung Oskar Reinhart, Winterthur 25, 34, 38, 114

Galerie Römer, Zurich 44

Fondation Prince M. 27, 28

Private Collections 1, 2, 5, 7, 8, 9, 12, 13, 15, 16, 21, 22, 29, 30, 33, 35, 37, 42, 45, 46, 53, 54, 55, 65, 66, 67, 69, 71, 72, 73, 74, 78, 79, 80, 82, 83, 84, 86, 87, 90, 93, 94, 96, 97, 99, 102, 105, 106, 107, 111

Acknowledgements

I should like to express my gratitude to His Excellency the Swiss Ambassador in London, Mr François-Charles Pictet, and to Mr Hans Kunz, former cultural attaché, for the keen interest they have shown in our project and for the many steps they kindly agreed to take on our behalf in the course of its preparation.

To all who so generously contributed information and allowed access to their collections and archives, I am much indebted. In London: Mr John Sunderland, librarian, Courtauld Institute of Art, Witt Library; Mrs Beth Houghton, librarian, The Tate Gallery; Mrs Rosemary Bird, Mrs Margie Christian, Mr William Drummond, and particularly Mr Richard Kingzett. In Paris: Mrs Catherine Hustache, conservateur, Bibliothèque centrale du Museum d'histoire naturelle; Mrs Anne van de Sandt, art historian. In Switzerland: Mr Philippe Monnier, conservateur du département des manuscrits, Bibliothèque publique et universitaire, Genève; Mr Paul Muller, librarian, Institut suisse pour l'Etude de l'art, Zurich; Mr Max Bollag, Zurich; Mrs Marianne Feilchenfeldt, Zurich.

My thanks are also due to my colleagues at the Musée d'Art et d'Histoire, Geneva, Danielle Buyssens, assistante-conservateur chargée de l'inventaire and Anne de Herdt, conservateur du Cabinet des dessins, for the friendly and invaluable help which they afforded me throughout the preparation of this exhibition.

Renée Loche

My first debt, as for so many of his ex-students, is to Michael Kitson, now Director of the Paul Mellon Centre for Studies in British Art. I must also thank Sir Trenchard Cox who made available to me the results of his own research on Agasse, as did Judy Egerton of the Tate Gallery.

Acknowledgements are also due to the following individuals and institutions for their assistance on numerous occasions during the preparation of this exhibition: Brian Allen, Paul Mellon Centre for Studies in British Art; Prof. E. Cochin, Hon. Archivist and Emeritus Professor of Pathology, Royal Veterinary College, London; Mr R. Fish, Librarian, Zoological Society of London; Miss Benita Horder, Librarian, Royal College of Veterinary Surgeons, Wellcome Library; Mr Arthur Jewell, Curator, Haslemere Educational Museum; Archives Department, Westminster City Libraries, Marylebone Library; Mr I. Lyle, Librarian, Royal College of Surgeons of England; Mr J. Sewell, City Archivist, Corporation of London Records Office; Mr W. Stallybrass, Assistant Librarian (retd.), The Royal Military Academy, Sandhurst; and of course Ruth Rattenbury and the staff of the Department of Exhibitions and Technical Services at the Tate Gallery.

Finally, I must thank Dennis Houlden of the Olivetti International Education Centre, Haslemere, for allowing me the time to work on this exhibition.

Colston Sanger

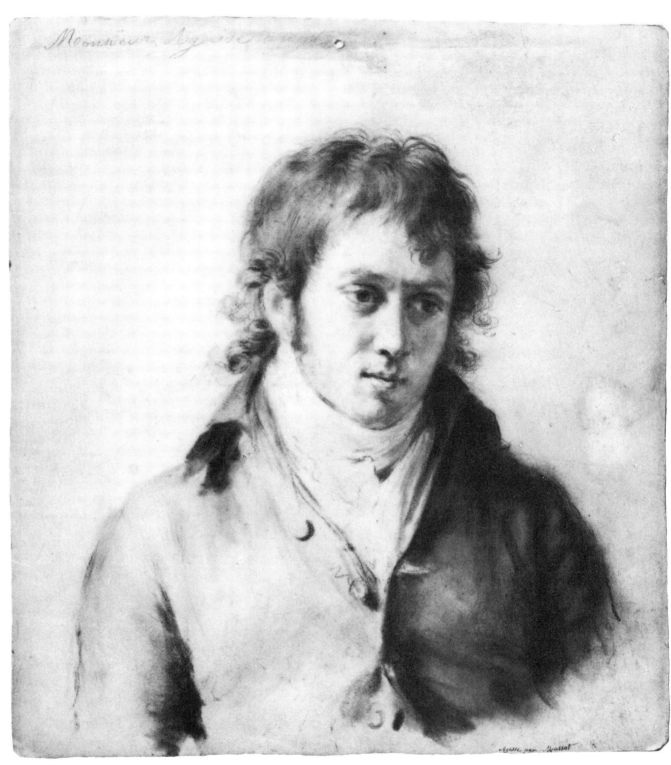

Firmin Massot: Portrait of Jacques–Laurent Agasse. Private Collection

Jacques-Laurent Agasse, a Painter to Rediscover

One might think that a painter who made his name in two different countries ought to be doubly well remembered by posterity. This is certainly not the case with Agasse, however, whose career was divided between Geneva and London. Neither Swiss nor British art historians have shown more than a passing interest in him, even though his work has always been snapped up by collectors and dealers alike.

The fact that so little has been written on Agasse up to now stems from the obscure feeling one gets from his pictures that here is a bafflingly atypical artist - who even in his Genevese period never conforms to the image one has of late eighteenth-early nineteenth century Swiss painting, and whose great English output does not really seem to fit stylistically with British art of Constable and Turner's day. He is so difficult to grasp as an artist that it has been perfectly possible for a Swiss museum to mistake an unsigned Stubbs for an Agasse (this was a long time before the major Stubbs exhibition at the Tate Gallery, of course), and for a leading collector to part with a considerable amount of money to secure a painting he thought was by Agasse which turned out to be a signed picture by William Huggins (1820-1884).

Known for his pictures of racehorses and greyhounds, Agasse was rather too quickly classed as one of those minor artists, an animal painter. While no-one would dispute his right to such a title, is it one which really does him justice? Does it take account of the luminous landscapes which sometimes act as backdrops to these 'animal portraits'? Does it give any indication that here is a painter influenced both by Neo-classicism and by the Romanticism of his day whose work is particular and subtle, shaped by his habit of working from nature, and reflects a concern with capturing the atmosphere of the country which we associate more readily with late nineteenth century painters ?

All these questions and many more that need to be asked in the presence of the assembled works make the holding of an exhibition worth while. This is not designed to be one of the great popular successes attracting many thousands of people, but is one of those exhibitions which are necessary, indispensable even, if we are to achieve a better understanding of the artistic phenomenon taking place in Europe between 1800 and 1850. It brings with it the promise of new discoveries and the seeds of new research.

There is a long and happy tradition of artists establishing themselves in their native country and then going to Britain to make a second career. Although Agasse is not of the international repute of Holbein the Younger, Van Dyck or Whistler, he did arrive in England from Switzerland with a technique and sensitivity that made him second only to George Stubbs as a sporting artist and painter of animals.

The Tate Gallery, home of countless masterpieces of British art, agreed to join with the Musée d'Art et d'Histoire in Geneva, with its rich collection of works by Agasse, to put on a major exhibition of his work - one which is deliberately not exhaustive, but which aims instead to show for the first time the very best of this Geneva-born, London-based artist. For the Tate to share the first exhibition devoted to his art is a logical step after the large Stubbs exhibition of 1984-85.

We are delighted that this collaboration between our two museums has been possible and would like to thank both the Pro Helvetia Foundation and Swissair for their support.

Our principal thanks must go to all the lenders without whose generosity this exhibition could never have been mounted. We are most grateful.

Claude Lapaire
Director
Musée d'Art et d'Histoire
Geneva

Nicholas Serota
Director
Tate Gallery
London

Abbreviations

Bibliography

1867 Cherbuliez
Joël Cherbuliez, *Genève, ses institutions, ses mœurs, son développement intellectuel et moral. Esquisse historique et littéraire,* Geneva, 1867

1876 Rigaud
Jean-Jacques Rigaud, *Renseignements sur les Beaux-Arts à Genève,* Geneva, 1876

1901 Crosnier
Jules Crosnier, 'Les écoles de dessin du Calabri', *Nos Anciens et leurs œuvres,* 1901

1902 Plan
Danielle Plan, 'Les collections du Docteur Gosse', *Nos Anciens et leurs œuvres,* 1902, pp. 9-20

1904 Baud-Bovy
Daniel Baud-Bovy, *Peintres Genevois du XVIII^e et du XIX^e siècle, 1766-1849,* II^e série, Geneva, 1904

1905 Brun I
Carl Brun, *Schweizerisches Künstler-Lexikon,* t. I, Frauenfeld, 1905

1905 Hardy
C. F. Hardy, *J. L. Agasse: his life, his work.* Manuscript, Geneva, Musée d'Art et d'Histoire (=MAH)

1908 Crosnier
Jules Crosnier, 'Bessinge', *Nos Anciens et leurs œuvres,* pp. 57-123

1910 Crosnier
Jules Crosnier, 'La Société des Arts et ses collections', Geneva, 1910

1911 Fournier-Sarlovèze
Fournier-Sarlovèze, *Louis-Auguste Brun. Peintre de Marie-Antoinette. 1758-1815,* Paris, 1911

1911 Gilbey
Sir W. Gilbey, *Animal Painters of England from the Year 1650,* t. III, London, 1911

1912 Stryienski
Stryienski, 'Le Musée d'Art et d'Histoire de Genève', *Les Arts,* no 131, 1912

1913 Baud-Bovy
Daniel Baud-Bovy, 'La peinture suisse', *L'Art et les artistes,* t. XVII, 1913, pp. 145-160 and 193-208

1913 Giron
Charles Giron, 'Les artistes animaliers à l'étranger: Suisse', *L'Art et les artistes,* t. XVI, 1913, p. 247

1914 Bovy
Adrien Bovy, 'La peinture genevoise', *Nos centenaires, Genève-Suisse, 1814-1914,* Geneva, 1914, pp. 525-550

1915 Annuaire
Jahrbuch für Kunst und Kunstpflege in der Schweiz. Annuaire des Beaux-Arts en Suisse, t. I, Berne, 1913-15

1916 Hardy 1
C. F. Hardy, 'The Life and Work of Jacques-Laurent Agasse', *The Connoisseur,* August 1916, pp. 191-198

1917 Cartier
A. Cartier, 'Coup d'œil sur les Arts à Genève de la fin du XVII^e siècle à l'époque de la Restauration', *Nos Anciens et leurs œuvres,* 1917, pp. 5-36

1917 Crosnier
Jules Crosnier, 'La peinture à l'exposition du Centenaire', *Nos Anciens et leurs œuvres,* 1917, pp. 37-62

1917 Hardy 2
C. F. Hardy, 'The Life and Work of Jacques-Laurent Agasse', *The Connoisseur,* January 1917, pp. 9-17

1921 Grellet
M. Grellet, *Nos peintres romands du XVIII^e et du XIX^e siècle,* Lausanne, 1921

1921 Hardy 1
C. F. Hardy, 'La vie et l'œuvre de Jacques-Laurent Agasse', *Pages d'art,* March 1921, pp. 65-68

1921 Hardy 2
C.F. Hardy, 'La vie et l'œuvre de Jacques-Laurent Agasse', *Pages d'art,* April 1921, pp. 101-104

1922 Sparrow
W.S. Sparrow, *British Sporting Artists from Barlow to Herring,* London, 1922

1922 Ziegler
Henri de Ziegler, 'Quelques tableaux', *Pages d'art,* March 1922, pp. 77-86

1927 Grellet
M. Grellet, 'Les Agasse du Musée de Genève', *La Patrie suisse,* 1927, no. 888, pp. 446-449

1929 Gielly
Louis Gielly, 'Un tableau inconnu de Jacques-Laurent Agasse', *L'Art en Suisse,* May 1929, p. 114

1929 Siltzer
F. Siltzer, *The Story of British Sporting Prints,* London, 1929

1930 Gielly
Louis Gielly, 'Musée de Genève, l'exposition Jacques-Laurent Agasse', *L'Art en Suisse,* March 1930, pp. 69-72

1935 Gielly
Louis Gielly, *L'école genevoise de peinture,* Geneva, 1935

1937 Gielly
Louis Gielly, 'Le Musée d'Art et d'Histoire à Genève', *L'Art vivant,* no. 212, July 1937, pp. 189-190

1943 Hugelshofer
W. Hugelshofer, 'Agasse und die Tiere', *Du,* January 1943, no 1, pp. 5-9, Zurich, 1943

1943 Huggler, Cetto
M. Huggler and A.-M. Cetto, *La peinture suisse au XIXe siècle,* Basle, 1943

1945 Deonna
Waldemar Deonna, 'Le Genevois et son art', *Genava,* t. XXIII, 1945, pp. 87-339

1945 Fosca
François Fosca, *Histoire de la peinture suisse,* Geneva, 1945

1945 Neuweiler
Arnold Neuweiler, *La peinture à Genève de 1700 à 1900,* with an introduction by Adrien Bovy, Geneva, 1945

1948 Bovy
Adrien Bovy, *La peinture suisse de 1600 à 1900,* Basle, 1948

1949 Bouffard
Pierre Bouffard, 'Jacques-Laurent Agasse et Firmin Massot', *Musées de Genève,* November-December 1949, p. 2

1953 Fulpius
Lucien Fulpius, 'Rapport de la Société des Amis du MAH', *Genava,* n.s., t. I, 1953, pp. 185-188

1959 Gordon-Roe
F. Gordon-Roe, 'Jacques-Laurent Agasse', *The British Racehorse,* September 1959

1959 Grant
Maurice Harold Grant, *A Dictionary of British Landscape painters from the 16th to the early 20th Century,* Leigh-on-Sea, 1952

1960 MAH
Le Musée d'Art et d'Histoire de Genève, 1910-1960, Album du Cinquantenaire, Geneva, 1960

1968 Herdt
Anne de Herdt, 'J.-L. Agasse dessinateur', *Musées de Genève,* no 82, pp. 2-4

1969 Hugelshofer
Walter Hugelshofer, *Schweizer Zeichnungen von N.M. Deutsch bis Alberto Giacometti,* Berne, 1969

1969 Millar
Oliver Millar, *The later Georgian Pictures in the Collection of Her Majesty The Queen,* London, 1969

1972 Pianzola
Maurice Pianzola, *Genève et ses peintres*, Geneva, 1972

1975 Deuchler, Roethlisberger, Lüthy
Florens Deuchler, Marcel Roethlisberger, Hans
Lüthy, *La peinture suisse du Moyen Age à 1900*,
Geneva, 1975

1977 Zelger
Franz Zelger, *Stiftung Oskar Reinhart Winterthur*, t.I,
Zurich, 1977

1978 Egerton
Judy Egerton, *British sporting and animal paintings:
1655-1867. The Paul Mellon Collection*, London, 1978

1981 Herdt
Anne de Herdt, 'Introduction à l'histoire du dessin
genevois, de Liotard à Hodler', *Genava*, n.s., t. XXIX,
1981, pp. 5-75

1982 Lapaire
Claude Lapaire, *Cinq siècles de peinture au Musée d'Art
et d'Histoire de Genève*, Geneva, 1982

1983 Kuthy
Sandor Kuthy, *Musée des Beaux-Arts, Berne. Catalogue
des peintures*, Berne, 1983

1985 Cormack
Malcolm Cormack, *Concise Catalogue of Paintings,
Yale Center for British Art*, New Haven, Connecticut,
1985

1988 Buyssens
Danielle Buyssens, *Catalogue des peintures et des pastels
de l'ancienne école genevoise*, Geneva, 1988

Exhibitions

1896 Geneva
Geneva 1896, 'Exposition nationale suisse,
Groupe 25: Art ancien'

1901 Geneva. Cercle des arts et des lettres
Geneva, Cercle des arts et des lettres, 1901,
'L'Ancienne Ecole genevoise de peinture'

1914 Geneva. MAH
Geneva, Musée d'Art et d'Histoire. 'Genève suisse,
Centenaire 1814-1914', retrospective exhibition

1916 Winterthur. Kunstverein
Winterthur, Kunstverein, January 1916,
'Eröffnungs-Ausstellung'

1924 Paris. Musée du Jeu de Paume
Paris, Musée du Jeu de Paume, June-July 1924,
'Art suisse du XVᵉ au XIXᵉ siècle', exhibition of
works from Holbein to Hodler

1925 Karlsruhe. Kunsthalle
Karlsruhe, Kunsthalle, 18 July-30 August 1925,
'Grosse Schweizer Kunstausstellung'

1928 Brussels. Palais des Beaux-Arts
Brussels, Palais des Beaux-Arts, April-August 1928,
'L'art suisse au Palais des Beaux-Arts de Bruxelles.
Le paysage au XIXᵉ siècle'

1930 Geneva. MAH
Geneva, Musée d'Art et d'Histoire, February-March
1930, 'Exposition d'œuvres du peintre genevois
Jacques-Laurent Agasse appartenant à des
collections privées, à l'Ariana et au Musée d'Art
et d'Histoire'

1935 London. Whitechapel Art Gallery
London, Whitechapel Art Gallery, 1935, 'Cricket
and Sporting Paintings'

1936 Berne. Kunsthalle
Berne, Kunsthalle, August-October 1936.
'Schweizer Malerei im 19. Jahrhundert'

1936 Geneva. MAH
Geneva, Musée d'Art et d'Histoire, 1936, 'Ancien art
genevois de la fin du XVIIIᵉ et de la première moitié
du XIXᵉ siècle'

1938 Venice
Venice, June-October 1938, Biennale

1939 Zurich
Zurich, 20 May-6 August 1939, 'Schweizerische
Landesausstellung, Zeichnen, Malen, Formen.
I: die Grundlagen'

1942 Geneva. MAH
Geneva, Musée d'Art et d'Histoire, 1942, 'Genève à travers les âges, art et histoire'

1942 Winterthur. Kunstmuseum
Winterthur, Kunstmuseum, 'Der unbekannte Winterthurer Privatbesitz, 1500-1900'

1943 Geneva. MAH
Geneva, Musée d'Art et d'Histoire, 1943, 'L'art suisse des origines à nos jours'

1944. Geneva. Musée Rath
Geneva, Musée Rath, 2-24 December 1944, 'Le dessin. 1. Rétrospective du dessin de l'école genevoise, de Liotard à Hodler'

1949 Florence. Strozzi
Florence, Palazzo Strozzi, 15 October-12 November 1949, 'Scuola ginevrina dell'Ottocento: pittura e scultura'

1959 London. Tate Gallery
London, Tate Gallery. 10 July-27 September 1959, 'The Romantic movement'

1963 Richmond. Virginia Museum of Fine Arts
Richmond, Virginia Museum of Fine Arts, 1963, 'Painting in England 1700-1850: Collection of Mr and Mrs Paul Mellon'

1964-65 London. Royal Academy
London, Royal Academy. Winter exhibition, 1964-65, 'Painting in England 1700-1850 from the Collection of Mr and Mrs Paul Mellon'

1966-67 London. Queen's Gallery
London, Queen's Gallery, Buckingham Palace, 1966-67, 'Animal Painting'

1968 Detroit and Philadelphia
Detroit Institute of Art, 9 Jan.-18 Feb., Philadelphia, Museum of Art, 14 March-21 April 1968, 'Romantic Art in Britain. Paintings and Drawings'

1968 Geneva. Maison Tavel
Geneva, Maison Tavel, 1968, 'Jacques-Laurent Agasse dessinateur'

1968 Winterthur, Chur, Lucerne, etc.
Winterthur, Kunstmuseum, 14 January-25 February: Chur, Kunsthaus, 3 March-15 April; Luzern, Kunstmuseum, 28 April-3 June 1968... 'De Töpffer à Hodler: le dessin suisse au XIXᵉ siècle'

1970 Jegenstorf. Schloss
Jegenstorf, Schloss, 6 June-18 October 1970, 'Rendez-vous à cheval. Pferde und Reiter um 1800'

1972 London. Royal Academy, Victoria and Albert Museum
London, Royal Academy and Victoria and Albert Museum, 9 September-19 November 1972, 'The Age of Neo-Classicism'

1972 Yverdon. Hôtel-de-Ville et Château
Yverdon, Hôtel-de-Ville et Château, 16 June-10 September 1972, 'Le cheval et l'homme'

1973 Copenhagen. Thorwaldsens
Copenhagen, Thorwaldsens Museum, 13 March-30 April 1973, 'Maetige Schweiz. Inspirationer fra Schweiz, 1750-1850'

1974 London. Hayward Gallery
London, Hayward Gallery. 1974, 'British Sporting Painting, 1650-1850'

1976 Geneva. Musée Rath
Geneva, Musée Rath, 25 November 1976-9 January 1977, 'Le Musée Rath a 150 ans'

1982 Lausanne. Musée cantonal des Beaux-Arts
Lausanne, Musée cantonal des Beaux-Arts, 23 July-12 September 1982, 'Fantaisie équestre'

1984 Geneva. Musée Rath. Dijon. Musée des Beaux-Arts
Geneva, Musée Rath, 12 April-12 June 1984; Dijon, Musée des Beaux-Arts, 2 June-17 October 1984, 'Dessin genevois de Liotard à Hodler'

1988 Atlanta. High Museum of Art
Atlanta, High Museum of Art, 9 February-10 April 1988, 'From Liotard to Le Corbusier, 200 Years of Swiss Painting, 1730-1930'

Chronology

1767

Born in Geneva on 24 March 1767 and christened in the 'Temple Neuf' on 21 April, the son of Philippe Agasse (1739-1827) and Catherine Audeoud (1737-1818). Descended from a well-to-do family of merchants of Huguenot origin, established in Geneva as early as the beginning of the 17th century, and later in Aberdeen, Scotland. His grandfather, Etienne Agasse, was made a citizen of Geneva in 1742.
Had a happy childhood both at his home in Plainpalais, Geneva, and at his family's country house in Crevin, at the foot of Mt Salève in Savoy. Even as a very young boy, spent much of his time in stables, kennels and farm-yards.

1774-1777

Discovered an illustrated book of Buffon's *L'Histoire Naturelle* and did some cut-out copies of the plates in the manner of Jean Huber. Produced his first drawing *The Foal* observed from nature.

1782-1786

His father enrolled him in the *Calabri* School of Drawing where he studied under Jacques Cassin and Georges Vanière, and won a 3rd prize in 1782. Made friends with Firmin Massot and Adam-Wolfgang Töpffer; all three worked together on a number of compositions.

1786-1789

Left for Paris to further his artistic training in the studio of David. At the same time, had courses in anatomy, dissection and osteology at the Museum. The Revolution brought his stay in Paris to an end.

1789

Back in Geneva. Made the acquaintance of a rich English aristocrat, a great lover of horses and coursing, George Pitt, who later became Lord Rivers.

c. 1790

Lord Rivers advised Agasse to accompany him to England. Discovered there the richness and originality of the British school of painting. His parents were ruined as a result of the Revolution, and Agasse was obliged to return to Geneva. Henceforth he had to make a living from his art.

1794-1796

Had to leave Geneva on account of political circumstances and found refuge in Lausanne.

1798

Associate of the Drawing Committee of the Société des Arts.
Sent in four pictures to the 3rd Salon of the Société des Arts. In the company of Pierre-Louis De la Rive and Töpffer went on sketching and painting tours round the countryside in the Mont Blanc and Evian areas of Savoy. Formed a friendship with the engraver Nicolas Schenker, Firmin Massot's brother-in-law, who engraved 6 plates from works by Agasse, which were published in album form.

1798-1799

Back for a second stay in Paris, where his uncle Henri-Albert Gosse tried to sell some of his paintings.

1800

Left for London and arrived there in October. Stayed with his friends, the Chalons, whose sons John-James and Alfred-Edward were students at the Royal Academy schools and later became Members of the Royal Academy. In November, started his Record Book in which he entered details of his works for the rest of his life.

1801

From then onwards was a regular exhibitor at the Royal Academy.

1802

Collaborated with the engraver Charles Turner for two plates *Preparing to start* and *Coming in* which were fairly successful.

1803
From this time was a regular visitor of Polito's menagerie at Exeter 'Change in the Strand, and he and Edward Cross, Polito's son-in-law, became great friends.

1805
Was the guest of Lord Rivers at Stratfield Saye in Hampshire, where he painted some of his finest compositions.

1806
Made the acquaintance of John James Masquerier, a painter of French origin settled in London.

1807-1808
Exhibited at the British Institution and later at the Sketching Society founded in 1808.

1810
Had lodgings in George Booth's house, Newman Street, a district inhabited by many artists. His landlord became a good friend and the family posed for him, especially the children who sat for delightful genre paintings like 'The Flower Cart in Spring' or 'The Pleasure Ground'.

1815
Lord Rivers, his patron, suffered financial setbacks and was obliged to sell Stratfield Saye, where Agasse had so often worked.

1816
Töpffer stayed with English collector, Edward Divett, and visited Agasse. In his letters to his wife Töpffer described his friend's successes and difficulties.

1818
Painted remarkably sensitive views of London and the Thames.

1819
While on a study tour in London, Dr. Louis-André Gosse, a cousin of Agasse, wrote down in his *Journal* (Ms 2677, BPU, Geneva) descriptions of their many meetings.

1820
Sent some of his works, through his sister Louise-Etiennette, to the July Salon held by the Société des Arts of Geneva.

1821
He obtained a commission from the Royal College of Surgeons of England for paintings to document Lord Morton's cross-breeding experiments.

1822
As from that year, perhaps to prove that he was not exclusively an animal painter, exhibited mostly genre paintings and portraits. Horace Vernet in London and met Agasse.

1823
Elected an Honorary Associate of the Société des Arts of Geneva.

1827-1828
Was commissioned by George IV to paint 'The Giraffe' (1827) and 'White Tailed Gnus' (1828) from the Royal Menagerie.

1828
Death of Lord Rivers.
Firmin Massot, who was staying with the Earl of Breadalbane, visited Agasse.

1833
From then onwards, rarely took part in exhibitions and seemed to retire from artistic life, although he went on painting his beloved horses and dogs - his favourite animals, as well as portraits.

1837
His sister, Louise-Etiennette, came to London.

1842
After more than ten years' absence from the Royal Academy, exhibited there again.

1845
'The Important Secret' was the last work he exhibited at the Royal Academy.

1849
Died in London on 27 December and was buried in St John's Wood Chapel.

1850
Posthumous sale at Christie's, 10 July.

Renée Loche
Jacques-Laurent Agasse and Geneva

There are a great many men of taste to be found
among the artists there, men of genius even,
men who anywhere else would be considered misfits.

Bourrit, *Itinéraire de Genève Lausanne et Chamoni,*
Geneva, 1791, p. 120

Geneva in Agasse's day – he was born there on 24 March 1767 – was a city with a population of some 22,000 huddled behind its ramparts, prosperous at last after going through harsh economic times and enduring repeated assaults on its freedom. Genevese society of the mid-eighteenth century, however, had just emerged battered and bruised from a difficult period, and was still reeling from the ructions between Voltaire and Rousseau, whose *Emile* was publicly condemned in 1762.[1]

Far from enjoying a blissful childhood in an idyllic age as his biographers fondly imagine[2], Agasse in fact grew up amid new political troubles which split Geneva down the middle. There were two opposing factions: the pro-Government Constitutionalists and the Representatives, a largely middle class group of opposition supporters made up of citizens and 'Natives', the Genevese-born offspring of foreigners denied all political rights. This internal strife made the eighteenth century known in Geneva as 'the century of discord'[3]. It culminated in the Pacificatory Edict of November 1782, dubbed *The Black Law*. All Genevese were obliged to take an oath of allegiance to the Edict or forfeit their rights. Agasse's father, Philippe, refused to sign it, however, and his name appears in the list of citizens and members of the bourgeoisie who opposed the new constitution.[4] His occupation is given there as *merchant,* which makes nonsense of Hardy's assertion that Agasse's father came from an aristocratic family and had neither a regular income nor profession, a notion later maintained equally strongly by Baud-Bovy.[5]

Philippe Agasse showed his dissenter's colours again when he became involved in the popular Irish exile of 1783.[6]

The troubles led a number of Genevese who were opposed to the conservative government to leave home and settle abroad, particularly in England[7]. Among them were the physicist Jean-André De Luc, François d'Ivernois, who became a British citizen, Etienne Dumont, and Mallet-du-Pan, who in 1798 founded the *Mercure Britannique* which published a great many articles calling for resistance to the French invasion.

Agasse was not to remain aloof to all these goings on. On his arrival in England he was to sign the letter written by the Genevese emigrants to 'the very honorable Lord Wawkesbury, Minister and Secretary of State at the Foreign Office', Kennington, 9 December 1801, calling on him to urge 'the French Government to give it [Geneva] back the independence it in no way deserved to lose.'[8]

A more detailed study of the part Agasse and his family played in the political events of the day may help to pinpoint the real reasons – other than the obvious attraction of England – for Agasse's self-imposed exile.

The artistic climate in Geneva

It is not really possible to talk of an art as such in Geneva before the eighteenth century. The reasons for this are historical, economic and geographical, and are as many as they are varied.

The Reformation adopted in 1536 and the hard line Calvin took on the cult of religious and mythological images alike between them ensured that interest in art remained at a very low ebb. The Chamber of the Reformation was set up in 1646 to see that Calvin's Sumptuary Laws were obeyed. It

curbed ostentation in every sphere, from furnishing to decorative or easel painting. It also laid down precise rules governing dress and personal adornment and forbade all architectural embellishment of private houses inside and out.

There are other reasons for the virtual non-existence of a peculiarly Genevese art. Although safe from the grasping clutches of the House of Savoy, Geneva was still struggling in the seventeenth century to hold on to its independence and was going through harsh economic times. It had to accommodate and feed a great influx of people who had fled France for religious reasons. Preoccupied with defending its freedom, Geneva was in no state to devote much of its energy to the arts.

The eighteenth century saw the threats of war recede and give way to a sense of ease. The descendants of the Huguenots who had had such an important part to play in the economic development of

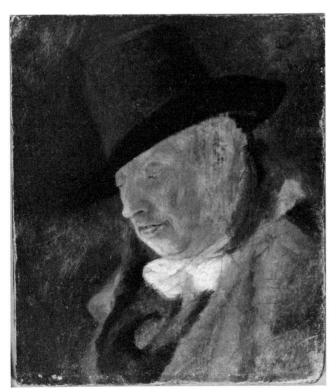

Jacques-Laurent Agasse: Portrait of Philippe Agasse, the artist's father. Private Collection

Geneva were by now perfectly integrated in the country which they had adopted and whose faith and ideals they shared. The Refuge gave Geneva a great many artists who were to have a major hand in the creation of a Genevese school of painting.

Notable among these were Liotard and Agasse, whose 'international' career took Genevese art out of its strict geographical boundaries and gave it much farther reaching dimensions.

A state drawing school opened in Geneva in 1751, with Pierre Soubeyran as its first director. He was very specific in his definition of the school's aims. These were closely linked to the interests of the craftsmen who formed 'La Fabrique', as he made clear when he declared, '... the arts we ought to foster are those which produce objects of commercial value - gold and silversmithing, jewellery-making, enamelling, gem-cutting and shaping, textile printing, etc. What governs the price of such objects and determines whether or not they will sell, and to whom, is the quality of the draughtsmanship involved. It is because of the drawing schools that similar manufacturing industries thrive in France. The one and only thing that will enable the manufacturing industries in this city to tower above local competitors which may spring up is a drawing school of our own.'[9]

In 1786 the Grand Council put the running of the drawing school known as the Ecole du *Calabri* into the hands of the Société des Arts. It is widely accepted that the school was a source of great stimulation for craftsmen, clockmakers, enamellers and jewellers. Its influence on the Fine Arts was negligible, however, contrary to the traditional view handed down from the nineteenth century and only recently disproved.[10] With the exception of Firmin Massot, the majority of Genevese artists either never attended the school or spent only the briefest of time there, like Agasse.[11]

With no Academy of the Fine Arts in Geneva, artists had to piece together an individual training of their own. For many this meant going to Paris: Jean-

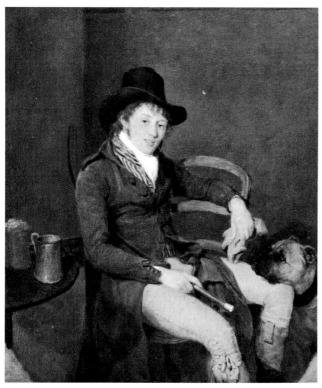

Firmin Massot and Jacques-Laurent Agasse: Portrait of Jacques-Laurent Agasse. Winterthur, Museum Stiftung Oskar Reinhart

Pierre Saint-Ours, for instance, studied under Vien, Adam-Wolfgang Töpffer under Suvée, and Agasse under David.

Agasse left Geneva for Paris in 1786. He was able to complete his training there in David's studio, thanks to the good offices of Jean Coteau.[12] His aunt, Louise Agasse, refers to his helpfulness in her Diary, '.. Visited by a M. Couteau [sic], a Genevese who has done my brother the most tremendous favour in persuading his son's teacher, the eminent History painter M. David, to take Agasse on as a pupil...'[13] A few days later she added, 'We are getting ready to call on Agasse's master, M. David and are lucky enough to be allowed to visit him in his studio. This is magnificently decorated with the two most beautiful pictures, one of the sons of Horatius vowing to their father that they will win, and the other of Belisarius being led by a begging child. These two pictures have excited the admiration of the connois-

seurs who rank M. David top of the list of painters. He thinks Agasse is naturally gifted.'[14]

Agasse emerged from his time with David with a solid training in draughtsmanship while neatly managing not to succumb to the lures of history painting except on a very few occasions. Such an aberration was the mysterious 'Phaeton', perhaps painted in collaboration with Massot and Töpffer, which is mentioned in a letter written to the latter from London on 29 November 1802, '... By the way, my sister will probably have told you that I finally dispatched the Phaeton. If those tedious features had not cost me so much to produce, there would have been a much tidier profit at the end of it. I think the way I have divided it up I make at least £1 more than you do, but my word! that is not a penny too much for all the trouble that daub has given me.'[15] This was followed much later by 'Androcles and the Lion', 'Alexander subduing Bucephalus', 'The Death of Adonis', and 'Remus and Romulus' (Cat. no. 18).

A Genevese school of painting

The Genevese painters who make up what is traditionally known as the Old Genevese school of painting[16] were essentially concerned with three distinct areas. Liotard applied his genius to the art of portraiture and revitalized it, shaking off the dourness which had marked it during the seventeenth century. Saint-Ours brought all his brilliance to bear on historical subjects. De la Rive broke new ground with landscape painting, declaring that 'landscape is the only possible subject for study for an artist fortunate enough to have been born in this beautiful country; he needs nothing more than the nature which surrounds him to find fame'. Landscape compositions still feature large in his own work, however, and clearly reveal the hold the historical and Italian traditions of painting continued to have on him.

The emergence of a truly Genevese school was really the result of the very close relationship -

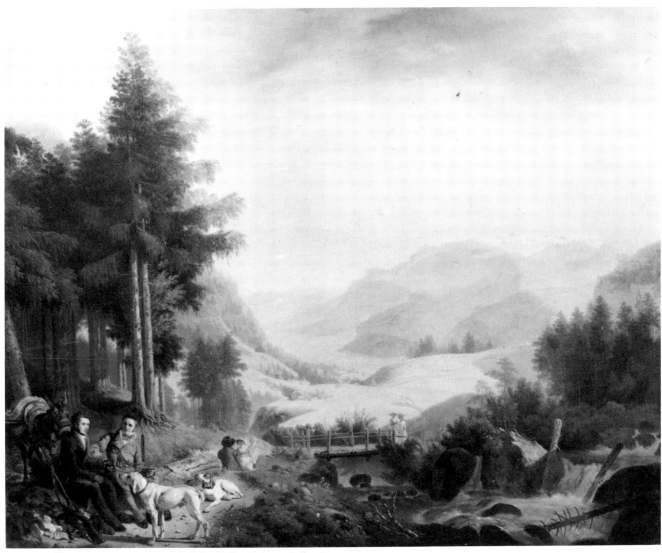

A.-W. Töpffer, F. Massot, J.-L. Agasse: Mégève Valley. Private Collection

sometimes marred by angry debates and rows, it is true[17] – which developed between Firmin Massot, Adam-Wolfgang Töpffer and Agasse. They were all equally influenced by each other as they exchanged ideas, methods and 'recipes', and it was in this pooling of talents that the Genevese school was to find its unity and its raison d'être. The three friends went off together on drawing tours of the countryside around Geneva, collaborated on pictures, often to remarkable effect (Cat. nos. 1, 2, 6 and 9), and had paintings on show in the same exhibitions.

So in August 1798 we find them all showing together, along with Saint-Ours and De la Rive, at the third exhibition organised in Geneva by the Société des Arts and the last to be put on before French annexation. Agasse had four pictures in the exhibition: no. 28 'Tumble from a Phaeton', no. 29 'Picture of Animals', no. 33 'Portrait of a Man with a Horse', and no. 114 'Dog'.[18]

Although by then settled in London, Agasse took part – with the help of his sister Louis-Etiennette who acted as intermediary – in the exhibition orga-

nised in Geneva in 1824 by the Société des Amis des Beaux-Arts, again showing alongside Töpffer and Massot, who were joined for the first time by the young landscape painter François Diday (1802-1877). Founded in 1822, the Société des Amis des Beaux-Arts aimed 'to encourage artists by buying good and appropriate examples of their work, and so to nurture talents which might one day enhance the name of our country and enrich our national heritage'.[19] Prospective members had to buy shares and the pictures were then drawn by a lottery. According to Du Bois-Melly, '213 shareholders paid their subscription, making it possible for 25 small canvases bought by the society to be drawn by lot after being on public exhibition.'[20] Agasse was represented by two pictures, "Stable Interior" (Cat. no. 16) and 'A Snowy Morning' (Cat. no. 43).

Agasse was to maintain artistic links with Geneva throughout his long English career, and regularly sent pictures to his sister[21] which Massot and Töpffer then undertook to sell through exhibitions[22]. The handbook of the Salon organised in July 1820 by the Société des Arts, for instance, lists 6 paintings by Agasse: no. 1 'Arab Horse in a Stable with Two Figures', no. 2 "Hunting Subject: Three Riders and their Dogs on a Marsh", no. 3 'Two English Coaches at a Standstill' (Cat. no. 34), no. 4 'View of Waterloo Bridge in London: Two Sailors Help a Young Woman out of a Boat' (Cat. no. 38), no. 5 'A Young Greyhound', and no. 6 'Several Studies of Animals under the same number".

Like his two friends, but some 30 years earlier[23], Agasse felt drawn to England. Thanks to his future 'patron' George Pitt, he was able to get his first taste of the independence and freedom of English painting as early as about 1790, and to see, as Töpffer was later to put it, that 'there is nothing these people dare not do'. Contact with English art brought about not only an overhaul of Agasse's manner and his palette, but also a profound change in his vision and his sources of inspiration.

A solitary figure

By a strange coincidence, the same epithets so often used of his compatriot Jean-Etienne Liotard could equally well be applied to Jacques-Laurent Agasse: original, unusual, isolated in a world which had no time for him, proud, and misunderstood by his contemporaries. Like Liotard, he too was ignored by the critics of his day, and it was not until 1904 that a detailed study was made of his work by Daniel Baud-Bovy.[24] It took an English art lover by the name of Charles Frederick Hardy, who was fascinated with his art and personality, to contemplate in about 1905 publishing a work entitled 'J.L. Agasse: his Life, his Work, his Friendship'.[25] It never reached publication unfortunately, but the manuscript survives (Geneva. Musée d'Art et d'Histoire) and still serves as an indispensable starting point and reference for all research. The first and only exhibition devoted to Agasse was in 1930.[26]

But what of Agasse the man? His character remains difficult to grasp even though in a great many respects he fits perfectly the picture of the typical Genevese conjured up by so many writers and travellers.

His physical appearance was unremarkable: 'height 5 feet 1 inch, eyebrows and hair both chestnut brown, oval-shaped face, grey-brown eyes, medium-sized mouth and nose.'[27] He was sensitive and ironic by nature, and mocking about himself and his disappointments: '... People tell me that my sudden success is making quite a stir with you [...] It is true that I now have quite a fortune considering the length of time it has taken me. But I am still in the same old boat I have always been in, because I still have not got a studio. For the last two months I have done nothing but chase around the place and I do not think I can take the slightest step forward as long as that is the case. As for making progress, I am not like you - I go backwards. I dare say the day my letter reaches you a good part of your household will raise their glasses to the poor devil I am!'[28]

His friend Töpffer fathomed his character better than anyone else. He went to see Agasse while on a visit to England in 1816, and gave a very affectionate account of his old friend and his doings in his regular letters home to his wife: '... We went to see Agasse [...] I found him little changed, still just the same man, not nearly as out of control or irrational as we were led to believe, I do not know why. He was very pleased to see me [...] I thought very highly of his work. He is busy, but he certainly has not been putting by a tidy fortune, far from it, if external appearances are anything to go by [...] He has the contentment of someone who lacks a great deal but who has looked to Philosophy to reconcile him to doing without the things he cannot have [...]'[29] Three days later he adds, 'I have seen a great deal of Agasse - the reputation he has in Geneva is quite undeserved. In some respects he is still basically the same, it is true, but one cannot help but admire his rectitude and virtue. His only fault is in not being in tune with the depravity of the century. He needs to be more flexible and unbend a little so that he can adapt more easily to circumstances. He has a well-earned reputation here as a leading horse painter and has the highest respect of all who know or met him...'[30] Töpffer seems to have been quite taken up with his friend's welfare, and he launches straight into the subject in a letter to his family written in June 1816: '... I am not in London at the moment so I cannot give you any news of Agasse, but I think I have told you about him in some of my other letters. He is still the same man, quite out of place in this corrupt world with his rather starchy honesty and boundless candour. There are few people worthy enough to appreciate him. His simple, understated virtues are not of this time - common people make fun of him and educated ones marvel at him [...]'[31] If Töpffer's account is to be believed, Agasse's avowed desire to return to his native Geneva was entirely heartfelt: 'He is certainly eager to come back to Geneva, but knows how difficult it is to find work. He has often spoken about it to me. You can see that he nurses the

Jacques-Laurent Agasse: Portrait of Louise-Etiennette Agasse, the artist's sister. Private Collection

idea to himself, but does not know how to put it into action. It is not that he is sick of this country, on the contrary, he likes it very much and has the highest regard for England and the English, but he feels the pull of his native soil [...]'[32]

Massot, on the other hand, was highly critical of Agasse's obsession with England, and openly questioned his professed love of Geneva when he observed, '... Agasse has not changed nearly as much as I was led to believe. He is still the same sort of man, still the same old Agasse, but even more so. Regardless of his visitor's patience, he carries on, still hooked on dogs, horses, animals and carriages. As for his Anglomania, it has degenerated into complete madness, Geneva never had a bitterer or more absurd detractor than him...'[33]

But the most touching account we have of Agasse is without doubt the one given by his sister Louise-

Etiennette in a letter to her cousin Louis-André Gosse in which she asks him to persuade her brother to return to Geneva: '... This is why I am convinced that if he had been able to show off his talents to full advantage when he first arrived in London, things would have been very different and he would have felt a different man. As it was, circumstances meant that he saw his peers in the worst possible light. He quickly came to despise their judgement to refuse giving in to them. He has thrown up fortune firmly in favour of art. He knows as well as anyone that 99% of the population are fools. He has never been able to understand, though, that you cannot change people and that you cannot go blithely along pretending you have nothing to do with them and following your own brilliant notions and inspiration, but that what you have to do instead is work with them as long as they are useful to you. Self-evident though this may be, my brother is so set in his ways that he will never try it so I have given up urging him to. I now confine myself to persuading him to leave this Country where all he gets is fame and no money, and return to his homeland where he can be sure of finding both. I am always being confronted by circumstances, dear friend, which convince me that this is not a groundless hope I am offering him, but that all it needs to turn it into a reality is for him to say 'yes'. I base this on the steady stream of praise his work receives. The majority of foreign artists who come to call are Frenchmen prompted to come by his reputation which they find more than justified when they see his work. They are unanimous in their praise, all say they have never seen anything to rival his pictures for truth to nature, all believe that the man who painted them is at the top of his class. I am fairly sure that if my brother had a well-presented studio with an array of striking drawings and paintings on the walls of the sort I know he has, he would have a great many visitors and do a good trade with the crowds of foreigners passing through or staying here. It is not that I imagine he would sell an enormous number of paintings this way - I know

that always depends on luck - but there is no doubt in my mind that he could give as many lessons as he chose to, and could charge a handsome fee for each. When they have asked me if he is coming, a number of his fellows have given me the impression they wished he had stayed where he belonged [...]'[34]

Louise-Etiennette emerges from this document as a caring and devoted friend, but one without any illusions about her ability to influence her solitary brother. She was to visit Agasse in London in 1837, in a bid to persuade him to return to Geneva perhaps, and very probably again in 1841.[35]

There are still a great many unknowns in Agasse's life and work: was he really, for instance, as 'isolated' in England as tradition would have us believe, or was it, on the contrary, an atmosphere which he found particularly suited to his lifestyle and conducive to his work? Was he influenced by England? Certainly, but less than it might seem. England was a form of escape for him, but he found a style there.

Looking at the very best of his work we can now place him as an artist - here is a painter who combines a tremendous feel for nature with a matchless 'understanding' of animals.

As Baud-Bovy lucidly observes of Töpffer, Massot and Agasse, the most important thing, in the end, is the 'remarkable way these three artists, Genevese by birth and tradition but with their artistic and cultural roots in France, should have reflected the influence of the English masters in their work as early as the beginning of the century, when there was to be no evidence of this in France for another twenty years. And, to our mind, the unsung glory of the Old Genevese school is that it beat its rich relation, the French school, to a discovery which was to be equally profitable in relative terms to them both, which gave the French school the triumph of ushering in the landscape movement in 1830 and brought the Genevese school the very best work its founders could produce [...] and which made of Agasse, if we are not mistaken, one of the most touching and lyrical of all modern animal painters.'[36]

Translated by Fabia Claris

1 See particulary François d'Ivernois, *Tableau Historique et Politique des Révolutions de Genève dans le XVIII⁰ Siècle... par un Citoyen de Genève,* Geneva, 1782.

2 Cf. Daniel Baud-Bovy, *Peintres Genevois, II⁰ série,* Geneva, 1904, p. 94, and Hardy Ms., p. 6.

3 Cf. Jean-Pierre Ferrier, 'Le XVIII⁰ Siècle, Politique Intérieure et Extérieure', in: *Histoire de Genève des Origines à 1798,* Geneva, 1951.

4 Quoted by Robert Felalime in: *La Genève de mes Ancêtres,* Geneva, 1979, p. 253: 'List of Citizens and Burghers who refused to take the oath required by the Edict of 1782': 'No 76, 3 January 1785, Agasse, Philippe [s. of. Etienne] B[ourgeois]. Merchant.' The original document is in the State Archives in Geneva [AEG].

5 Cf. *op. cit.,* p. 94. It is true that Philippe Agasse married Catherine Audeoud whose family were of Huguenot descent and had been made members of the Bourgeoisie as early as 13 February 1704.

6 Council Record, June 1783, pp. 552, 560, AEG. I am grateful to Danielle Buyssens for pointing out this document to me.

7 On the relations between Geneva and England, and on Genevese emigration there, see Bernard Gagnebin, 'Les Relations entre Genève et l'Angleterre' in *Atlantis,* April 1946, no. 4.

8 Dumont Ms. 39, fol. 41 to 47, BPU, Geneva. Also on the letter are the signatures of the two Chalon brothers, James and Alfred-Edward, along with that of their father. It is also worth noting that in his *Journal pendant l'Emigration,* published by Baron Portalis in Paris in 1910, about the French emigration to England, Danloux mentions Agasse as one of the circle of emigrants who met up in his studio.

9 Report on the state drawing School, 25 February 1762, Jalabert Ms. 77/3, p. 8, BPU, Geneva.

10 Cf. Anne de Herdt, *Introduction à l'Etude du Dessin Genevois, de Liotard à Hodler,* in *Geneva,* ns., 1982, p. 22 and following.

11 See Lucien Boissonnas's introduction to 'Agasse as Draughtsman' in this catalogue, p. 194.

12 Jean Coteau, born Geneva 1739, died after 1812. He was an enamel and porcelain painter who seems to have worked almost exclusively in France. For more about him, see Léo R. Schidlof, *La Miniature en Europe aux 16⁰, 18⁰ et 19⁰ Siècles,* vol. 1, Graz, 1964, p. 174. Agasse had lodgings with Coteau during his time with David. Cf. Louis Reau, *Histoire de l'Expansion de l'Art Français,* vol. II, Paris, 1928, p. 292: 'Alphabetical List of Swiss Artists enrolled at the Paris Academy: 'Jacques-Laurent Agasse, 5 September 1787, Geneva-born painter, aged 20, living with M. Coteau, an enameller. M. David's pupil.'

13 Louise Agasse, Diary of a journey to Paris in 1786, Ms. 2613, BPU, Geneva, no page numbering.

14 *Idem.*

15 Letter from Agasse to A.-W. Töpffer, George Street, Portman Square, London, 29 November 1802, 1638 Ms., BPU, Geneva.

16 See Danielle Buyssens, *Catalogue des Peintures et des Pastels de l'Ancienne Ecole Genevoise de Peinture,* Geneva, 1988.

17 Cf. Danielle Buyssens, 'Une Main de Trop pour un Portrait', in *Genava,* ns., vol. XXXV, 1987, pp. 49-53.

18 *Notice des Tableaux et des Portraits exposés dans le Sallon* [sic] *de la Société des Arts* [hand-written], lst compl. day, from 6 to 9 Vend., Year 7 (Société des Arts Archives).

19 Cf. Charles DuBois-Melly, *De la Rive et les Premières Expositions de Peinture à Genève,* Geneva, 1868, p. 24.

20 Cf. *op. cit.,* p. 24.

21 There are 20 items in the inventory of Louise-Etiennette Agasse's estate carried out after her death in April 1852 which relate to pictures by Agasse (Minutes of the notary A.J.E. Richard, lst half-year of 1852, no. 16, act no. 136, fol. 5 recto and verso, AEG).

22 Cf. Madame Gosse's letter of 7 August 1814 to her son Louis-André: 'Our London courier has sent a picture to his sister which she is to sell through MM. Massot and Töpffer. It is of a stable in Germany with a horse at the manger and a young German tugging at a second horse to make it come in. The attitudes are so true to life and the painting is so perfect that it all seems real. The stable paraphernalia, too, is all wonderfully done. We must see what the painters have to say about it.' Baud-Bovy Archives 158, BPU, Geneva.

23 Töpffer, for his part, was to stay there in 1816 at the invitation of an English art-lover called Mr Divett who bought a great many of his paintings. Massot, meanwhile, was to make a visit to Scotland in 1828 to see the Marquess of Breadalbane.

24 Daniel Baud-Bovy, *Peintres Genevois 1766-1849, II⁰ série,* Geneva, 1904, pp. 89, 130, 141, 148.

25 Ms. in the Musée d'Art et d'Histoire in Geneva.

26 Musée d'Art et d'Histoire, Geneva, *Exposition d'Oeuvres du Peintre Genevois Jacques-Laurent Agasse (1767-1849) appartenant à des Collections Privées, à l'Ariana et au Musée d'Art et d'Histoire,* 7 p.

27 Cf. Ticket of passage no. 2295 issued on 22 December 1798 to Jacques-Laurent Agasse, citizen of Geneva, 1798 Chancellery, no. 4, p. 557, AEG.

28 Letter from Agasse to Adam-Wolfgang Töpffer, George Street. Portman Square, London, 29 November 1802, ... Ms., BPU, Geneva.

29 Letter from Adam-Wolfgang Töpffer to his wife, London, 25 May 1816, Ms. suppl. 1638, fol. 101-2, BPU, Geneva.

30 *Idem,* fol. 103-4.

31 Letter from Adam-Wolfgang Töpffer to his wife, Bystock, Devon, 21 June 1816, Ms. suppl. 1638, fol. 105-6, BPU, Geneva. Part of this letter is also reproduced in Baud-Bovy, *op. cit.,* p. 111.

32 *Idem,* fol. 106.

33 Letter to Mme de Geer, née Massot, London, 8 June 1828, signed Ms. 1945/35, BPU, Geneva.

34 Letter (only fragments of which survive) written from Geneva and dated 16 August 1819, Ms. 2666, correspondence of C.-A. Gosse, fol. 9-11, BPU, Geneva.

35 Cf. Passport application, Geneva, 12 May 1837. 'Passport issued this day to Mlle Louise-Etiennette Agasse, a lady of independent means, accompanied by her maid, born and resident in Geneva, travelling to London by way of Paris. Description: 64 years old, medium height, chestnut brown hair, high forehead, chestnut brown eyebrows, brown eyes, medium-sized nose and mouth, round chin, oval-shaped face, ordinary colouring. Valid for 1 year at her request.' Chancellery Ab 1837, no. 34, AEG.

36 Cf. *op. cit., Peintres Genevois,* p. 18.

Danielle Buyssens
The Shaping of an Aesthetic Identity

Painters work for Art-Lovers:
it is Art-Lovers who make a Painter's name

F. Tronchin, *First Lecture on Painting,*
31 December 1787

While Jacques-Laurent Agasse was undergoing his training as an artist, his native city was also being educated: in the midst of all the social, political and economic upheaval of the eighteenth century, Geneva was learning to appreciate art.

1. The first cautious steps

Private collections had, of course, long been in existence despite the severe sumptuary laws, but Calvin's city was forthright in its lofty contempt of the fine arts, and art lovers kept a low profile in Geneva, taking care not to let their private lives interfere with their public duty. So we find even the famous François Tronchin (1704-1788) voicing his uncertainties about the future of his collection to his brother, and wondering if he should really leave behind him this 'dangerous invitation' to the upright citizens of Geneva to deviate from the path of righteousness.[1]

The structure of these collections reflected the outward-looking nature of the fine arts in Geneva: pictures by Genevese artists make a very late appearance in the collectors' catalogues. These people were truly cosmopolitan: they bought pictures by foreign artists and they bought them abroad.

Very few artists actually born in Geneva were able to make a career there for themselves at this period. One notable exception was the portrait painter Robert Gardelle (1682-1766), to whom Genevese flocked in enormous numbers, and who poured out an ever-increasing stream of gloomy likenesses of stern faced sitters on his return to Geneva, only

rarely bursting out with anything that really deserved to be called a picture. It is clear from a handful of pictures, though, that he once aspired to something greater. We can see a possible court painter in the portrait of him as a young man painted in Germany by David Le Clerc[2], and this was a future he clearly could have had on the evidence of the work he produced under Nicolas Largillière in Paris.

Geneva offered little encouragement to artists and for the most part Genevese painters preferred to travel elsewhere to learn their craft and find buyers for their work. Writing in 1770, Pierre Soubeyran was keen for there to be no misunderstanding about the scope of the newly opened Ecole de Dessin of which he was the first President - it was to be nothing if not narrow: 'It has never been our aim here to turn out first-class Sculptors or Painters..., because there is no call for them in Geneva; what we need are Artists who will produce sound Commercial pieces, and work for the good of the city and not for some god of Beauty.'[3]

Responsibility for the Ecole de Dessin was to fall next to the Société des Arts, founded jointly in 1776 by a learned aristocrat called Horace-Bénédict de Saussure and a clockmaker called Louis Faizan. Its declared aims were to encourage the development of Geneva's various manufacturing industries - essentially the watch and jewellery-making trades headed by 'La Fabrique' - and to foster a spirit of competition among them. It is true that the Société opened its doors to artists in 1778 when it started up a life drawing class, but they were only being offered a sort of taster, '...at least then they can be ready to get the very most from the Schools in Paris and Rome.'[4]

A few private classes had sprung up by this time. The most famous, at times legendary, one was run

by Nicolas Henri Fassin (1728-1811), a very mediocre painter from Liège known as the 'Chevalier', who was credited with training a veritable army of artists during the very short stay he made in Geneva in 1769-70.

2. The upheaval of the revolution

Less than twenty years later, at the height of the Revolution, the fine arts suddenly obtained access to the Genevese public life. Contrary to what one might expect, moreover, it was the reactionary aristocratic elite who were largely responsible for this dynamic turn of events.

The widespread and repeated bursts of unrest which had gathered momentum towards the end of the eighteenth century came to a head in 1782 with the initial overthrow of the oligarchic government. It was essentially a lower and middle class revolt spear-headed by the highly skilled craftsmen and small tradesmen who formed the elite of La Fabrique. The government was re-established with the help of foreign powers and imposed a very repressive régime. Life was made harder still by the severe economic difficulties which beset the country from 1787/8 onwards.

As a result of the troubled events of 1782, the Société des Arts was re-organised and brought under government control in 1786. This piece of state intervention was clear evidence of the deep suspicion with which the government regarded the activities of the Société and of its determined resistance to the social and economic reforms demanded by the craftsmen.

The first person appointed by the government to run the Société des Arts was François Tronchin, a leading member of the reactionary 'Negative'[5] party. He seems to have decided to agree to the lesser of the two evils confronting him and allow minor reform . He directed all his efforts towards making the Société a strictly artistic concern: one of the first things he did was to deliver to the Société's general meeting a series of lectures exclusively on the subject of painting.[6]

There was still no question, however, of letting the people of Geneva see any of the foreign art which represented the bulk of the private collections. The three 'Salons' organised by the Drawing Committee of the Société des Arts in the closing years of the eighteenth century centred on the work of Genevese artists, and so can be said to have fulfilled the Société's declared aim of encouraging local 'arts' in this respect at least.[7]

The purpose of this essay is not to discuss the political strategy which led to the sudden catapulting of the arts into the public eye, but rather to examine the way in which this taste for art was apparently suddenly and miraculously 'imported' into Geneva - by looking at the choice of works held up as examples of good art, and at the way these were used to mould the public's aesthetic judgement.

3. An identity for Genevese art

The Société des Arts was so keen to establish the concept of a truly Genevese art that it was only with a certain reserve that it allowed the work of foreign artists who had been or were living and working in Geneva to be included in the Salon of 1789. In its report the Drawing Committee was to express its 'hope that in a year or two there will not be any hanging space for them, it will all have been taken up by Genevese.'[8]

Some people were even unhappy to find pictures by Fassin on show, as is clear from a comment written by an 'art-lover' published in the *Journal de Genève:* 'I was very pleased to see three pictures by M. le Chevalier de Facin on show there, and if some of the people around me seemed to regard him as an intruder in this exhibition that is because they are ignorant of all that we owe him. It was his visit to Geneva from 1769 to 1770 which gave our talented young artists the chance to flourish.'[9]

In fact this line of reasoning springs from the

same concern as the discrimination it sets out to attack: the need to demonstrate at all costs that the art on show comes from Geneva, even if this means implicitly denying that the artists could have studied anywhere else.

But is the fact that it was produced in Geneva really enough to make this a 'Genevese' art? And what critical standards are in fact being applied to it? Are these paintings being judged alongside pictures from other schools, or should they be considered in isolation as constituting a peculiarly (albeit nascent) local form?

Councillor Lullin, Vice-President of the Drawing Committee, clearly plumps in his report for the second approach. Avoiding all comparisons which might in any way show up Genevese art, and putting the emphasis firmly on the future, he declares, '... that this exhibition has already proved (...) that the Directors of our Academy can not only give our Pupils good advice but they can also set them a fine example to follow; that there are and will be painters able to tackle the beauty of our area and of the surrounding countryside in the way it deserves to be; and that should we ever want to commemorate in paint a particularly outstanding instance of courage or bravery in the contemporary history of our little republic then we would find painters of our own blood more than equal to the task.'[10]

If the Councillor feels bound to talk about the future it is because of the difficulty of talking about Genevese painting in any other terms at this stage, and certainly as a school with a clearly defined framework of standards and points of reference. There was as yet no past to provide a point of comparison or contrast and so help speed up the critical process.

Although the critics of the day may have felt the lack of any local tradition, however, it was not because there was a dearth of 'ancestors', but because these, once denied, were not easy publicly to reinstate.

The famous Genevese pastel painter Jean-Etienne Liotard (1702-1789) died just before the opening of the 1789 Salon and one of his self-portraits was subsequently included in the show and another of his works in the 1794 Salon. The aim was perhaps to put Genevese art into 'its historical context'. There is no mention of him in any of the contemporary reviews, at all events, unlike the miniaturist Jean Petitot (1607-1691) who was often quoted as a reference in his field.

Of course, Liotard's popularity waned along with that of the other artists of his generation: Neo-classicism had already swept them firmly aside. His reputation was to be re-established in the nineteenth century, when the concept of a peculiarly Genevese 'aesthetic identity' was finally born. Liotard was then heralded as a typically Genevese painter 'with a regard for accuracy no Frenchman ever possessed.' But until then he was probably considered first and foremost as a typical product of the cosmopolitanism so favoured by the Age of Enlightenment.

While the craft of miniature had enjoyed more than a century of respectability, and it was perfectly possible to mention Petitot's name, to bring up Genevese artists 'of the past' would have been tantamount to rejecting publicly as groundless all the fears that had once been expressed about the fine arts. The reviews of the day, at all events, prudently steer well clear of such a delicate subject and say nothing of the artists who were too quick to defy the ban.

4. The adoption of a theory of aesthetics

Attractive as it might be, then, the idea of an art suddenly springing up of its own accord, without reference to anything else, was not one which served any useful critical purpose. It failed to provide any standards by which to assess the quality of different works of art, but had the advantage, instead, of glossing over the number of artists who were actually trained in other schools.

Many critics turned away from home, therefore, and found a frame of reference in the various theo-

ries of aesthetics formulated abroad. Two such were the 'art-lovers' whose views were published in letters to the *Journal de Genève*.[11]

Their letters are couched in the most popular style of the day - a neo-classical rendering of the Italian mode of criticism - and praise works for being '*grandioso*'or displaying 'majesty', 'elegance', 'beautiful order', 'richness of composition' or 'brilliance of execution'.

More revealing of their general philosophy is the fact that only Poussin and Wouwerman are held up (by the author of the first *Letter)* as figures to emulate: both artists of undisputed standing, who ceased from this moment to be identified with their respective schools but became part instead of some great artistic pool of the past. The furthest the second of the writers was prepared to commit himself was in advising the young Firmin Massot (1766-1849) to go to Rome where he would find 'models and masters to follow in the many pictures there and in our compatriots Saint-Ours and Vaucher [...]'

He distinguishes himself, however, by delivering a virulent attack on Geneva when he counsels Massot with these words: '...I would urge him to leave Geneva: he has nothing and nobody to emulate there, he is wasting his time.' Yet the people he urges him to look to in Rome are his 'compatriots' Jean-Pierre Saint-Ours (1752-1809) and Constant Vaucher (1768-1814): this is surely tantamount to acknowledging that the artists of Geneva had already mastered the neo-classical theory of art for themselves.

In this way the art-lovers and 'enlightened' artists, at least, managed through their use of language to allude amongst themselves to a set of values which they could then apply to art without making any direct reference to anything or anyone remotely compromising. It should be stressed that this clandestine adoption of a theory of aesthetics served the purposes of artists and art-lovers alike: the Genevese could take all the credit for producing the theory, and, because the whole process of 'importing' it had been so covert, it could be kept and used as a piece of private knowledge by a privileged few.

5. A call to nature

The art-lovers obviously sought to promote more than their own personal enjoyment of art. In publishing their ideas, they were hoping to broaden the horizons of people at large. To achieve this, they had to educate the public and, more fundamentally, convince them that an interest in art was a worthwhile end in itself.

Their pronouncements were also directed at artists, and here too the aim was to mould or even programme their way of thinking. Commenting on the approach adopted by the first we find the second author writing, 'The few criticisms he makes and the way he makes them cannot help but be of great use to Artists (...), especially since they spring from a man familiar with nature.'

Both men point in a series of such oblique references to the study of nature as being the proper business of art. The first even goes so far as to give Fassin as a teacher the credit for initiating the move away from studio study to work direct from 'our beautiful countryside'. We know perfectly well, however, the importance the latter attached to copying the Old Masters in general and the Dutch in particular.[12]

It would be as wrong of us to see their writings as an early call to Realism. The nature they are talking about is a 'carefully chosen' and 'ordered' one, in keeping with contemporary ideals.

Although they were symptomatic of the general 'revivalist' tendency which was sweeping Europe, these repeated calls to artists to work from nature undoubtedly had very specific local implications. By 'returning to nature' the Genevese could conveniently distance themselves from the foreign schools and their 'mannerist' ways - for, in spite of everything, it was still vitally important gradually to make this break.

'Mannerism' is explicitly rejected and 'truth' advocated in its stead by Tronchin in the first of his *Lectures* to the Société des Arts in 1787, when he declares that 'Painters are distinguishable one from another only by the particular 'manner' of seeing and painting nature which each adopts and makes his own. If a picture can be identified as the work of an individual artist it is because the differences which exist between his weak copy and the perfect original from which it is taken have betrayed him. There are no *manners* in nature: the sort of painter I would prize above all others would be one I was never able to recognise.'[13]

Tronchin extends the same logic to the field of art appreciation and is as exacting as ever in his requirements. He concedes that a knowledge of the different manners is necessary in order for the critic to be able to distinguish between the various schools and artists, but stresses that the '*critical* Art-Lover' must not allow himself to be swayed by any of these superficial elements, '...I believe that in a great many instances the *critical* Art-Lover's eyes are better than the Artist's: the impartial Art-Lover judges a picture on its faithfulness to nature alone ...'[14]

6. The wind of independence blowing from England

This blacklisting of 'Mannerism' undoubtedly owes a great deal to William Hogarth (1697-1764) who denounced it thus in the introduction to his *Analysis of Beauty* published in 1753: 'What are all these *manners,* as they are called, of which even the greatest masters are guilty, and whose only virtue seems to be that they differ as much from one another as they do from nature, if not strong proof of the dogged attachment of these artists to an error which their overweening conceit transforms, in their eyes, into an established truth?'[15]

Tronchin is so close to Hogarth in his thinking that it seems more than likely that he read Hogarth's treatise when it first appeared. It was certainly not long, at all events, before its sentiments were echoed in Geneva: 'Hogarth's remarkable work entitled *An Analysis of Beauty* was often quoted but had never been translated'[16], declared the editors of the *Bibliothèque Britannique* which published much altered extracts from it in 1799.[17] The artistic community was also quick to acknowledge its debt to Hogarth. Adam-Wolfgang Töpffer (1766-1847), for example, was dubbed 'the Hogarth of Geneva' in 1802[18], and, like his son Rodolphe (1799-1846)[19], readily admitted the influence of Hogarth's *Analysis* on his work.

The *Bibliothèque Britannique or Selection of Extracts from English Periodicals and other Sources...* was started in 1796 in order to 'make England's literary and scientific output accessible to people on the continent'.[20] The aim was to include pieces which could be used to shape current thinking on a range of intellectual issues, as a quick survey of the 'Littérature' series published at the end of the eighteenth century makes plain. There are pieces inviting comparison and even emulation of different theories of art and of course gardening; others designed to promote the concept of the 'useful arts'; others still weighing up the relative merits of the Arts and Sciences; and others, finally, clearly defending literature against the thinly-veiled criticisms of Rousseau.

Sometimes these translations and reports embody exactly ideas which had been put forward in the same way a few years earlier in the *Journal de Genève*.[21] On a more general note, with their informing principles of 'interest and especially utility',[22] they give us a good indication of the prevailing concerns of the day.

It is very interesting, therefore, to find two articles in the 1799 issue devoted to Joshua Reynolds (1723-1792)[23] who shared Hogarth's views on Mannerism and urged artists to eschew a slavish imitation of the Masters[24]. The Genevese painter and miniaturist Pierre-Louis Bouvier (1766-1836), a friend of the Töpffers and like them eager to be free from the constraints of convention, was to include Reynolds' writings in his 'List of works on Painting which I recommend reading' appended to his *Manuel des*

Jeunes Artistes et Amateurs en Peinture published in 1827.[25]

7. The attraction of England

The Genevese had always had an understandable religious sympathy with the English, but during the eighteenth century they became veritable Anglophiles,[26] reflecting in microcosm the pattern of things in the rest of Europe: France no longer reigned supreme, and attention was increasingly being focussed on England. There were numerous contemporary descriptions of this wave of interest in England[27]. The account given by Louis Simond, a Frenchman who stayed in Geneva in the first years of the Restoration before settling there for good some time later, is typical: 'The Genevese are naturally well-disposed towards the English: their religions, styles of government, and customs bind them together with mutual ties of sympathy and friendship. Moreover, they are not neighbours - a negative condition vital if there is to be good understanding between nations. A great many young Englishmen used to be educated in part in Geneva; an even greater number of Genevese used to go to England in pursuit of their fortune, or of learning, and most well brought up people of both sexes understand the language.'[28]

The artists and craftsmen of Geneva were not slow to head for England. Jean Petitot (1607-1691) was the first of many to visit England and settled there for a long time. After him came Jean-Etienne Liotard (1702-1789) who stayed there on two occasions. Barthélemy Du Pan (1712-1763) painted at the court of George II. Louis-Ami Arlaud (1751-1829) spent nearly ten years in London. François Ferrière (1752-1839) lived there for six years, staying for some of this time as a lodger with the Chalons, a Genevese family with two painters to its name, Jean-Jacques, known as John (1778-1854), and Alfred-Edouard (1781-1860), a family that was later to take in Jacques-Laurent Agasse. Much shorter visits were in

order after the Restoration for Adam-Wolfgang Töpffer (1766-1847), Firmin Massot (1766-1849) and Amélie Munier-Romilly (1788-1875). To this admittedly selective list we should also add those artists who had long-standing English friendships, like Jean Huber (1721-1786), famous for his prodigious output of wickedly mocking images in the spirit of Voltaire, and his son Jean-Daniel (1754-1845).

The 'English fever' reached its peak when the revolutionary unrest was at its height. The 1782 exiles fled to England to escape the repression that followed the re-establishment of the old regime, and were welcomed with open arms by what they saw as the land of independence and freedom. Not long afterwards, England was to be hailed as a model of political stability and attract in its turn all those opposed to the ideas generated by the French Revolution which had taken Geneva by storm.

The founding of the *Bibliothèque Britannique* shortly after the second Revolution in Geneva, at a time when the threat of French rule was beginning to come home to people, amounted to a quasi militant demonstration of the special relationship which existed between Geneva and England. After annexation, the publication was to represent one of the forms of 'passive resistance' open to the Genevese.[29]

8. From theory to practice

It would be wrong, however, to talk in terms of English art influencing the aesthetic judgement of François Tronchin or any of the other Genevese artlovers. They seem to have been more interested in the 'theoretic approach' than in the works themselves. This tendency is clearly reflected in François Tronchin's first *Lecture*. In a passage which comes just before his celebration of nature as the supreme value in art, he draws up a list of the 'schools' which anyone aspiring to the title of 'Connoisseur' must be able to identify. The Italian school heads the list of course, and is given detailed sub-divisions. Next comes the Flemish school, in which he includes

Dutch painting. This is followed by 'the German and Swiss Painters, and a few English Artists' he yet finds worth singling out. Well and truly bottom of the list comes the French school, given only a bare mention.

The reference to English painters, as indeed to German and Swiss artists, seems really only to be a sort of 'goodwill gesture', however. They were not to be alluded to again. Tronchin was to hold forth at length instead in his second *Lecture* on the respective merits of the Italian, Flemish and Dutch schools. Even the French school gets a mention - admittedly as a fine example of an art following the dictates of fashion and seeking above all to create an 'effect'.

It would certainly be premature to talk of an 'English school' as such developing around a group of artists sharing particular qualities, a distinctive 'manner' no less. What Tronchin was after at this juncture, meanwhile, was a philosophy linked to the idea of a school.

The lack of references to English art is perhaps also attributable to the meagreness of its standing on the continent at that time: it would surely have been 'improper' to put it on a par with the types of painting then being trumpeted as standards of excellence in Europe, and to do this would undoubtedly have been to cast doubts on the judgement of a supposed connoisseur.

Tronchin was caught in a terrible dilemma: if he agreed with Hogarth's views on Mannerism, then he would have by the same token to accept his utter rejection of the concept of connoisseur. It was precisely in this capacity, however, that he himself had intervened before the Société des Arts. A close reading of his first *Lecture* reveals him to have been very ill at ease with the concepts of the 'Art-Lover' and the 'Connoisseur' and shows him switching from one to the other in a bid to decide which is more meritorious.

For all his protestations of impartiality, Tronchin is unable ultimately to conceal his particular fondness for the Dutch school and it is Dutch paintings which at that time take the prize for truth to nature with 'their quite outstanding, highly alluring finish and their incomparably harmonious use of colour'.[30]

We should not hope therefore to find in the works of Tronchin or of the two art lovers of 1789 the seeds of a 'modern' theory of art or the first hint of the great Romantic movement which England was to have such a hand in launching. They were all three - and particularly Tronchin, who was noticeably more conservative than the other two - manifestly keen to adopt a well-established set of values.

The movement was already afoot, though, and young eyes were quick to turn to English art. An 'English naturalism' has already crept into the 'Portrait of the Young Misses Mégevand' painted jointly in the early 1790's by Firmin Massot, who provided the figures, Adam-Wolfgang Töpffer, who contributed the landscape, and Jacques-Laurent Agasse, who was responsible for the dog.[31]

In the end, the dilemma in which Tronchin and the two art-lovers are caught may consist of wanting to satisfy two mutually exclusive desires. They seek on the one hand to be guardians of quality, watching over the standards both of the pictures themselves and of their own scholarship, while on the other they demand that Art should once more follow nature. It was a dilemma that was not easily to be resolved, and it was only after a great deal of critical debate that the Genevese version of the Romantic theory of art began to emerge in the nineteenth century.[32]

Translated by Fabia Claris

1 Letter from F. Tronchin to his brother Jean-Robert, dated 10 March 1786 (Lavigny Archives, Private Collection), quoted by R. Loche in *De Genève à l'Ermitage, les Collections de François Tronchin,* written in conjunction with M. Pianzola as a catalogue to the exhibition held at the Musée Rath in Geneva in 1974. For more on Tronchin, see also M. Natale, *Le Goût et les Collections d'Art Italien à Genève du XVIIIᵉ au XXᵉ Siècle,* Geneva, 1980, pp. 15-25.

2 Collection of the Société des Arts, Geneva, repr. in *Nos Anciens et leurs Œuvres,* vol. X, 1910, p. 36.

3 *Sur le Dessin d'après le Modèle Nu dans l'Ecole de Dessin,* 1 February 1770, Jalabert Ms. 77/1, p. 66, BPU. For the history of the Ecole de Dessin, see A. de Herdt, *Dessins Genevois de Liotard à Hodler,* exh. cat., Musée Rath, Geneva, 1984, pp. 35-36.

4 *Précis Historique de la Société pour l'Avancement des Arts,* Geneva, 1792, p. 8.

5 The party owes its name to its unremittingly 'negative' response to the demands for social and political reform made by the lower middle classes.

6 'De la Connaissance des Tableaux', delivered on 31 December 1787, 'Des Caractères Constitutifs qui Distinguent les Ecoles de Peinture', 24 May 1788, and 'De la Conservation des Tableaux', no date, published together in a pamphlet entitled *Discours Relatifs à la Peinture* in 1788.

7 For more on the first exhibitions to be held in Geneva, see P. Chessex, 'Documents sur la Première Exposition d'Art en Suisse: Genève 1789' in *Zeitschrift für Schweizerische Archäologie und Kunstgeschichte,* 1986, Bd. 43, H 4, pp. 362-6.

8 'Extraits des Rapports qui ont été faits à l'assemblée générale des Associés Bienfaiteurs de la Société pour l'Avancement des Arts, le 24 Septembre 1789', *Supplément au Journal de Genève* of 17 October 1789, p. 4.

9 'Lettre adressée aux Rédacteurs', *Journal de Genève,* no. 41, Saturday 17 October 1789, pp. 169-70.

10 *Op. cit.*

11 *Op. cit.,* and 'Lettre adressée aux Rédacteurs' in *Journal de Genève,* no. 43, Saturday 31 October 1789, pp. 176-7.

12 See letter from N.-H. Fassin to F. Tronchin, 5 June 1776: 'Forgive me for always turning to Wouvermans, Berghem and Both. I am such a keen follower of these masters that I only ever refer to Nature when it looks as it does in their pictures.' (Tronchin Archives, 191, no. 10, f. 208, BPU).

13 *Op. cit.,* p. 8 (the word 'manners' is underlined by the author).

14 *Ibid.,* pp. 8-9.

15 Translation by Olivier Brunet, Paris, 1963, p. 157 [p. 6 of original edition]. The first complete but rather corrupt French version was published in Paris in 1805 by the Dutchman Hendrik Jansen.

16 'Littérature' series, vol. XIII, Year VIII [1800], Preface, p. 9.

17 'Analysis of Beauty, etc. An analysis of beauty written in order to clarify the rather vague ideas on taste presently current. By W. Hogarth', published in three extracts in the series on 'Littérature', vol. XI. Year VII [1799], pp. 333-63, 454-76, and vol. XII,

Year VII, pp. 42-62. This is what the copy editor responsible had to say of the job of preparing the extracts for the French press: 'Hogarth was not a writer and had more ideas than method. We have tried to express his train of thought as clearly as possible, following a more natural order, and making cuts from time to time.' Hogarth's account of manners scarcely figures at all; all that is left of it is this very loose reference: 'Hogarth complains in his introduction of the prejudice and stubbornness of professionals and declares that his work is directed particularly at those who have as yet neither preconceptions nor technical knowledge where art is concerned.' (First extract, p. 344).

18 See T. C. Bruun-Neegerard, *De l'Etat Actuel des Arts à Genève,* Paris, 1802, p. 11.

19 See Anne de Herdt, *op. cit.,* p. 57, note 69.

20 *Bibliothèque Universelle,* Prospectus, 1836, p. 1.

21 The *Journal de Genève* appeared in its first form from 1787 to 1794; there were two further issues in 1796; it was then the organ of the Société des Arts.

22 Vol. XIII, Year VIII [1800], Preface, p. 3.

23 'Notice sur le Chevalier Reynolds', Vol. X, Year VI [1799], pp. 355-60; 'Caractère de Sir Josué Reynolds (par Jackson)', preceded by 'Caractère du Peintre Gainsborough (par Jackson)', vol. XI, Year VII [1799], pp. 203-15.

24 While expressing the utmost contempt for Hogarth, Reynolds was to take up some of his ideas himself: see Olivier Brunet's introduction to his translation of Hogarth's *Analysis of Beauty,* Paris, 1963, pp. 90-2.

25 Cf. p. 624: 'Le Chevalier Josué Reynolds, ses Œuvres, traduites de l'anglais par Jansen'.

26 It is important to remember that as well as the special religious, cultural and sociological bonds which already united them, Geneva and England developed flourishing trade links during the eighteenth century. For a very useful account of these, see H. Jahier, *Les Relations Economiques Anglo-Genevoises dans la seconde moitié du XVIIIᵉ siècle (vers 1740-1793), suivies d'une Note sur les Relations Economiques entre l'Irlande et Genève,* typescript thesis submitted to the University of Paris IV Sorbonne, 1984.

27 Cf. Louis Réau, *L'Europe Française au Siècle des Lumières,* Paris, 1951. Despite the indisputably nationalistic line taken by the author, there is a useful account of this phenomenon in the third part of the book entitled 'The Anti-French Reaction'.

28 Louis Simond, *Voyage en Suisse fait dans les années 1817, 1818 et 1819,* vol I, 1824, p. 367.

29 Who can forget how exasperated Napoleon was to come across this city 'where everyone speaks English too well'?

30 Second *discours,* p. 22.

31 Musée d'Art et d'Histoire, Geneva (Acc. no. 1946-8); cf. Buyssens, 1988, no. 208.

32 Cf. D. Buyssens, 'Rodolphe Töpffer contre *Le Courrier du Léman:* un débat esthétique à Genève en 1826', *Bulletin de la Société d'Etudes Töpfferiennes,* no. 15, December 1986, pp. 1-5.

Colston Sanger

Agasse in London

Agasse arrived in London in the autumn of 1800. He was already set up with a connection (he had met the Hon. George Pitt, the future 2nd Lord Rivers in Geneva in about 1790) and he had - or soon saw the need for - a plan of action. He wrote to his friend, the Genevese painter and caricaturist Adam-Wolf-gang Töpffer on 29 November 1802: 'I want to try with your assistance to work out for myself a new road to riches - in short, I have a scheme of my own'.[1]

The scheme, if scheme it was, was to establish himself in England as a sporting painter - in the days before Landseer, a position even lower in Academic esteem than that of landscape painter, but neverthe-less a well-developed and, more important, a separate market with its own conventions and hierarchy of talent. Given Agasse's background, training and disposition, the scheme was eminently practical. He intended, first of all, to establish himself as a painter of thoroughbred horses and dogs, working directly for rich sportsmen and relying on the introduction of Lord Rivers; second, and as a concomittant, to enter the lucrative sporting print business; and third, to establish a shop-window, as it were, of pictures for open sale at the London exhibitions.

It was, then, probably through Lord Rivers, a member of the racing set centred around the Prince of Wales, that Agasse gained a commission in June 1801 to paint a portrait of 'Gaylass', a black mare owned by E.H. Delne-Radcliffe, the Prince of Wales's racing manager. The portrait was exhibited at the Royal Academy in 1802. Other commissions followed: of 'Bay Ascham', bred by the Earl of Lons-dale, in 1802; 'Sorcerer', owned by Sir Thomas Charles Bunbury, in 1803; 'Miscreant', bred by Sir Frederick Poole, in 1804; 'Stargazer', a 'brood mare famous racer' as Agasse describes her in his *MS.*

Record Book[2], in 1805; and in 1809 the Wellesley Grey Arabian (Cat.no.31). All of these were, it may be surmised, stud portraits. 'Bay Ascham', for exam-ple, whose ancestry included both the Darley and the Godolphin Arabians, was never trained for rac-ing; and 'Sorcerer' was at stud in 1803.[3] Certainly the services of the Wellesley Grey Arabian - one of two spectacularly good-looking horses of Persian Arab-ian blood imported by the Hon. Henry Wellesley, youngest brother of the Duke of Wellington - were advertised as early as 1803.[4]

The second aspect of Agasse's scheme was the collaborative venture he established in 1802 with the engraver Charles Turner, then at the outset of his own career. Their first project was the pair of prints 'Preparing to Start' and 'Coming In', scenes of Oxford undergraduates and gentlemen riders racing for the Hunters' Stakes at Port Meadow, Oxford on 4 August 1802. Turner, in his 'Time Book', noted:[5]

Expence attending my Races	[£]
Pay'd Mr. Agasse for Painting the horses --	5.. 5 -
Painting, My time - 14 [days] at 10.6	7 7 -
Copper.. -------------------------	3..14 -
Grounds --------------------------	5.. 5..0
Prooving the two Plate, - 17 ..at 1.4 -	1.. 2..8
Printing the Proposals -------18/-------	18
Expences Drawing Oxford on their Acc 1.1	
	1.. 1..-
Printing. 160.. on Plain, - 3 ---	3.. ..-
Paper for Do --------------------	2..12 6
Writing [*ie.,* inscriptions] for both Plates	14
My Time on Engraving) ..11 Weeks both Plates - -	34. 13. -

Published on 20 January 1803, the prints were dedicated to Lord Francis Spencer (who was not placed in the race) and G.F. Stratton (who came in

first). Spencer was the youngest son of the Duke of Marlborough, with whom Turner had a distant connection through his mother who was the curator of the porcelain treasures at Blenheim.

A later entry in Turner's 'Time Book' suggests that the collaboration continued, though not without upset. In August 1803, Turner noted that he had gone to Brighton to attend the race meeting there with Agasse:[6]

Thur[sday] 4th.. Went to Brighton -----------
Friday. 5. Arrived at Brighton ------------------
Expences during my stay with Board
& Lodging &c [£] 8. 0. 0
Bought Maria 14 Yds. of French
Black Lace at 7/Yd. 4.. 18. 0
Exchanged 1 pr. of Races in Colours for
a Silk Shaul & left with Mr. Furgurson
2 pr. on Return.
Went to paint the Race but Agasse did
not come & was obliged to Return
at a Loss of a Week &------------------ 12. 0. 0

These details, vivid in themselves, provide a useful insight into the early nineteenth century sporting print business. It was a strictly commercial operation. Usually it was the publisher who organised the project, bringing the artist and engraver together, providing the money, arranging the pre-launch publicity and sorting out the distribution.

Occasionally a particularly entrepreneurial engraver or artist (or perhaps more relevantly, one at the outset of his career) might also act as publisher - as Charles Turner did for the venture with Agasse.[7] Major prints or series might be advertised in advance for sale on subscription (*i.e.,* at a lower, pre-paid price) and were often dedicated to famous sportsmen - a stratagem widely-used to ensure sales and, incidentally, to seek patronage. Finally, retail distribution and sale would be handled by a complex network of provincial printsellers often on a 'sale or return' basis, as is clear from the entry in Turner's 'Time Book' quoted above.

How successful Agasse's venture was it is difficult to say. Certainly the collaboration with Charles Turner seems to have lasted until about 1818, and thereafter Agasse worked with several of the well-established print publishers in London, including Ackermann, Colnaghi and Francis Moon. Moreover, several of his subjects went through more than one edition. The pair of coaching scenes 'The Broad-wheeled Wagon' and 'The Mail Coach', for example, while not exactly sporting subjects, were first issued in 1820 by J. Watson, then republished in 1824 (when the 'Mail Coach' was also re-engraved by M. Dubourg).

The third aspect of Agasse's scheme was to establish himself as a painter of sporting subjects for sale at the London exhibitions. Already in 1801, just six months after his arrival in London, two of his paintings - 'A Disagreeable Situation' (cat. 7) and 'Portrait of a Horse, the Property of J. Abbot, Esq.' - were accepted for the Royal Academy exhibition, and he continued to exhibit at the Academy until 1845 (although more sporadically from the mid-1820s onwards). He also tried the other London exhibitions: the British Institution (in 1807-11 and again in 1831-32), the 'Old' Society of Painters in Water-Colours (in 1816 and 1820) and the Society of British Artists (from 1824 onwards, but infrequently). At the same time, he may also have sent pictures to the provincial exhibitions. Certainly he is known to have sent pictures to the Liverpool Academy in 1810, 1812 and 1813. The works he exhibited there in 1813 - 'A Hare, Study of a Greyhound and 'Study from a beautiful Arabian Horse' - were on offer for ten guineas the three.[8] Töpffer's comment when he visited Agasse in London in 1816 and found his painting room stacked with unsold canvases seems apposite: 'He has never found homes for his exhibited pictures and the poor devil goes round and round in circles trying to earn a few guineas, but doesn't always manage it'.[9]

If Agasse had patrons in the traditional sense then George Pitt, 2nd Baron Rivers (1751-1828) was cer-

tainly the most constant. Rivers was devoted to racing and coursing and was an enthusiastic breeder of horses and greyhounds at his country estates at Stratfield Saye in Hampshire and Hare Park near Newmarket. His greyhounds, in particular, were famous. He gave them names beginning with 'P' while he was still the Hon. George Pitt and with 'R' after his succession as the 2nd Baron Rivers in 1802. Agasse worked frequently at Stratfield Saye, where in 1806-07 he painted his large composition 'Lord Rivers' Stud Farm at Stratfield Saye' (Cat.no.23). He also worked at Hare Park, as well as at Rivers' estates at Rushmore Lodge near Shaftesbury in Dorset and Sudeley Castle in Gloucestershire. Rivers' enthusiasm for coursing is reflected in some of Agasse's most brilliant canvases. Outstanding among them are the supremely elegant portrait of two greyhounds 'Rolla and Portia' of 1805 (Cat.no.17) and the Portrait of 'Lord Rivers on horseback' coursing with friends on Newmarket Heath, his arm raised to shade his eyes from the sun, painted in 1818 (Cat.no.41).

Francis Augustus Eliott, 2nd Baron Heathfield (1750-1813), also deserves mention as a patron. Agasse may have worked for him from as early as 1801. The son of General Heathfield, the governor and defender of Gibraltar, Heathfield knew Rivers and shared his interest in horse breeding. Like his father, General Heathfield, he served in the army and rose to the rank of general. He was actively involved in the foundation of the Royal Veterinary College in 1792 and in what was to become the Royal Army Veterinary Corps.[10] Given this background, he would surely have appreciated the finer points of Agasse's consciously naturalistic portrait exhibited at the Royal Academy in 1811 as 'Gentleman on Horseback (Lord Heathfield)' (Cat.no.32).

But apart from thoroughbred horses and dogs, Agasse also painted exotic foreign animals. From 1803 onwards, he became a regular visitor at the menagerie established by Polito at Exeter 'Change in the Strand and continued by Polito's son-in-law Edward Cross. In the 1830s and 1840s (after Cross moved the menagerie to his new Surrey Zoological Gardens at Kennington) he also worked at the menagerie in the New Road established by Polito's cousin, William Herring. Agasse's first recorded subject is in June 1803: 'A curious african animal of the Antelope tribe 3 q Size', and over seventy-five subjects (including copies) are noted in his *MS. Record Book* between 1803 and 1848. The species represented range from the best-known jungle animals - lions, tigers, leopards, cheetahs, *etc.* - to those newly-imported that appealed to him because they were 'curious': 'a curious [whitish?] Antelope 14 12'; 'A curious small kind of slouth for mr cr[oss] small' - probably a South American ant-eater or armadillo; 'A curious animal [from] Siera leone 14 b 12'. In scale, his subjects range from small studies to elaborate finished portraits such as the 'Two Leopards' (Cat.no.29). Surprisingly, none of his animal subjects were exhibited, although the 'Two Leopards' together with the 'Two Tigers' and 'Two Lions' (Cat.nos.27 and 28) were bought by Lord Rivers. Others, the 'Zebra' (Cat.no.14) for example, were bought by Herring and, no doubt, also by Edward Cross who became Agasse's lifelong friend. It was Cross who in his position of supplier of animals to the Royal Menagerie probably secured Agasse's entrance at Windsor, and who almost certainly gained for him the commission from George IV to paint the 'Nubian Giraffe' and the 'White-tailed Gnus' in 1827-28 (Cat.nos.59 and 60).

Agasse's scientific naturalism, his interest in the 'curious', led in 1821 to his being commissioned to document what must rank as one of the most bizarre experiments of early nineteenth century veterinary science (Cat.nos.47-52). George Douglas, 16th Earl of Morton (1761-1827) and Vice-President of the Royal Society, had wanted - just why is not at all clear - to domesticate the quagga in Britain. He had a male quagga (an African animal similar in appearance to a zebra) but unfortunately no female,

Jacques–Laurent Agasse: Sorcerer, the black horse. 1803. Geneva, Musée d'Art
et d'Histoire, acc. no. 1910–87

After Running. 1807. Engraved by Charles Turner after Jacques–Laurent Agasse

so he put the quagga to a seven-eighths Arabian chestnut mare. The resultant offspring, a mule, was not surprisingly 'so little satisfactory in point of form that the experiment went no further'.[11] The mare was next put to a black Arab stallion belonging to Sir Gore Ouseley. Of this second match, the offspring were thought to show markings as if of quagga influence and, therefore, to support - as Morton pointed out in his 'Communication' to the Royal Society - the ancient belief in telegony (the supposed influence of a previous sire on the offspring of a female by a later sire).[12]

When Agasse first arrived in London he stayed with the Swiss Chalon family at 8 Church Lane, Kensington. The two sons, John James and Alfred Edward - both future Royal Academicians - were then students at the Royal Academy schools, and it was from Church Lane that Agasse sent his first two exhibits to the Academy in 1801. In 1802 he moved to North Portman Mews, off Baker Street (variously described as 43 George Street or 30 Adam Street West in the Academy catalogues) and then in 1803 to Paddington Green, close to the cattle market alongside the basin of the Grand Junction Canal. In 1806 he was again at North Portman Mews, but in 1810 he moved to No. 4 Newman Street, where he was to remain for the next twenty-five years.

It is difficult today to imagine Newman Street - an unprepossessing turning off Oxford Street - as being the heart of an artistic quarter. But in the early nineteenth century, the area to the north of Oxford Street - Great Tichfield Street, Berners Street and Rathbone Place, Charlotte Street, Howland Street, London Street, and above all, Newman Street - 'Art Street'[13] - housed a vast concentration of painters, sculptors and engravers. To take Newman Street alone, in 1810 Benjamin West, the President of the Royal Academy, was living at No.14, his fellow-Academicians ranged on either side: Henry Howard, appointed Academy Secretary in 1811, at No.5; James Ward at No.6; John Jackson at No.7; and Henry Thomson, George Dawe and Thomas Stot-

hard at nos 15, 22 and 28 respectively. Joseph Faring-ton, the 'Dictator' of the Academy, lived not far away in Charlotte Street. It was here, too, in New-man Street and the streets surrounding, close to their elders and mentors, that Academy students and aspiring artists - Agasse among them - chose to live. 'I now employ my days in painting at home and the evenings in drawing at the Academy as is cus-tomary', Samuel Morse wrote to his parents;[14] and, after the evening's drawing at the Academy, the stu-dents would, as Richard Redgrave recalled, 'assem-ble at each other's rooms to drink ale-grog or egg-flip' and to discuss their art and its difficulties.[15] In addition, the area offered not only a well-developed infrastructure of subsidiary trades - artists' colour-men, picture-frame makers, marble merchants and copper-plate and lithographic printers - but also a relatively constant and easily accessible market for skill. Redgrave, for example, remembered that some of his fellow-students at the Academy schools eked out their incomes by designing for silversmiths as well as by painting portraits or working as draughts-men for the wood engravers.[16]

For Agasse, Newman Street held the promise of fresh professional contacts. Through the Chalon brothers, who were co-founders with Francis Stev-ens of the 'Society for the Study of Epic and Pastoral Design' in 1808 (later the more homely 'Bread and Cheese Society' or simply the 'Chalon Sketching Society)[17], he met Robert Trewick Bone (the younger son of the enameller Henry Bone RA), the miniature painter Samuel Stump and the Shakes-pearian subject painter Michael Sharp (a pupil of Sir William Beechey). He was also on friendly terms with J.J. Masquerier, with whom he collaborated in 1814 on the topical 'The Allies in Paris' (engraved by F.C. Lewis)[18] and, from 1822 onwards, with the Hoflands.[19]

The move to Newman Street also introduced a period of relative domesticity in Agasse's life. At No. 4 Newman Street, he settled down as something between a lodger and a friendly uncle (who hap-

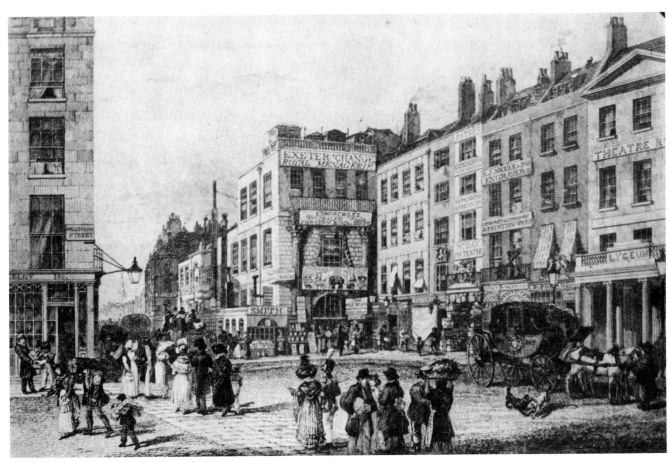

Menagerie at Exeter 'Change, early 19th century. Anonymous engraving

pened to live over the stable at the end of the garden) to the children of his landlord George Booth. In artistic terms, the move led to a whole new range of subjects. On the opening of Waterloo Bridge in 1817 he branched out into Thames River views (Cat. nos. 38, 39 and 40). With the Booth children for models, he tried his hand at the childhood genre market with such pictures as 'The Hard Word' of 1820 (Cat. no. 46) or 'The Pleasure Ground' of 1832 (Cat. no. 62). From there he went on to variations on the traditional 'Cries of London', as in the refreshingly unsentimental 'The Flower Cart in Spring' of 1822 (Cat. no. 53) or 'The Contrast' of 1829 (Cat. no. 61).

By the early 1830s, however, Newman Street was changing. Leases were falling in and the houses were being sub-divided into furnished lodgings and workrooms and the area was declining into what W. M. Thackeray called its 'fashion-deserted, gaunt and lonely old age'. His Tom Tickner ('who did those sweet things for the "Book of Beauty"'), 'superb' Sepio and Professor Rubbery, 'the school drawing-master', succeeded Benjamin West and the assembled Academicians.[20] For Agasse, too, the 1830s were years of change and decline. Lord Rivers had died in 1828; Exeter 'Change was demolished and Edward Cross moved his menagerie to Kennington. In about 1836, Agasse himself left Newman Street for lodgings at No. 2 Lower Southampton Street, Fitzroy Square.[21] His contributions to the

public exhibitions became rarer. Indeed, he ceased to exhibit at the British Institution after 1832 and sent nothing to the Royal Academy from 1834 until 1842. He still kept up his old lines - horses and dogs, animals (though now fewer in number and necessarily studied at Herring's menagerie in the New Road) and childhood subjects such as 'The Cavalcade' (Cat. no. 68) - but increasingly portraits became the mainstay of his business. For example, in his *MS. Record Book* in May 1836 he notes:

P. of mr Banting..	12.b 10
P. of Mrs Banting	12 b 10
P. of Miss Banting -	12 b 10
P. of Master Banting	12 b 10

Without denying the quality of some of Agasse's portraits - and those of Edward Scheener of 1823 and of Edward Cross in 1838 (Cat. nos. 54 and 71) are cases in point - many of them must have been commissioned out of sympathy for the old man's plight. His sitters were for the most part drawn from his immediate circle of acquaintances. Several portraits of the Cross family, for example, attest to their long-standing friendship with Agasse. Edward Cross and his wife sat for portraits in 1819 and 1820 and again in 1838 (Cat. nos. 71, 72), as did Cross's sister-in-law Miss Polito (in 1824, 1837 and 1844) and Mrs Cross's friend Miss Woolf (in 1823 - Agasse also worked up the portrait into a fancy picture). Joseph Hetherington, a job-master or horse dealer whose stables in Green Street, Grosvenor Square must have provided many subjects for Agasse in previous years, sat for his portrait in 1820 and again in 1846 ('a head...small'), as did Mrs Hetherington (in 1843) and Miss Hetherington (in 1846).

Many of Agasse's sitters can be identified as members of the expatriate Swiss Huguenot community in London. Apart from Mr and Mrs Edward Scheener, he also painted the wife and young son of Dr Acret, who became his medical attendant in his last years.[22] In April 1841 he lists in his *MS. Record Book* 'Begun many years before. A family picture of

mrs. Vyers and daughters...' (Cat. no. 66) probably the family of Anthony Vieyres, a watch and clock maker in Pall Mall.[23] The names of the Misses Buchwald and Schneider (later Mrs Powles) occur several times from 1835 onwards.[24] Mrs Powles's husband may have been 'Revd. Cowley Powles' who sat for a portrait in January 1845, and their young son the model, perhaps, for the 'Infant Hercules, a portrait Size of life half length' listed in October 1844. One of the last entries in Agasse's *MS. Record Book* is the 'Begun 8 years, and not finished, portraits of Miss Buchwald, Mrs Powles a child &c. Kitcat' of 1848.

Listed under 1837 in Agasse's *MS. Record Book* is the subject 'A personified fountain Size of life - Kitcat' (Cat. no. 70). The female figure rising out of the water, arms crossed and with dripping-wet long blond hair, is unlike anything else in Agasse's work. Inspired perhaps, like so much early Victorian fairy painting, by Titania in Shakespeare's *A Midsummer Night's Dream,* the subject seems to have held a morbid fascination for him and was repeated several times.[25] It is doubly strange when set among his ordinary range of subjects, between the 'Fox hounds in the kenel' *(sic)* and a 'P[ortrait] of Mrs Hering',[26] and alongside an invitation from George Lane-Fox of Bramham to see the St. Leger run at Doncaster in September 1838[27] and 'For a Sign. painted a falow deer' of March 1839.

In the early 1840s, already in his mid-seventies, Agasse made one last rally. In 1842, after an absence of almost ten years, he reappeared among the exhibitors at the Royal Academy (with 'A Fishmonger's Shop', Cat. no. 74). His 1843 exhibit, 'Making the Most of their Pen'orth', is today untraceable, as is that of 1844, 'Scene in a Zoological Garden' - "No more for sale in this land" (accompanied in the Academy catalogue by a verse from Cowper's *Task*).[28] 1844 also marks his last appearance at the Society of British Artists (with 'Portrait of a Young Girl - a Study'),[29] and 1845 his last appearance at the Academy (with 'The Important Secret,' painted in 1838).

At some time in late 1842 or early 1843 Agasse moved back to Newman Street, not to the Booths at No. 4 but to a furnished room opposite at No. 83, above the shop of Robert Davy, an artists' colour-man. He continued to paint in Herring's menagerie almost to the end,[30] but with few exceptions the productions of his last years are otherwise unremarkable. In October 1843, for example, he lists 'Boarding the Enemy,' (a boat manned by six sailors under attack by a polar bear – apparently illustrating an incident during Sir James Ross's expedition to the Northwest Passage in 1843[31]), and in August 1845 a genuinely new subject, proudly listed as an 'Historical picture. The gun powder plot. 3/4'. The last entry in his *MS. Record Book* is in October 1849: 'The visit to the farm. A repetition'. He died two months later on 27 December 1849 and was buried in St. John's Wood Chapel. His remaining works were sold at Christie's on 10 July 1850 to defray the funeral expenses: the sum realised was 21.15.6.

What is one to make of Agasse? How successful was he as a painter? In his animal paintings and in his knowledge of anatomy he is clearly the equal of Stubbs and also of Landseer, but without the anthropomorphism of the latter. In his childhood genre subjects, he can be compared to Francis Danby, William Mulready or W.F. Witherington but, again, without the moralising or mawkish sentimentality of later Victorian genre painting. His Thames river-views, such as the 'Landing at Westminster Bridge', share the same atmosphere of harmonious, eighteenth-century, pre-industrial calm that is to be found in George Garrard's paintings for Samuel Whitbread.[32] Overall, Agasse's evident concern to present a faithful record of human and animal affairs is perhaps best characterised as 'Biedermeier', a term lacking the programmatic connotations of 'Romanticism' or 'Realism' but often used in a broader European context to identify a distinctive and un-selfconscious sense of innocence in the art and social life of the early nineteenth century.

Another less conventional measure of Agasse's contemporary reputation is the number of copies he was asked to make of his pictures. In the case of a portrait, for example, if it was successful copies would naturally be called for. It is not at all surprising, therefore, that he painted at least four copies of his 'Miss Cazenove on a Grey Horse', originally exhibited at the Royal Academy in 1808. Similarly, he painted several copies of his 'Lord Heathfield': the original, exhibited at the Royal Academy in 1811, and a further three copies after Heathfield's death in 1813, one of which was presented to the Prince Regent by Heathfield's nephew. In much the same way, he painted multiple copies of his portraits of thoroughbred horses. For example, he painted two copies of 'Gaylass', three of 'Bay Ascham' (one a smaller '3/4 size' copy), and no less than five of the Wellesley grey Arabian (in two different versions). Exhibition pictures, too, were repeated – such as the 'The Hard Word' (Royal Academy, 1821), of which he made at least four copies and which was also engraved by Richard Syer.

In the early 1800s, but less frequently thereafter, he was also in demand as a specialist supplier of animal staffage in pictures by other artists,[33] and that his expertise in horseflesh was recognised is indicated by an entry in his *MS. Record Book* in 1812: 'Sketch of a horse in motion...for an R.A.'.

As to patrons and collectors, here the contrasts are extreme: on the one hand, Lord Rivers, Lord Heathfield, Lord Morton, Sir Gore Ouseley and George IV; on the other hand, Edward Cross, Joseph Hetherington and the Misses Buchwald and Schneider. Equally, the prices he was able to command at the highpoint of his career – £300 for the 'Lord Rivers' Stud Farm' or the 200 guineas for the 'Nubian Giraffe' – stand in stark contrast to the almost derisory amounts offered at the sale of his work at Christie's after his death. Perhaps, today, the last word should go to an earlier commentator on Agasse: 'Myself, I have seen just enough of Agasse to desire an opportunity of seeing a great deal more'.[34]

1 Quoted D. Baud-Bovy, *Peintres Genevois,* 2 vols, Geneva, 1903-4, II, p. 108.

2 Coll. Musée d'Art et d'Histoire, Geneva. Agasse's *MS. Record Book* is the prime source for what is known of his life and work. He began it in November 1800 shortly after his arrival in London and continued until his death in 1849. In it he recorded everything that he painted and drew, usually under precise dates, listing subjects and sizes (in inches or as *small, kitcat* etc). It is not all-inclusive, although it appears that Agasse's intention was that it should be so. The first few entries are in French, the rest in English.

3 *Racing Calendar* 1803, p. 373, 'Advertisments of Stallions'.

4 *Racing Calendar* 1803, pp. 359-60, 'Advertisments of Stallions'.

5 British Library, Department of Manuscripts, *Add.MSS 37, 525,* f. 4, *verso.*

6 *Ibid,* f. 42 and *verso.*

7 Often an artist-engraver partnership would establish a market by publishing a first edition themselves, and then sell the rights to future editions. *Preparing to Start* and *Coming In,* for instance, first published by Turner in 1802, were later republished in colour by Ackermann in 1806.

8 Liverpool Academy of Arts catalogues, 1810-14, Liverpool Public Library.

9 Quoted Baud-Bovy, *op. cit,* II, pp. 114-5 (English trans.).

10 See L. P. Pugh, *From Farriery to Veterinary Medicine,* Cambridge, 1962, p. 48.

11 Royal College of Surgeons, William Clift, MS *List of Pictures (1820-40).*

12 *Phil. Trans.,* III (1821), pp. 20-22.

13 Mrs Bray, *Life of Thomas Stothard, RA,* London, 1851, pp. 29-30.

14 Letter to his parents dated 20 September 1811, quoted in Edward Lind Morse (ed.), *Samuel F. B. Morse, His Letters and Journals,* 2 vols, Boston, 1914, I, p. 56.

15 F. M. Redgrave (ed.), *Richard Redgrave, CB, RA, A Memoir,* London, 1891, p. 27.

16 *Ibid,* pp. 34-5.

17 See Jean Hamilton, *The Sketching Society 1799-1851,* London, 1971. Agasse attended only one of the Society's Friday evening gatherings, in 1848.

18 For Masquerier see R. R. M. See, *Masquerier and his circle,* London, 1922.

19 Thomas Christopher Hofland, a landscape painter hardly known today, had in 1814 won out over J. M. W. Turner in the competition at the British Institution for a work 'proper in Point of Subject and Manner to be a Companion' to a painting by Claude or Poussin with his 'Storm off the Coast of Scarborough.' Turner's entry was the infamous 'Apullia in search of Apullus - Vide Ovid' (Tate Gallery). For Hofland's wife, Barbara, who was an author in her own right, see Thomas Ramsay, *The Life and Literary Remains of Barbara Hofland,* London, 1849.

20 W. M. Thackeray, 'The Artists' in *The Yellowplush Papers and Early Miscellanies,* George Saintsbury (ed.), *The Oxford Thackeray,* 17 vols, London, 1908, Vol. I, pp. 576-97.

21 Perhaps at the prompting of Sir Charles Forbes, see Hardy, MS, p. 184.

22 See Agasse, *MS. Record Book,* May 1828 'P. of a lady. Small. mrs Acret' and March 1831 'Pt of young Acret small'. William Acret, a surgeon, lived in Francis Street, Tottenham Court Road and later in Torrington Square (*Boyle's Court Guide,* 1824, 1835).

23 The *Post Office London Directory* of 1838 lists an 'Anthony Vieyres, Watch & Clockmaker' at 40 Pall Mall.

24 *Boyle's Court Guide* for 1835 lists a 'Miss Schneider' at 60 York Terrace, Regent's Park.

25 Specifically, in 1837, 1838 and June 1843 (a reduced version).

26 These entries occur on either side of the 'Personified Fountain' in Agasse's *MS. Record Book* in 1837.

27 And, incidentally, to paint an equestrian group portrait of Lane-Fox, his son and nephew (finished in June 1839).

28 Hardy suggests (MS, pp. 214-5) that this apparently anti-slavery subject may have been yet another portrait of the black woman who appears in *The Contrast* of 1829. The verse in question is: Slaves cannot breathe in England; if their lungs Receive our air, that moment they are free; They touch our country, and their shackles fall.

29 Hardy suggests (MS, p. 215) this could be the 'Portrait of miss vieres - small' of the 'P. of Miss Georgiana Booth. very small' or the 'P. of a Suisse girl. very small' of April, May and August 1841 respectively.

30 The last wild animal subjects listed in his *MS. Record Book* are in 1848: 'An East India bull' and 'A Llama'.

32 See Baud-Bovy, *Peintres Genevois,* II, p. 144. Interestingly, Landseer's famous 'Man Proposes, God Disposes' of 1863-64 appears to be similar in conception - in the same way that his 'Arab Stallion with an Attendant' is similar to Agasse's 'The Wellesley Grey Arabian led through the Desert' of c. 1810 (coll. Paul Mellon, Upperville, Virginia).

32 See Stephen Deuchar, *Paintings, Politics & Porter: Samuel Whitbread and British Art,* exhibition catalogue, Museum of London, 1984); also Celina Fox, *Londoners* (exhibition catalogue, Museum of London, 1987), p. 172.

33 For example, the following entries in his *MS. Record Book:* 'A spaniel dog in another man's picture. Size life' (29 May 1806); 'P. of a chesnut gelding, & a white terrier dog. background by mr Barret. size Kitcat' (6 September 1806); and '4 horses in another Artist's pictures' (June 1814).

34 W. S. Sparrow, *British Sporting Artists from Barlow to Herring,* London, 1922, p. 237.

Catalogue of Paintings

An asterisk against the title indicates
works exhibited in London.

All works were shown in Geneva
except Cat. nos. 60 and 69,
(exhibited in London only)
and Cat. nos. 24 and 29
(not exhibited in either place).

*1 Portrait of Nosky Calandrini in a Farmyard near Geneva *c.* 1786

Jean Marc, nicknamed Nosky, Calandrini (1764-1814) was the son of Catherine Antoinette Fuzier-Cayla and the banker and senior civil servant François Calandrini. On 17 September 1782 he married Marianne Cramer, daughter of Catherine Wesselow and the councillor Philibert Cramer. The Calandrini family were originally from Lucques but espoused the Reformation and fled to the safety of Geneva. They very quickly rose to prominence and a succession of three marriages saw them connected to the Tronchin family.

This portrait was painted jointly by Agasse, Adam-Wolfgang Töpffer and Firmin Massot. The three friends enjoyed sketching in the open air in the countryside around Geneva and often went on drawing expeditions to Haute Savoie, using the Agasse family's country house at Crevin, at the foot of the Salève, as their base. The age of the young man in the picture is evidence that it was painted about 1786 before Agasse went to Paris to study under David.

Massot has shown Nosky Calandrini as a dashing young gentleman. Over his ankle-length yellow trousers he sports a cut-away coat with gold buttons inspired by an English style very much in fashion in the 1790s, and this is set off by the pumps with large buckles which he wears on his feet. Clearly visible hanging from his belt is one of the two chatelaines it was correct to wear - the done thing was to jingle the charms on the ends of these. His hat is a 'Swiss style' tricorn.

Drawing on his extraordinary mastery of animal anatomy, Agasse manages to convey both the power and the tension in the magnificent bay horse he contributes to the picture. His portrait of the hound gazing faithfully up at its master, meanwhile, reflects already the affectionate interest he was to have in animals throughout his career. The buildings, along with the rest of the background, are by Töpffer, and are recognisable as the stables at Frontenex near Geneva. The light carriage by them, a 'whisky', drawn by four horses, is by Agasse.

There is a serenity and happiness about the whole picture obviously shared wholeheartedly by the young aristocrat who seems as yet blissfully unaware of the political strife tearing Geneva apart.

A partly torn statement on the back reads, 'Portrait of Nosky Calandrini by Massot, Agasse, left by Henri Tronchin to Mlle Christiane Tronchin. The executors: Robert Martin and J. Marion'
Oil on board 19⅞ × 24 (50.5 × 61)

Provenance
Nosky Calandrini, Geneva; Armand-Henri Tronchin-Calandrini, Bessinge, near Geneva; Christiane Tronchin, Bessinge, near Geneva; James-Tronchin, Lavigny; Laurent Rehfous, Geneva; Bernard Naef, Geneva

Literature
Inventory of the effects of Armand-Henri Tronchin, carried out after his death by Maître Audeoud, Minutes 1866, 3, no. 184, 15. VII. 66, no. 18 (AEG); *Nos Anciens,* 1908, p. 113, repr.; Pianzola, 1972, p. 34 repr.

Private Collection

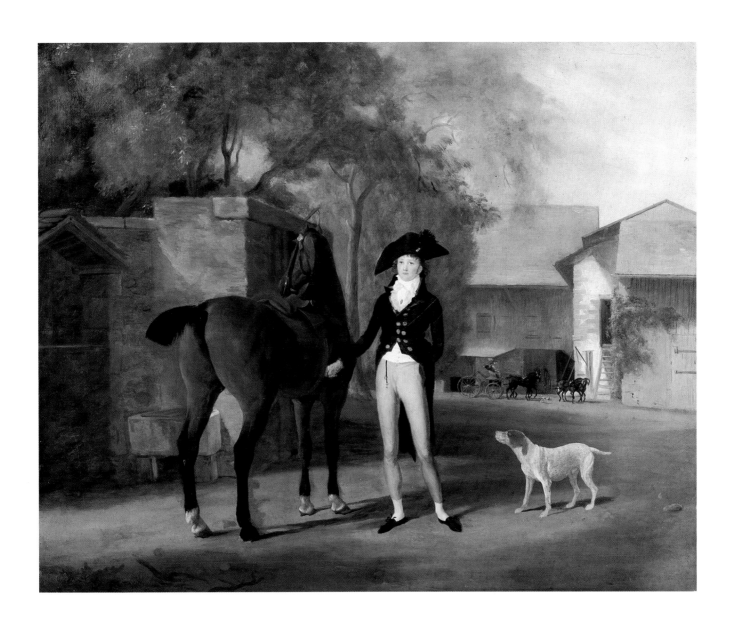

*2 Horse, Rider and Black Dog in a Landscape c. 1790

There is a school of thought which holds that the rider is Agasse himself, and this is a theory which a comparison of the features in Massot's portrait of Agasse painted c.1795 (Fondation Oskar Reinhart, Winterthur; cf. Zelger, op. cit., repr. p. 235) with those of the horseman shown here would seem to support.

Agasse, here aged between 20 and 25, has painted himself in riding clothes. His style of dress is typical of the years 1789-92: a close-fitting, buttoned coat with long tails, tight breeches, and what was known as a 'boat' shaped hat. As he was to do in his portrait of Audeoud-Fazy painted a few years later (Cat. no. 4), he has given pride of place here to the horse, which takes up most of the picture. At its feet is Agasse's favourite dog, a bulldog.

The landscape is almost certainly by Töpffer and shows a path in the woods at Crevin, at the foot of the Salève.

This painting should be compared with the 'Portrait of Jacob-Marc Peschier: Rider in a Landscape' (oil on canvas, $14\frac{1}{8} \times 17$ (36×43). Private Collection) painted c.1796/98, also in conjunction with Töpffer, who once again provided the landscape.

Oil on panel $20\frac{1}{4} \times 21\frac{5}{8}$ (51.5×55)

Provenance
...; ex Genevese collection, Paris; Laurent Rehfous, Geneva

Exhibition
Hôtel de Ville and Château, Yverdon, 16 June-10 September 1972 (1)

Private Collection

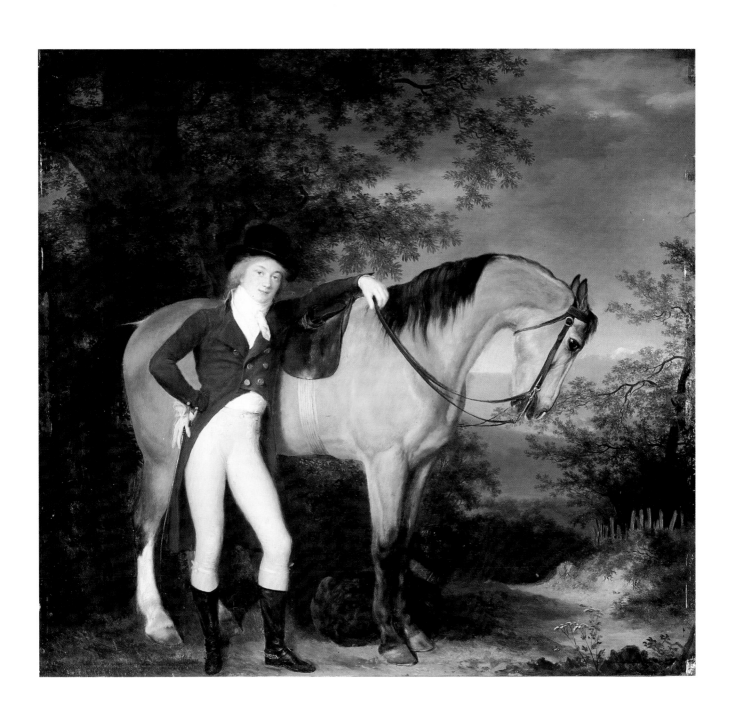

*3 The Forge at Lausanne 1795-1796

Agasse fled the revolutionary ferment that was gripping Geneva and settled for a time in Lausanne, where this picture was painted in about 1795 or 1796.

The subject of this painting is one which had been popular with Dutch painters from Wouwerman on and had regained its standing in English art as early as the eighteenth century. Agasse is clearly influenced here by George Morland (1763-1804), whose work he would have been able to see on his first visit to England, and particularly perhaps by his 'Stable Interior' (National Gallery, London) exhibited at the Royal Academy in 1791.

This picture is somewhat of a rarity in Agasse's œuvre: very few such fully developed paintings are known for this period in his career. The originality of the picture lies in the way Agasse has balanced the commonplace character of the scene with the sur-prising elegance of the horses he has chosen to include. Instead of the carthorses we would expect to see in this rustic setting, we are confronted by graceful racehorses: the contrast could not be more striking.

This painting was very probably exhibited at the third Salon of the Société des Arts in Geneva in September 1798, and an etching of it was made by Agasse's friend Nicolas Schenker (Paris 1760-Geneva 1848) in 1800. A drawing entitled 'The Blacksmith' (black crayon and stump heightened with white chalk on unbleached paper, $7\frac{3}{4} \times 10\frac{3}{4}$ [19.7 × 27.5]) in the Musée d'Art et d'Histoire in Geneva (Acc. no. 1968-48) was perhaps a preliminary study for this painting.

Until recently a copy or second version of the painting was known to exist in a collection in Geneva.

Possibly inscribed top right, but not legibly
Oil on canvas $17\frac{1}{8} \times 21\frac{1}{8}$ (43.5 × 53.8)

Provenance
...; Syndic Jean-Louis Masbou, Geneva; given by the Syndic to the Société des Arts, Geneva, 1826

Exhibitions
Musée d'Art et d'Histoire, Geneva, February-March 1930 (1826-3); *ibid.,* 1942; Musée Cantonal des Beaux-Arts, Lausanne, 23 July-12 September 1982 (9)

Literature
Cherbuliez, 1867, p. 347; Baud-Bovy, 1904, pp. 101-2, repr. pl. XVIII; Brun, I, 1905, p. 16; Hardy, 1905, pp. 15-16; Crosnier, 1910, p. 207; Fournier-Sarlovèze, 1911, p. 15; Gilbey, 1911, p. 4; Grellet, 1921, p. 31; *ibid.,* 1927, p. 448; Gielly, 1935, p. 126; Deonna, 1945, p. 299; Bénézit, I, 1976, p. 52; Thieme and Becker, 1985, new ed., vol. I, p. 499; Buyssens, 1988, no. 2, repr.

Musée d'Art et d'Histoire, Geneva (Acc. no. 1826-3)

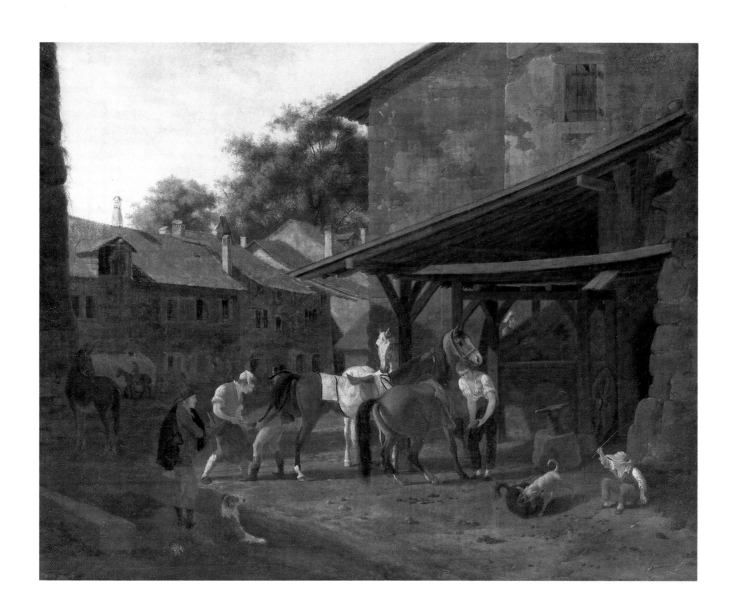

4 Portrait of Frédéric-Samuel Audéoud-Fazy (1767-1836) 1796-1800

Frédéric-Samuel Audéoud-Fazy was descended from an old Dauphiné family whose members escaped to Geneva during the second Refuge and were made citizens of the city in 1704. Under the old Régime he served on the Plainpalais council and held the posts of treasurer and registrar. He was a Liberal and was elected deputy to the legislative council in 1793. Under the Empire, he became a constituency representative for the Department, and was elected deputy to the Council of Representatives in 1814. He emigrated to Paris in 1818, and was naturalised French in 1823. He opened a bathing establishment in the rue Saint-Lazare and began producing mineral water chemically using the techniques perfected by Genevese chemists. He died in Paris in 1836.

Dressed in riding clothes, the young Audéoud cuts an elegant figure in the centre foreground of this picture resting his right arm on his horse's saddle and looking down at the hound standing stock still at his feet. As the preparatory sketch for this picture (Cat.no.92) makes even clearer, what interests Agasse above all here is the bay thoroughbred. His portrait of the horse is masterly in its fine observation of detail and captures the animal in all its magnificence.

The painting is almost certainly set in Audéoud-Fazy's estate at Plainpalais where he engaged in stock breeding. There is an old church in the background. In the middle ground a rider has been thrown to the ground. Sheep graze tranquilly to the left the while.

The colour range throughout the picture is very delicate, the light green of the trees and the grass contrasting with the dark green of the shadows and the blueish grey of the sky and the clouds. The light is that of a beautiful autumn morning and lends great subtlety to the scene.

The picture was painted in Geneva before Agasse left for England. Danielle Buyssens points out pertinently that it 'reminds one of Reynolds', whose work Agasse would indeed have been able to see on his first visit to London. Certainly it shows that Agasse had completely mastered his art by even this early stage in his career.

Oil on board 9¼ × 16⅝ (23.2 × 29.6)

Provenance
Fazy, Geneva; Aline-Charlotte Pictet de Seigneux, Geneva; Aloys de Seigneux, Geneva; given by him to the Musée d'Art et d'Histoire, Geneva, November 1913

Exhibitions
Cercle des Arts et des Lettres, Geneva, 1901, p.15 (repr. XXIX); Palais des Beaux Arts, Brussels, April-August 1928 (1); Musée d'Art et d'Histoire, Geneva, February-March 1930 (1913-68); Venice, June-October 1938, p.104, repr.; Musée d'Art et d'Histoire, Geneva, 1942, p.34; Strozzi, Florence, 15 October-12 November 1949 (1, repr.); Schloss Jegenstorf, 6 June-18 October 1970 (6, repr.); Thorvaldsen, Copenhagen, 15 March-30 April 1973 (9, repr.); Musée Rath, Geneva, 1976 (4)

Literature
Baud-Bovy, 1904, p.104, repr.91; Hardy, 1905, pp.22-3; Fournier-Sarlovèze, 1911, p.15; Baud-Bovy, August 1913, p.197 repr.; Annuaire, 1915, pp.141-2; Grellet, 1921, pp.31, 55; Hardy, 1, 1921, p.72 repr.; *ibid.,* 1921, repr.; Grellet, 1927, p.446 repr.; Gielly, 1935, pp.119, 123, 127 repr.; *ibid.,* 1937, p.190 repr.; Hugelshofer, 1943, repr.26; Huggler and Cetto, 1943, repr.13; Bouffard, 1949, p.3 repr.; Musée d'Art et d'Histoire, Geneva, 1960, p.27 repr.40; Buyssens, 1988, no.29, repr.

Musée d'Art et d'Histoire, Geneva (Acc.no.1913-68)

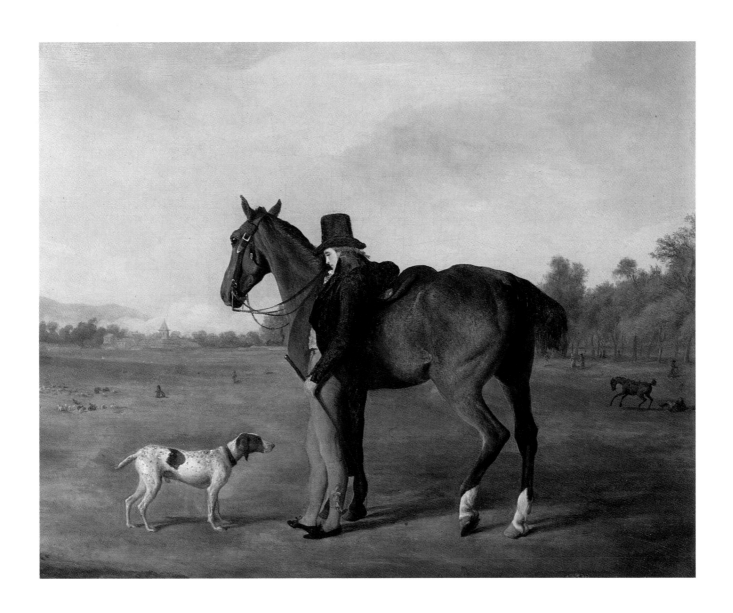

5 Two Horses in a Landscape 1799

Agasse has used the landscape around Geneva with the mountains of Savony in the distance to provide a calm and peaceful setting for this painting of a magnificent grey mare and a muscular stallion. The attitude of the two horses suggests that what we are seeing here is a preliminary to mating.

The picture must have been painted shortly after Agasse's first visit to England, some time between 1799 and 1800. The influence of English painting is certainly clearly visible in the way his palette has changed and his composition gained in unity. There are obvious similarities, furthermore, in terms of subject-matter and composition between this picture and the drawing of 'Two Horses' (Cat. no. 91).

Inscribed in brown ink on the back, 'Agasse pinx. Geneva'. A label written in black ink by the connoisseur Laurent Rehfous reads, 'Horses in/ landscape./ by Agasse ex Ador collection.' [the word 'Ador' is underlined]
Oil on panel $10\frac{5}{8} \times 14$ (26.9 × 35.7)

Provenance
...; Ador, Geneva; Laurent Rehfous, Geneva; Jacques Salmanowitz, Geneva

Literature
Gielly, 1935, p. 222

Private Collection

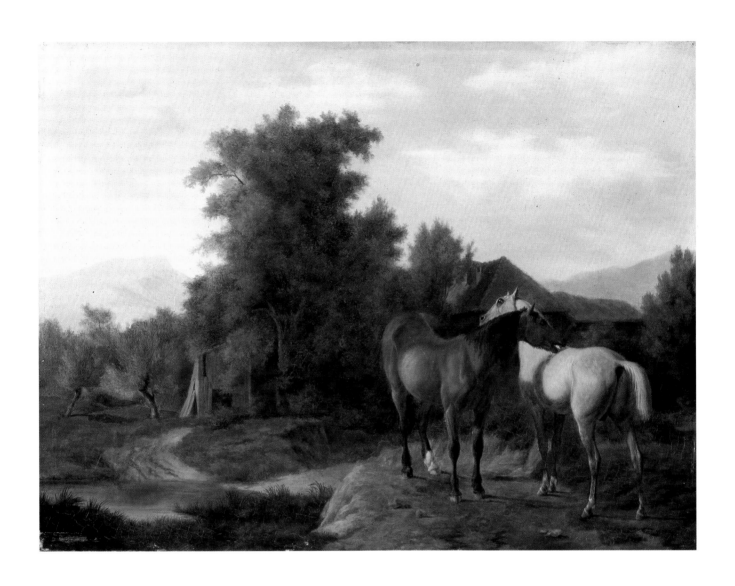

6 The Horse Fair at Gaillard *c.* 1799

This is a good example of the mutually beneficial collaboration which Agasse went in for with Töpffer and which was to continue well after Agasse's move to England, as the following request he made in a letter dated 29 November 1802 makes clear: '...Can you brush in 1 or 2 nice, first-rate, genuine 'Töpffer' backgrounds for me on panel, not more than 11 inches long and proportionately high. Get going on them straightaway, and let me know - or get someone else to if you can't yourself - as soon as they are ready... If you've got anything ready and waiting, that would be even better... I need it as a sample...' (letter from Agasse to A.-W. Töpffer, London, 24 November 1802, Ms. suppl. 1638, BPU).

Although Töpffer put this landscape together in his studio, he has succeeded in capturing the idyllic calm of the countryside to be found just outside Geneva in Savoie amid the Voirons and Salève mountain ranges and with the Sixt valley in the distance.

Agasse has brought a tremendous sense of move-ment to Töpffer's background by introducing into it a host of different people and animals, giving us almost his entire repertoire of characters, it seems, some of whom were to feature in other canvases. The donkey in the centre foreground, for instance, already appears in a study made in 1799 (Musée d'Art et d'Histoire, Geneva, Acc. no. CR7, cf. Buyssens, 1988, no. 50, repr.), while the grey horse on the left is the same as the one in the 'Rider and Grey Horse' of 1797 (Musée d'Art et d'Histoire, Geneva, Acc. no. CR4, cf. Buyssens, 1988, no. 47 repr.).

'The Horse Fair at Gaillard' is similar in style to other pictures of the same period, like 'Halt in front of a Farm' (Musée d'Art et d'Histoire, Geneva, Acc. no. 1826-4, cf. Buyssens, 1988, no. 3 repr.), and must have been painted in about 1798, when Agasse, Töpffer and De la Rive went on their sketching trip in the countryside around Geneva (cf. De la Rive's letter to his wife, 1 June 1798, Ms. 3238, BPU, Geneva).

Inscribed bottom right, 'Agasse f'
Oil on canvas 26¾ × 31⅞ (68 × 81)

Provenance
Saladin de Lubières; Odier-Baulacre family, Geneva; given by Jacques-Antoine Odier-Baulacre, Geneva, to the Musée d'Art et d'Histoire, Geneva, 1859

Exhibitions
Musée d'Art et d'Histoire, Geneva, February-March 1930 (1859-2); *ibid.,* 1942 (p. 34)

Literature
Cherbuliez, 1867, p. 347; Rigaud, 1876, p. 239; Brun, I, 1905, p. 16; Fournier-Sarlovèze, 1911, p. 16, repr. p. 14; Giron, 1913, p. 247; Hardy, 1, 1921, p. 70 repr.; *ibid.,* 1921, repr.; Grellet, 1927, p. 448; Gielly, 1935, pp. 126-7; Deonna, 1945, p. 299; Fosca, 1945, p. 112; Bénézit, I, 1976, p. 52; Buyssens, 1988, no. 1, repr.

Musée d'Art et d'Histoire, Geneva (Acc. no. 1859-2)

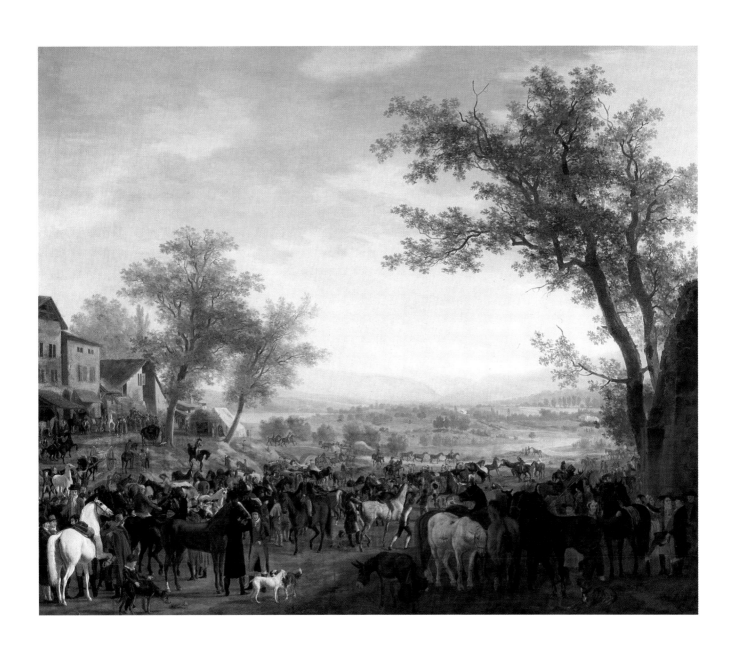

*7 A Disagreeable Situation 1800

This is a tremendous picture in which Agasse displays a spirit rarely glimpsed elsewhere in his painted work and therefore worthy of particular notice here. The scene is set in a wide, wooded landscape, under a brilliant sky, and a light barouche drawn by four magnificent grey horses has just lost its balance rounding a great sweep of unmade road. The front two horses have swerved abruptly off course making the two behind fall sharply down onto their hindquarters. The driver, meanwhile, is pulling desperately on the reins in a bid to regain control. The obvious cause of the incident is the dog in the foreground terrifying the team of horses with its barking.

Tradition has it that the very elegant driver and his charming companion are none other than Agasse and his sister Louise-Etiennette. It is a theory supported by the evidence of other known portraits of Agasse and his sister, particularly the two pastels in the Musée d'Art et d'Histoire in Geneva worked on jointly by Agasse and Firmin Massot in about 1795

and Agasse's self-portrait of 1790 (Cat.no.2), and Agasse's two drawings of Louise-Etiennette, one dated *c*.1800 (Cat.no.88), and the other a pencil sketch which must be a study for 'A Disagreeable Situation'. The dog is the German mastiff celebrated in a red chalk drawing to be found some time ago in a private collection in Geneva.

Finely worked in every detail, the picture was the result of a great many preparatory drawings (see particularly Cat.no.93), and it seems to have played a decisive part in launching Agasse on his English career. Although there is no mention of it in the *MS. Record Book* started by Agasse in November 1800, it was Agasse's first exhibit at the Royal Academy, exhibited there with his 'Portrait of a Horse' in 1801. It seems likely, therefore, that it was painted early in 1800, perhaps while Agasse was still in Geneva, and that, as Daniel Baud-Bovy cogently observes, it smoothed Agasse's 'entry into English high society' (*op. cit.,* 1904, p.106).

Oil on canvas 38⅛ × 47½ (97 × 120.7)

Provenance
John Allnutt, Clapham, London (for whom the picture was painted); H.A. Knox, Waycroft, Tyrells Wood, Leatherhead; J. Abbott (dealer); sold Sotheby's, London, 1954; Colnaghi, London, 1954

Exhibitions
Royal Academy, London, 1801 (566); Hôtel-de-Ville and Château, Yverdon, 16 June-20 September 1972 (3, repr.)

Literature
Baud-Bovy, 1904, p.106; *Burlington Magazine,* December 1954; Gordon-Roe, September 1959, p.340

Private Collection

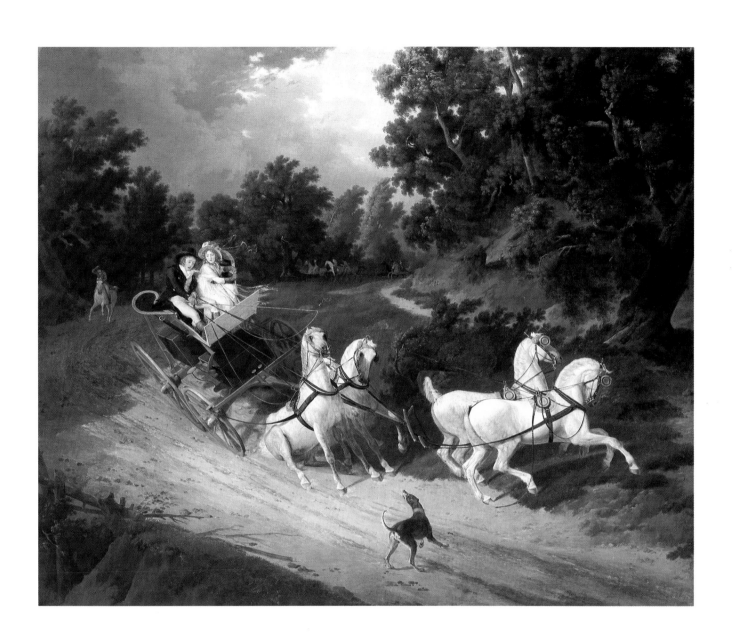

8 The Blacksmith: the Open Air Forge *c.* 1800

Agasse again tackles the theme of 'The Forge' (Cat. no. 3) here, but this time he sets his subject in the broad, open countryside around Geneva close to the Grand-Saconnex with the Jura mountains just visible in the distance. To the right of the picture a large grey horse waits patiently for the blacksmith to finish shoeing him. His assistant holds up the horse's hoof while the blacksmith shoes it. A magnificent brown horse frisks about by a tree on the left, and in the background a hussar is breaking in a pair of horses while two of his companions stand talking in front of a tent. The whole scene is a skilful combination of warm light and carefully considered shade.

Because of the similarity between the group of soldiers in this painting and the hussars in 'Halt in front of a Farm', *c.* 1798 (Musée d'Art et d'Histoire, Geneva, Acc. no. 1826-4), it seems likely that this picture was painted at the same date and that the background landscape may well have been, like that in the Geneva picture, the work of Adam-Wolfgang Töpffer.

There is a quick sketch of the same subject in the Fondation Oskar Reinhart's collection in Winterthur (cf. Zelger, *op. cit.*, p. 35, cat. no. 11, with some doubts over attribution).

Oil on canvas 16 × 22⅝ (40.5 × 57.5)

Provenance
...; Gaston Pictet, Colovrex, Geneva

Exhibitions
Kunsthalle, Berne, 1936 (5); Musée d'Art et d'Histoire, Geneva, 1942 (3)

Literature
Gielly, 1935, p. 222; Zelger, 1977, p. 35, no. 11 (quoted)

Private Collection

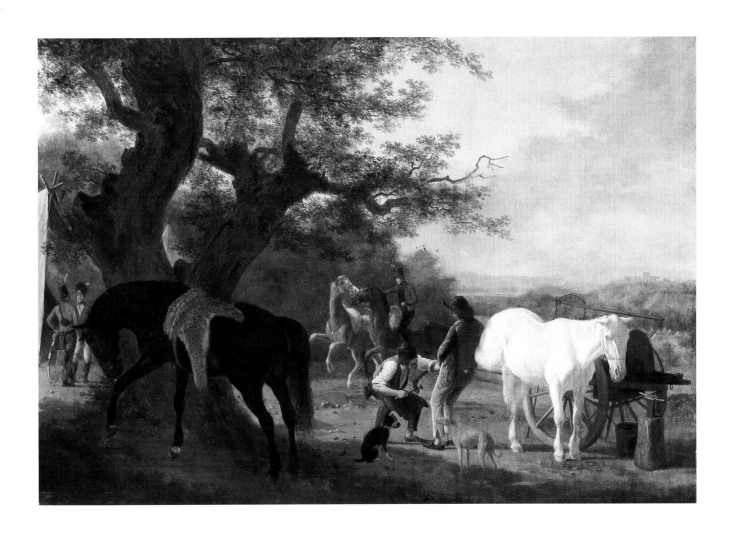

*9 Elisabeth Tronchin (1792-1857), future Baronne de Gingins, with her Brother, Armand-Henri Tronchin (1794-1865) *c.* 1800

The subtle balance of colour, the lightness of touch, and the clarity and control of the drawing combine to make this a very delicate picture of Elisabeth and Armand Henri Tronchin, the young children of Jean-Louis Robert Tronchin and Théodora-Hélène-Elisabeth Tronchin-Calandrini painted here by Agasse in collaboration with Massot and Töpffer.

Elisabeth (1792-1857) married Louis, Baron de Gingins et d'Eclépens. Armand-Henri (1794-1865) was successively Captain of the horse artillery in the service of the Netherlands, and Federal Lieutenant-Colonel of artillery, and was decorated with the medal of the Fidélité Helvétique. In 1823 he married Emma Calandrini, daughter of Jean-Marc Calandrini and Marianne Cramer.

The age of the two children makes it possible to date this picture *c.* 1800, just before Agasse left for England.

The same donkey, also painted by Agasse, turns up again in an oil sketch of 'The Return from Market' by Firmin Massot painted, according to Baud-Bovy, in about 1795 (cf. Baud-Bovy, 1904, repr. p. 74). There are marked similarities, moreover, between this picture of Elisabeth Tronchin and Massot's portrait of 'Isaline Fé' painted *c.* 1785-90 (Musée d'Art et d'Histoire, Geneva, Acc. no. 1921-2).

A label on the back reads, 'Portrait of Henri Ronchin and Mme de Gingins as children by Massot, Agasse and Töpffer. Left by Henri Tronchin to Mlle Christiane Tronchin. The executors: Rob. Martinet J. Marion' [the end has been torn off]
Oil on panel 28¾ × 22⅞ (73 × 58)

Provenance
Tronchin, Bessinge, near Geneva; Henri Tronchin, Bessinge, near Geneva; Christiane Tronchin, Bessinge, near Geneva; James-Tronchin, Lavigny; Laurent Rehfous, Geneva; Bernard Naef, Geneva

Private Collection

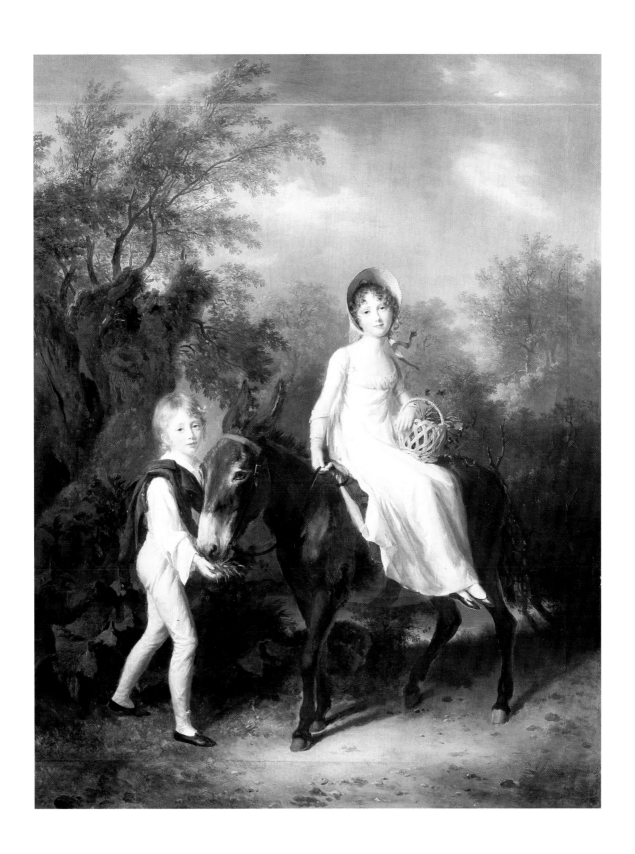

Agasse is pandering in this picture to the enthusiasm the English had developed as early as the late eighteenth century, largely through exposure to engravings, for pictures of carriages, wagons and coaching scenes of all kinds.

Agasse was to tackle this subject more than once. His *MS. Record Book* lists no fewer than three versions in oil. The first, on show here, was painted in May 1801. A second version followed in December of the same year, 'December 1, Copie [sic] of the wagon, same size' (whereabouts unknown), and a final, smaller one (12⅝ × 19 [32×48], Private Collection) in 1820, '7 August Copy of the wagon small'.

If confirmation of the subject's popularity were necessary, the picture was engraved by J. Baily (1810-1838), almost certainly from a highly finished watercolour identical in all but the tiniest detail of the landscape to the 1820 version (cf. exh. Dr Fritz and Peter Nathan, 1922-1972, Zurich, no. 176), and the engraving published by J. Watson, 7 Vere Street, Bond Street, London, on 20 November 1820 (cf.

Charles Lanes, *Sporting Aquatints and their Engravers,* vol. 2, Leigh-on-Sea, 1979, p. 89) as a pair to 'The Mail Coach' (Cat. no. 111).

The heavy-wheeled wagon, shown here well laden and drawn by four pairs of powerful carthorses, regularly ferried goods between London and Ludlow over a distance of some 142 miles. From what we can gather from the London almanacs from 1791 to 1824, the starting point for the wagon was 'The Green Man' inn in Oxford Street.

The same goods wagon appears in the background of 'The Halt of the Portsmouth Stage Coach' (Cat. no. 34).

This picture may amount to little more than a charming anecdote in terms of its subject-matter, but the central focus is really elsewhere, on Agasse's sensitive and finely judged drawing of a typically English landscape and his use of warm golds to recreate the light of a beautiful summer's evening with its characteristic long shadows.

Oil on canvas 25⅛ × 30⅜ (64×77)

Provenance
Birmann Fund, Basle (1915)

Exhibition
Schloss Jegenstorf, 1970 (7)

Literature
MS. Record Book, 'May 1801 1 d. A Wagon, with figures'; Hardy, 1905, p. 35; Gilbey, 1911, p. 6; Gordon-Roe, September 1959, p. 342; Öffentliche Kunstsammlung, Kunstmuseum, Basle, Catalogue *19./20. Jahrhundert,* Basle, 1970, p. 7, repr.

Öffentliche Kunstsammlung, Kunstmuseum, Basle

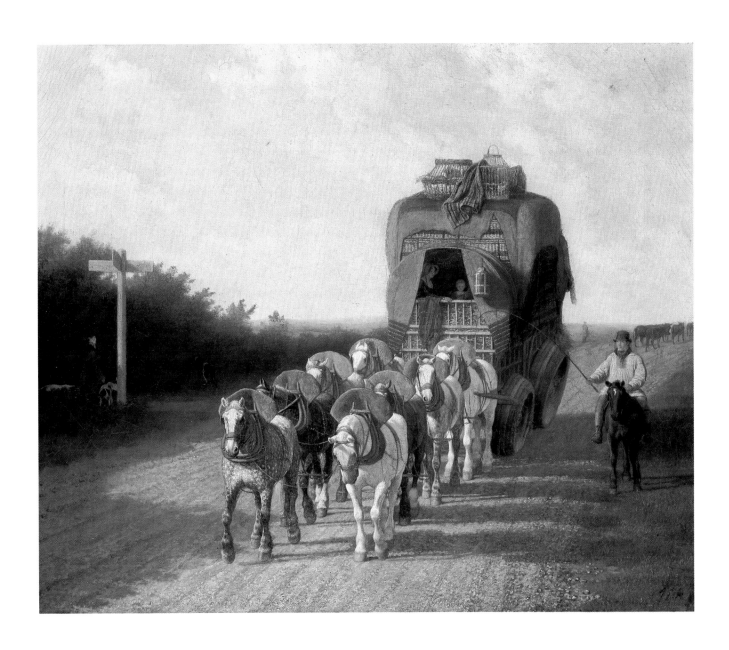

Tradition would long have it that the scene was set in Hertfordshire at the country seat of the first Viscount Melbourne. According to Lord Brocket, however (cf. letter from Lord Brocket to Judy Egerton, July 1988), the setting here is not Brocket Hall although it boasted a racecourse as early as the 19th century, and a great many leading figures, including the Prince Regent, gathered there.

The entries in Agasse's *MS. Record Book* for June to August 1803 make it clear that he stayed at Brocket Hall during that period.

The picture harks back in some ways to earlier works completed before Agasse left Geneva. The treatment of the horses, for instance, is reminiscent of that of the horses in 'The Forge at Lausanne' (Cat. no. 3) and 'The Pack' (Musée d'Art et d'Histoire, Geneva, Acc. no. 1931-8), and the warm brown tones are evidence of Agasse's enduring interest in and regard for Dutch painting. But the composition, meanwhile, has become much bolder. The placing of the key figure is dramatic: he rides out ready for the hunt from a gateway to the right of the picture with the pack at his heels. There is a dynamic play of light and shade in the picture: the two hunters and the pack around them are held in a pool of light which pours through the arch and reaches up to touch the tops of the trees and the buildings in the courtyard. The landscape is at once lighter and more polished than any Agasse produced during his Genevese days. The subtle balance of colour he achieves and his skilful manipulation of the tonal range give the picture a much greater sense of unity and help to make it one of the most successful of his early 'English' offerings.

There is a very thorough study of the pack in a private collection (oil on canvas, $11 \times 15\frac{1}{8}$ [28×38.5]). We can see from the two preparatory studies (Cat. no. 99) which exist for the picture what changes Agasse made in the final version.

Albert Lugardon (Rome 1827–Geneva 1909) produced a lithograph of 'Departure for the Hunt' for the Société des Amis des Beaux-Arts in 1861.

Oil on canvas $26\frac{3}{4} \times 31\frac{7}{8}$ (68×81)

Provenance
...; Georges-Adrien de Seigneux, Geneva; bequeathed by him, 1912

Exhibitions
Geneva, 1896 (1079); Cercle des Arts et des Lettres, Geneva, 1901 (33, repr.); Musée d'Art et d'Histoire, Geneva, February–March 1930 (1913-66); *ibid.,* 1942 (p. 34); *ibid.,* 1943 (891); Musée Rath, Geneva 1976 (3)

Literature
MS. Record Book, '1803 June 15: A hunting going out in the morning/portrait of horses, Small size, in Hartfordshire.'; Baud-Bovy, 1904, p. 110; Brun, I, 1905, p. 16; Hardy, 1905, p. 49; Fournier-Sarlovèze, 1911, p. 15; Bovy, 1914, p. 538; Annuaire, 1915, p. 142; Hardy, 1, 1916, p. 195; Grellet, 1921, p. 31; Hardy, 1, 1921, pp. 67, 79 repr.; *ibid.,* 1921, p. 4 repr.; Gielly, 1935, p. 131; Hugelshofer, *Agasse,* 1943, p. 8 repr.; Fosca, 1945, p. 112; Bénézit, I, 1976, p. 52; Buyssens, 1988, no. 28, repr.

Musée d'Art et d'Histoire, Geneva (Acc. no. 1913-66)

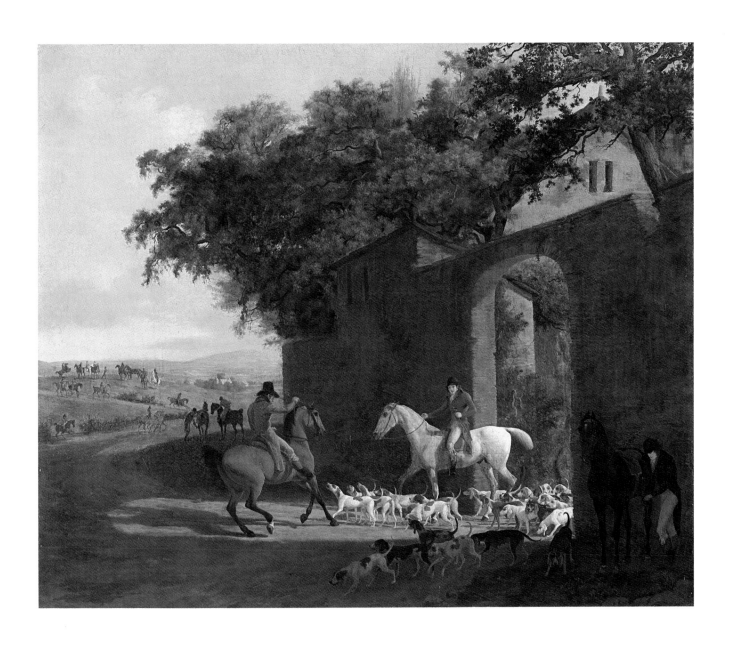

12 Getting Ready for the Hunt *c.* 1803

The picture is set in flat, open country which stretches out to a line of gently rolling hills in the distance. Four horses are waiting to set off for the hunt. A haughty grey with its rider already up paws the ground impatiently in front of a pack of hounds, while a young hand on the right of the picture leads a saddled horse over to a group of riders bustling about close to a stable.

Although there is no reference to it in his *MS.* *Record Book,* there can be no doubt that Agasse was already in England by the time it was painted. It can be compared with 'Departure for the Hunt' (Cat.no.11), and it may very well also have been painted in Hertfordshire in about 1803. Certainly, here once again we find Agasse using a warm palette and manipulating the light in the picture to conjure up the peace and tranquillity of a beautiful summer morning.

Oil on canvas 19¾ × 24¼ (50 × 61.7)

Provenance
...; ex English collection; ...Jacques Salmanowitz, Geneva

Literature
Gielly, 1935, p.122

Private Collection

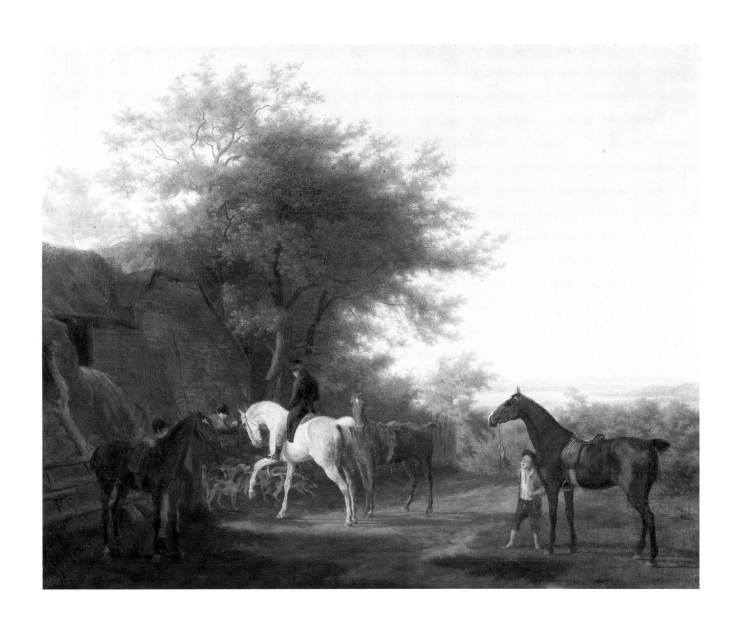

13 Horsewoman Jumping a Fence *c.* 1803-1805

Horsewomen were a very popular theme in the nineteenth century: they represented the very embodiment of the new, freer woman who was beginning to emerge from a society then in a state of complete flux.

Agasse was to tackle this subject on several occasions. The most famous instance is his portrait of Mademoiselle Cazenove (Cat.no.69). In a letter written to his wife from London on 28 May 1816, Töpffer has this comment to make on Agasse's work, '...but what will surprise you most are some very beautiful horse pictures, and a portrait of a woman full at once of grace and movement, so pleasing that I would like to own it and would, I think, have bought it had he been willing to sell it to me' (Ms. suppl.1638 fol.106, BPU, Geneva).

The setting is a hunting scene with a rider and the pack in the background on the left and an elegant horse-woman perfectly at ease as she rides side-saddle and jumps a fence on her grey horse.

The horse is very reminiscent of the one coming out of the estate gateway in 'Departure for the Hunt' (Cat.no.11), and this, coupled with the treatment of the landscape, makes it likely that this is one of Agasse's early works, painted during his first few years in England, in about 1803-5. The horse-woman's dress seems to confirm this date: it is typical of the style of ladies' riding clothes then in fashion.

Inscribed in an unidentified hand in brown ink on the back, 'Agasse'
Oil on canvas 10¾ × 14⅛ (27.2 × 36)

Provenance
...; Jean de Saussure, Geneva; Yves de Saussure, Geneva

Private Collection

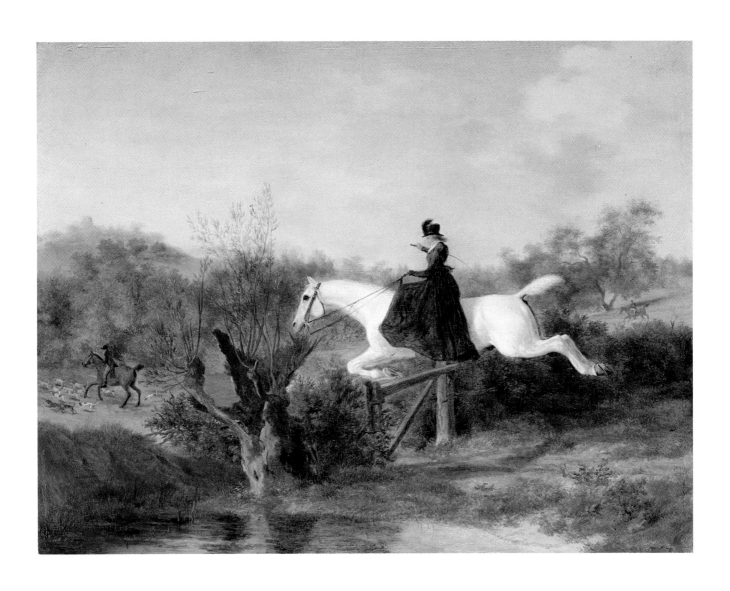

A female zebra stands on the ledge of a rocky hill-side, facing left, seen in profile; another zebra in the middle distance on the left is seen partly from behind.

Agasse's interest in wild animals lasted all his life. At least seventy-five subjects (including repetitions) are noted in his *MS. Record Book* between 1803 and 1848. Their species range from the best-known jungle animals - lion, tiger, zebra, leopard, cheetah, etc. - to those newly-imported species that appealed to him because they were 'curious': for example, 'a curious whitish antelope', 'a curious small kind of sloth', 'a curious animal of the buffalo tribe', 'a curious animal [from] Siera Leone'.

Agasse studied most of his wild animals in London menageries. He was a regular visitor at the menagerie established by Polito at Exeter 'Change in the Strand, and continued by Polito's son-in-law Edward Cross, who moved the menagerie to his new Surrey Zoological Gardens at Kennington in 1829. He also worked at the menagerie in Euston Road established by Polito's cousin W. Herring - the original owner of the Mellon 'Zebra'.

Oil on canvas 24¾ × 30 (63 × 76)

Provenance
W. Herring, by descent to - Fitt; Dr Fritz Nathan and Dr Peter Nathan, Zurich, 1965 from whom purchased by Paul Mellon; Yale Center for British Art.

Literature
MS. Record Book, either '29 [June 1803] A Zebra female 3 q. Size' or 'July 1 [1803] Copy of the Zebra Same Size'; Egerton, 1978, p.180, no.184; Cormack, 1985, p.12.

Yale Center for British Art, Paul Mellon Collection

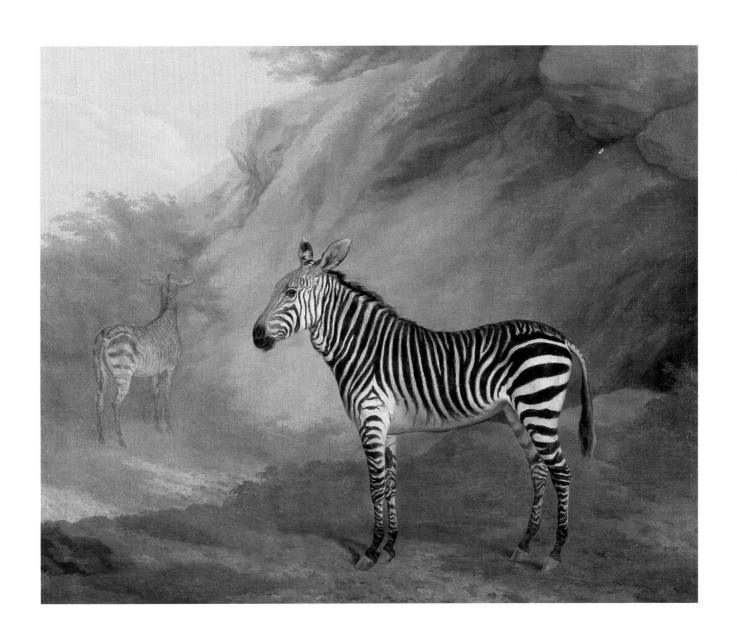

*15 Interior of a Brewery Stable 1804

This picture and 'The Brake' (Cat.no.33) were painted as a pair. According to Daniel Baud-Bovy (cf.Ms. in Baud-Bovy Archives, BPU), they were bought by Charles Martin to adorn his house at Malagnou near Geneva, and were split up after his death.

Both scenes belong to the world of stables, stud farms, markets and fairs so popular with Agasse as backdrops for his studies of animals.

'The Stable Yard' is almost certainly the painting mentioned in Agasse's *MS. Record Book,* '10 November 1804 1 d. A horse dealer, large composition, half Lth. S.', and exhibited at the Royal Academy in 1805 as no. 274.

The scene takes place in an English stable yard bustling with people going about their different businesses and alive with animals and poultry. At the centre of the composition, thrown into relief by a strong shaft of light, a stable lad holds a grey horse by the reins, while a horse-dealer in a blue frock-coat extols its virtues to an old gentleman who glances down to examine the beast.

The whole of the canvas is worked in browns and harks back to 'The Forge at Lausanne' and to the 'Stable Interior' in the Museum in Geneva. From the scale of the picture, however, and Agasse's obvious mastery of a rigorous technique, it is clear that he has developed considerably as an artist since coming into contact with English painting.

Agasse almost certainly found the subjects for this painting and its pair in stables like that of his friend Mr Hetherington - whose portrait he painted in August 1820 (cf. *MS. Record Book)* - where such people were often to be seen and where he had made friends with a variety of grooms and horse-dealers (Cat.no.33).

Oil on canvas 36¼ × 48 (92 × 122)

Provenance
Charles Martin, Geneva; Antoine Martin, Geneva; William Martin, Château de Vessy, near Geneva; Maurice Odier, Geneva; art market, Zurich

Exhibitions
Cercle des Arts et des Lettres, Geneva, 1901, p.15, pl. XXXII; Musée d'Art et d'Histoire, Geneva, February-March 1930 (39); *ibid.,* 1936 (32 repr.)

Literature
Cherbuliez, 1867, p.347, Baud-Bovy, 1904, p.110; Hardy, 1905, p.53; Gielly, March 1930; *ibid.,* 1935, pp.131, 221

Private Collection

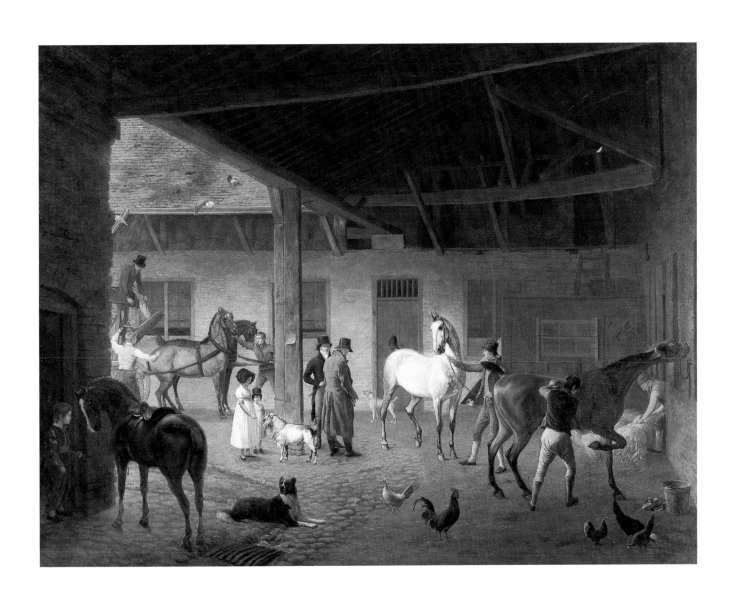

*16 Grey Horse and Groom in a Stable c. 1804

This was one of Agasse's favourite subjects and one he often tackled. There are no fewer than eight entries between 1801 and 1825 in his *MS. Record Book* for pictures on this theme: 'September 1801. 1 d. Small stable, a grey horse, a greyhound, figures'; 'July 1802 1 d. a chestnut horse, kicking and a white dog in a stable'; 'March 1804 1 d Inside of an ale house stable. Kitkat s'; '28. June 1804 Copy of the inside of the ale house stable, Small'; '29 September 1804 Copy again of the ale house stable. Kitcat'; '12 July 1810 Inside of a stable. Kitcat'; '13 July 1810 Copy of dito - small'; and '30 April 1825 P. of horses in a stable. 14 b. 17 Mr Musters'. To these should be added the versions painted before 1800, when Agasse was still in Geneva.

This is a difficult picture to date. Its style places it during Agasse's early years in England, and it may, therefore, be one of the 1804 versions, the 1810 one being the painting in the Fondation Reinhart's collection (cf. Zelger, *op. cit.,* p. 25, no. 6).

A copy of this picture with a few minor changes - the addition of a black dog on the left and a bucket on the right against the palisade - came up for sale at Sotheby's in London on 12 June 1980 (no. 18).

Inscribed on the back of the frame, 'Geneva Société des Amis des Beaux Arts 1824'
Oil on canvas 24⅝ × 29 (62.5 × 76)

Provenance
Louise-Etiennette Agasse, the artist's sister, Geneva; Société des Amis des Beaux-Arts, Geneva, 1824; Madame Marcet, Geneva, 1825; by descent to Horace de Pourtalès, Geneva; Bernard Naef, Geneva.

Exhibitions
Kunsthalle, Berne, August-October 1936 (2); Hôtel de Ville and Château, Yverdon, 16 June-20 September 1972, repr.

Literature
Société des Amis des Beaux-Arts, Geneva, General Assembly held on 11 January 1825 ('no. 3 painting by Agasse obtained by Madame Marcet. Action 112')

Private Collection

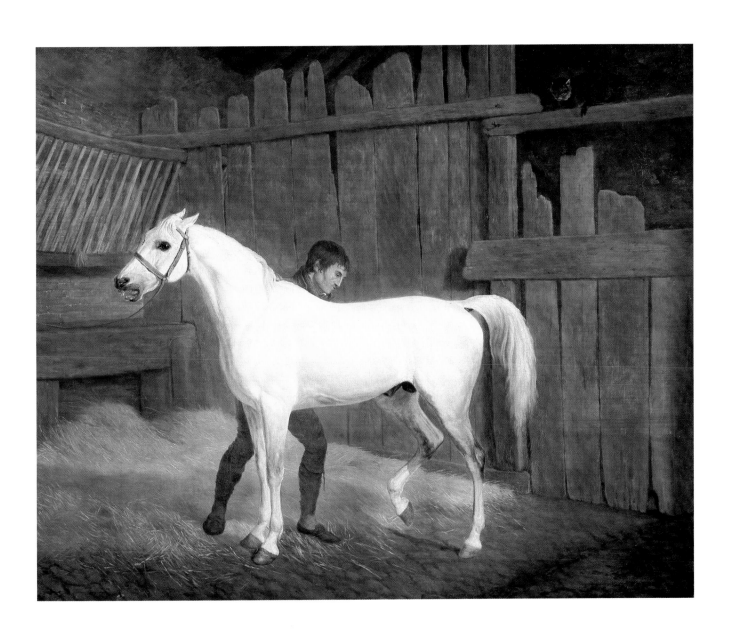

There are numerous references in Agasse's *MS. Record Book* to paintings of greyhounds, starting in 1804: '29.November 1804 small, of a grey hound' (whereabouts unknown), '17.April 1806 portrait of a grey hound white as large as life in background h. length' (whereabouts unknown), '16.September 1807 P. of nine grey hounds. Hant's. Size 3/4' (Mellon Collection, Upperville), '31.January 1810. Portrait of a black grey hound. S.v. small' (whereabouts unknown), '6.February 1813; A pocher: two grey hounds. S.3 1/2' (whereabouts unknown), '26.February 1814. Copy of a horse in gallop and black greyhound. Small' (whereabouts unknown). They were almost certainly all painted on Lord Rivers' Hampshire estate which he owned until 1815 and which boasted a greyhound stud famous throughout England. One of these two dogs appears in the various portraits of Lord Rivers (Cat.nos.41 and 55).

This life-size portrait shows two of Lord Rivers' magnificent greyhounds in their kennel at Stratfield Saye. We know their names and form from a partly effaced inscription on the bottom of the stretcher: 'Rolla won the cup at Marbl... march 1805 Portia won the cup ast... nov 1803'.

Judy Egerton has pointed out that Lord Rivers gave his greyhounds 'names beginning with P while he was still the Hon. George Pitt, and with R after his succession as 2nd Lord Rivers' (1978, p.184).

This is one of Agasse's finest works, combining perfect draughtsmanship with anatomical precision. No one else could capture so convincingly the elegant stance and enigmatic quality of these two magnificent creatures.

A pen and brush drawing of Rolla survives in a private collection.

Inscribed bottom left, 'J.L.A.'
Oil on canvas 60⅝ × 48⅜ (154 × 123)

Provenance
(almost certainly) Lord Rivers' collection, Stratfield Saye; ...;ex English collection; bought from the Bollag Gallery, Zurich, 1929

Exhibitions
Musée d'Art et d'Histoire, Geneva, February–March 1930 (1929-77); *ibid.,* 1943 (890)

Literature
MS. Record Book, '1805 December 14: Sdy of two Grey hound size life. Hants'; Baud-Bovy, 1904, p.111; Gielly, March 1930, pp.75, 79, repr.; *ibid.,* 1930, pp.119–120; Darier, 1931, pp.17–18; Gielly, 1935, pp.128-9, 132 repr.; Hugelshofer, *Agasse,* 1943, p.5 repr.; Huggler and Cetto, 1943, repr.12; Bovy, 1948, p.89 repr.58; Lapaire, 1982, no.61 repr.; Buyssens, 1988, no.36 repr.

Musée d'Art et d'Histoire, Geneva (Acc.no.1929-77)

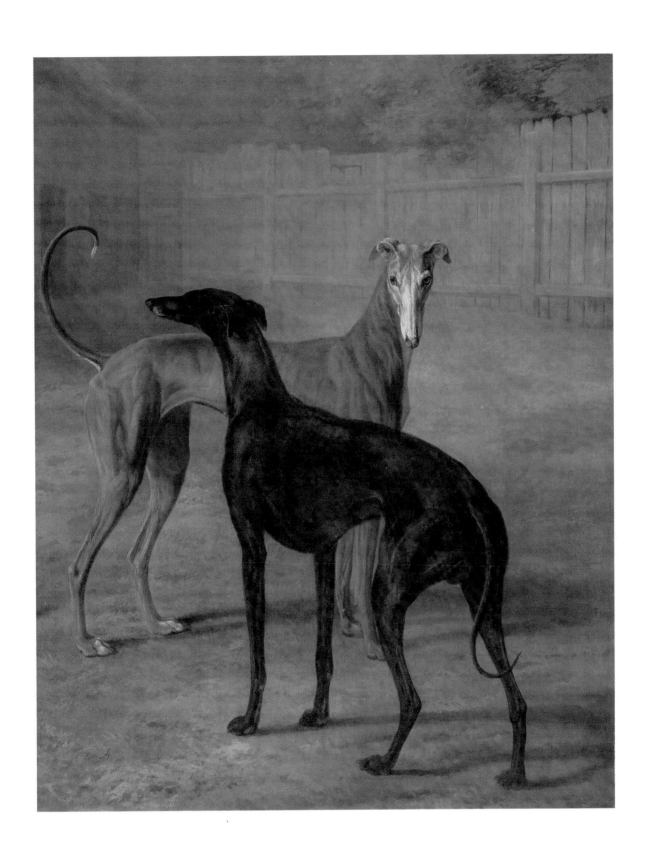

*18 Romulus and Remus and the She-Wolf 1805?

As his friend Töpffer observes in a letter of 28 May 1816, between 1812 and 1813 Agasse 'set about painting history. He has produced an Androcles and the Lion - the animal recognising its benefactor and rubbing against him like a friend instead of tearing him to pieces is excellent -, Alexander subduing Bucephalus in front of his daddy Philip - a truly perfect painting as far as the horses are concerned -, Romulus and Remus suckled by a beautiful she-wolf, the death of Adonis killed by a boar...' (Cf. letter to his wife, London, 28 May 1816, Ms. supl. 1638, fol. 106, BPU, and quoted in Baud-Bovy, 1904, p. 115).

Agasse's *MS. Record Book* includes two references to a painting of Romulus and Remus, first in the entry for 24 March 1805, 'The woolf size life in the p[ortrait] of Remus and Romulus', and then for 15 January 1810, 'Remus and Romulus and nurse S. 3/4'. The dating of this picture is somewhat problematic. Hardy (cf. Ms. *op. cit.*, p. 79) takes as his starting point the reference made in Agasse's *MS. Record Book* 1805 to 'the life size she-wolf in the picture of Romulus and Remus' and believes that the painting was put to one side and taken up again five years later, to re-appear in the *MS. Record Book* for January 1810 as 'Romulus and Remus and their Nurse'. As Danielle

Buyssens emphasises, however, Agasse describes the 1810 painting as ¾ size, or 31½ × 26⅝ (80 × 67.5) and this in no way tallies with the Geneva picture, which we are left to conclude was both begun and finished in 1805 (cf. 1988, *op. cit.*, no. 42).

Hardy also comments on the way Agasse surprises us by depicting the she-wolf neither as a 'ferocious beast nor as the symbolic animal we have come to expect in representations of the Romulus and Remus story, but as an affectionate domestic creature'. His observation is lent considerable weight by the recent 'discovery' in one of Agasse's sketchbooks (Private Collection) of a number of studies for this picture in which the she-wolf is replaced by a large dog surrounded by putti-like children. For an analysis of possible influences on this composition, see Danielle Buyssens (cf. *op. cit.*).

Agasse made some preparatory drawings of the she-wolf in 1805, 'February Sdy of a b. woolf. small size', 'March Copy of the woolf, very small', and in 1809, 'September 1 forgot August Copie of a woolf Small size'. Gauci made a lithograph of the picture but, according to Hardy (Ms. *op. cit.*), the stone broke before the print could be run off.

Oil on canvas 72⅜ × 61⅝ (184 × 155)

Provenance
painted for Francis Augustus Eliott, Lord Heathfield, Buckland Abbey; probably through the family to Sir George Meyrick, London; bought from Colnaghi, London, 5 February 1982

Exhibition
Hayward Gallery, London, 1974 (125)

Literature
MS. Record Book, '1805 March 24: The woolf size life, in the p[icture] of Remus and Romulus'; Baud-Bovy, 1904, p. 115; Hardy, 1905, pp. 57, 79; Gilbey, 1911, p. 14; Hardy, 1, 1916, p. 195; *ibid.*, 1921, p. 4; *ibid.*, 1, 1921, p. 67; Deonna, 1945, p. 280; Bénézit, I, 1976, p. 52; Egerton, 1978, p. 180; Buyssens, 1988, no. 42 repr.

Musée d'Art et d'Histoire, Geneva (Acc. no. 1982-17)

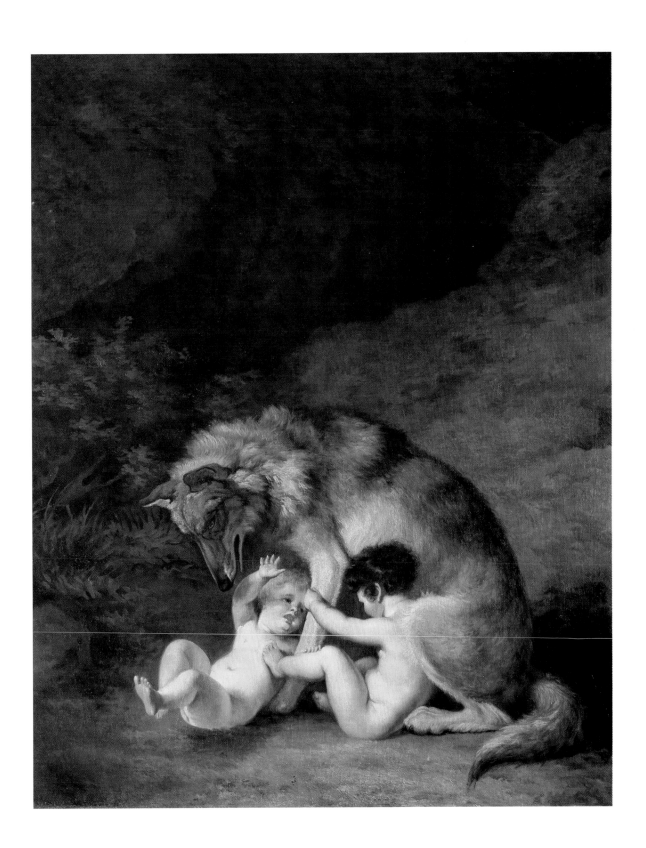

*19 Two Hunters with a Groom c.1805

A date of c.1805 is suggested because the treatment both of the horses and the landscape is similar to that of the painting in the Mellon Collection entitled 'A Little Bay Stallion from Lord Heathfield's Stud', two versions of which are listed in Agasse's *MS. Record Book* as having been painted in February and March 1805, possibly in Devonshire.

This picture may be the one listed by Agasse in his *MS. Record Book* as '[3 January 1806] pt. of two horses, a bay hunter & a Stalion Evergreen. 3/4 Size Hants'. The landscape, a view over rolling countryside to distant blue hills, might well be Hampshire - possibly at or near Stratfield Saye, Lord Rivers' country estate. The two horses are a bay and a chestnut, but the angle at which the chestnut is painted does not reveal its sex, and Agasse usually noted the inclusion of any figure as prominent as the groom.

Oil on canvas $25\frac{1}{16} \times 29\frac{7}{8}$ (63.6 × 75.9)

Provenance
...; Oscar & Peter Johnson, from whom purchased by Paul Mellon, 1969; presented to the Tate Gallery by Paul Mellon through the British Sporting Art Trust, 1979.

Exhibition
British Sporting Paintings, Fermoy Art Gallery, King's Lynn, 1979 (14).

Literature
Egerton, 1978, p.183, no.188, repr. pl.62.

Tate Gallery

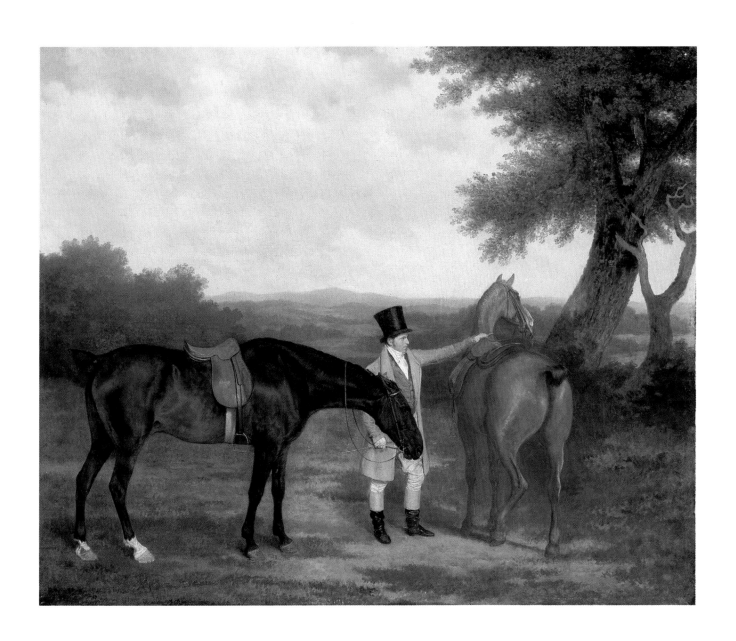

*20 George Irving on Horseback in an Extensive Landscape *c.* 1805-1815?

The scene is a pleasure ground. In the foreground a gentleman is riding on a chestnut hack accompanied by a King Charles' spaniel. Beyond and to the right are three other riders: two gentlemen and a lady who rides side-saddle. In the distance is a three-arched footbridge over a stream and, beyond that, gently rising wooded slopes. In the far distance to the left, only just visible through the trees, is what appears to be a grand, classical mansion.

This picture has not been positively identified with any entry in Agasse's *MS Record Book*. The figure on horseback in the foreground is said to be a portrait of George Irving (1774-1820), the son of John Irving of Burnfoot, Ecclefechan, Dumfrieshire and brother of John Irving. John Irving, the brother, was a partner in Reid Irving & Co., who in 1816-17 won a contract reputedly worth over a million pounds to supply uniforms to the Russian army. In 1826 he was elected as one of the two Members of Parliament for the rotten borough of Bramber in Sussex. After the 1832 Reform Act, he stood unsuccessfully for Clitheroe in Lancashire (at the general election in December 1832) and for Poole in Dorset (in 1834). He was eventually re-elected in July 1837 for Antrim, Ireland (F. Boase, *Modern English Biography*, 3 vols, London, 1897).

Oil on canvas 34 × 44 (86.5 × 110)

Provenance
...; Private Collection, Copenhagen; Sotheby's New York, 5 June 1986, lot 49

Harari & Johns Ltd, London

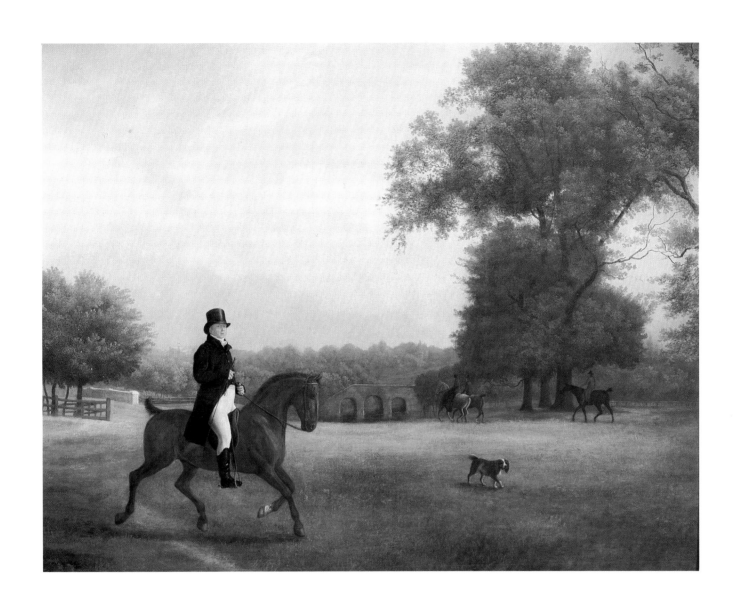

*21 Portrait of a Black Hunter and a Grey Mare 1806

Set in a woody grove the painting centres on a black hunter apparently making overtures to a grey mare whose dazzling coat is thrown into sharp relief by the shaft of brilliant sunlight in which she stands. Agasse has managed with incomparable skill to capture both the natural beauty and purity of the breed and the particular character of these individual animals.

This picture is not referred to in any of the literature on Agasse. It was almost certainly painted on Lord Rivers' estate at Stratfield Saye, however, and seems a likely candidate for the picture mentioned in Agasse's *MS. Record Book* for 24 June 1806: 'Pt [portrait] of a black hunter and a white mare. Size Kitcat'. The grey mare, seen here foreshortened, appears again in the foreground of Agasse's large composition entitled 'Lord Rivers' Stud Farm at Stratfield Saye' (Cat. no. 23).

Inscribed bottom left, 'J. L. Agasse'
Oil on canvas 23⅝ × 28 (60 × 71)

Provenance
...; Bollag sale, Zurich, 1934 (Cat. no. 2); Hausamann, Zurich

Literature
MS. Record Book, '24. June 1806 pt. of a black hunter and a white mare. Size Kitcat'

Private Collection

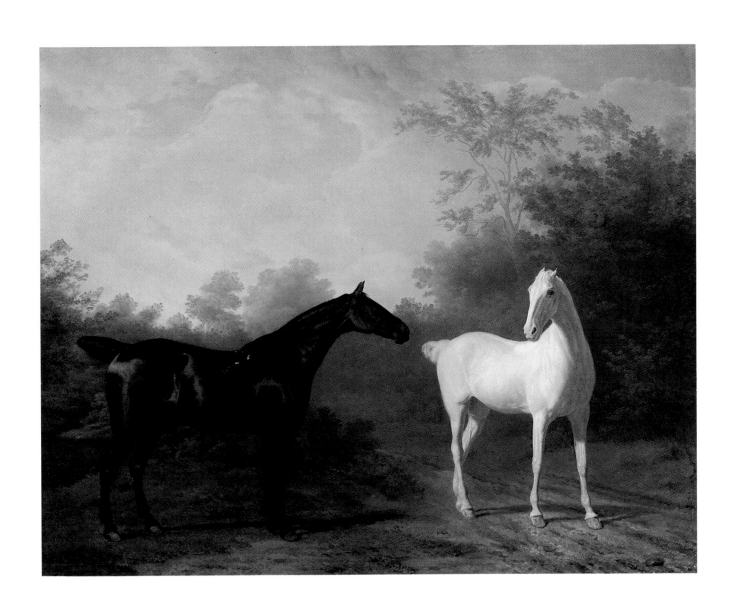

*22 Two Horses and a Greyhound Seen in a Landscape *c.* 1806?

Two splendid chestnut horses occupy a central position in the background of this picture. The one on the right is seen from the side, its head turned slightly away from us, in an attitude which shows it off to fullest advantage, and to which Agasse was often to have recourse.

With its landscape of tufted trees, complete with pond to the right and line of blue-grey hills in the distance, this picture could well be set in Hampshire, where Agasse painted some of his best canvases. The dog in the painting is the young greyhound called Snowball belonging to Lord Rivers (Cat. no. 41), and its presence here lends support to the idea that the two horses also belonged to him and came from his stud (Cat. no. 23).

This picture does not appear in Agasse's *MS. Record Book,* but it is close in composition and in style to the 'Portrait of a Black Hunter and a Grey Mare' (Cat. no. 21). It seems likely, therefore, because of the similarity in the treatment both of the animals and the landscape, that it is of similar date, that is to say *c.* 1806.

Oil on canvas 24 ⅝ × 26 ⅜ (62.5 × 67)

Provenance
2nd Lord Rivers, Stratfield Saye; ?...; sold Sotheby's, London, 6 July 1949, no. 14; Hausamann, Zurich, 1949

Exhibitions
Tate Gallery, London, 1934; Whitechapel Art Gallery, London, 1935

Private Collection

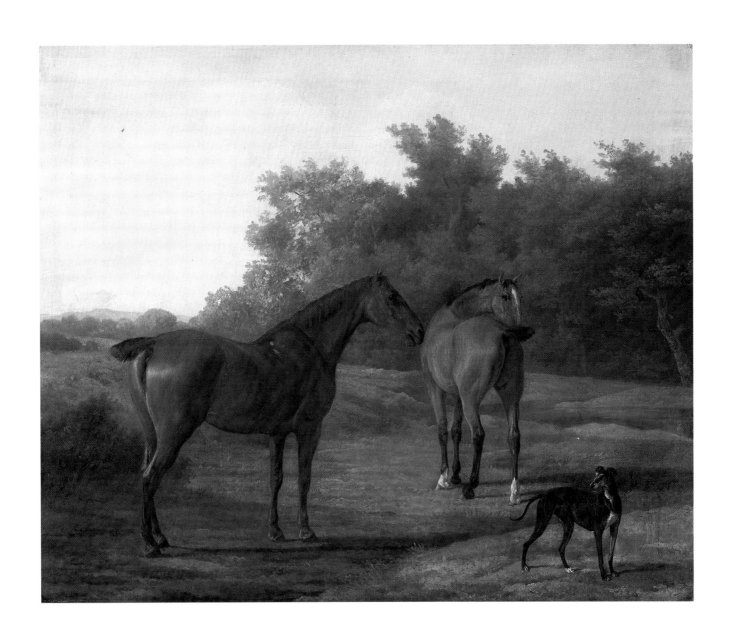

*23 Lord Rivers' Stud Farm at Stratfield Saye 1806-1807

This masterly work was begun in July 1806 at or near Lord Rivers' estate at Stratfield Saye, as may be inferred from the note 'Hants' in the margin alongside the entries that precede it in Agasse's *MS. Record Book.*

In the centre foreground are a colt and a mare, seen in profile facing to the left. These may be portraits of Whalebone, the future winner of the Derby in 1810, and Penelope his dam. Whalebone was bred by the Duke of Grafton. His sire was Waxy, brother to Worthy, whose portrait Agasse painted in 1807: '[29 May 1807] P. of the Stalion Worthy. s.Small half-length' and '[15 December 1807] Cpy of the stalion Worthy. S. 3/4'.

To the left of the colt and mare are a small boy and a youth who holds out his hat containing, perhaps, some sugar-loaf to entice the colt towards him. Behind them is a pond which extends to the left of the picture and, beyond that, a steeply rising bank topped by a line of thickly planted trees. In the pond and under the deep shade of the trees, lit here and there by gleams of sunlight, are about twenty mares, some with their foals at their side. At the extreme left, in a field at the top of the bank, are two foals at play at the heels of a mare who turns her head towards them with a motherly gesture.

Returning to the foreground, in the centre right, a foal standing head-on to the spectator turns its head to a setter dog. The setter stretches its nose inquisitively up to the foal. Behind this group, a foal scratches its cheek with its hind leg and, most striking of all, a white mare - much foreshortened - descends towards the pond, her hindquarters almost to the level of her head.

In the middle distance are some twenty to thirty mares and foals in attitudes of the utmost variety and, beyond these, riding alongside a wooden fence is a gentleman on horseback, possibly Lord Rivers, followed by a groom who stoops from his saddle to refasten the gate he has just passed through. In the same plane, but at the centre left, are two more horses, probably stallions, each led by a groom.

In the field on the far side of the fence, two young horses are sportively poised on their hindquarters, while yet others are grouped around a large tree that rises against an opaque, but cloudless sky. For the rest, there are even more horses in the distance, and the horizon on the right consists of low hills that barely rise above the gabled ends of some farm buildings.

Agasse exhibited this picture at the British Institution in 1807 (as 'View of an extensive stud farm'). According to Hardy, MS., quoting a conversation with Lionel Booth in 1903, it was bought by Lord Rivers for £300, who subsequently gave or bequeathed it to the artist.

Oil on canvas 60 × 84 (152.3 × 213.3)

Provenance
Bought by Lord Rivers, but subsequently given or bequeathed by Rivers to artist; ...; Arthurton; Sotheby's 6 July 1949, lot 19, repro; ...; purchased by Paul Mellon, 1979; Yale Center for British Art.

Exhibitions
B.I. 1808, no.431 as 'View of an extensive stud farm'; ? Tate Gallery, Sporting Room (Arthurton Coll.), 1934-39

Literature
MS. Record Book, 21 December 1807, 'A stud farm. this begun in Jully 1806. Size 7 feet by. 5'; D. Baud-Bovy, *Peintres Genevois,* Geneva, 1904, II, p.111; C-F. Hardy, 'J.L. Agasse: his life, his work, and his friendships', MS, pp.68-77; and 'The Life and Work of J.L. Agasse' Part 1, *Connoisseur,* XIV (Aug.1916), pp.191-198, repr.p.195; F. Gordon Roe, 'Jacques L. Agasse', *'The British Racehorse',* Sept 1959, pp.336-342, 378, repr.p.337; Cormack, 1985, p.12

Yale Center for British Art, Paul Mellon Collection

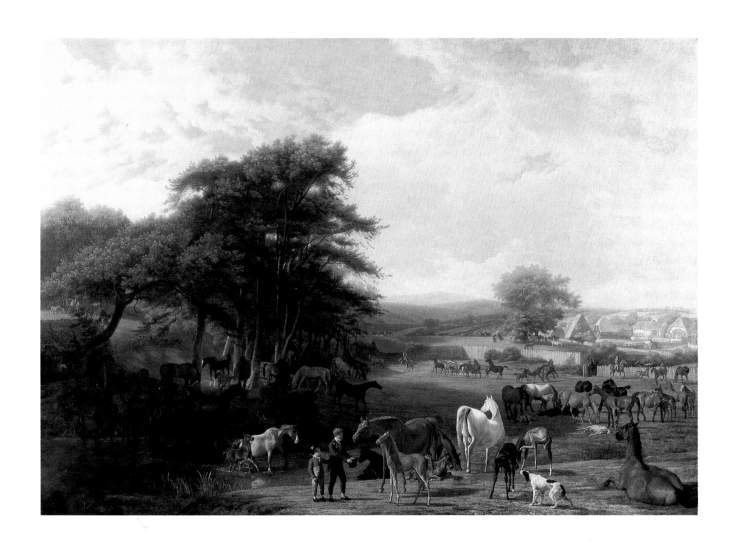

24 Horses under Trees at Stratfield Saye 1806-1807

This is an unusual subject for Agasse but it gives clear evidence of his prowess as a landscape painter. There is scarcely any action in the scene: animals graze quietly and there is not a human figure in sight apart from the shepherd with his dog to the left of the composition. The landscape has a primordial quality and the combination of this and the picture's obvious technical accomplishment aptly conjures up the idyllic harmony of grazing animal and nature seen in the soft light of a late summer afternoon.

The picture was painted on Lord Rivers' estate at Stratfield Saye and is stylistically akin to Agasse's large composition 'Lord Rivers' Stud Farm at Stratfield Saye' (Cat.no.23). It must therefore have been painted at the same date, *c.*1806. It may correspond to the entry in the *MS. Record Book* for '3 January 1806 Pt of 7 horses at grass. Hant's s. Bishop 1/2 length Size'. It is reasonable to speculate that the two landscape studies referred to by Agasse in July 1806 served as the basis for this composition.

Oil on canvas 20 × 30⅛ (51 × 76.5)

Provenance
2nd Lord Rivers, St Mary, Dorset; ...; sold Sotheby's, London, 6 July 1949, (No.17); Fishmann, London

Exhibitions
Tate Gallery, London, 1934; Whitechapel Art Gallery, London, 1935; Musée Cantonal des Beaux-Arts, Lausanne, 1982 (11)

Literature
Moselle, Bd.1, 1979, no.3

Aarau. Aargauer Kunsthaus (Acc. no.378)

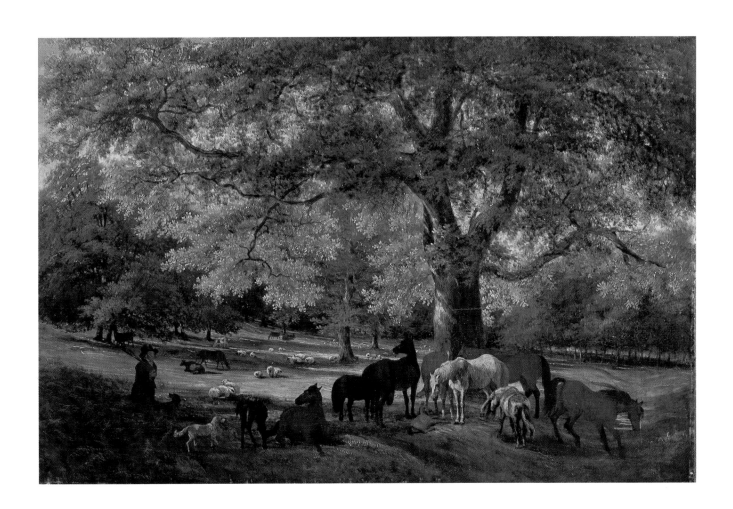

*25 Grey Horse in a Meadow 1806-1807

Although it is signed in full, this painting fails, as indeed do some of Agasse's other major works, to appear in his *MS. Record Book.* Zelger (*op. cit.,* p. 24) points both to the attitude Agasse shows the horse in and to the accuracy and precision with which he studies its anatomy as evidence that what we have here is nothing less than a real animal 'portrait' - a genre of which Agasse was a past master.

This is one of a long series of pictures of animals Agasse painted in Hampshire for Lord Rivers (Cat. nos. 23 to 26).

There are distinct similarities, particularly as far as the stance of the animal is concerned, between this picture and both 'A Little Bay Stallion from Lord Heathfield's Stud', painted in 1805 (Paul Mellon Collection, cf. Egerton, 1978, no. 187), and 'Grey Horse in a Wooded Landscape' (Private Collection, cf. *Fantaisie Equestre,* Musée Cantonal des Beaux-Arts, Lausanne, 1982, Cat. no. 6, repr. in col.), which dates from the same period as the painting in the Reinhart Collection, that is *c.* 1806-1807.

Inscribed bottom right, 'Agasse'
Oil on canvas 33½ × 44¼ (85 × 112.5)

Provenance
George Pitt, 2nd Lord Rivers, Stratfield Saye ?; by descent to J. R. Lane-Fox, Bramham; Lord Bingley, Bramham; Rodolphe Dunki, Geneva; bought by Oskar Reinhart, 1937

Exhibition
Kunstmuseum, Winterthur, 1942 (10)

Literature
Zelger, 1977, p. 24 no. 5 (and the preceding bibliography)

Museum Stiftung Oskar Reinhart, Winterthur

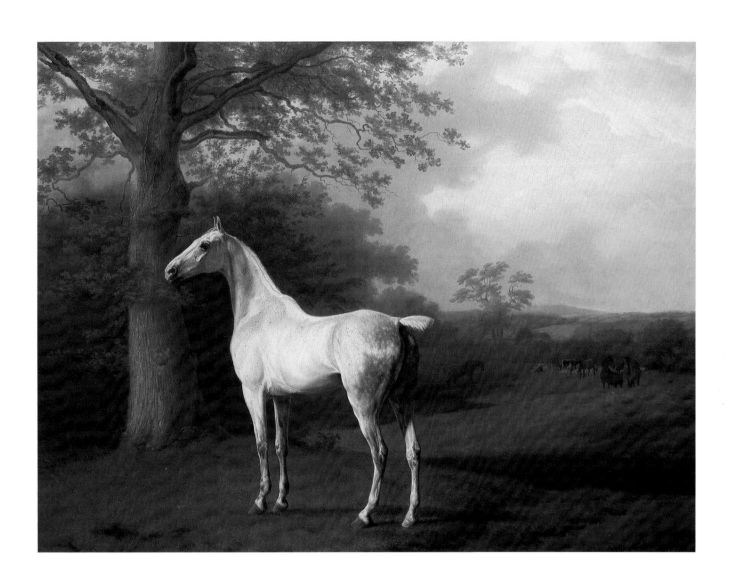

*26 Lord Rivers' Groom Leading a Chestnut Hunter towards a Coursing Party in Hampshire 1807

The groom wears Lord Rivers' livery, dark blue waistcoat with yellow collar and cuffs and cockaded hat trimmed with yellow. The group of riders in the background probably includes the 2nd Baron Rivers (1751-1828) of Stratfield Saye, Hampshire, Agasse's first, most important and most faithful English patron; and since Agasse records that this scene was painted in Hampshire, it is probably near Stratfield Saye. Lord Rivers bred greyhounds both at Stratfield Saye (where he also had a famous stud) and at his Cambridgeshire estate, Hare Park, aptly named and conveniently situated for coursing meetings at Swaffham and Newmarket.

Agasse reflected Lord Rivers' enthusiasm for coursing in some of his most brilliant canvases. Lord Rivers, shading his eyes from the sun, is the central figure in 'Lord Rivers and his friends coursing' of which there are two versions: (i) ? painted 1815; coll. George Lane Fox, Bramham Park, Yorkshire; exh. Arts Council, *British Sporting Paintings 1650-1850,* 1974-5, 126; (ii) ? painted 1818, coll. Musée d'Art et d'Histoire, Geneva. A portrait of Lord Rivers walking in his park with two of his greyhounds (coll. Jockey Club) was engraved in mezzotint by J. Porter, published 1827 (repr. Frank Siltzer, Newmarket, 1923, facing p.130). A larger than life-size portrait of Lord Rivers' greyhounds 'Rolla and Portia', 1805, is in the collection of the Musée d'Art et d'Histoire, Geneva. A group of nine greyhounds, almost certainly painted for Lord Rivers is in the collection of Mr and Mrs Paul Mellon.

Inscribed 'J.L. Agasse' lower left
Oil on canvas 26¾ × 24⅝ (67.9 × 52.5)

Provenance
George Pitt, 2nd Baron Rivers, by family descent to George Henry Lane Fox Pitt-Rivers; bequeathed by him to Mrs Stella Edith Maumen, by whom sold through John Baskett to Paul Mellon 1969; presented to the Tate Gallery by Paul Mellon through the British Sporting Art Trust, 1979.

Literature
MS Record Book, 'September 22 1807 P[ortrait] of a chestnut horse led by a groom - Hant's - s[ize] ¾'; Egerton, 1978, no.191, repr. pl. 64; *The Tate Gallery 1978-80,* p. 33, repr. in col.

Tate Gallery

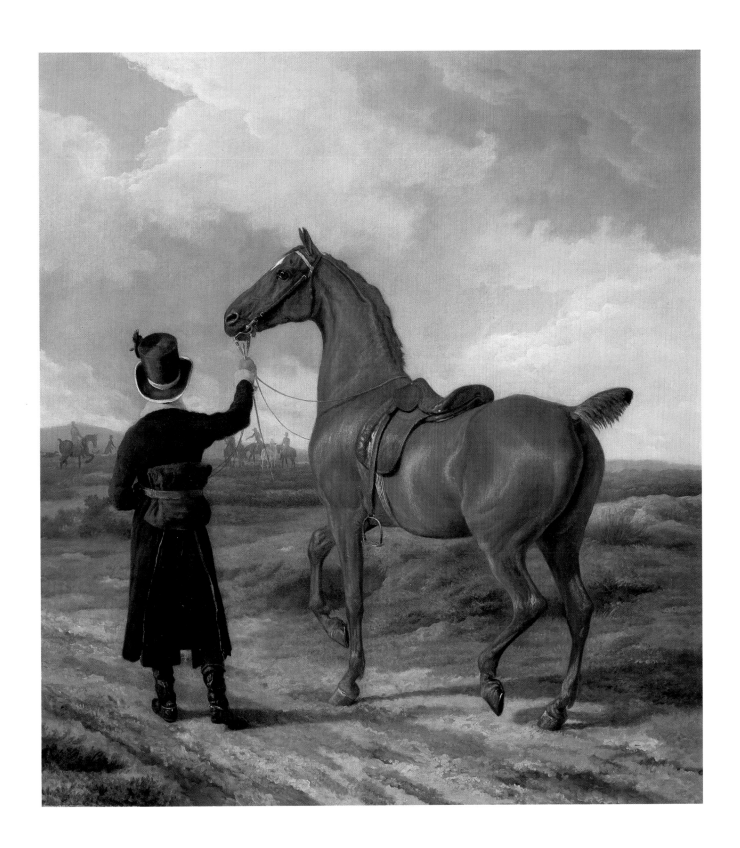

27 Two Tigers, Life Size 1808

Oil on canvas 93 × 113 (236.5 × 287)

Provenance
Lord Rivers; ...; ex English collection; G. & L. Bollag Gallery,
Zurich, 1930

Exhibition
Kunsthaus, Zurich, 1-19 September 1936 (Cat. no. 2)

Literature
MS. Record Book, '6. May 1808 Group of two tigers, as large as life.
Canevas 10 ft. 2 inches by 8 feet 1 inch'; Baud–Bovy, 1904, p.111;
Hardy, 1, 1916, p.196; *ibid.,* 1, 1921, p.67; *Schweiz. Illustrierte Zeitung,*
17 September 1930, no. 38, repr.; Gielly, 1935, p.131

Collection Prince M.

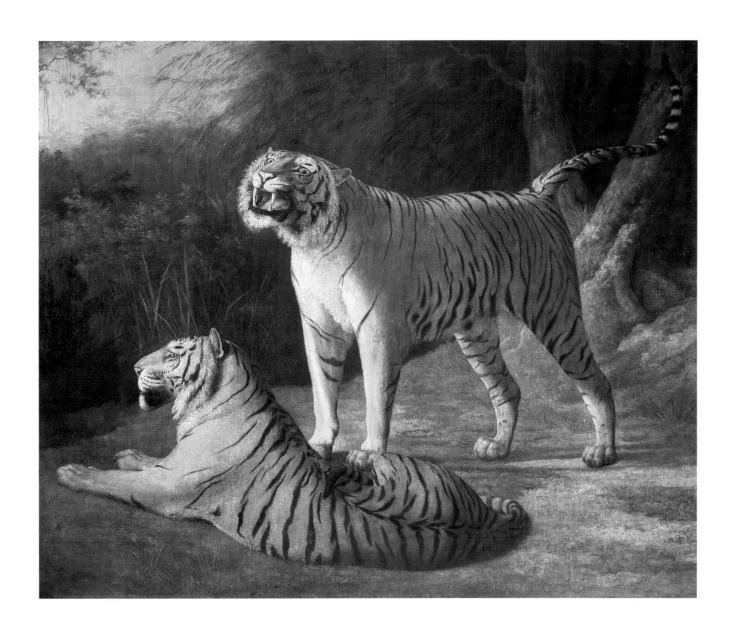

28 Two Lions, Life Size 1808

Agasse had an abiding interest in wild animals throughout his career, and never tired of painting them. He began working at Polito's menagerie at Exeter 'Change on the North side of the Strand in 1803. There he struck up a friendship with Polito's son-in-law Edward Cross who was later to take over the ownership of the menagerie (cf. Agasse's portrait of him, Cat. no. 71). Agasse's *MS. Record Book* lists no fewer than five paintings of lions, dating from 1808 (the one on show here); 1812, '5 september A group of lions, S. ¾' (whereabouts unknown); 1814, 'July A group of lions g small' (whereabouts unknown); 1825, 'April A group of welps between a Lion and Tigres' (Cat. no. 57); and 1847, 'The Lions tigres C. g. dito' (whereabouts unknown). There are seven references to pictures of tigers, starting in 1808 (the picture on show here); 1810, '6. June A Tiger size life c 7 feet by 6' (whereabouts unknown); 1814, '20. May A Tiger small' (Mellon Collection?); 1820, '20. September A tigress and welps ½ length' (whereabouts unknown); 1824, 'September Newly discovered by Europeans an East Tiger 14 b. 12' (whereabouts unknown); 1825, 'April A Group of the Sumatra tigers, size of life' (whereabouts unknown); and 1840, 'August A group of tigers ¾' (whereabouts unknown).

Adam-Wolfgang Töpffer refers to Agasse's passion for wild animals in a letter written to his wife during his visit to London in 1816, '... He [Agasse] took me to a beautiful menagerie with dozens of lions, little whelps, tigers, hyenas, an elephant, and, what is worse, a whale. I saw a lamb there living in a cage with a very big lion, and this lion is great friends with Agasse. He ran to kiss him. He is the finest lion you ever saw, and he returned each and every one of his friend Agasse's civilities...' (Ms. supl. 1638, fol. 106, BPU).

Agasse's cousin André Gosse (Cat. nos. 42 and 87) described in his diary the work he saw Agasse doing in the menagerie while he was staying in London in 1819, '... Saturday 19 June ... Went to see Agasse ... went with him to Mr Cross' menagerie where Agasse is drawing an orang-outang, an enormous elephant, an enormous lion, a lioness and her whelps, a tiger, some tame hyenas...' (Diary of André Gosse recording his stay in England, 16 June 1819–20 April 1820, Ms. 2677, BPU).

These two very big canvases were almost certainly designed for the menagerie at Exeter 'Change. Their style is much freer, somewhat broader than is usual with Agasse, verging on the sketchy. They are painted very quickly and thinly using sweeping brush strokes, the aim being to produce something primarily decorative. The painting of the two lions bears the traces of a great many changes of heart. Pencil sketches for these two pictures survive in a private collection.

Oil on canvas 80¼ × 121½ (204 × 283)

Provenance
Lord Rivers; ...; ex English collection; G. & L. Bollag Gallery, Zurich 1930

Exhibition
Kunsthaus, Zurich, 1–19 September 1936 (Cat. no. 1)

Literature
MS. Record Book '31. December 1808 A Group of two Lions. Size life. Canevas. 10 f. 2 inches by 8 f. 1 in'; Hardy, 1, 1916, p. 196; *ibid.,* 1, 1921, p. 67; *Schweiz. Illustrierte Zeitung,* 17 September 1930, no. 38, repr.; Gielly, 1935, p. 128; *Neue Zürcher Zeitung,* 1 September 1936, p. 4, repr.

Collection Prince M.

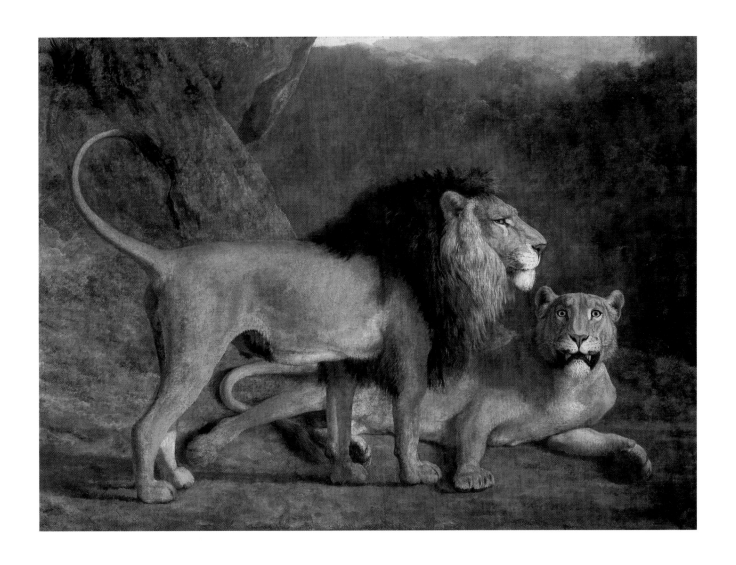

29 Two Leopards 1808

Two Indian leopards are playing in what appears to be the entrance to a cave. One stands on all fours in profile to the left, while the other lies on its back beneath and playfully pokes its left hind paw into the standing leopard's belly.

This wonderfully observant picture was painted at the menagerie in Exeter 'Change in 1808. It is listed in Agasse's *MS. Record Book* on 5 November 1808 as 'A group of Leopards size life. canvas 5 f. by 4.' and is quite possibly one of a series, for Agasse also lists in May 1808 a 'Group of two tigers, as large as life - Canvas - 10 f 2 inches by 8 feet 1 ins' and in December 1808 a 'Group of two Lions. Size life. Canvas. 10 f 2 inches by 8 f. 1 in.' (both now Coll. Prince M., Cat. nos. 27 and 28). All three pictures were bought by Agasse's friend and patron, Lord Rivers, who on his death in 1828 bequeathed the 'Two Leopards' to his nephew George Lane Fox of Bramham.

Inscribed: 'J.L.A.' bottom left, and dated indistinctly '1808'. An old label on the reverse bears the inscription 'Two leopards playing in the Exeter 'Change Menagerie in 1808'.
Oil on canvas 60 × 48½ (152.4 × 123.2)

Provenance
Painted at the menagerie at Exeter 'Change in 1808; bought by Lord Rivers; bequeathed to George Lane Fox; by descent; Christie's, 15 July 1988, lot 35, repro.

Literature
C-F. Hardy, 'The Life and Work of Jacques-Laurent Agasse, Pt. 1', *Connoisseur,* XLV (August 1916), pp. 191–8, repro. p. 96.

Private Collection

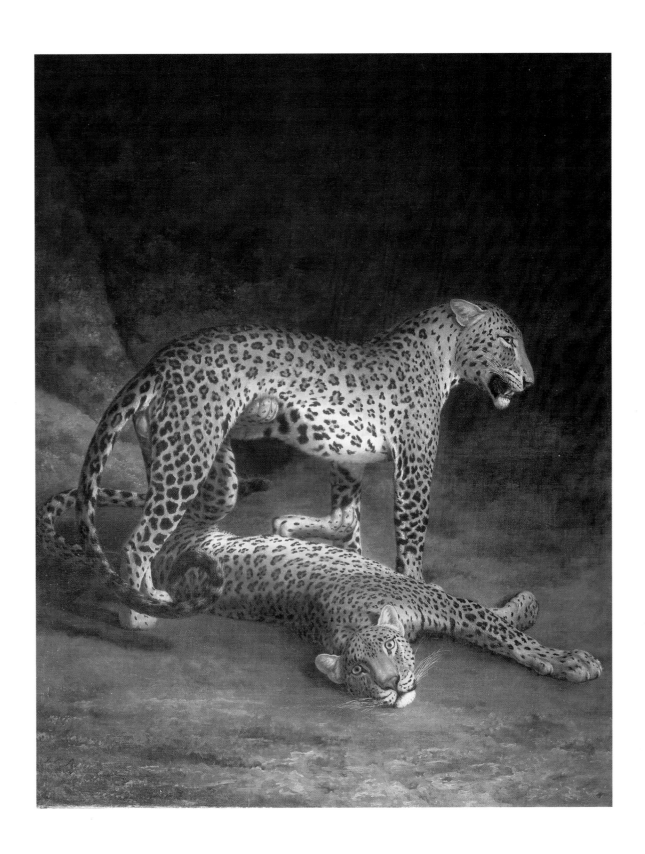

30 Daniel Beale with his Favourite Horse on his Farm at Edmonton 1808

In the foreground, on the left, a bay horse waits ready saddled, watched by a greyhound on the right. There is a shed in the background and in front of it, with his back to us, stands a gentleman in a top hat and frock-coat talking to a rustic. Hens scratch the ground around them, and a sow suckles her young nearby.

Agasse did not give the picture this title himself – indeed, there is no reference at all to Daniel Beale in his *MS. Record Book*. It ought to be emphasised, however, that very few names are given other than those of his two patrons, Lord Rivers and Lord Heathfield, or of friends whose portraits Agasse painted. An old label on the back of the painting reads, 'Daniel Beale/ at his farm at/ edmonton ville/ his Favourite horse/ 464'. The fact that it is in a nineteenth-century hand suggests that it was probably written by the owner of the picture himself.

The style of the picture makes it likely that it was painted during Agasse's first stay in England. It may be the picture given in the *MS. Record Book* for 18 July 1808, 'P[ortrait] of a little bay horse background, a farm yard, ¾ size'.

Inscribed in monogram bottom left, 'J.L.A.'
Oil on canvas 24¾ × 30 (63.5 × 76.5)

Provenance
...; ex English collection; sold Sotheby's, London, 18 November 1983 (no. 12, repr. in col.)

Private Collection

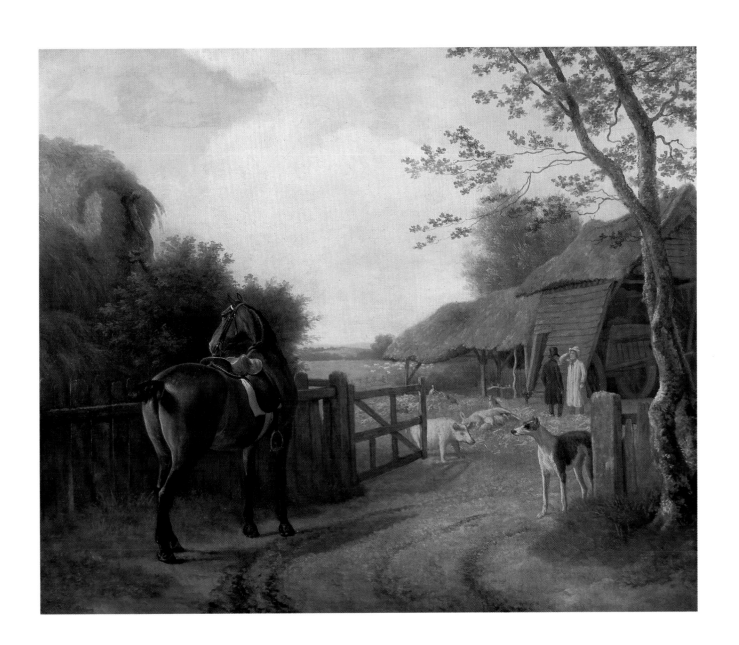

*31 Portrait of the Grey Wellesley Arabian with his Owner and Groom in a Stable 1809

This is one of Agasse's most important works, one of the very few to be signed in full, and without doubt the most brilliantly successful of his horse 'portraits'. The Hon. Henry Wellesley (1773-1847), the Duke of Wellington's youngest brother, returned to England in 1803 after serving in the Indies. In August of the same year he imported two Arabian/Persian cross horses, one grey, the other chestnut. Both were called 'Wellesley Arabian', but it was the grey which attracted the most attention from the racing fraternity. According to John Lawrence (*History and Delineation of the Horse,* 1809, pp. 281-2), the horse was 'Persian or Syrian with a considerable admixture of Arabian blood'. Judy Egerton (*op. cit.,* p. 185) argues that, because of his diplomatic links with the Shah of Persia, Henry Wellesley could well have had the benefit of expert advice when making his choice. *The Sporting Magazine* of August 1810 describes the 'Wellesley Arabian' as 'a horse of great substance and power', already the winner of numerous races at Newmarket.

The painting on show here is the first one of the Wellesley mentioned in Agasse's *MS. Record Book,* '25 August 1809 P. of a beautifull [sic] grey Arabian small the Wly, two figures, in a stable. Small ½ length'. There are other references to the same horse. 'September 1809 Portrait of ditto lead and groom small size' - this version (present whereabouts unknown) must be the picture submitted by Agasse's sister to the Société des Arts for inclusion in the exhibition they held in Geneva in July 1820, Cat. no. 1. Agasse's note for '18 April 1810 Copy of the Wlys Arabian with figures and C. small ½ length' probably refers to the version in the Mellon Collection (Cf. Egerton, *op. cit.,* no. 192). Two other entries may also refer to the Wellesley Arabian, '28 July 1815 a grey Arabian horse begun some years before half length' (whereabouts unknown), and 'October 1816 Copy of the grey horse in the desert. Small' (whereabouts unknown).

The painting was engraved by Charles Turner and the engraving published by Agasse himself on 19 August 1810 (cf. Alfred Whitman, *Charles Turner,* 1907, p. 224, no. 644).

Benjamin Marshall (1768-1834) also painted the Wellesley Arabian and his version was engraved by John Scott in 1809.

Inscribed bottom left, 'J.L. Agasse'
Oil on canvas 33½ × 43⅜ (85 × 110)

Provenance
...;Brigadier K.F.W. Dunn, Bencombe House, Uley, Dursley, Gloucestershire, 1980; sold Sotheby's, London, 9 December 1981 (No. 233 repr.)

Literatures
Ms. Record Book '25 August 1809 P. of a beautifull grey Arabian small the Wly, two figures, in a stable. Small ½ length.' *Discours de M. le professeur De la Rive,* given at the 3rd annual session of the Société des Arts, Geneva, 1 August 1850; Hardy, 1905, pp. 77-9; Gilbey, 1911, p. 6; Hardy, 1, 1916, p. 196; *ibid.,* 1, 1921, p. 68; Egerton, 1978, no. 185 (quoted)

Private Collection, by courtesy of Hildegard Fritz-Denneville Fine Arts Ltd, London

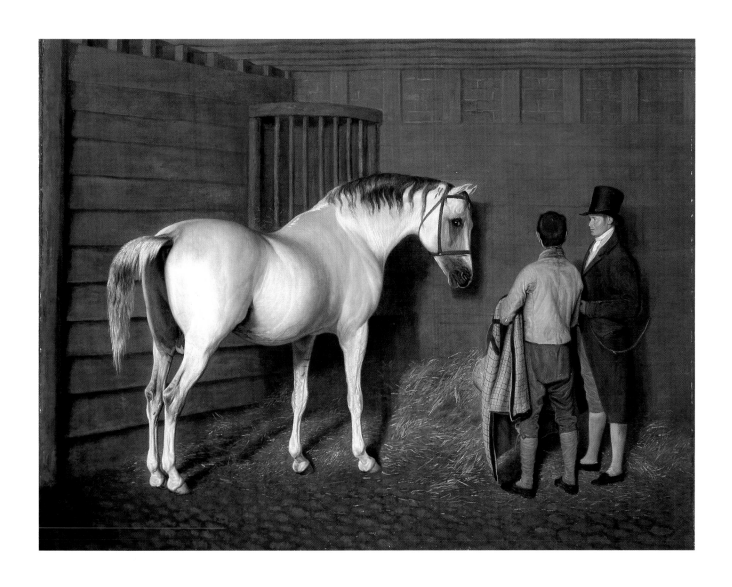

*32 Portrait of Lord Heathfield (1750-1813) 1811?

Francis Augustus Elliot, 2nd Lord Heathfield (1750-1813), was the son of General George Augustus Heathfield, the defender of Gibraltar. He served in the army like his father, rising from cavalry Commander in 1795 to General. He was an excellent horseman and a friend of both Lord Rivers and the Prince of Wales. Agasse had the good fortune to be taken under his wing.

As its Vice-President, Lord Heathfield was able to gain Agasse an entry into the *Royal Veterinary College*. This meant that Agasse could make frequent visits to the dissection room, museum, forge and paddocks which were all part of the establishment. Agasse won a commission from the college, furthermore, to paint six pictures including the different cross-breeds thrown up by Lord Morton's experiments (Cat. nos. 47 to 52).

Agasse painted four portraits of Lord Heathfield, each differing slightly from the others, mainly in the treatment of the landscape. All four versions are listed in Agasse's *MS. Record Book*. The first, which is probably the one in the Museum in Geneva, is dated 26 March 1811. Two more were painted in 1813, 'January 15 Copy of Lord Heathfield on horseback s. ½ length' (Royal Collection, Windsor, cf. Oliver Millar, *The Later Georgian Pictures,* 1969, p. 3, no. 650), and 'May 15 Copy of Lord Heathfield ½ length' (coll. Sir G. Tappas-Gervis-Meyrick, Bodorgan), and the final version in 1814, 'February 8 1814 Copy of late Lord Heathfield s. ½ length' (Kunstmuseum, Lucerne), painted after Lord Heathfield's death.

There are many similarities between this picture and the 'Portrait of Lord Rivers Coursing at Newmarket with his Friends' (Cat. no. 41). The most striking element in the picture is the horse - for Agasse, as Adrien Bovy has so rightly observed, 'the rider is there only to show off his mount' (cf. *La Peinture Suisse,* Basle, 1948, p. 49). It is worth noticing the difference in Agasse's approach to man and horse in this picture. The rider he paints as a mere stereotype without much substance, reserving all his energies for the thoroughbred, which he paints with enormous sensitivity and care, conveying its mixture of nervous power and beauty with consummate skill. This is a penetrating portrait, rooted in minute observation and quite remarkable for its truth to nature.

His time with David gave Agasse a confidence of approach and a clarity and precision in his draughtsmanship. He paints the horse as the living, moving creature it is, bringing out every nervous ripple in its muscles and every shimmer of colour in its glossy coat with a naturalism which makes no concessions whatsoever to the prevailing conventions of the day so religiously adhered to by his contemporaries. As we know, Agasse, like Stubbs, attended classes in both anatomy and dissection, but he combines his detailed knowledge of anatomy with a keen understanding of animal psychology. He is not content to limit his pursuit of truth to an accurate representation simply of form. His paintings always reflect the warmth of interest, love and affection he has for his subject.

Inscribed bottom left, 'J. L. A.'
Oil on canvas 50 × 39¾ (127 × 101)

Provenance
...; Marshall Spink, London 1952; given by the Société des Amis du Musée d'Art et d'Histoire, Geneva

Exhibition
Royal Academy, London, 1811 (529)

Literature
MS. Record Book, '1811 March 26: Lord Heathfield/ P[ortrait] of a Gman on a bay scool horse Size 1/2 length'; Baud-Bovy, 1904, p. 116; Hardy, 1905, pp. 96-8; *ibid.,* 1, 1916, p. 196; Fulpius, 1953, p. 186 repr.; Buyssens, 1988, no. 40 repr.

Musée d'Art et d'Histoire, Geneva (Acc. no. 1952-70)

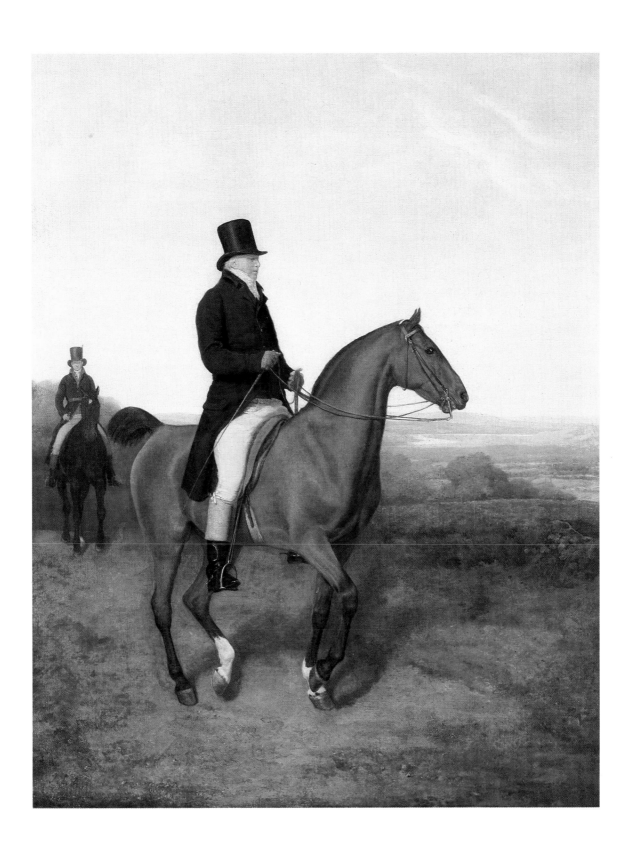

*33 The Brake *or* A Horse Dealer's Yard 1811

In this picture painted in 1811 and exhibited the following year at the Royal Academy, Agasse uses the same technique he employed in the picture to which this is a pair (Cat.no.15): vivid, finely observed details crowd the canvas, but the eye is irresistibly drawn to the brake and two horses brilliantly defined in a burst of sunlight at the heart of the picture. The black horse walks steadily forward, stroked by a stable boy, while the fiery dapple grey rears up on its hind legs. The old coachman, meanwhile, sits on unperturbed, his whip resting on his knees.

The action takes place in the same stable yard in both pictures, but it is seen from inside in the first and from outside in 'The Brake'. Here the shed has disappeared, the courtyard is open, and in the distance a group of trees pushes up into a blue sky still dotted with a few soft clouds.

Initialled bottom right, 'J.L.A.'
Oil on canvas 40⅛ × 49⅝ (102 × 126)

Provenance
Charles Martin, Geneva; Antoine Martin, Geneva; Gustave Martin, Geneva; sold Sotheby's, London, 21 January 1984 (No.99)

Exhibitions
Royal Academy, London, 1812 (327); Cercle des Arts et des Lettres, Geneva, 1901, p.155, pl.XXXL; Musée d'Art et d'Histoire, Geneva, February-March 1930 (45); *ibid.,* Geneva, 1936 (32, repr.)

Literature
MS. Record Book '2. May 1811 The break or a horse dealer's yard, Size ½ length'; Baud- Bovy, 1904, p.112; Hardy, 1905, pp.98-9; Gielly, March 1930; *ibid.,* 1935, pp.131, 221

Private Collection

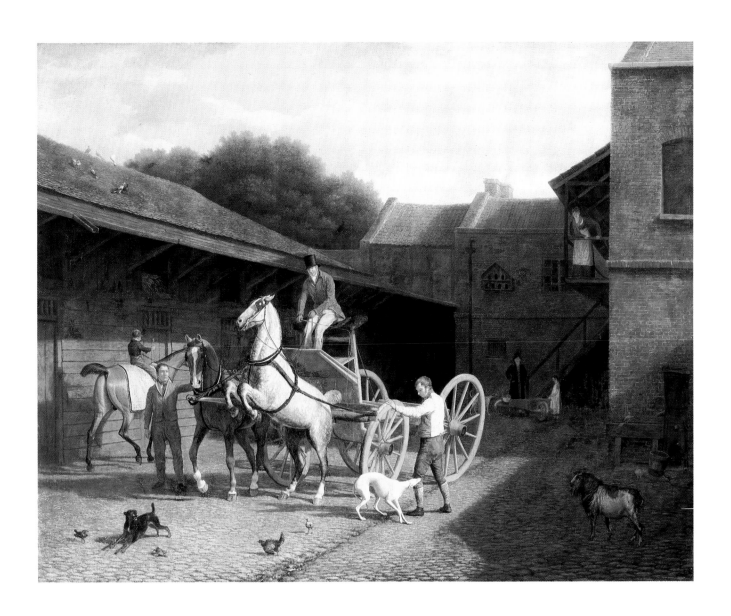

*34 Halt of the Portsmouth Stage-Coach 1815

The scene is set in front of an inn called the 'Saint George and Dragon'. One stage-coach has just arrived and unloaded almost all its passengers. A second stage-coach, meanwhile, is ready to set off in the opposite direction.

F.L. Wilder (cf. *Sporting Prints,* New York, 1978, p. 209, pl. 92) suggests that this is the stage's last halt at Horndean, outside Petersfield. This is based perhaps on a reading of Harper's account (*The Portsmouth Road and its Tributaries,* London, 1895, p. 216), '...We only changed [horses] once between Portsmouth and Godalming and that was at Petersfield, but the stages were terribly long, and we afterwards used to get another team at Liphook...'.

Agasse painted three versions of this subject, all attributed in his *Ms. Record Book* to the same day, 10 November 1815. The first and largest listed is the one in the Reinhart collection (cf. Zelger, *op. cit.,* p. 26) and is the painting exhibited at the Watercolour Society in 1816 under the title 'Coachmen Meeting and Comparing Notes'.

The second version (cf. Zelger, *op. cit.,* p. 26) was last heard of in a collection in England in 1962. The third, described by Agasse as '...Dito [Stage-coach] with alterations. Kitkat' and also in an English collection, was shown at the exhibition of *British Sporting Painting 1650-1850* held at the Hayward Gallery, London, 13 December 1974-23 February 1975, Cat. no. 127, repr. (oil on canvas, 28½ × 36 [72.4 × 91.4]).

One of the three versions was exhibited at the Salon of the Musée de la Société des Arts, Geneva, in July 1820, Cat. no. 3, under the title 'Two stationary English Stage-Coaches'.

The Winterthur version provided the basis for an engraving by Charles Rosenberg. The first state of this aquatint was published by J. Watson, 7 Vere Street, Cavendish, London, on 21 February 1832, as 'The Last Stage on the Portsmouth Road', and the second on 21 February 1833 as 'The Road Side' (cf. Charles Lane, *Sporting Aquatints and their Engravers,* vol. 1, Leigh-on-Sea, 1979, p. 76).

Oil on canvas 40½ × 50⅜ (103 × 128)

Provenance
...; private collection, London; Marshall C. Spink, London; Koblitz, Lugano; Fritz Nathan Gallery, Saint-Gall

Exhibition
Watercolour Society, London, 1816

Literature
MS. Record Book '10. November 1815 Stage-coach figure etc. 1/2 length'; Hardy, 1921, pp. 40, 112; Zelger, 1977, pp. 26-8 (with the preceding bibliography)

Museum Stiftung Oskar Reinhart, Winterthur

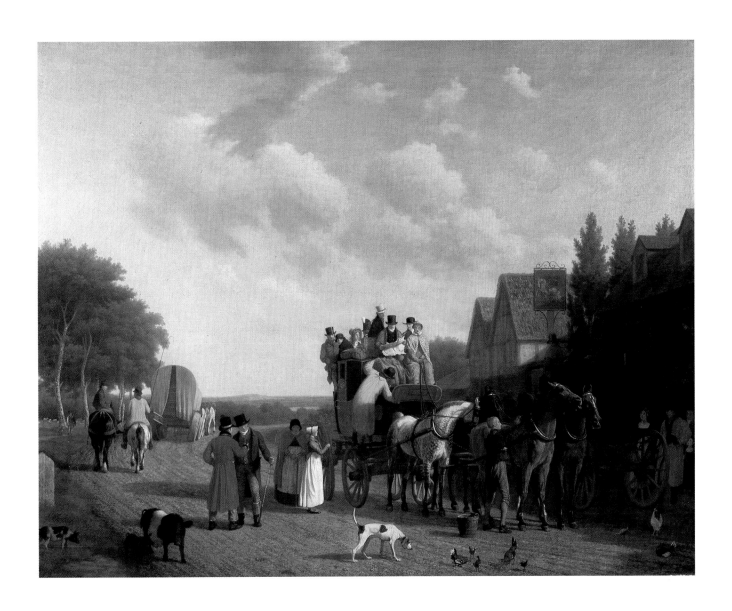

*35 Dash, a Setter 1816

Agasse's affection for dogs and his interest in them as subject-matter is evident in a great many of his early works painted well before he left for England.

In this life-size portrait of a splendid brown and white setter at the foot of a tree Agasse has caught the particular character of the animal in all its detail. This painting must be the one given in Agasse's *MS. Record Book* for May 1816, 'P. of A setter dog ½ length', and not, as Hardy maintains (cf. Ms., Musée d'Art et d'Histoire, Geneva, p. 53), the study of a white hunting dog listed by Agasse for 19 October 1803, 'Sdy [Study] of a white setter dog b. half Lh Size Size life'.

Dash was almost certainly one of a famous pack of hounds and this 'portrait' of him was probably commissioned by his owner, rather in the way that commemorative paintings so often were of successful racehorses of the day.

The picture was engraved in aquatint by Charles Turner (1773-1857) and published, undated, in London by R. Ackermann Jnr with the following captions: bottom left, 'Painted by J.L. Agasse'; bottom centre, 'London. Published by R. Ackermann Jun.r at his Eclipse Sporting Gallery. 191 Regent Street (Between Conduit St. & New Burlington St.)'; bottom right, 'Engraved by C. Turner' (cf. A. Whitman, *Charles Turner,* London, 1907, p. 223, no. 639).

Inscribed in monogram at the top of the tree trunk, 'JLA'
Oil on canvas 50⅛ × 39½ (127.5 × 100.5)

Provenance
sold Christie's, London, 11 November 1960;
Marshall C. Spink, London

Literature
MS. Record Book, 'May 1816. P. of a setter dog ½ length';
Hardy, 1905, p. 53; Hardy 1, 1921, repr. (eng.)

Private Collection

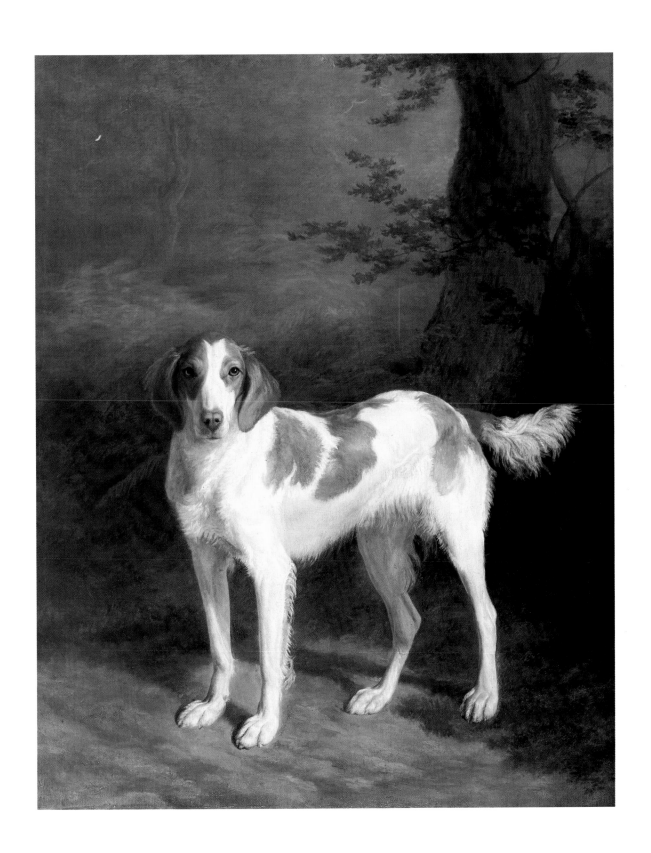

*36 The Country Fair 1817

This painting, exhibited at the Royal Academy in 1817, marks a new development in Agasse's work. Taking a lead from English painting, Agasse introduces a greater degree of openness and movement into this picture and so creates a sense of light and space entirely missing from his earlier works, notably 'The Horse Fair at Gaillard' (Cat. no. 6) which is otherwise very close to it in terms of subject-matter. Gone now are the browns of his earlier period - instead his palette has become lighter and softer. The sky, meanwhile, is more finished, and the background generally - based on an English landscape and reminiscent of a number of very popular prints of the day - has a more important part to play in the composition of the picture as a whole.

The subject is a market scene bursting with wittily drawn characters and amusing details. But what immediately catches our eye and stands out most prominently is the magnificent black stallion with its glistening black coat meticulously painted down to the last detail. The contrast between the horse and the bright blue of the sky and the lighter areas of the picture could not be more dramatic and proves yet again what a very fine animal painter Agasse is.

There is a quiet charm about this picture very much in keeping with the nineteenth century English taste for narrative, quasi-literary pictures.

Inscribed bottom right, 'J.L.A.'
Oil on canvas 28 × 36 (71 × 91.5)

Provenance
...; James Patry, London (1888); Sir Walter Gilbey, London; sold as part of the Gilbey collection, Christie's, London, Spring 1910, Cat. no. 68, p. 13; bought by Leggatt, then by a dealer, client of the London dealer Harry Arthurton. Given by the Société Auxiliaire du Musée d'Art et d'Histoire, Geneva, December 1910

Exhibitions
Royal Academy, London, 1817 (71); Kunstverein, Winterthur, January 1916 (1); Musée du Jeu de Paume, Paris, June- July 1924 (1); Musée d'Art et d'Histoire, Geneva, February-March 1930 (1910-89); Zurich, 20 May-6 August 1939 (534); Strozzi, Florence, 15 October-12 November 1949 (3); Musée Rath, Geneva, 1976 (2)

Literature
MS. Record Book, '1817 March: Market Day S. Kitcat'; Baud-Bovy, 1904, p. 117; Hardy, 1905. p. 113; Bovy, 1914, p. 532 repr.; Cartier, 1917, p. 24 repr.; Crosnier, 1917, p. 48; Grellet, 1921, p. 31; Hardy, 2, 1921, p. 117 repr.; *ibid.,* 1921, repr.; Rivoire, 1922, p. 10; Ziegler, March 1922, pp. 78, 81 repr.; Grellet, 1927, p. 448 repr.; Gielly, March 1930, p. 71; *ibid.;* 1935, p. 131; Neuweiler, 1945, p. 69 repr.; Bovy 1948, p. 89; Buyssens, 1988, no. 17 repr.

Musée d'Art et d'Histoire, Geneva (Acc. no. 1910-89)

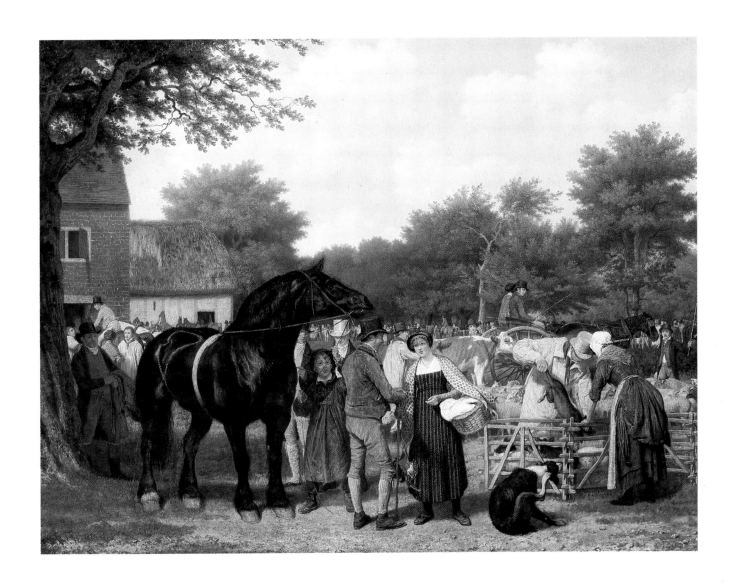

*37 Market Day: the Black Stallion 1818

A huge black Clydesdale stallion dominates the foreground of this picture in which Agasse explores further the subject he had tackled a year before in 'The Country Fair' (Cat. no. 36).

This new version gives a sense of being much more densely packed. Agasse has left some people out, altered others, changed the buildings, and blocked up the background landscape with a barrier of trees, leaving us with only the odd glimpse of blue sky.

The servant girl with the basket on her arm - who appears in both pictures - is thought to be a Scottish maid employed by Agasse's friends the Chalon brothers, painters like him who hailed from Geneva

but had settled in London (cf. Buyssens, 1988, *op. cit.,* no. 17).

A label on the back of the frame, written in General Dufour's hand, reads, 'a market near/ London/ Agasse/ Given to Gen. Dufour/ after the Sonderbund war (1848).' The picture was in fact delivered to him by Agasse's sister, as her letter of 5 June 1866 testifies (cf. letter from Louise-Etiennette Agasse to General Dufour, Plainpalais, 5 March 1848, Dufour Archives IV, no. 29).

'The Black Stallion' has often been confused by Agasse scholars with 'Friday Afternoon at Smithfield Market' (1824), which was exhibited at the Salon of the Musée Rath in Geneva in 1834.

Inscribed in monogram bottom left, 'JLA'
Oil on canvas 23 × 24⅛ (58.3 × 61.4)

Provenance
given by the artist to General Henri Dufour, Geneva, 1848; L'Hardy-Dufour Collection, Geneva; Ernest de Beaumont, Geneva; Annette Aubert-de Beaumont, Geneva

Exhibitions
London, 1881 (5); L'Hardy-Dufour Collection, Geneva, 1896 (1077, repr.); Cercle des Arts et des Lettres, Geneva, 1901, p. 14, pl. XXVIII; Musée d'Art et d'Histoire, Geneva, February–March 1930 (3); *ibid.,* 1943, p. 98

Literature
MS. Record Book, 'August 1818 C. of a few figures from the market day to complite the original study of a black cart stalion. 2 feet'; Inventory of General Dufour's effects, June 1866, under the heading of 'Pictures and works of art' (Dufour Archives): Baud-Bovy, 1904, p. 116; Hardy, 1905, p. 114; Gielly, 1935, p. 221

Private Collection

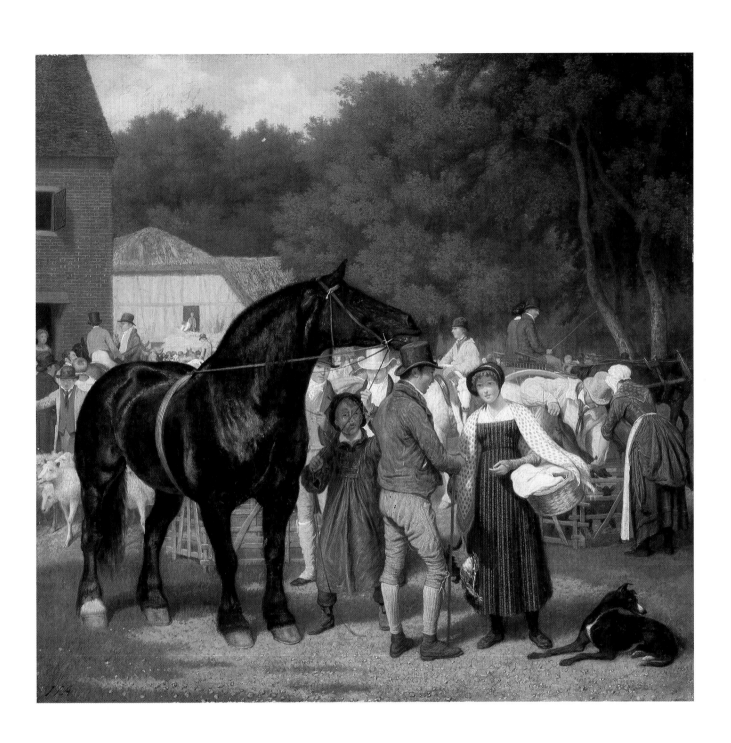

*38 Landing at Westminster Bridge 1818

This picture, like the next, is one of a series of London views Agasse painted in 1818: 'July 25 A view of Lambeth from Westminster bridge small' (Cat. no. 39), 'August A view at Blackfriars Bridge with a sailing boat, small', '10. October 1818 Westminster boys. Sailing. Small'.

Agasse produced two paintings of this subject. The first was large, '4. April 1818 Landing at Westminster Bridge S. 3 feet half by feet 4 inches' [113.4 × 75.6] (whereabouts unknown). The second was smaller, 'May sketch of dito small', and must be the picture on show here.

Franz Zelger (op. cit., p. 28) deals at length with the question of identifying the version Oskar Reinhart bought, and addresses himself to the task of unravelling its provenance, basing his ideas particularly on the information provided by Baud-Bovy (cf. 1904, p. 142) and by Hardy (cf. Agasse Archives, Musée d'Art et d'Histoire, Geneva). The larger of the two versions was exhibited at the Royal Academy in 1818 as no. 220, and one of the two at the 1820 Salon in Geneva, as no. 4 'View from Waterloo [sic] Bridge, London: Sailors Helping a Young Woman out of a Launch (with a sail)'. This must be the one listed as no. 4 in the inventory of Agasse's sister's effects carried out after Louise-Etiennette's death (Act of the notary A. J. E. Richard, 19 March 1852, no. 136, AEG).

Agasse is trying his hand in this picture at a subject which had long been popular with painters. The first of these was undoubtedly Canaletto whose 'London Seen through an Arch of Westminster Bridge' dates from 1746/7 (Duke of Northumberland's collection, cf. exh. cat. *Manners and Morals, Hogarth and British Painting 1700-60,* Tate Gallery, London, 15 October 1987-2 January 1988, no. 176). The picture was engraved by R. Parr and published in 1747 by John Brindley. It is tempting to imagine that Agasse was familiar with the engraving and was inspired by it to use the same device of 'framing' his composition in one of the arches of the bridge (for other possible sources of inspiration, see Zelger, op. cit., pp. 28-29).

The right side of the picture is thrown into dark shadow by one of the arches of the bridge. Through it we can make out Waterloo Bridge, inaugurated on 18 June 1817, Somerset House and the buildings on the right bank of the Thames. Four oarsmen can be seen rowing in the background - early evidence of the English fondness for the sport. But the originality of the composition lies in the way the figures in the foreground bring the scene to life. The influence of the English watercolour school is clear here in the painstaking precision with which this picture is painted, the subtlety of its colours and the iridescence of the light which plays on the gently rippling waters of the river.

Oil on canvas 13¾ × 21 (35 × 53.5)

Provenance
Louise-Etiennette Agasse, Geneva; Binet-Hentsch, Geneva; Lachenal-Maunoir, Geneva; Franz-Emile Horneffer-Maunoir, Geneva; Siegfried Horneffer, Geneva; Rodolphe Dunki, Geneva

Exhibitions
Salon of the Musée de la Société des Arts, Geneva, 1820 (4); Musée d'Art et d'Histoire, Geneva, 1936 (33)

Literature
MS. Record Book, '4. April 1818 Landing at Westminster Bridge S. 3 feet & half by 2 feet 4 inches'; Hardy, 1905, pp. 115-7; *ibid.,* 2, 1916, p. 10; Sparrow, 1922, p. 237; Musées de Genève, November-December 1949; Zelger, 1977, Cat. no. 8 (with the preceding bibliography)

Museum Stiftung Oskar Reinhart, Winterthur

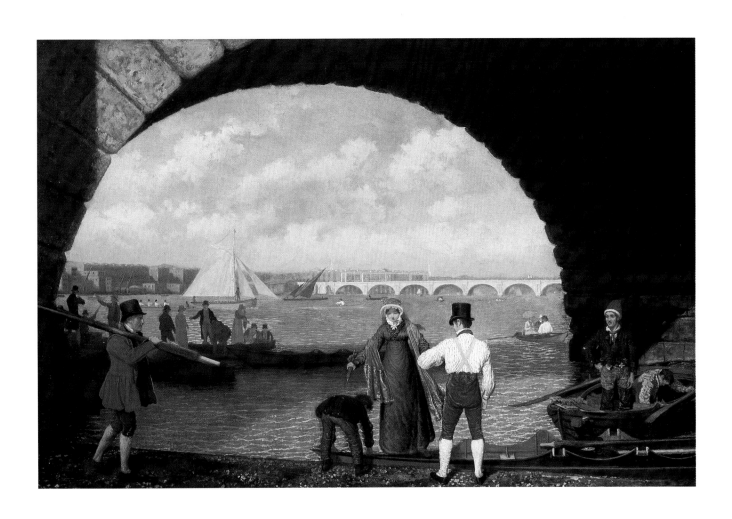

*39 View of the Thames from Westminster Bridge Looking towards Lambeth 1818

Here, as in 'Landing at Westminster Bridge', the river scene is framed by one of the stone arches of the old bridge, throwing into relief the sunny sky with its scattering of light clouds beyond.

In the foreground an elegantly dressed young couple have just settled themselves down for a pleasure ride, and a young boy is pushing their boat out. Still standing, the boatman is taking off his red coat before setting to with the oars. On the far right of the picture two small children are watching the scene closely, hand in hand.

Everything, from the Thames itself to the myriad different craft on its calm waters, is steeped in a golden light – the cutter, the racing boat with its crew of white-shirted rowers, the pleasure boats, and the sailing boats in the distance. All contribute to the charm and sense of happy ease which permeate the scene and which are so brilliantly evoked by the subtle balance of tones in the picture. The old

ecclesiastical Lambeth Palace can be seen in the background.

In the posthumous sale of Agasse's work held by Christie's in 1850, this painting was catalogued as 'Lambeth Palace, with fishing boats – from the river'. It was designed as a pair to the painting catalogued in the sale as no. 11, 'Westminster Abbey – the companion', which refers almost certainly to the first version of 'Landing at Westminster Bridge'.

When the picture now in the Thyssen-Bornemisza Collection was offered for sale by Sotheby's on 14 March 1984 it was described in the catalogue as a pair to 'View of the Thames at Southwark looking towards Blackfriars Bridge and St. Paul's Cathedral, to the far right Albion Mill' (no. 93 in the same sale). There is no mention of that painting in Agasse's *MS. Record Book*, unless it can be the work he refers to when he writes, 'Forgot in August. [1818] A view blackfriars bridge with a sailing boat. Small'.

Inscribed in monogram top right, 'JLA'
Oil on canvas 13¾ × 20½ (35 × 52)

Provenance
Artist's sale, Christie's, London, 1850 (no. 10); Lionel Booth, London; ...; sold Sotheby's, London, 14 March 1984 (no. 94, repr.); Nathan Gallery, Zurich; bought for the Thyssen-Bornemisza Collection

Literature
MS. Record Book, ' 1818 luly [sic] 25 A view of Lambeth from Westminster bridge small'; Baud-Bovy, 1904, p. 147; Hardy, 1905, p. 118

Fondazione Thyssen-Bornemisza, Lugano

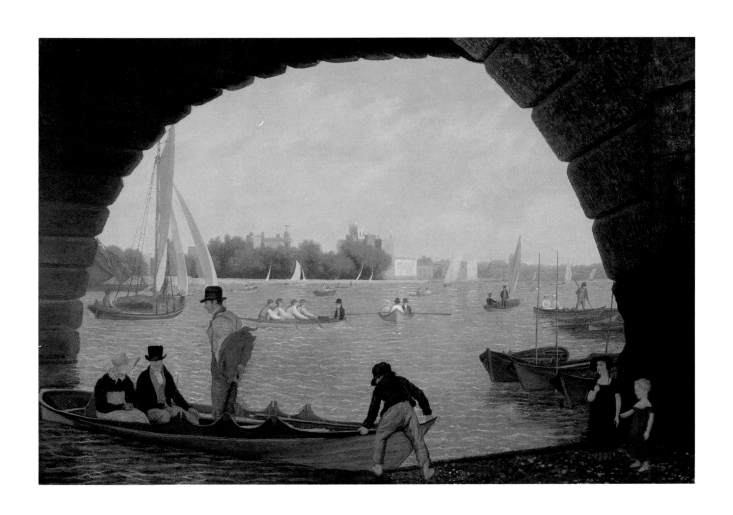

*40 Blackfriars Bridge with a view of St Paul's *c.* 1818

In the years 1814 to 1818 Agasse painted a number of Thames views culminating in his large 'Landing at Westminster Bridge', exhibited at the Royal Academy in 1818 (Cat. nos. 38, 39). The present picture is perhaps identifiable with the 'Westminster barge. Sailing. Small' or the 'Forgot in August A view of blackfriar Bridge with a fishing boat. Small' listed by Agasse in his *MS. Record Book* in October 1818, although by 'small' Agasse usually meant a painting approximately sixteen by twenty inches (40.7 × 50.5 cms). The setting is probably Savoy Stairs, below the Adelphi. The barges in the foreground are coal lighters, used to transport the coal upstream from the collier wharves at Wapping. On the far right, in the distance, is the Albion Mill.

Oil on canvas 23 × 37½ (58.4 × 95.3)

Provenance
...; Christie's, 6 April 1973, lot 104 (as 'J. Poole'); Ackermann, 1977; Mr and Mrs Timothy Edwards

Literature
Baud-Bovy, *1904,* p. 147; G. Grigson, *Britain Observed,* London, 1975, p. 90

Tim Edwards

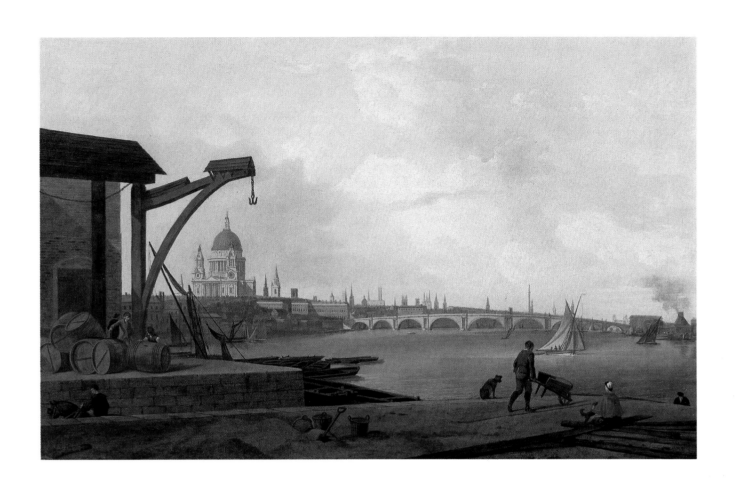

*41 Portrait of Lord Rivers (1751-1828) Coursing at Newmarket with his Friends 1818

Lord Rivers was Agasse's first and most influential patron, and he commissioned numerous pieces from him from 1800 onwards. George Pitt (1751-1828), only son of the first Lord of Stratfield Saye, succeeded his father to the title of 2nd Lord Rivers in 1803. He was among the Prince of Wales' personal friends. Lady Charlotte Perry, writing of him in her diary in 1810 describes him as 'a pleasant, elegant man, one of the last of that breed of dandies from a bygone age' (cf. *Diary of a Lady-in-Waiting,* published in George E. Cockayne, *The Complete Peerage of England, Scotland, Ireland, Great Britain and the United Kingdom,* Vol. I, 1838, p. 42).

Lord Rivers had large stud farms and greyhound kennels at Stratfield Saye and at Hare Park, near Newmarket (for more on Lord Rivers' greyhounds, see Cat. nos. 17, 22 and 55).

There are three references in Agasse's *MS. Record Book* to portraits of Lord Rivers at the Newmarket races. The first version, entered in 1815, '1815 March, Portrait of a Gm coursing. began 4 years before. L. Rivers ½ length', was probably painted for Lord Rivers' nephew, Lane Fox of Bramham Park (Trustees of the Bramham Park Estate). The second version, which is very probably the one now in the Musée d'Art et d'Histoire in Geneva, was painted in 1818, '1818 Jun: C[opy] of Lord Rivers [sic] on horse back. a sporting picture S. ¾', and exhibited at the Royal Academy in 1819. The third version, painted after Lord Rivers' death, dates from 1835, '1835 march: Copy of the p[ortrait] of the late L. Rivers as seen upon the heath at Newmarket. Kitkat' (ex private collection, London, sold Sotheby's, New York, 4 June 1987, no. 90, repr.)

In this splendid composition, one of Agasse's most prestigious works, Lord Rivers is shown on horseback, at the Newmarket races. A dazzling light plays on the entire scene causing the rider to shield his eyes from the sun with his left hand in an extraordinarily elegant gesture. Lord Rivers is accompanied by two friends, a groom and two greyhounds, one of which, on the right of the composition, is the famous Young Snowball, winner of countless races (Cat. no. 22). Agasse's portrayal of the three magnificent horses is particularly fine.

Agasse was to paint Lord Rivers' portrait on two subsequent occasions. One version is mentioned in his *MS. Record Book* for 1825, 'April 1825 P. Copy of a hole length figure of Lord Rivers with grey hound. 20 b. 24'. This is probably the painting bought by George IV, of which no trace survives other than the reference in the Royal Archives at Windsor to 100 guineas on account of a settlement with Agasse in 1827 'for a portrait of Lord Rivers' (cf. Oliver Millar, *The Later Georgian Pictures in the Collection of Her Majesty The Queen,* 1969, vol. I, p. 3). It seems probable that this picture was the one reproduced in an engraving by J. Porter published in London by Colnaghi on 9 May 1827 with the caption, 'To the King's most Excellent Majesty this portrait of the Rt. Hon. George Pitt, Lord Rivers, is by gracious permission dedicated by His Majesty's most devoted and humble subject and servant, Martin Henri Colnaghi' (repr. in *Pages d'Art,* 1921).

Inscribed bottom left, 'JLA'
Oil on canvas 36¼ × 28 (92 × 71)

Provenance
...; Sir Walter Gilbey, London; sold with the rest of his collection, Sotheby's, London, Spring 1910 (Cat. no. 67, p. 13); Legatt, London; came into the hands of the art dealer Carter; sold by him to the Musée d'Art et d'Histoire, Geneva, through the London dealer Harry Arthurton, December 1910

Exhibitions
Musée d'Art et d'Histoire, Geneva, February-March 1930 (1910. 86); *ibid.,* 1942 (p. 34); *ibid.,* 1943 (886); Strozzi, Florence, 15 October-12 November 1949 (4); Schloss Jegenstorf, 6 June-18 October 1970 (9)

Literature
MS. Record Book, '1818 June C[opy] of Lord Rivers [sic] on horse back. a sporting picture S. ¾; Hardy, 1905, p. 118; Baud-Bovy, 1914, p. 354 repr.; Hardy, 2, 1917, pp. 10, 15; Grellet, 1921, p. 31; Hardy, 2, 1921, p. 119 repr.; Grellet, 1927, p. 446; Gielly, 1935, pp. 133, 135 repr.; Baud-Bovy, 1948, p. 89, repr. 57; Lapaire, 1982, no. 60 repr.; Buyssens, 1988, no. 14 repr.

Musée d'Art et d'Histoire, Geneva (Acc. no. 1910-86)

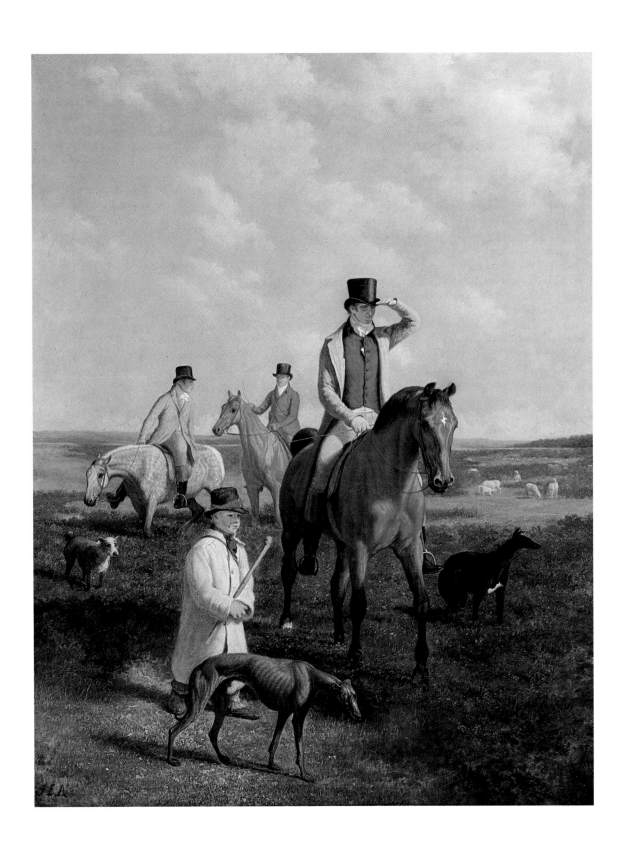

*42 Portrait of Louis-André Gosse 1819

Louis-André Gosse came to visit his cousin Agasse in the summer of 1819 while in London to complete his medical studies. His *Diary (Voyage en Angleterre, 16 June-28 November 1819, Ms.2677, BPU)* is a mine of valuable information about Agasse's life and work, and friends and connections.

Louis-André Gosse was born in Geneva in 1791, the son of Henri-Albert Gosse and Louise Agasse, and studied medicine in Paris, qualifying there in 1816. After travelling in Europe, he returned to his native city to practice. In 1820 he co-founded the Geneva Dispensary with Drs Prevost and Dupin. He became a member of the Philhellenic Committee in Geneva and was appointed Paymaster General of the Greek fleet. His devotion to the Hellenic cause earned him a great many honours - the freedom of the cities of Poros and Athens and of the island of Calavrée, and the title of Knight of the Order of the Saviour which he was granted in 1834, to name but a few. In 1833 he married Blanche Le Texier, daughter of Jean-Charles Firmin Le Texier and Hippolyte Elisabeth Barbe Céard.

Agasse painted Louis-André Gosse's portrait on two separate occasions, first of all in about 1798 (Cat.no.87), and then in 1819 when Gosse came to London. Gosse seems to have taken a great interest in the whole process and describes the various stages in his diary: 'Friday [25 June]... went to see Agasse. He is painting my portrait' (fol.7b), 'Friday [2 July]... he [Agasse] does not want to finish my portrait...' (fol.11a), 'Saturday 3 [July]... Went to see Agasse. He was busy on my portrait until 3 o'clock. Working slowly through lack of habit with him. Excellent, but obsessively minute, sketch from nature' (fol.11b), 'Wednesday 7 [July] ...Went to see Agasse. He has spoilt my face in the process of touching up the portrait...' (fol.35a), 'Wednesday 11 August... I went to Agasse's house, he has re-touched my portrait' (fol.46b), 'Sunday 5 September... I had taken my portrait along, and it was admired by everyone. Madame Sylvestre maintains that I've got a pair of pistols instead of eyes' (fol.67b). The face which looks out at us from the plain, dark background devoid of props is an expressive one: the mouth is finely drawn and the eyes are sharp, at once penetrating and humorous. In this small painting Agasse displays a keen understanding of psychology and to this he applies his skills as a draughtsman and as a colourist to create a portrait which is both truthful and affectionate.

Oil on wood 9 × 7 (23 × 18)

Provenance
Louis-André Gosse, Geneva; Hippolyte Gosse, Geneva; Claire Maillart-Gosse, Geneva

Exhibitions
Salon of the Musée de la Société des Arts, Geneva, 1823 (11); Cercle des Arts et des Lettres, Geneva, 1901 (not in cat.); Musée d'Art et d'Histoire, Geneva, February-March 1930 (20)

Literature
MS. Record Book '18.July 1819 Portrait of Mr G. a head. Small'; Louis-A. Gosse, *Voyage en Angleterre,* 16 June-28 November 1819, fol.7a, 11a, 11b, 13c, 33a, 34b [Ms. 2677, BPU]; Plan, 1902, p.15; Baud-Bovy, 1904, pp.119, 121, repr.no.83; Hardy, 1905, pp.120-1; Brun, I, 1905, p.16; Crosnier, 1916, pp.33-36, repr.Hardy, 1, 1916, p.192; *ibid.,* 2, 1917, p.12; *ibid.,* 1, 1921; Gielly, 1935, p.221

Private Collection

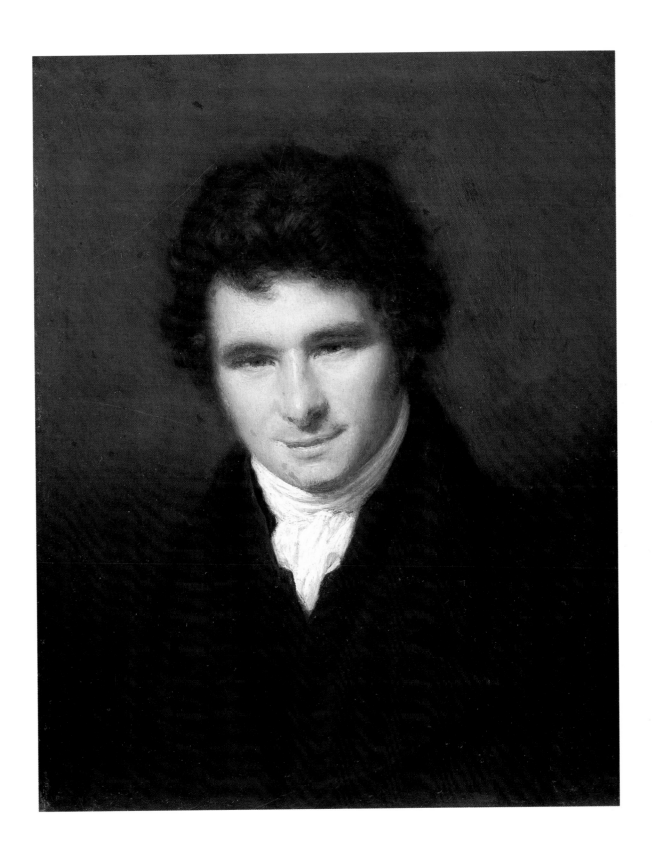

*43 A Snowy Morning 1819

Agasse painted two versions of this delightful scene, detailed in his *MS. Record Book* as '23 February 1819. A cart. Snow effect v small' and 'April 1822. Snowly Morning. altered from first 18 by 14' (whereabouts unknown). The first, and smaller, of the two is the one in the Museum in Geneva.

The provenance of the version shown here leads one to think that this is the picture mentioned in the inventory of Agasse's sister's effects drawn up on 6 August 1852 after Louise-Etiennette's death: '13 Black horse, snow effect, study, unframed, 15 Frs' (Minutes of the notary A.J.E. Richard, 1st half-year of 1852, no.16, Act.no.136, folio 5, recto, AEG).

According to Baud-Bovy (Baud-Bovy Archives, fiche 116, BPU), there was a lithograph of 'A Snowy Morning' in the Booth collection.

'A Snowy Morning' is very definitely one of Agasse's most successful subject pictures. All its finely observed, carefully drawn details combine to produce a vivid evocation of the first snow of the winter: the solitary carriage drawn by a single great black horse, the obvious good humour of the passengers all muffled up against the chill of the cold winter morning, the red coat worn by one of the women which glows like a beacon in the otherwise unbroken white of the snow-covered landscape.

Oil on panel 12¾ × 10⅞ (32.5 × 27.5)

Provenance
Louise- Etiennette Agasse, the artist's sister, Geneva; Société des Amis des Beaux Arts, Geneva; Madame Marcet, Geneva; Gaston Pictet-Thomeguex, Geneva; Jean Lullin, Geneva

Exhibitions
Royal Academy, London, 1820 (437); Musée d'Art et d'Histoire, Geneva, February-March 1930 (46); *ibid.,* 1943 (887)

Literature
MS. Record Book, '1819 February 23. A cart. Snow effect v small'; *Registre des Délibérations,* Société des Amis des Beaux-Arts, Geneva, 23 November 1824; *Assemblée Générale* of the same, 11 January 1825; Baud-Bovy, 1904, p.117, repr.87; Hardy, 1905, pp.119, 138; Gielly, March 1930, p.71; *ibid.,* 1935, pp.132, 222; Fosca, 1945, p.112

Dépôt de la Fondation Jean-Louis Prevost, Musée d'Art et d'Histoire, Geneva (Acc.no.1985-15)

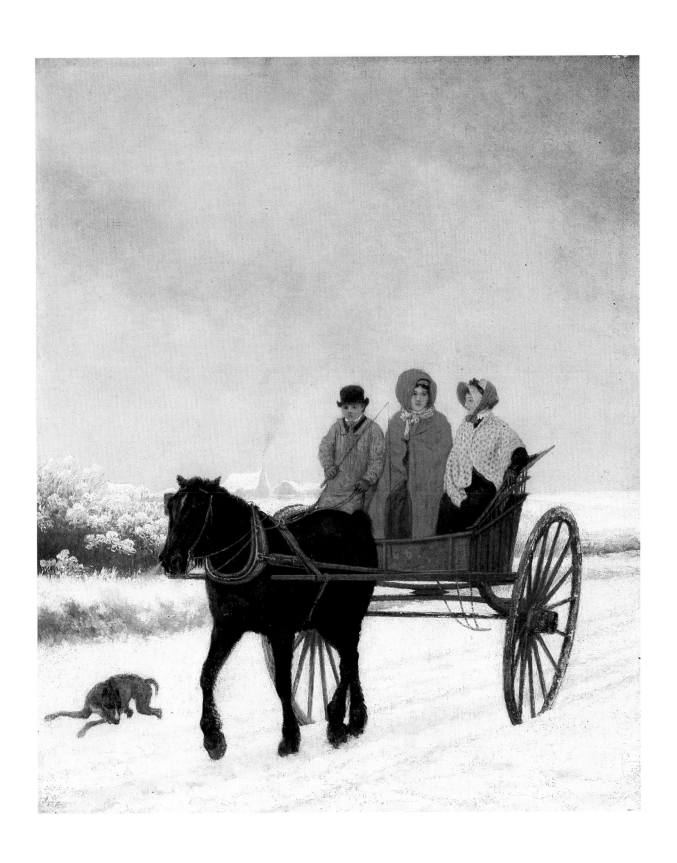

*44　The Mail Coach　c. 1819

Mail coaches were a very popular form of transport at the beginning of the nineteenth century because of their elegance, comfort and speed. The English versions boasted a number of technical refinements, such as a sprung suspension and capacious boxes front and back for stowing luggage and mail. Coaches in general had the added advantage of not being subject to tolls.

This particular coach, marked 'Cambridge', is being drawn at a brisk pace by four horses along an open road through woody country. The sky darkens as storm clouds gather but a warm twilight glow suffuses the whole scene. As their harness catches the sun's dying rays, it is the elegance and beauty of the horses once again which are made to stand out in this painting.

Agasse refers twice in his *MS. Record Book* to pictures of a 'Mail Coach', '8 December 1818: A mail coach evening small' and '18 June 1819 A Mail coach 3/4'. The later version, now lost, was exhibited as no.131 at the Watercolour Society in 1820. The two engravings of the scene by F.C. Lewis and J. Watson were based on a watercolour version painted the same year (Cat.no.111). From the details Agasse gives of time of day and size, it seems likely that the picture on exhibition here is the one referred to in the entry for 1818. Hardy, however, maintains, but without offering any grounds for so doing, that the 1818 version was a sketch for the large picture of 1819 (*op. cit.,* p.119).

Oil on canvas $19\frac{5}{8} \times 24\frac{1}{4}$ (50 × 61.5)

Provenance
...; Naville collection, Cham, near Zurich; Römer, Zurich

Literature
Hardy, 1905, p.119; Hugelshofer, 1947, no.3

Galerie Römer, Zurich

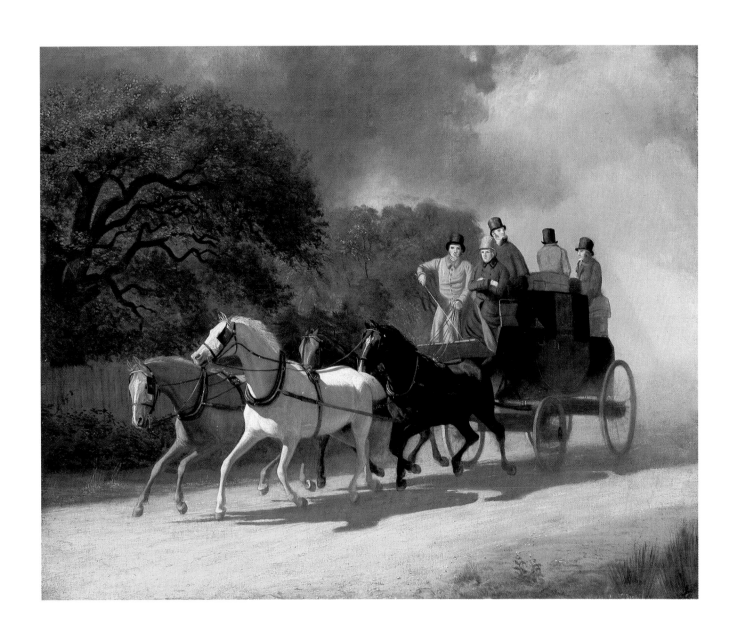

45 Portrait of Edward Scheener 1820

Agasse always resented his being referred to exclusively as an animal painter, and from 1820 onwards, perhaps with a view to proving such arbitrary classification wrong, he devoted some of his efforts to genre paintings and portraits.

Edward Schenker, known by the name of Edward Scheener, was the son of Jean-Timothée Schenker-Moré, a violinist of Genevese origin. He acquired British citizenship and became an attaché to the Foreign Office in London. He left London for Geneva with his wife, who was probably also of Genevese descent. According to Baud-Bovy (*op. cit.,* 1904, p. 42), Scheeners were distant cousins of Agasse through the Plantamour family.

Agasse painted Edward Scheener in 1820 and 1823 (Cat. no. 54). He also painted two portraits of Scheener's wife, both in the same month in 1821: 'July 1821 Portrait of Mrs Schoener [sic] ½ length

small' (Oil on canvas. 21 × 17⅛ [53,5 × 43,5 cm]. Private Collection). 'July 1821 P.[ortrait] of the Od [sic] Mrs. Edward Skinner [sic] Mrs. Edward Skinner [sic] small' (whereabouts unknown).

Agasse achieves a very polished finish in this portrait, close to that found in miniature and reminiscent of enamel in its fineness and delicacy. Worth noting, too, is the harmonious use he makes of colour, and the way the white of the jabot and the light blue and pale yellow of the rest of his clothes stand out against the grey background.

Contrary to Baud-Bovy's assertion (*op. cit.,* p. 121), endorsed by Hardy (*op. cit.,* p. 128), this is not the full-length portrait of Edward Scheener (Cat. no. 54) exhibited at the Royal Academy in 1821 together with 'The Hard Word' (Cat. no. 46), but quite definitely the half-length one.

Oil on canvas 6½ × 5⅞ (16.5 × 15)

Provenance
Edward Scheener, London; bequeathed by him to Charles Brocher's family, Geneva; Marie Brocher, Geneva; Charles Chenevière, Geneva

Exhibitions
Royal Academy, London, 1825, (155); Musée d'Art et d'Histoire, Geneva, February–March 1930 (11)

Literature
MS. Record Book '10. July 1820 P. of M. Schoener, small'; Baud-Bovy, 1904, p. 143; Gielly, 1935, p. 221

Private Collection

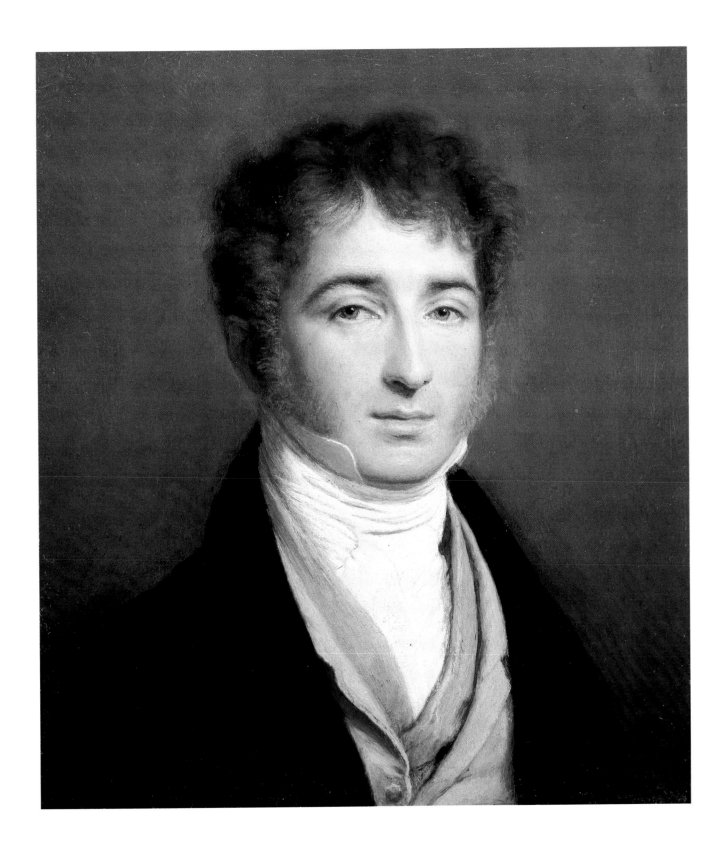

*46 The Hard Word 1820

There are six references in Agasse's *MS. Record Book* to 'The Hard Word': 'May 1820 the hard word p[ortrait] of a child. 24×20', '15 June Copy of the hard word', '15 July Dito of the hard word. 24×20', '26 September Copy of the hard word small', '26 September Forgot dito same size', and 'November 1842 Copy of the hard word. Size 14 by 12'.

One version, in all probability the first, was exhibited at the Royal Academy in 1821, as no.329. According to Hardy, 'the original would have been bought by Lord Rivers' (Agasse Archives, Musée d'Art et d'Histoire, Geneva). Because of its size, the painting on show here can only be either the first or the third version. Agasse sent one of the copies to Geneva, where it was exhibited in 1834, 'Agasse, London. 3. The Hard Word' (A. V.) (cf. *Explication des Ouvrages de Peinture, Dessin, Sculpture et Gravure Exposés dans le Salon du Musée Rath le 15 Août 1834*, Geneva, 1834). Another, small-size version belonged to the Booth family (Private Collection, England). Rigaud seems to have been aware of its existence because he apparently refers to it in his *Renseignements sur les Beaux-Arts à Genève* when he speaks of '...this painting, currently in London...' (*op. cit.,* p.241).

Agasse also produced a very finished drawing of the same subject (Cat.no.112), and one of the painted versions was to provide the basis for the mezzotint by R. Syer which Agasse himself published.

This delicate and sensitive painting of the young Lionel Booth clearly demonstrates Agasse's prowess as a portraitist.

Inscribed in monogram top left, 'JLA'
Oil on canvas 24×20 (61×51)

Provenance
...; English collection; Bollag Gallery, Zurich, 1921

Exhibitions
Kunsthaus, Zurich, 1-19 September 1936 (6); Kirchgemeindehaus, Wädenswil, 1955

Literature
MS. Record Book, 'May 1820 The hard word p.[ortrait] of a child. 24×20', or, '15.July 1820 dito of the hard word. 24×20'; Baud-Bovy, 1904, p.121; Hardy, 1905, pp.126-7; *ibid.,* 2, p.101

Private Collection

Morton, according to his own account in his 'A Communication of a singular fact in Natural History' read before the Royal Society on 23 November 1820 had some years before attempted to breed from a male quagga (Cat.no.47) and a seven-eighths Arabian chestnut mare. The mare, which had never been bred from before, produced a hybrid bearing 'both in her form and in her colour, very decided indications of her mixed origin' (Cat.no.48). Later, Morton sold the Arab mare to Sir Gore Ouseley who bred from her with a black Arab stallion (Cat.no.49). Of this second match, the first, second and third offspring were thought to show markings similar to those of the quagga (Cat.no.50, 51 and 52). It was these markings - the dark line along the ridge of the back and the stripes across the neck and legs - which were the subject of Morton's 'Communication', although, as Sir Arthur Keith was later to object, they might well have been 'a reappearance of atavistic characters derived through sire or dam' (quoted LeFanu, p.91).

The relevant entries in Agasse's *MS. Record Book:*

'[25 April 1817] P. of a Quaga. s. small' and copies on 28 April ('s.small') and 12 May ('very small')

'[February 1821] C. of a Quaga. 24 b. 20'

'Painted in the country. For Surgeons Hall., P. of a Percian Stalion...dark Chesnut. 24. b. 20'

'S. hall P. of a 2 years coalt produce of dito. 24. b 20'

'for the hall P. of a brood mare &. foal. 24 b 20'

'[June? July?] [1821] hall P. A bay fili. 24 b 20'

'October 6. [1821] Fr. [?] college of Surgeons, from a drawing. portrait of a mule Quaga. 24. b 20'

C.F. Hardy (*op.cit.,* p.135) quotes a resolution of the Board of Curators of the Museum of the Royal College of Surgeons of 16 March 1821 authorising Sir Everard Home, acting on their behalf, to 'give such directions as he shall judge proper respecting the paintings of the Quagga and the unusual circumstances connected with the foals of the Arabian mare in the possession of Sir Gore Ouseley'. For this commission consisting of the five paintings (Cat.nos.47, 49, 50, 51 and 52) Agasse was paid 60 guineas on 19 September 1821 (LeFanu, *loc.cit.*).

*47 A Male Quagga from Africa: the First Sire

*48 **Hybrid Foal, which the Arab Mare Bore when Sired by the Quagga**

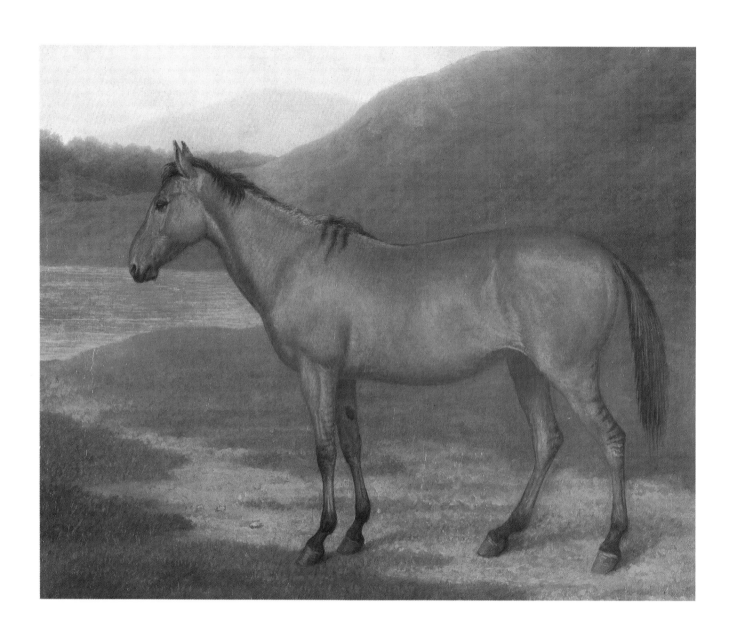

*49 **Black Arab Stallion: the Second Sire**

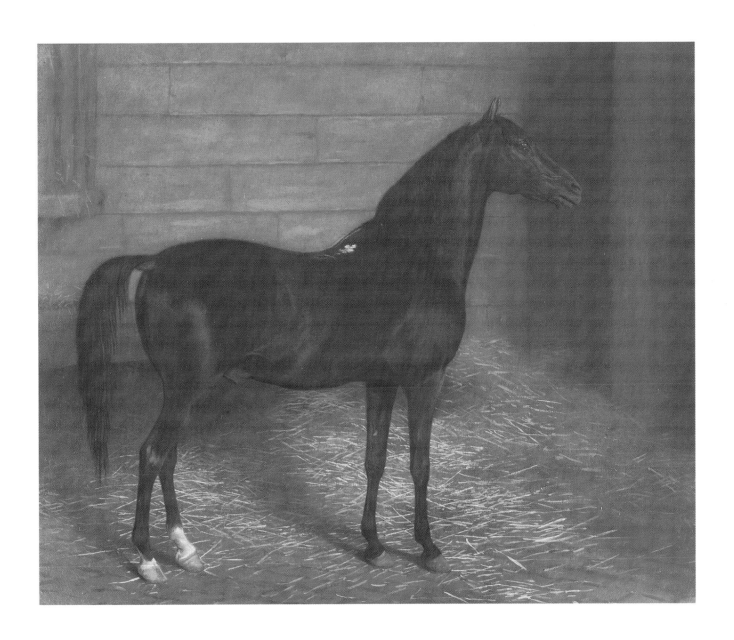

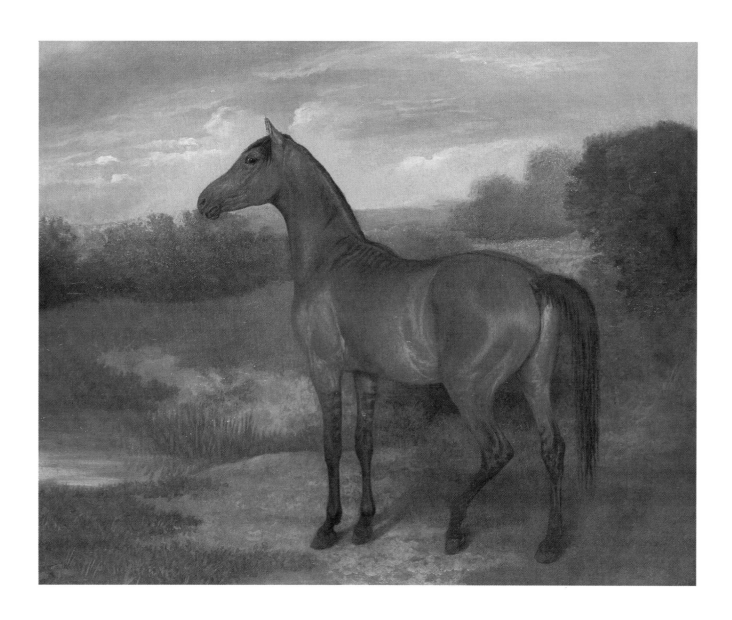

*51 **Colt, Second Progeny of the Arab Mare, when Sired by the Arab Stallion**

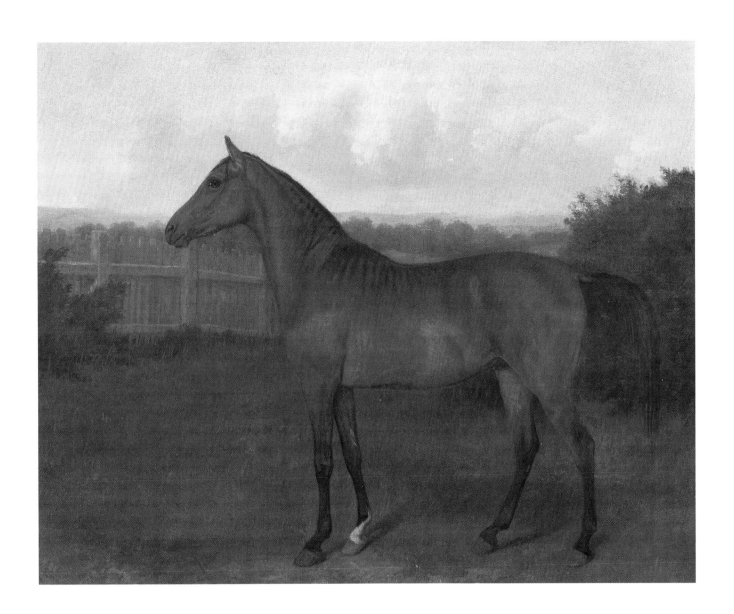

From the evidence of his *MS. Record Book* it would appear that Agasse painted the 'C. of a Quaga' of February 1821 from his earlier picture of April 1817, possibly as a sample to put before the Board of Curators. The other four pictures were evidently those begun 'in the country' - perhaps at Sir Gore Ouseley's stud farm in Hertfordshire - during March-July 1821. In none of them has Agasse made any attempt to display his knowledge of the animal by selecting any difficult or unconventional pose. They are, for the most part, scientific records: the animals are shown in profile either to left or right, in attitudes just sufficiently studied to give an effective appearance of life. Only in the group of the mare with its youngest foal has the artist found an opportunity to show his intimate feeling for his subject.

The remaining picture of the hybrid foal (Cat. no. 48), or 'mule Quaga' as Agasse calls it, was commissioned in October 1821, presumably to complete the set. For this picture Agasse was paid a further 12 guineas on 26 December 1821 (LeFanu, *loc. cit.*). The animal in question was not at Sir Gore Ouseley's stud in Hertfordshire, but had remained at Lord Morton's estate in Scotland and Agasse painted it from a drawing.

Oil on canvas, each 19 × 23 (48 × 58)

Provenance
Painted for the Royal College of Surgeons

Literature
Recorded by Agasse in his MS. Record Book under 1821; The Earl of Morton, 'A communication of a singular fact in Natural History', *Phil. Trans.,* III (1821), pp. 20-22; C-F. Hardy, 'J.L. Agasse: his life, his work, and his friendships', MS; W.R. LeFanu, *A Catalogue of the Portraits and other paintings, drawings and sculpture in the Royal College of Surgeons of England,* London, 1960, pp. 91-92, nos. 278-83; F. Gordon Roe, 'Jacques L. Agasse', *The British Racehorse,* Sept. 1959, pp. 336-42, 378

Hunterian Collection, Royal College of Surgeons of England

*52 **The Arab Mare with her Third Foal by the Arab Stallion**

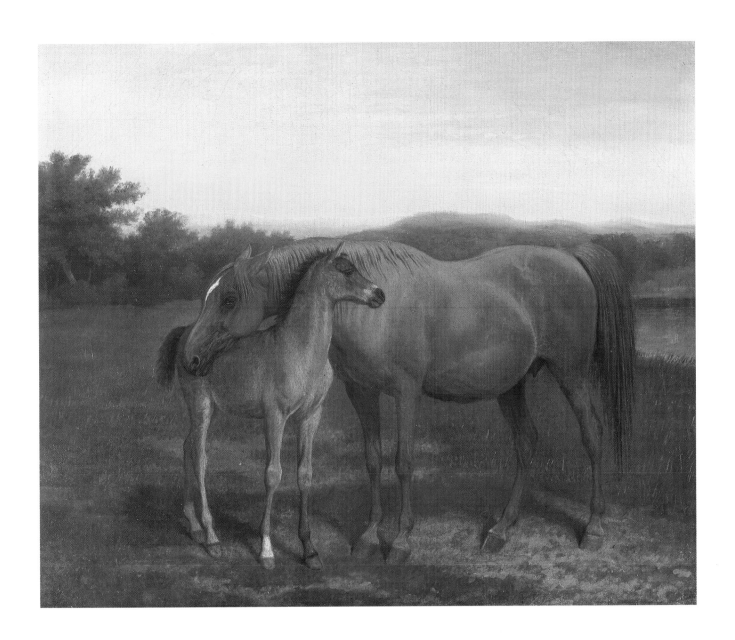

*53 The Flower Cart in Spring 1822

This is one of the many genre paintings like 'The Pleasure Ground' (Cat. no. 62), 'The Contrast' (Cat. no. 61) and 'A Snowy Morning' (Cat. no. 43) which Agasse regularly exhibited at the Royal Academy from 1822 onwards.

The scene is set in Soho Square round the corner from Agasse's lodgings in Newman Street in the house of his friend George Booth and his young family, who often posed for him. The flower seller holding the flower pot is none other than Agasse himself, the taller of the two boys is Lionel Booth, and the smaller, seen from behind, is his brother Johnny.

Each of the figures is finely studied, and every flower and plant on the cart precisely arranged in a stunning still life. There is a humble poetry in the red brick architecture, clear sky and golden light of the picture which calls the works of Charles Dickens irresistibly to mind.

Agasse painted two versions of 'The Flower Cart', one in May 1822, and the other in September 1825, 'september 1825 Copy of the picture of the flowers cart. small'. Franz Zelger (*op. cit.,* p. 32) maintains, in the face of contradictory evidence, that the picture in the Fondation Reinhart in Winterthur is the first version. The size given in Agasse's own *MS. Record Book,* however, makes it much more likely that the painting on show here is in fact that first version and the picture exhibited at the Royal Academy in 1823 as no. 466, and this is a view shared furthermore by Daniel Baud-Bovy (cf. Baud-Bovy Archives, Department of Manuscripts, BPU).

There are a great many differences between the two versions. One is portrait shaped and the other landscape shaped. There is no sign of little Lionel Booth in the Winterthur picture; instead, a man on a dapple grey horse appears in the background. The black dog is in a different place in each picture, and the background in the 1825 version is far more open.

Inscribed in monogram bottom left, 'JLA'
Oil on canvas $20\frac{7}{8} \times 17\frac{1}{2}$ (53 × 44.3)

Provenance
Charles Chenevière, Geneva

Exhibitions
Royal Academy, London, 1823 (466); Musée d'Art et d'Histoire, Geneva, February–March 1930 (13); *ibid.,* 1936 (35); *ibid.,* 1942, p. 34 (5)

Literature
MS. Record Book, 'May. 1822 The flowers cart of the spring 18 by 14'; Baud-Bovy, 1904, p. 122; Hardy, 1905, pp. 138–41; *ibid.,* 2, 1917, p. 9, repr. p. 10; *ibid.,* 2, 1921, p. 101; Sparrow, 1922, p. 237 (dated 1823); Siltzer, 1929, p. 39; Gielly, March 1930, p. 71, repr.; *ibid.,* 1935, pp. 132, 221; Bovy, 1948, p. 89; Grant, 1959, vol. V, p. 390; Zelger, 1977, no. 9 (quoted)

Private Collection

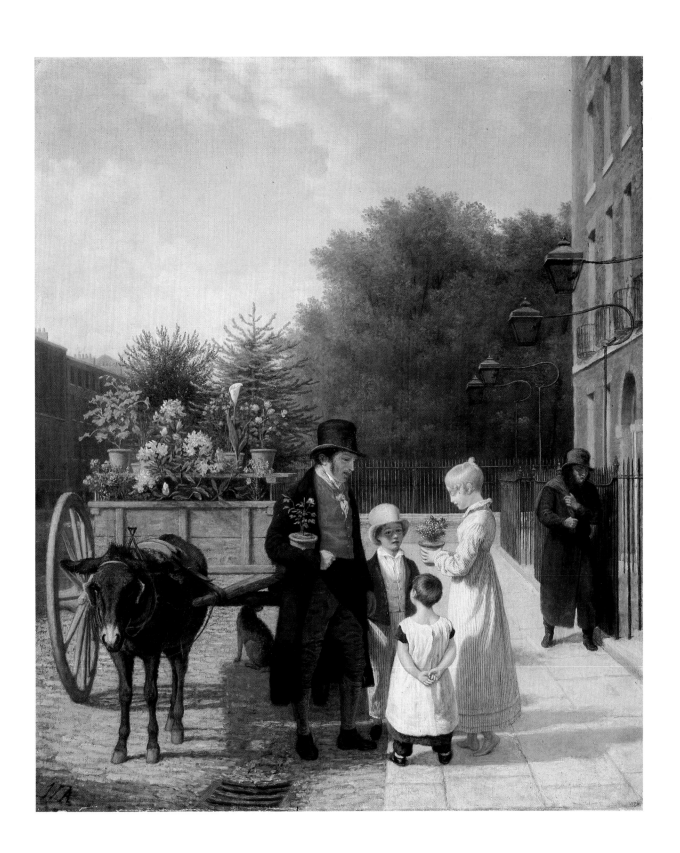

*54 Full-Length Portrait of Edward Scheener 1823

In this full-length portrait, Edward Scheener is seen standing in front of a table in his office. He is wearing a close-fitting coat, and his brilliant white jabot and clear, fine-featured face shine out against its dull black. His right hand rests casually on a book. On the table near him is a red dispatch case bearing the insignia of the Foreign Office, to remind us of his high office and of the equally high opinion he had of himself (cf. Hardy, *op. cit.*, p. 129).

This painting has much in common with a number of Victorian portraits. In it Agasse makes skilful use of contrast, introducing among the dense blacks and dark blues of the clothes and drapery a brilliant red armchair.

Oil on canvas 39⅜ × 29⅜ (100 × 74.5)

Provenance
Edward Scheener, London; bequeathed by him to Charles Brocher's family, Geneva; Marie Brocher, Geneva, 1930; Charles Chenevière, Geneva

Exhibition
Musée d'Art et d'Histoire, Geneva, February–March 1930 (10)

Literature
MS. Record Book 'December 1823 P. small hole length of Mr Schoener'; Baud-Bovy, 1904, pp. 121, 143; Hardy, 1905, p. 152; Gilbey, 1911, vol. 3, p. 15; Gielly, March 1930, p. 70, repr.; Gielly, 1935, p. 221

Private Collection

55 Portrait of Lord Rivers with two Greyhounds *c.* 1825

Out for a walk with his two greyhounds, Lord Rivers faces us here, dressed in a long brown coat, boots and a top hat. He looks slightly to the right and grips a long walking-stick in both hands.

The lightly wooded moorland landscape, with its background of low hills, is very similar to the one in the 'Portrait of Lord Rivers Coursing at Newmarket with his Friends' (Cat. no. 41) which also features the two dogs we see here. The black greyhound is Young Snowball, son of the famous and truly remarkable Snowball, who was not only the first greyhound to be entered in a race but the winner of every race he ran.

Agasse painted Young Snowball in January 1810, and the picture was engraved using a mixture of techniques in a combination of etching, mezzotint and aquatint by Charles Turner (cf. Hardy, *Connoisseur,* 1916, p. 197, repr.) and published, according to Hardy, in 1818 (cf. Ms., Musée d'Art et d'Histoire, Geneva, 1905).

There is no mention of this portrait in Agasse's *MS. Record Book,* but it can be compared stylistically with the picture painted in 1825 for which Agasse's entry reads, 'P.[ortrait] Copy of a whole length figure of Ld. Rivers with greyhound' and of which only Syer's engraving is known to survive.

Oil on canvas $42\frac{1}{8} \times 36$ (107 × 91.5)

Provenance
Lord Rivers, ?Stratfield Saye; ...; Brigadier- General Baker-Baker; by inheritance to his descendants; sold Christie's, Geneva, 24 April 1970, no. 47a, repr.

Private Collection

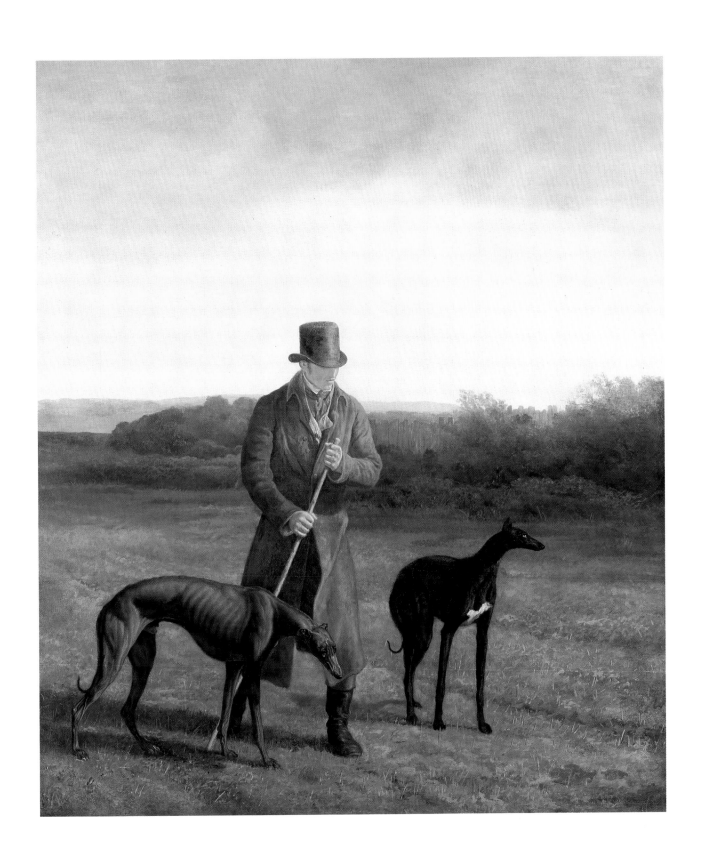

*56 Portrait of Albinos, a Negro Girl 1825

A negro girl sits on a step, her left hand supporting her chin and her right hand resting on her knee. Agasse has painted her against a plain background so that all the light in the picture falls on her pale-coloured clothes - her yellow cotton dress with its sprigs of flowers and her white bonnet and apron. This throws her face and long hands into dramatic relief and emphasises their blackness.

Painted in 1825, this is a preliminary study for 'The Contrast' (Cat.no.61). It may well be the picture listed in the inventory of Louise-Etiennette Agasse's effects made on 6 April 1852 after her death, '3. A Negro girl. 120 Fr.' (Minutes of the notary A.J.E. Richard, 1st half-year of 1852, no.16, act no.136, folio 5 recto, AEG).

Oil on canvas 13⅝ × 12 (34.6 × 30.5)

Provenance
Louise-Etiennette Agasse, the artist's sister, Geneva; Jean-Louis Masbou, Geneva; ?Tollot, Geneva; Tremblay, Petit-Saconnex, Geneva, 1865; Gustave Revilliod, Geneva; bequeathed by him to the City of Geneva in 1890 together with the Musée Ariana Collections; transferred to the Musée d'Art et d'Histoire in 1940

Exhibitions
Room 6, Musée d'Art et d'Histoire, Geneva, 4 July-9 August 1914; *ibid.,* February–March 1930 (55); *ibid.,* 1936 (39); *ibid.,* 1943 (892); Strozzi, Florence, 15 October-12 November 1949 (7)

Literature
MS. Record Book, '1825 September: P[ortrait] of a negro Girl Albinos - small head'; Baud-Bovy, 1904, p.123, repr. 88; Brun, I, 1905, p.16; Hardy, 1905, pp.161, 168-71; Crosnier, 1917, p.47; Grellet, 1921, p.31; Hardy, 2, 1921, p.108 repr.; *ibid.,* 1921, repr.; Bouffard, 1949, p.3 repr.; Bénézit, I, 1976, p.52; Lapaire, 1982, no.62 repr.; Buyssens, 1988, no.48 repr.

Musée d'Art et d'Histoire, Geneva (Acc.no. CR 5)

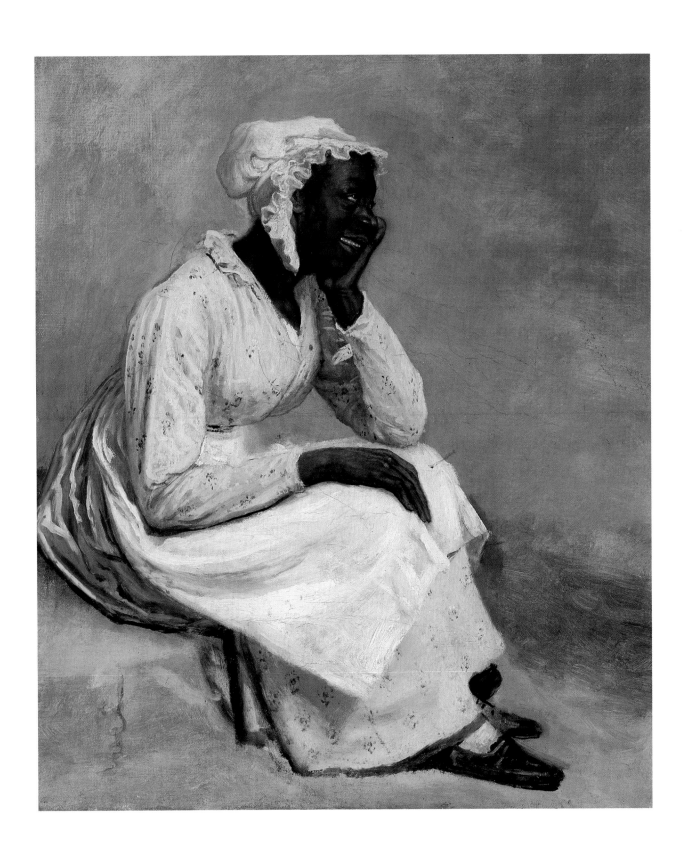

*57 A Group of Whelps Bred between a Lion and a Tigress at Windsor (Liger Cubs) 1825

In the foreground are the three six-month old cubs, each with tiger markings. One is sleeping, a terrier beside him, its head over the cub's neck; one is standing facing right; and one is sitting, seen from behind. In the background, within a cage, are their dam the tigress and their sire the lion.

A royal menagerie was maintained at Sandpit Gate in Windsor Great Park until 1830. Agasse's friend Edward Cross, the proprietor of the menagerie at Exeter 'Change in the Strand, supplied George IV with specimens from at least 1824; and it was probably through Cross that Agasse received two commissions from George IV to paint 'The Nubian Giraffe' in 1827 and the 'White-tailed Gnus' in 1828.

Inscribed: 'Bred Windsor Octr 1824. Painted when six months old' upper right
Oil on canvas 14 × 12 (35.5 × 30.5)

Provenance
The artist's sale, Christie's, 10 July 1850 (the last of four items in lot 4, 'The linkeum, chita, riman dayan, tiger and the tigerlions'), bt. Booth; ...; anon. sale, Sotheby's, 7 April 1965 (188, as 'Liger cubs with a terrier, the parents in a cage beyond'); Dr. Tomasini, Paris; Agnew, 1968 from whom purchased by Paul Mellon; Yale Center for British Art

Literature
MS. Record Book April 1825, 'A group of welps between a Lion and a Tigres. 12. b. 14.'; Egerton, 1978, p. 188, no. 197, repr. pl. 66; Cormack, 1985, p. 12

Yale Center for British Art, Paul Mellon Collection

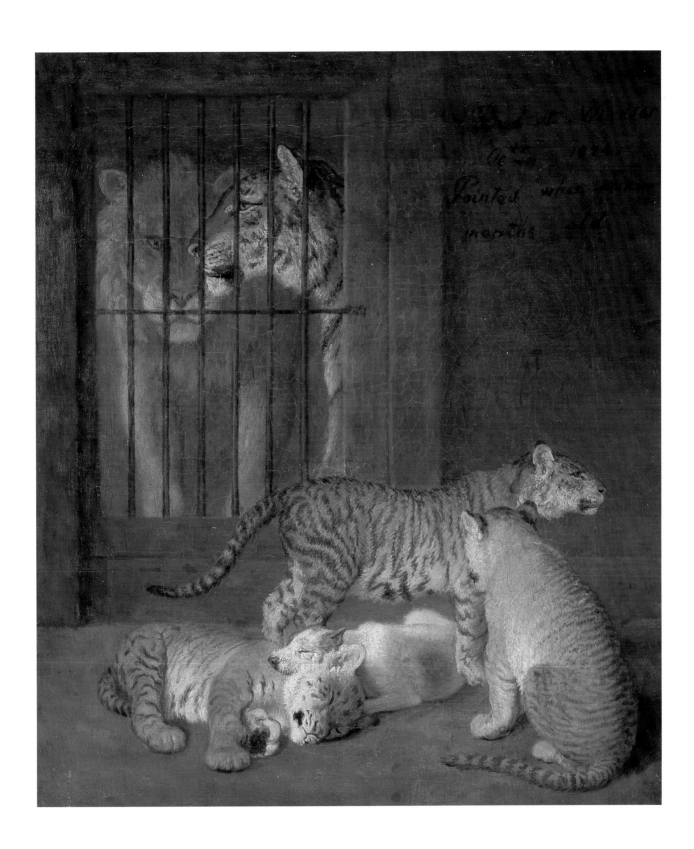

*58 Two Clouded Leopards from Sumatra *c.* 1825

This study of two leopards in a clearing in a forest, one sitting facing the spectator, the other standing seen partly from behind, is not apparently recorded in Agasse's *MS. Record Book*. It may be related to the 'A group of the Sumatra tiger Size of life' recorded in early 1825, though it is unlikely that Agasse confused the terms 'leopard' and 'tiger' as Stubbs did in the titles of his engravings.

Inscribed: 'Sumatra' lower left
Oil on canvas 14 × 12 (35.5 × 30.5)

Provenance
...; anon. sale, Sotheby's, 7 April 1965 (195, repr.); Dr Tomasini, Paris; Agnew, 1968 from whom purchased by Paul Mellon; Yale Center for British Art

Literature
Egerton, 1978, p. 189, no. 198; Cormack, 1985, p. 12

Yale Center for British Art, Paul Mellon Collection

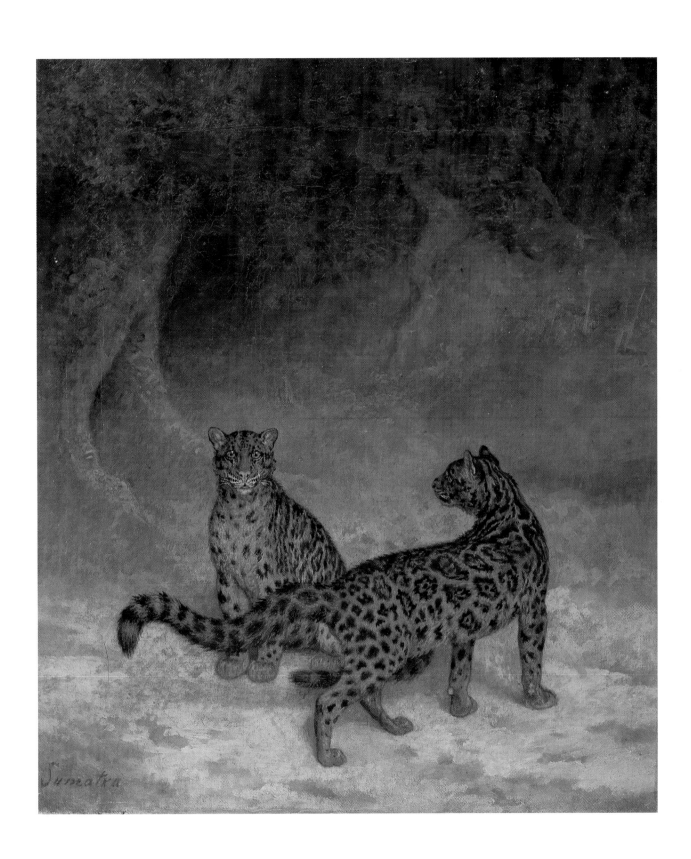

Sumatra

The giraffe is seen standing in a paddock near a hut. With it are its two Arab keepers who offer it a basin of milk. Beside them stands a third figure dressed European-style in a top hat and long, black frock coat. In the background on the left are two Egyptian cows.

The giraffe was one of a pair raised from young on camel's milk by some poor Arabs in the province of Sennaar in the Nubian desert. It was presented to George IV in 1827 by Mehemet Ali, Pasha of Egypt. The other giraffe, the larger of the pair, was presented to Charles X of France.

The two giraffes reportedly made the forty-five days' journey from Sennaar to Cairo, strapped to the backs of camels, in the autumn of 1826. From Cairo, they were ferried down the Nile to Alexandria. The 'French' giraffe was then shipped to Marseilles, where it remained for the winter, and then travelled on to Paris, by foot. The 'English' giraffe was shipped to Malta, where it rested for six months before completing its journey to London. It arrived at Waterloo Bridge in the evening of Saturday, 11 August 1827. The reporter of the *Literary Gazette,* on the spot, described the scene thus: 'A large craft, with a suitable awning of tarpaulins, was...provided, in which the cameleopard, two Egyptian cows, two Arab keepers, and an interpreter, were brought from the vessel... and immediately lodged in a roomy warehouse, under the Duchy of Lancaster Office. Here they remained till Monday morning, about five o'clock, when Richardson's spacious caravan, with four horses, was ready to transport them to Windsor. Into this vehicle they were all safely stowed, and by it conveyed to Windsor the same evening. Having been lodged in security, the king himself hastened to inspect his extraordinary acquisition, and was greatly pleased with the care which had been

taken to bring it into his presence in fine order'. A footnote adds: 'The two cows accompanied the cameleopard (we believe) in the character of wet nurses.' (*op. cit.,* p. 554).

Unfortunately, the giraffe had been seriously weakened by its arduous journey and it lost the use of its legs. An elaborate pulley was made to enable it to stand up, but, in the summer or autumn of 1829, it died. The skin, stuffed by Gould and Tomkins, was given to the Zoological Society by William IV. When the Society's museum was dispersed in 1855, the stuffed skin was acquired by Dr. Clift, a zoological pathologist.

Edward Cross, the proprietor of the menagerie at Exeter 'Change, had been commanded by George IV to supervise the arrangements for landing the giraffe and transporting it to Windsor. His account (Royal Archives, Windsor, Georgian Papers, 25624-6) includes the item: 'By the especial Command of His Majesty. To my own Expences and time...attending the Arrival of the Giraffe many journeys down the river for the purpose of preparing every thing necessary for Landing it from on Board the Penelope and conveying it to Cumberland Lodge & remaining with it many days and afterwards in attending and assisting its removal to its habitation at Sandpit Lodge and very many journeys to construct a Steel support in consequence of its weakness & attending the application of it - and also to construct a Triangle to remove it from the slings by which it was suspended in order to remove it into the great Paddock, continuing with it near Six weeks during the period it remained out of doors... £100.0.0.' In the same account under 30 May 1828 are the items: 'To Cash Paid to Mr. Bittlestone for a Steel Support for the Giraffe - £5.5.0' and 'To Cash paid to Dᵒ for Altering the same - £1.1.0'. Also at Windsor is the

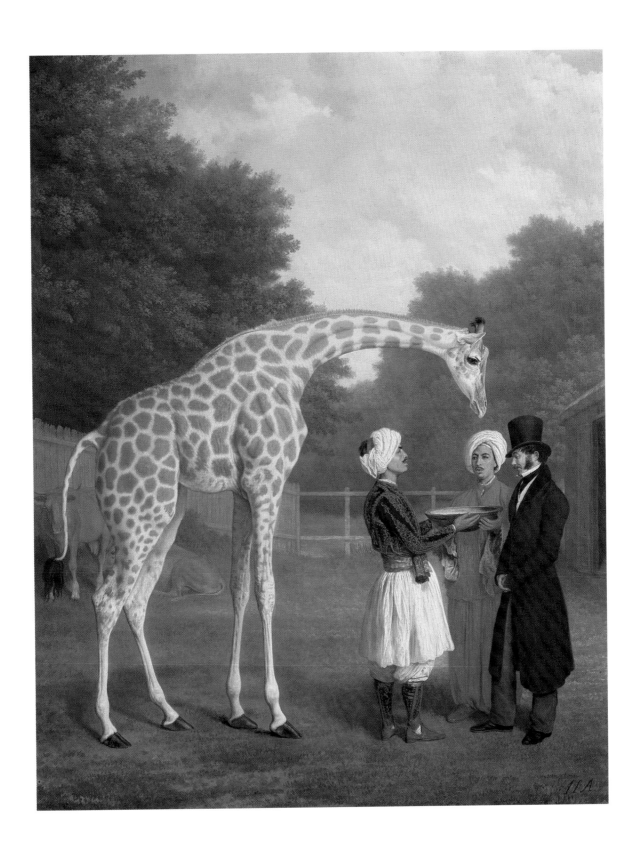

account of William Mayor, the 'Keeper of the Camel Leopard': 'August 11 1827 to October 26th. 11 weeks. £11.11.0' (Georgian Papers, 25593).

Agasse almost certainly gained the commission to paint the giraffe through Edward Cross, and the figure in European dress in the picture is often described as being a portrait of Cross. Hardy, however, asserts that it is not, and conjectures that it may be a portrait of the European agent of the Pasha (MS, pp. 166-7).

The painting is listed in Agasse's *MS. Record Book* in October 1827 as 'For his Majesty. The Zarifa and portraits of his three Keepers. ½ length', together with a reduced copy, 21 by 17 inches (53×43 cms). His account (Georgian Papers, 26557) lists only the original painting, for which he was paid 200 guineas and £18.17s, for the frame. Another small picture of the giraffe is listed in his *MS. Record Book* in February 1829. This picture is also now on loan to the Zoological Society of London.

One other painting of the giraffe exists, by R.B. Davis (1782-1854); who was later appointed animal painter to William IV. It shows the giraffe in a variety of poses, against a background of an imaginary jungle of palm trees and English oaks (Royal Coll., on loan to the Zoological Society of London). However, the arrival of the giraffe coincided with George IV's amorous entanglement with Lady Conyngham, who seemed to the Princesse de Lieven to have 'not an idea in her head, not a word to say for herself; nothing but a hand to accept pearls and diamond with, and an enormous balcony to wear them on' (quoted Lambourne, *op. cit.*). The King's attachment to both the giraffe and Lady Conyngham provided an easy target for the caricaturists of the day. As early as September 1827, a month after the arrival of the animal, a caricature 'The Cameleopard, or a New Hobby' (attrib. William Heath; coll. British Museum, Prints and Drawings) appeared showing the King and Lady Conyngham riding on the giraffe. For the caricaturists, the giraffe epitomised the King's taste for extravagance. In 'The Great Joss and his Playthings' by William Seymour (coll. British Museum, Prints and Drawings), the giraffe is shown affectionately nuzzling against the King, who is depicted as a Chinese mandarin, seated on the Treasury tea-pot. Scattered around the King are models of the most notable, and expensive, architectural achievements of his reign: the Brighton Pavillion, the enlarged Buckingham Palace and Decimus Burton's Ionic screen at Hyde Park Corner. On a shelf behind are stacked numerous Commissioners' or 'Waterloo' churches, some falling over. Below, a column of toy Life Guards led by the Duke of Wellington, pictured as a cock with a baton in his claw, is climbing a see-saw supported by a Chinaman with a large pair of scissors in his pocket.

The pulley constructed by Mr Bittlestone to help raise the giraffe to its feet provided an even better subject. William Heath produced 'The State of the Giraffe' (coll. V.&A. Museum, Print Room), showing the weakened animal, wearing shoes and stockings, being raised by a windlass turned by the King and Lady Conyngham. A note in the margin adds: 'I suppose we shall have to pay for stuffing him next'. In John Doyle's lithograph 'Le Mort' (coll. British Museum, Prints and Drawings), the giraffe has died. The King, his back to the spectator, handkerchief to his eyes, comforts Lady Conyngham who is also crying. Meanwhile, Lord Eldon, the Lord Chamberlain, plays a funeral lament on the bagpipes.

Inscribed: 'J.L.A.' bottom right
Oil on canvas 50⅛ × 40 (127 × 101)

Provenance
Painted for George IV; recorded in the inventory of Carleton Palace, no. 643; later at Windsor, no. 1111; lent to the Zoological Society of London, Regent's Park in 1924

Literature
Anon, 'The cameleopardis, or giraffe', *The London Literary Gazette and Journal of Belles Lettres,* no. 553 (25 August 1827), pp. 553-5; anon, 'The Giraffe', *The Zoological Magazine,* no. 1 (1833), pp. 1-14; R. Owen, *'Notes on the Anatomy of the Nubian Giraffe', Trans. Zoological Society of London,* II (1841),. pp. 217-48; Baud-Bovy, Peintres Genevois, 1904, II, pp. 124, 148; R. Lydekker, 'On Old Pictures of Giraffes and Zebras', *Proc. Zoological Society of London.* II (1904), pp. 339-41; C.-F. Hardy, 'J. L. Agasse: his life, his work, and his friendships', MS.; Berthold Laufer, *The Giraffe in History of Art,* Chicago, 1928, p. 89; Geoffrey Grigson, *Country Life,* CVI (1949), p. 758; Basil Taylor, *Animal Painting in England,* 1955, p. 53, repr. pl. 62; L.S. Lambourne, 'A Giraffe for George IV', *Country Life,* CXXXVIII (1965), pp. 1498-1502; Oliver Millar, *Paintings in the Royal Collection: Later Georgian Pictures,* 1969, no. 651, repr. pl. 284; Raymond Lister, *British Romantic Art,* 1973, p. 159, repr. pl. 38; Oliver Millar, *The Queen's Pictures,* 1977, p. 137, repr. pl. 153

Exhibitions
Tate Gallery, London, *The Romantic Movement,* 1959, no. 8; Queen's Gallery, Buckingham Palace, London, *Animal Painting, Van Dyck to Nolan,* 1966-67, no. 26; Detroit and Philadelphia, USA, *Romantic Art in Britain,* 1968, no. 103

Her Majesty The Queen

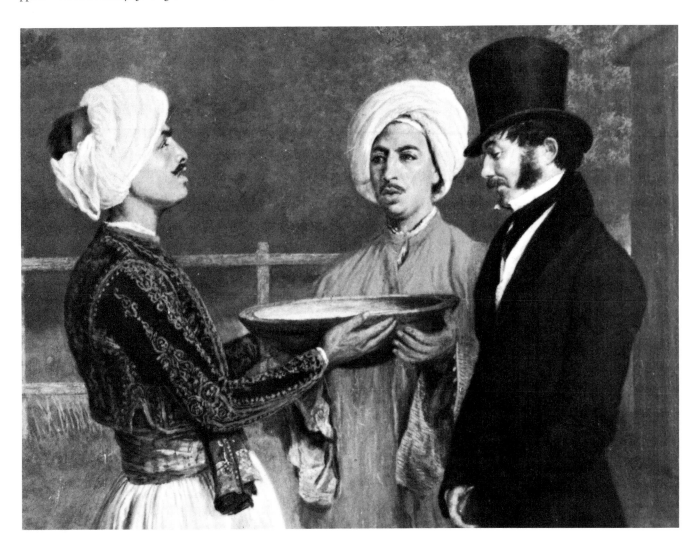

*60 White-tailed Gnus 1828

Two gnus are standing in the foreground, with a third lying down behind them. In the distance is a herd of gnus and, further away, a herd of zebras. The animals are seen in spacious English countryside, probably the part of Windsor Great Park where they were kept.

The gnus had been imported for George IV by Edward Cross, the proprietor of the menagerie at Exeter 'Change in the Strand, who also supervised the Royal Menagerie at Sandpit Gate, Windsor. Cross's account for work done for George IV, presented on 14 September 1830, includes the items: 'To Cash paid for Lighterage &c to convey from on Board the *Slaney* lying at Woolwich a Zebra & two Gnus... £3.10.0': 'To Cash paid for Wharfage Landing & at Waterloo Wharf... £1.10.0'; 'To Cash paid for Caravans to convey the same to Windsor Park... £5.0.0'; 'To Cash paid a Farrier for himself and three

men to dress the feet of the Gnus and Zebra... 12s' and another for £1.0.0 for the payment of labourers who assisted in unloading the gnus and zebra (all under 8 June 1827). In the same account under 4 January 1828 are the items: 'To Cash paid Expences landing a Gnu, and west India Dock Charges... £1.5.0' and '...for a Caravan to convey it to Windsor park £3.0.0' (Royal Archives, Windsor, Georgian Papers, 25624-6).

Like that for 'The Nubian Giraffe', Agasse almost certainly obtained the commission to paint the three gnus through Edward Cross. The painting is listed in his *MS. Record Book* in September 1828: 'Finished a picture of Knus. for his Majesty - S.½ length'. His account includes under September 1828 one hundred guineas 'For a Picture of the Gnus by command', and £18. 17*s*, for the frame. His receipt is dated 23 January 1829 (Georgian Papers, 26557).

Inscribed: 'J.L.A.' bottom left
Oil on canvas. 50¼×40 (127.6×102)

Provenance
Painted for George IV; recorded at Windsor in 1879, no. 1106; lent to the Zoological Society of London, Regent's Park in 1924

Literature
C-F. Hardy, 1905 MS; Oliver Millar, 1969, no. 652, repr. pl. 286

Her Majesty The Queen

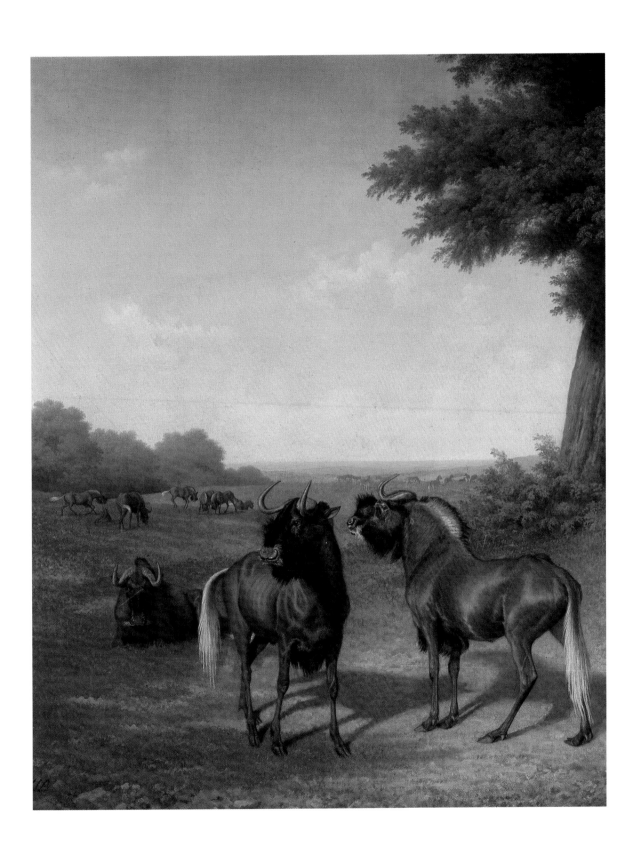

*61 The Contrast 1829

There are two references to this subject in Agasse's *MS. Record Book,* 'February 1829 Finished the picture of the contrast begun two years before. Kitcat' and 'June 1829 an improved copy of the Contrast Kitcat'.

The two versions are the same size, and the differences between them are minimal and essentially involve only the street scene and the buildings in the background. The provenance of the picture on show here, and particularly the reference to it in the catalogue of the sale held after Agasse's death by Christie's in 1850, make it probable that this is the canvas exhibited at the Royal Academy in 1829 and the first of the two versions. The second version can be traced back to an old Genevese family and so it is likely that Agasse sent it to his sister Louise-Etiennette in Geneva who regularly undertook to sell work for him there.

The painting is set in the market at Hungerford where two flower girls, one black and the other white, have come to sell their wares. Agasse was to paint the market again in March 1841, 'March a view of Ungerford [sic] with flowers 14×12 Begon many years before'.

The scene is an unusual one and in choosing to depict it, Agasse has demonstrated an independence of mind which is equally out of the ordinary. The young white girl in her ragged and threadbare clothes may be poor but with her full basket of flowers and her obvious freedom she provides a marked contrast to the negro girl who sits on an empty basket dressed in servants' clothes. In underlining so forcefully the differences between the two girls Agasse was hoping perhaps to expose the social injustices of his day.

Inscribed in monogram on the fountain, 'JLA'
Oil on canvas 36¼ × 27¾ (92 × 70.5)

Provenance
Posthumous sale of the artist's collection, Christie's, London, 10 July 1850 (no. 21); Lionel Booth, London; ...; ex English collection; Leger Gallery, London; Katz Gallery, Basle; bought by the Kunstmuseum, Berne, 1978

Exhibition
Royal Academy, London, 1829 (508)

Literature
MS. Record Book, 'February 1829 Finished the picture of the contrast begun two years before. Kitcat'; Baud-Bovy, 1904, p. 122; Hardy, 1905, p. 168, Kuthy, 1983, p. 96, no. 312, repr.

Kunstmuseum, Berne (Acc. no. G 1978-3)

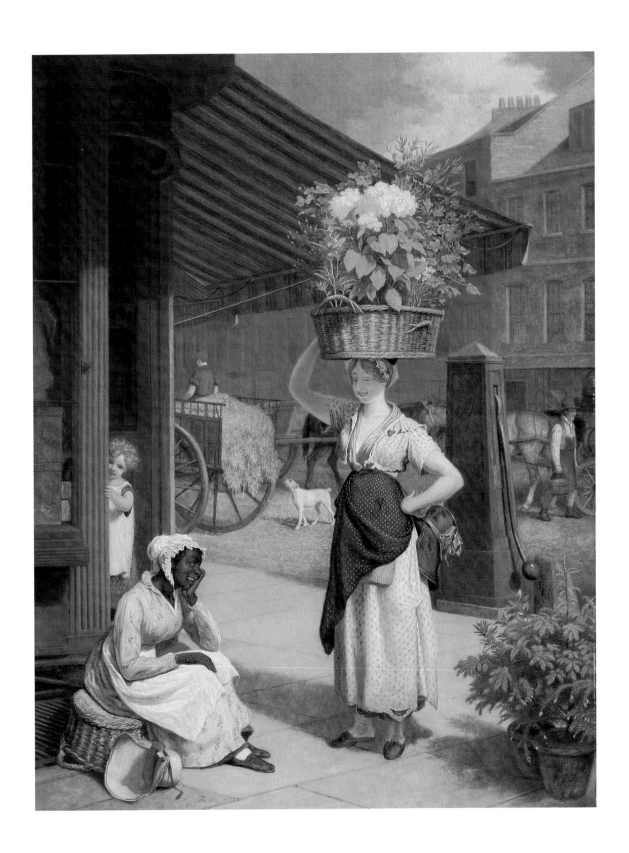

Although known principally for his animal paintings, Agasse finds himself equally at home as a painter of genre pictures, able to take a lively and affectionate look at life in the first half of the nineteenth century and produce narrative, almost literary pictures with confidence and ease. Like 'The Flower Cart' (Cat.no.53), 'A Snowy Morning' (Cat.no.43), 'The Contrast' (Cat.no.61) and others, 'The Pleasure Ground' was put together from a stock of sketches which Agasse had ready and waiting for use on a suitable occasion.

The picture is set in an open area planted with trees, probably Hampstead Heath. There is a strong contrast between the dark, shadowy leaves of the trees in the foreground and the subtle shades of the light-filled field and woods in the background.

From 1810 onwards Agasse had lodgings in the house rented by the Booths at 4 Newman Street. He was to become a firm friend of the family and develop a particularly close relationship with the Booth children, who were devoted to him. It was an association which was to have a profound effect on his work. He drew the children again and again, always with the same care and passion for truth displayed in his animal paintings, including them not just in sketches but in finished pictures like 'The Hard Word' (Cat.no.46) and 'The Important Secret' (Cat.no.67).

So in 'The Pleasure Ground' we can pick out the young Louisa Booth - whose portrait is in the Musée d'Art et d'Histoire in Geneva - in the young girl sitting with her back to us near the swing, and her sister Ellen (who appears in 'The Important Secret') in the girl at her side. To make it even more intimate, Agasse includes himself in the picture as he did in 'The Flower Cart' (Cat.no.53), this time in the guise of a gardener.

Agasse painted two versions of this scene in the same month of the same year, July 1830. One is mentioned in the inventory of Louise-Etiennette Agasse's effects carried out after the artist's sister's death and dated 6 April 1852, '2. The Swing 90 Fr.' (cf. Minutes of the Notary A.J.E. Richard 1st half-year of 1852, no.16, Act no.136, fol.5 recto, AEG). The first version is in the Fondation Oskar Reinhart in Winterthur and differs from the second, the one on show here, in only minor respects: it is slightly larger, and the attitude of the young boy lying on the ground on the right in the foreground is not quite the same. It was exhibited at the British Institution in London in 1832 (466), and at the Society of British Artists, also in London, in 1833 (295).

This charming picture captures all the happy, carefree artlessness of childhood. Agasse has managed to tease out the poetry of the scene without sentimentality. The picture may seem to lack unity because of its undifferentiated treatment of detail. However, these closely observed, finely drawn figures do more than simply support the narrative; shining through comes Agasse's very real love for children.

Inscribed bottom right, 'J.L.A.'
Oil on canvas 17½ × 14⅛ (44.5 × 36.0)

Provenance
ex Genevese collection? Syndic Jean-Louis Masbou, Geneva

Exhibitions
Musée du Jeu de Paume, Paris, June-July 1924 (2); Kunsthalle, Karlsruhe, 18 July-30 August 1925 (2, repr.); Musée d'Art et d'Histoire, Geneva, February-March 1930 (1892-13); Zurich, 20 May-6 August 1939 (541); Musée d'Art et d'Histoire, Geneva, 1942, p.34; *ibid.*, 1943 (885); Strozzi, Florence, 15 October-12 November 1949 (6); Tate Gallery, London 10 July-27 September 1959 (9); Royal Academy and Victoria and Albert Museum, London, 9 September-19 November 1972 (5, repr.); Grand-Saconnex, Geneva, 16-29 September 1985 (22); High Museum of Art, Atlanta, 9 February-10 April 1988, p.90 (22, repr.)

Literature
MS. Record Book, '1830 July: dito [The pleasure ground]. Smaller'; Rigaud, 1876, p.239; Baud-Bovy, 1904, pp.122-3, 128, repr.86; Brun, I, 1905, p.16; Hardy, 1905, pp.177-80; Stryienski, 1912, p.28 repr.; Hardy, 2, 1917, pp.9, 11 repr.; Grellet, 1921, p.31; Hardy, 1, 1921, p.83; *ibid.*, 1921, p.7 repr.; Baud-Bovy, 1924, p.175; Grellet, 1927, p.448 repr.; Gielly, 1935, p.132; Huggler and Cetto, 1943, repr.11; Deonna, 1945, p.299; Fosca, 1945, p.112; Bovy, 1948, p.89; Grigson, 1949, p.758; E. de Keyser, L'Occident romantique, Genève 1965, repr., Bénézit, I 1976, p.52; Lapaire, 1982, no.58 repr.; Thieme and Becker, 1985, Bd I, p.499; Buyssens, 1988, no.5, repr.

Musée d'Art et d'Histoire, Geneva (Acc. no. 1892-13)

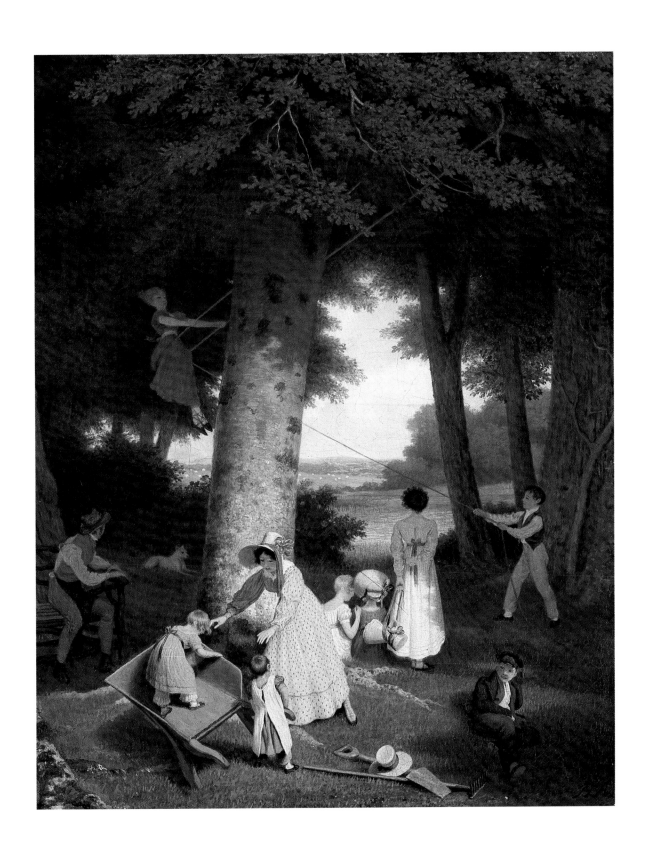

*63 The Vicuna 1831

Three vicunas of tender build with swan-like necks and long fine silky hair are portrayed on a grassy hillside: one looking towards the spectator, one facing left, one lying down seen partly from behind. This is probably one animal portrayed in three different attitudes.

Oil on canvas 14 × 12 (35.5 × 30.5)

Provenance
The artist's sale, Christie's 10 July 1850 (the third item in lot 3, 'The lama, alpaca and the viennia [sic]', bt Booth; ...; anon. sale, Sotheby's, 7 April 1965 (191, repr.); Dr Tomasini, Paris; Agnew, 1968 from whom purchased by Paul Mellon; Yale Center for British Art

Literature
MS. Record Book in August 1831 'ptng of the vigunia 14 12'; Egerton, 1978, p. 189, no. 199; Cormack, 1985, p. 12

Yale Center for British Art, Paul Mellon Collection

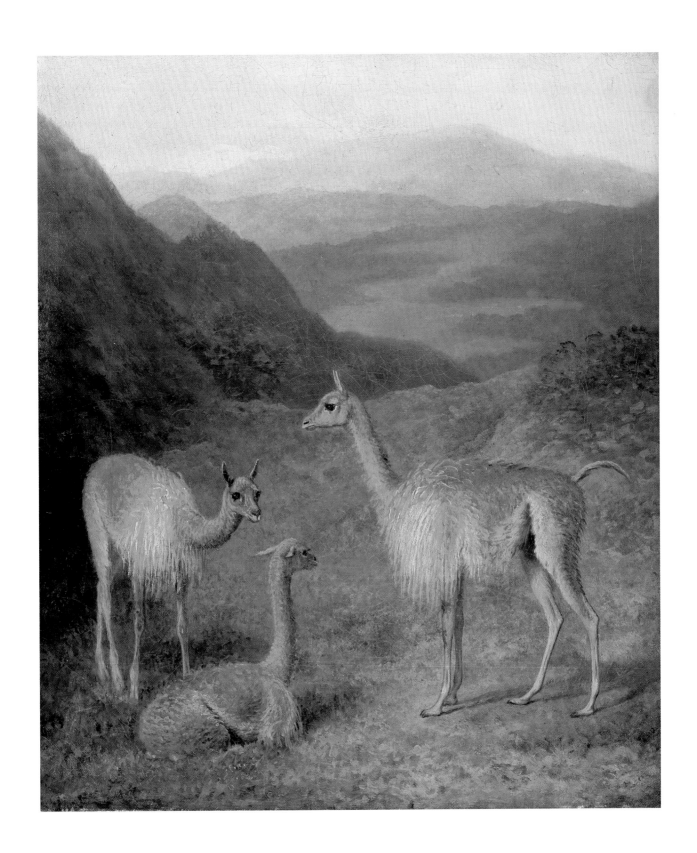

*64 The Guanaco 1831? *or* 1848?

A guanaco stands in the foreground facing right, its head turned towards the spectator. It is clearly an animal of larger and sturdier build than a vicuna, with a darker face and shorter and coarser hair.

Both the vicuna and the guanaco are members of the llama family and are native to the highlands of South America. The wool of both is prized, that of the vicuna being particularly fine and valuable. *'The Pictorial Museum of Animated Nature'* (1856-58) records that the guanaco is hunted with dogs in Chile, but 'during the chase they are said to turn upon their pursuers, neigh loudly, and then take to their heels again': presumably the llama family trick of spitting. The vicuna's notable swiftness of movement probably saved it from being hunted as game. Agasse does not record painting the guanaco. The picture appears to be of the same date as the 'Vicuna'; this subject may, however, be 'A Llama' recorded in June 1848.

Oil on canvas 14 × 12 (35.5 × 30.5)

Provenance
Probably the artist's sale, Christie's, 10 July 1850 (the first item in lot 3, 'The lama, alpaca and the viennia'), bt. Booth; ...; anon. sale Sotheby's, 7 April 1965 (190, as 'A Male Vicuna'); Dr. Tomasini, Paris; Agnew, 1968 from whom purchased by Paul Mellon; Yale Center for British Art.

Literature
Egerton, 1978, p.189, no.200; Cormack, 1985, p.12

Yale Center for British Art, Paul Mellon Collection

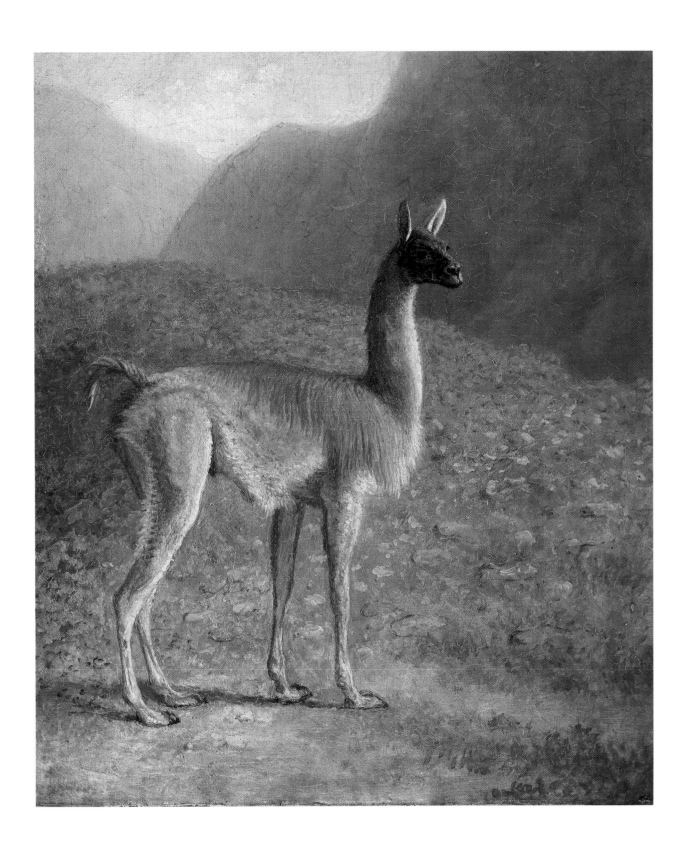

65 A String of Horses on the Way to Market 1833

A man on horseback leads a string of six cart-horses, each tied to the other, along a sunny road lined with trees past fields of grazing cattle which stretch away into the distance. A brown and white gun dog barks at them as they go.

Agasse produced three paintings of the subject, each with slight variations. The three different versions figure in his *MS. Record Book* under different titles: 'April 1821 A string of cart horses small' (inscribed in monogram, 'JLA', and in an unknown hand on the back of the original canvas, 'Painted by Agasse 1821', oil on canvas $12\frac{5}{8} \times 17$ [32×43.2], coll.

J.H. Appleby, St Helier Galleries, Jersey), 'September 1821 A string of nags very small' (oil, $9 \times 11\frac{3}{8}$ [23×29], ex coll. Etienne Duvel, Geneva, present whereabouts unknown), and finally the picture on show here, painted 12 years later, 'April 1833 In the string for market. Sunshine effect Kitcat'.

In the version in the Appleby collection, the scene has been turned round so that the horses face the left of the picture, and the dog accompanying them is black. The landscape is more rolling and made up of gentle hills which stretch out into the distance.

Oil on canvas $36\frac{1}{2} \times 28$ (90×71)

Provenance
...;sold Christie's, London, 18 June 1928; Lucas, 1928; ...;
Charles Bordier, Geneva

Exhibition
Musée d'Art et d'Histoire, Geneva, 1936 (38)

Literature
Gielly, 1935, p.221

Private Collection

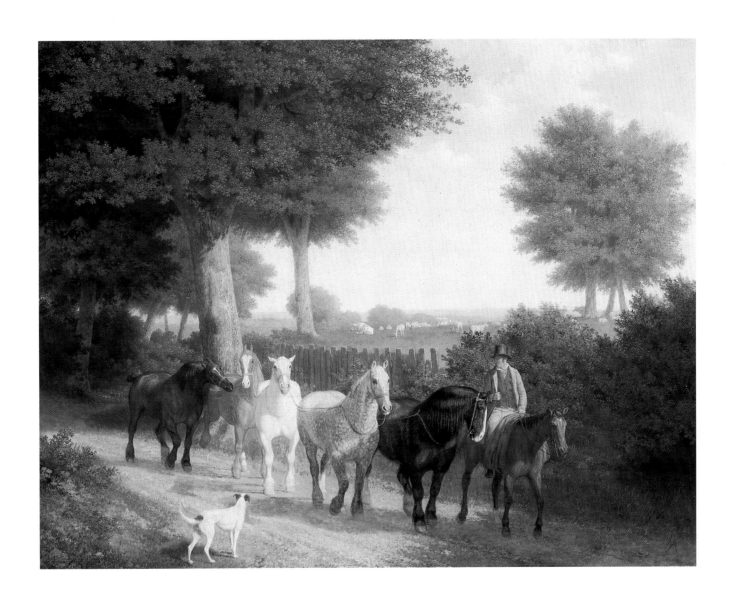

*66 Madame Vieyres and her Daughters 1833

Agasse has shown Mme Vieyres here with her two daughters. The Vieyres family were friends of Agasse's (cf. Baud-Bovy, *op. cit.,* p. 143). Anne-Catherine Vieyres, née Perrachon, married Antoine Vieyres, a clockmaker from Geneva who had settled in England. He figures in the London lists as a watch and clock maker (cf. Hardy, Ms, p. 124). The elder of the two young girls is Elisa; Agasse drew a portrait of her in charcoal which was to be found not very long ago in the Long-Jacobi collection in Geneva. Her younger sister, Marie Mélanie, married a fellow Genevese, Jean-Charles Jacobi, in England in 1843. The couple settled shortly afterwards in Geneva. Agasse also painted Marie Mélanie's portrait, as is mentioned in his *MS. Record Book* in 1841, '1841 April Portrait of miss vierres - small' (oil on canvas, 10×8 [25.5×20.3], Musée d'Art et d'Histoire, Geneva, Acc. no. 1933-9).

'Madame Vieyres and her Daughter' is one of the rare group portraits Agasse is known to have painted. The dating of the picture is somewhat problematic. Gielly (*op. cit.,* 1930, p. 70) follows the inscription written in an unknown hand on the back of the canvas which reads, 'painted by Agasse in London in 1831', and dates the painting 1831. In fact it was begun in 1833, 'October 1833 Prt of a mother and two daughters small halflength 24×20' (cf. *MS. Record Book*), and finished only in 1841, as the *MS. Record Book* shows.

This is a rather dry and conscientious piece in which we see Agasse applying the lessons he learnt in David's studio. There are definite similarities to certain of David's paintings, his 'Portrait of Madame Morel de Tangry', for example, which dates from before 1816 (Musée du Louvre, Paris). It is close, too, to the work of the Victorian painter George Clint (1770-1850), particularly his 'Portrait of the Three Harvey Sisters' of 1841 (cf. repr. in *The British Face: A View of Portraiture 1625-1850,* Colnaghi, London, 19 February-29 March 1986, p. 120, no. 59), and to the *Portrait of Four Sisters* by Alfred-Edward Chalon (cf. repr. in Christopher Wood, *The Dictionary of Victorian Painters,* 2nd ed., 1978, p. 567).

Oil on canvas 23⅝ × 19⅞ (60 × 50.5)

Provenance
Inherited by Jean-Jacques Elisée Long-Jacobi, Geneva; Pauline Long-Jacobi, Geneva; Hausamann, Zurich

Exhibition
Musée d'Art et d'Histoire, Geneva, February-March 1930 (58)

Literature
MS. Record Book, 'October 1833 Prt of a mother and two daughters small halflength 24 by 20'; Baud-Bovy, 1904, pp. 124, 143; Hardy, 1905, p. 206; Gielly, March 1930, p. 70; *ibid.,* 1935, p. 221

Private Collection

*67 The Important Secret 1833

For this charming portrait Agasse has once again used as models two of the Booth children. George Booth was Agasse's friend and landlord - Agasse had lodgings at 4 Newman Street in London. The little girl with the curly hair dressed in a white dress with tucks and a pink poke bonnet is the young Georgina. The little fair-haired boy in the brown open-necked pinafore whispering a secret in her ear is her brother George, born in 1826. Agasse had painted George before - he appears in 'Lionel Booth carrying his Brother George on his Shoulders across a stream in Windsor Great Park' (cf. sale held at Christie's, London, 15 April 1988, no.70a, repr.).

Agasse painted this subject twice in the same month of the same year, according to his *MS. Record Book,* 'July 1833 The Secret half length 3/4 of two children', and 'July 1833 Dito 12 by 14'. The larger of the two remained in the possession of the Booth family. Exhibited as no.19 at the Royal Academy in 1845, it was the last of Agasse's works to be shown in public. According to Hardy (*op.cit.,* p.191), the picture referred to in the *MS. Record Book* - 'september 1832 two children in the same canvas' - is a study for 'The Important Secret'.

Inscribed bottom left, 'JLA'
Oil on canvas 14 × 12 (35.5 × 30.5)

Provenance
...; Gustave Brocher, Geneva; Marie Brocher, Geneva, 1930; Charles Chenevière, Geneva

Exhibitions
Musée d'Art et d'Histoire, Geneva, February–March 1930 (8); *ibid.,* 1942, p.34 (6)

Literature
MS. Record Book 'July 1833 Dito 12 by 14'; Baud–Bovy, 1904, pp.124, 126, repr. p.124, no.89; Hardy, 1905, pp.191–2; *Promenade à l'Exposition du Centenaire 1814–1914,* Geneva, 1914, p.25; Cartier, 1917, p.47; Hardy, 2, 1921, repr.; Gielly, March 1930, p.71, repr.; *ibid.,* 1935, p.221; Thieme and Becker, revised ed., 1985, vol.I, p.498

Private Collection

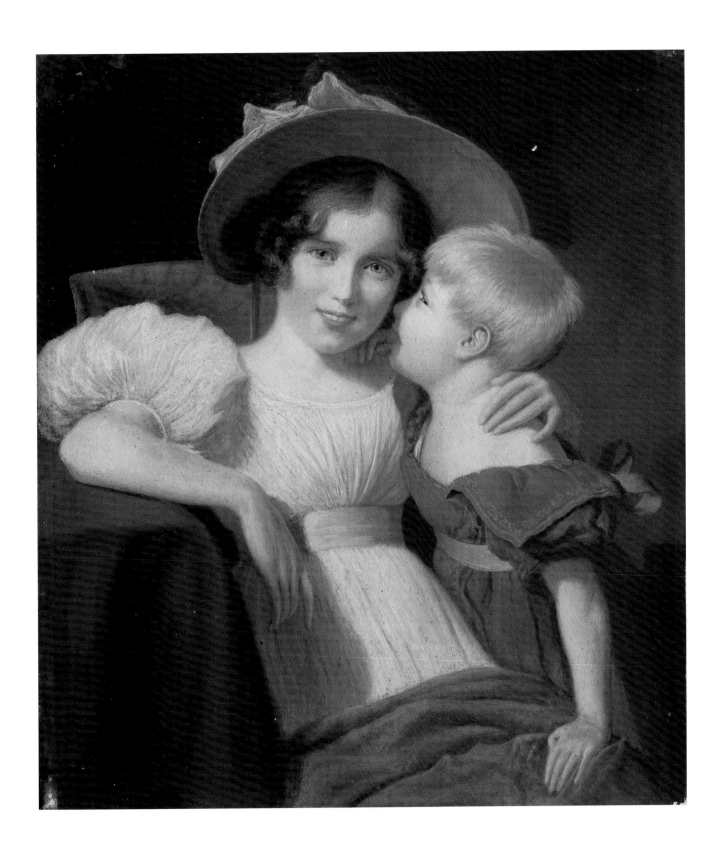

*68 Cavalcade of Children upon Donkeys 1835

Four children, their ages ranging from about four to twelve, with two donkeys ambling along a track in the open countryside. On the left, a pretty girl in a sun bonnet rides side-saddle on a light-coloured donkey. In the centre, the eldest child, a boy, raises a switch above his head as he sits astride a brown donkey. A little boy rides pillion behind him. Behind the donkeys on the right walks a more roughly dressed boy - probably the lad who looks after the donkeys.

Agasse in middle age turned towards sentimental subjects including children, of which there are several examples in this exhibition. The present picture is evidently a version of the 'Picture of figures with donkeys. 14. b 12' or the 'Children on Donkeys. 12. b 14' recorded by Agasse in his *MS. Record Book* in April 1831 and October 1833 respectively.

Inscribed 'JLA' lower right
Oil on canvas 17¾ × 13¾ (45 × 35)

Provenance
? The artist's sale, Christie's, 10 July 1850, lot 17 'Boys with donkeys', bt Booth; ...; Ackermann, 1963; Paul Mellon; Fritz-Denneville Fine Arts

Exhibitions
Ackermann, 1963 (11, as 'Children riding donkeys on a country road'); R.A., 1964-5 (283, 'Children and donkeys on a country path')

Literature
MS. Record Book, September 1835, 'Copie of the calvacade of children upon donkeys 17 b 14'

Private Collection by courtesy of Hildegard Fritz-Denneville Fine Arts, Ltd London

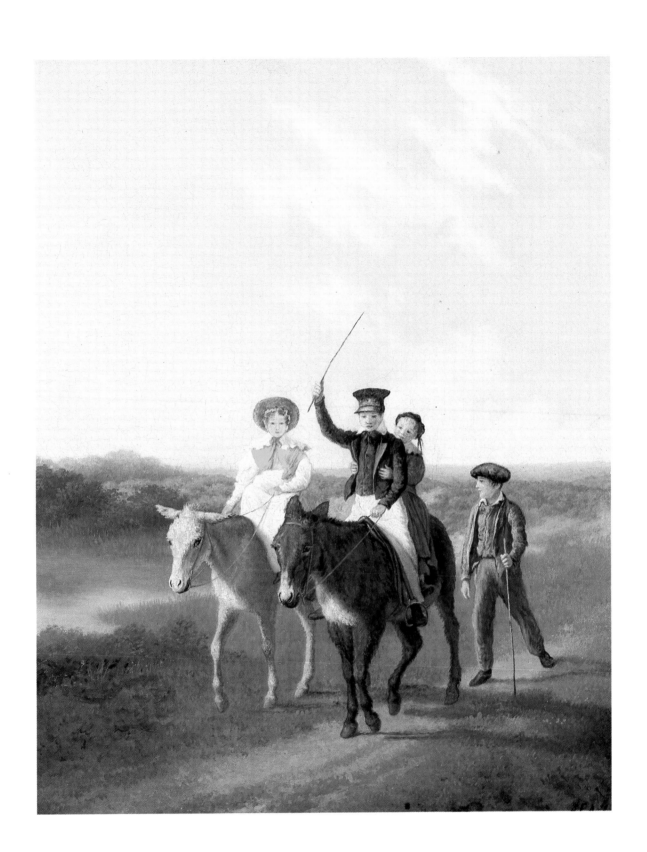

*69 Miss Cazenove on a Grey Horse 1835? 1842?

This picture is one of several versions of the 'P. of Miss C. on a grey horse. S. Bishops half length' listed by Agasse in his *MS. Record Book* in March 1808 and exhibited at the Royal Academy that year as (166) 'Portrait of a lady'. 'Miss C' is identified by Baud-Bovy as Miss Cazenove, who belonged to a family related to that of Agasse. There was also, however, an English branch of the Cazenove family, to which the sitter probably belonged (Hardy, *op. cit*, p. 71).

Apart from the original of 1808, Hardy suggests (pp. 113, 195) that the other versions may be identified with the following entries in Agasse's *MS. Record Book*: 'June [1816] Copy [from?] an old picture. portrait of a lady -Small' and 'dito. Small'; 'August [1835] Copy. A lady on horseback. Kitcat'; and 'March [1842] A copy of the lady on horseback. Kitcat'.

In the range of standard-size canvases sold by artists' colourmen in the early nineteenth century, a 'Bishop's half length' was 56×44 inches (142.3× 118.8 cm) and a 'Kitcat' was 36×28 inches (91.5× 71 cm). The present picture is probably, therefore, either that painted in 1835 or 1842. Another, smaller version (exhib. London, Whitechapel Gallery, *Cricket and Sporting Pictures*, 1935; sold Sotheby's, 6 July 1949) has the dimensions 29×24 inches (73.5× 61 cm). This may be a standard 'Three-Quarter' size 30×25 inches (76.2×63.5 cm); and, since Agasse's 'Small' sizes are somewhat elastic, may be identified as one of the versions painted in June 1816.

Inscribed 'J. L. A.' bottom right
Oil on canvas 36×28 (91.5×71)

Provenance
...; Private coll., New York; Stephen Somerville, London

Literature
Baud-Bovy, *Peintres Genevois,* II, pp. 147; C- F. Hardy, 1905 MS., p. 71

Private Collection, New York

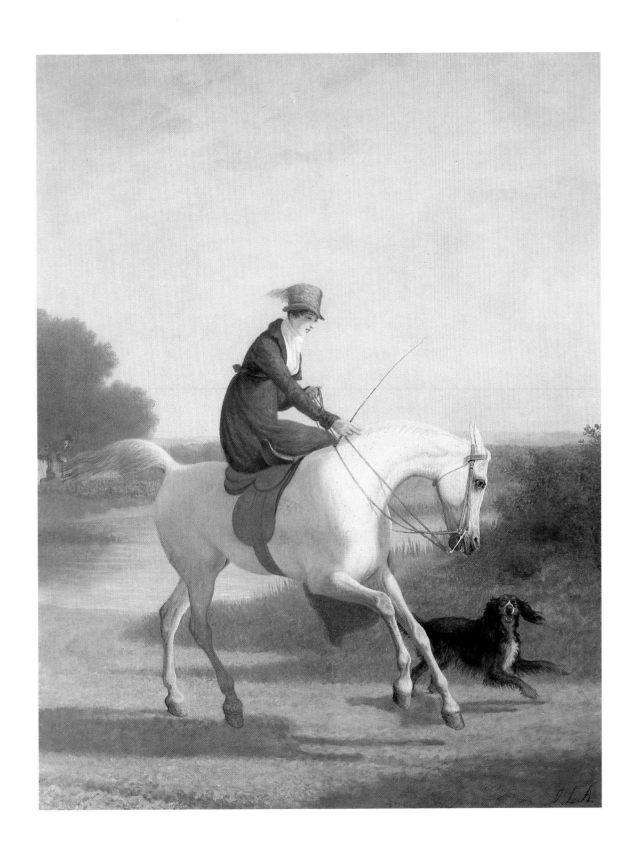

*70 The Fountain Personified 1837?

There are four entries for this subject in Agasse's *MS. Record Book, '1837 A personified fountain Size of Life 5 b 6 Kitcat',* '1838 The fountain Dito Kitcat', '1841 September Copy of the Fountain. Kitcat', and '1843 June Copy of the Fountain 24 b. 20'.

There are a number of differences, essentially in the treatment of the insects around the head of the figure, between the version in the Musée d'Art et d'Histoire in Geneva and the one painted in 1843 and inscribed on the back of the canvas, 'Ondine J.L. Agasse Pinx./ London, 1843' (Private Collection). The whereabouts of the other two versions are unknown.

One version appeared in the artist's sale held by Christie's on 10 July 1850 as no.12, 'Undine', and was bought by Lionel Booth.

In the inventory of Louise-Etiennette Agasse's effects dated 6 April 1852 and carried out after the death of the artist's sister, no.6 is described as 'A fountain, figure of a woman, no value' (cf. Minutes of the notary A.J.E. Richard, 1st half-year of 1852, no.16, Act 136, fol.5 recto, AEG).

What Agasse gives us in this picture of a 'Source' - which he improperly calls a 'Fountain' - is a personification of a natural phenomenon rather than the sort of classically oriented allegory Ingres tended to produce before him. Claude Lapaire (*op. cit.,* no.63) finds similarities between this picture and the works of William Etty, Fuseli and Blake. Also worth emphasising are the picture's close ties with German Romanticism, particularly with the work of Moritz von Schwind.

Hardy, for his part, believes that it was the lush gardens and waterfalls at Bramham which inspired Agasse to paint this unusual picture (cf.Ms., 1905, p.199).

Inscribed in monogram bottom left, 'JLA'
Oil on canvas 36 × 27¾ (91.5 × 70.5)

Provenance
...; English collection; Bollag, Zurich; bought at Christie's sale, Geneva, 24 April 1970, no.406

Exhibition
Musée d'Art et d'Histoire, Geneva, February–March 1930 (5)

Literature
MS. Record Book, '1837: A personified fountain Size of life. Kitcat'; Hardy, 1905, pp.199, 202; Gielly, 1929, pp.114–5 repr.; *ibid.,* March 1930, p.71; Lapaire, 1982, no.63 repr.; Buyssens, 1988, no.41, repr.

Musée d'Art et d'Histoire, Geneva (Acc. no.1970-18)

*71 Portrait of Mr Cross 1838

Agasse painted this portrait of his old friend Edward Cross in 1838. When they had first met, over thirty years earlier, Cross had been an importer of, and dealer in, wild animals at the menagerie, Exeter 'Change in the Strand. He was now, in 1838, the well-to-do proprietor of the Surrey Zoological Gardens, Kennington. He stands facing the spectator, wearing a black stove-pipe hat and frock coat, and holding a lion cub in his arms.

The picture is listed by Agasse in his *MS. Record Book* under 1838 as 'Forgot a P. of Mr Cross. Size of life, with hands – Kitcat'. Both it and the portrait of Mrs Cross (no. 72) were lithographed by G. Gauci the same year.

Oil on canvas 38¼ × 29¾ (97.2 × 75.6)

Provenance
Commissioned by the sitter; ...; Mrs F.E. Emerson, by whom bequeathed to the Zoological Society of London, Regent's Park

Literature
Baud-Bovy, Peintres Genevois, II, p.125; C-F. Hardy, 1905, MS.; C. Neve, 'Agasse at Cross's Menagerie', *Country Life,* April 1972, pp.860-1

Zoological Society of London

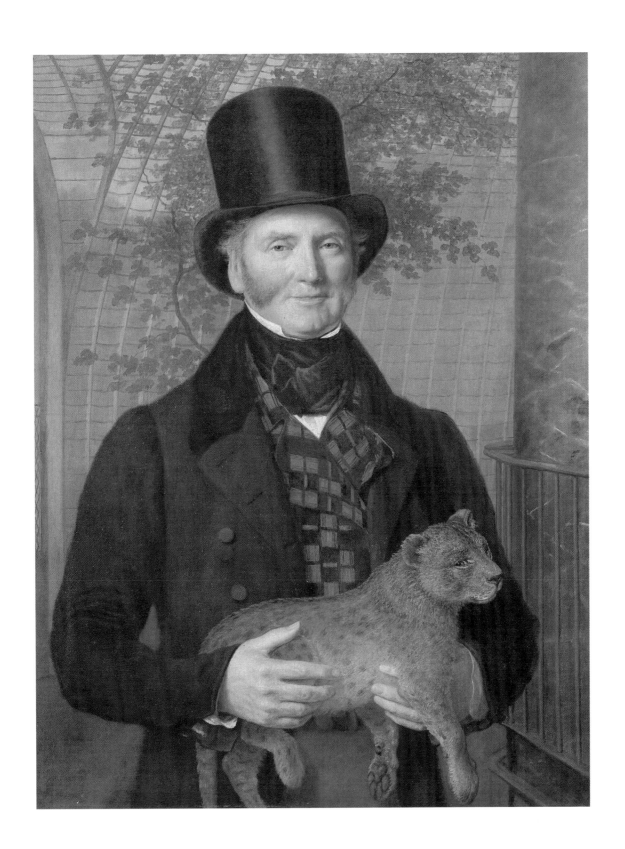

*72 Portrait of Mrs Cross 1838

The companion portrait to no. 71, the *Portrait of Mr Cross*. Mrs Cross is seated in a tub chair, dressed in a mob-cap with a patterned shawl draped over her shoulders. Her face is plump and somewhat stolid.

Agasse apparently painted three portraits of Mrs Cross. The first is listed in his *MS. Record Book* on 5 October 1820 as 'P. of Mrs Cross. small'. The other two are both listed under 1838 as 'P. of Mrs Cross, Size of life with hands. Kitcat' (the present picture) and 'P. of another Mrs Cross. small'.

Oil on canvas $38\frac{1}{4} \times 29\frac{3}{4}$ (97.2 × 75.6)

Provenance
Commissioned by the sitter's husband, Edward Cross; ...; Mrs F.E. Emerson, by whom bequeathed to the Zoological Society of London, Regent's Park

Literature
Baud-Bovy, *Peintres Genevois,* II, p.125; C-F. Hardy, MS., 'J.L. Agasse: his life, his work, and his friendships'; C. Neve, 'Agasse at Cross's Menagerie', *Country Life,* April 1972, pp.860-1

Zoological Society of London

*73 Still-Life of Flowers and Fruit 1838? 1840?

In the closing years of his life Agasse was to divide his energies equally between the study of still-lifes and flower painting. His *MS. Record Book* lists 'September 1836 A picture of Flowers small', 'May 1838 A picture of Flowers 17 b 14', and 'September 1840 A Pture of Flowers 17 by 14'.

Other than the Yale picture of 1848, to which there is no reference in the *MS. Record Book*, (Cat. no. 75), the painting on show here is the only known example of a still-life by Agasse. Given the dimensions detailed in the *MS. Record Book* this picture must have been painted in either 1838 or 1840.

Rose, crimson and white carnations, French marigolds, and geraniums have all been arranged in a porcelain vase with a white peony and red dahlia to create a sumptuous floral display flanked by a pumpkin, a basket of grapes, and a wilting dahlia.

Agasse was an early student and a lifelong admirer of Dutch painting, and its influence is clearly visible in the rich golds of this picture.

Oil on canvas 17⅜ × 13¾ (44.2 × 35)

Provenance
...; Gustave Brocher, Geneva; Marie Brocher, Geneva; Charles Chenevière, Geneva

Exhibitions
Cercle des Arts et des Lettres, Geneva, 1901; Musée d'Art et d'Histoire, Geneva, February–March 1930 (12)

Literature
MS. Record Book, 'May 1838 A Picture of Flowers 17 b 14', or, 'September 1840 a Pture [Picture] of Flowers 17 b 14'; Baud–Bovy, 1904, p. 123; Hardy, 1905, p. 199; *Promenade à l'Exposition du Centenaire 1814-1914,* 1914, p. 25; Cartier, 1917, p. 46, repr.; Hardy, 1, 1921, repr.; Gielly, 1935, p. 221

Private Collection

*74 A Fishmonger's Shop 1840

Painted in 1840, and listed in his *MS. Record Book* in February that year as 'The fish shop. ¾', this picture was one of Agasse's last exhibits at the Royal Academy.

The setting is perhaps Hungerford Market. On the fishmonger's slab are: some herring or mackerel in a tray, a sea trout, sole, skate, some cod and, above, some shrimps in a glass bowl, some turbot, a mullet, a carp and a pike. In the basket on the right is a lobster. Hanging on hooks from the shutter above are more turbot, what appear to be two fish-heads and a pair of monk fish, while on the pavement below are salmon, some flounder or dabs, eels in a tray and, possibly, an octopus.

No fishmonger by the name of 'John Young & Sons' is listed in the London street directories in the early nineteenth century. There was, however, a 'Leonard Young', a butcher, in Hungerford Market in 1840, and also a 'John Young & Son, scalemakers to her majesty' at 5½ Bear Street, Leicester Square.

Oil on canvas 25¼ × 30½ (64.1 × 77.5)

Provenance
...; Private coll; Christie's, 15 April 1988, lot 71, repr.

Exhibition
Royal Academy, 1842 (324)

Literature
Baud-Bovy, 1904, p.126; Hardy, 1905, Ms, p.204; W.S. Sparrow, *British Sporting Artists from Barlow to Herring,* London, 1922, p.236

Private Collection

*75 Studies of Flowers 1848

This study is not recorded in Agasse's *MS. Record Book,* but - according to the inscription - was painted in the penultimate year of Agasse's life. The flowers represented include: rosebay willowherb, columbine, clematis, opium poppy, laburnum, rose, pinks and carnations, morning glory, gaillardia, purple loosestrife, coreopsis and campion.

Inscribed: 'J.L.A.48' bottom left
Oil on canvas 19¼ × 33 (49 × 84)

Provenance
...; Sotheby's, 22 November 1961 (125); Paul Mellon; Yale Center of British Art

Exhibition
V.M.F.A, 1963, no.384, repr.pl.9; R.A., 1964–5, no.130

Literature
Cormack, 1985, p.12

Yale Center for British Art, Paul Mellon Collection

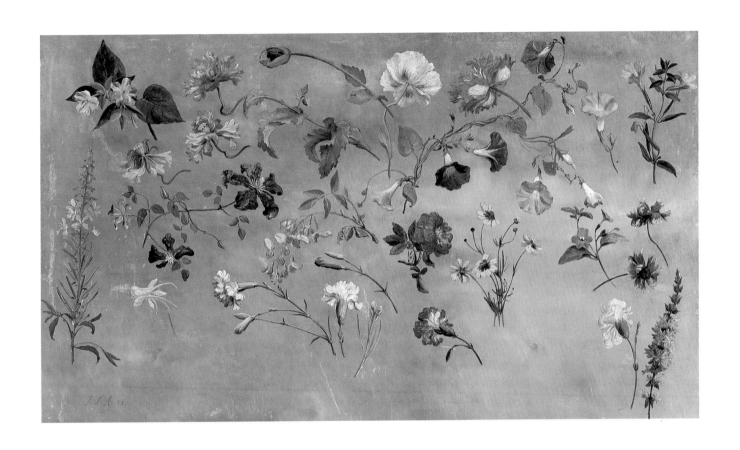

Lucien Boissonnas
Agasse as Draughtsman

Jacques-Laurent Agasse has long been recognised as a talented animal painter and hailed as a 'delightful small master'[1] for his subject pictures.

His graphic work shows him in a new light: here is a painter who is also a remarkable draughtsman, at home with all aspects of his art, from the pure outlines of paper cut-outs, to the combined flexibility of drawing and colour of painting provided by watercolour, not forgetting ink wash drawing, charcoal and stump, or the clarity and restraint of pencil drawing.

Agasse had two great passions as a child which he was to develop throughout his happy youth: studying and drawing the animal world. When barely three he is recorded as copying and cutting out the plates from a copy of Buffon's *L'Histoire Naturelle* which he had just received. He was probably inspired to do this after seeing the work of Jean Huber, master of the cut-out in Geneva, whose silhouettes were then widely known.

As an adolescent Agasse spent most of the year in his family's country house at Crevin. There he lived life at a country pace, surrounded by animals. As soon as he could, he learned how to ride and take care of the horse his father had given him. According to his aunt Louise Gosse, although Agasse was a gentleman, he had always preferred the country way of life and was more than ready to don the simplest of clothes and eat the coarsest of food; I have seen him sit down to the same bread as his dogs, rub down his own beautiful horses, muck out his own stable, do all his servant's work in short, whom he would have sitting in the back of a ravishing carriage while he himself was the coachman and thus had all the pleasure of driving his own horses.[2]

Agasse sought to give voice to his great love of horses through drawing. He gradually perfected his technique, realising early on that he could convey a more consistent sense of volume by using coloured crayons on tinted paper. At about the age of ten he produced 'A Colt' (fig. p. 192), a study of a horse frightened by the spaniel at its heels, remarkable for its skilful handling of movement and foreshortening.

The confidence apparent in this drawing and the mastery of perspective which Agasse already demonstrates at this stage spring almost certainly from his experience of cut-outs. With the absence of colour and volume the silhouettist has very limited means of expression at his disposal and the success or failure of his work hangs on the accuracy of his perspective and the clarity of his line. As the two cut-outs in this exhibition show (Cat. nos. 101 and 102), Agasse continued to display considerable virtuosity in this medium long after his departure from Geneva.

Impressed by their son's obvious talent, Agasse's parents sent him to the Ecole du Calabri in Geneva. This was a state-run drawing school which had only recently broadened the scope of its teaching to include more than the purely technical arts. The first life drawing classes were held there in 1778. Agasse was then eleven, the minimum age stipulated for enrolment. He duly attended the classes where he met and became friends with a fellow pupil, Firmin Massot. The two soon joined forces and worked together on pictures, first in pastels and later in oils, Massot providing the people and Agasse the animals.

While Massot aspired to portraiture, animals were still the subjects closest to Agasse's heart. It was along these lines that they divided their joint labours and they continued to work in this way when they were joined by their mutual friend Adam-Wolfgang Töpffer, whose part was to provide the landscapes.

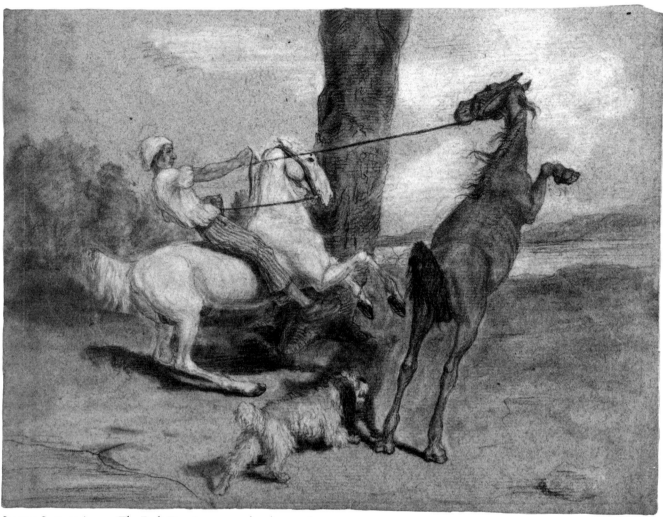

Jacques-Laurent Agasse: 'The Foal'. Drawing executed at the age of ten

The three complemented one another so well that it can be difficult to distinguish the individual artists' contributions. The lack of confidence which Agasse sometimes betrays in his own work may well owe its origin to those early collaborative pieces. Whereas the animals in his pictures always have an individual quality of their own, his people when not actually being portrayed are often generalised and figure only as supports, or even props, for the animals.

The uncertainty in his handling of these 'supporting' figures is obvious even at the planning stage of a picture when his ideas are still only in sketch form. The drawing entitled 'Sportsman, Horse and Dog' (Cat. no. 100) is a clear illustration of this. In this preliminary wash study the animals' 'features' are already well defined, while the man's face is still a blank, even though his relative position to both dog and horse has already been precisely determined.

Agasse also felt little confident about landscape, at least in the early days of his career. Shortly after his arrival in England, he wrote to his friend Töpffer (who had been responsible for providing the landscapes for their joint efforts), asking him to supply some landscape backgrounds for a major new work. His difficulties in this direction were to be easily

overcome, however, as is proved by his drawing of 'Trees in Dorset' (Cat.no.106), a finely executed preliminary study for an unknown painting sold as soon as it was completed. Not long after asking Töpffer to paint some backgrounds for him we find from his *MS. Record Book* that Agasse himself was now providing the same service for other painters.

At the age of twenty-one Agasse had the good fortune to come into a life annuity which his grandfather had left him (and which was to cease with the Revolution), and he took himself off to Paris to complete his training. He was lucky enough to get an opening into David's studio and studied there for three years. Seeing the work of his predecessors and his contemporaries confirmed the feeling Agasse had had for a long time, that by and large painting had failed to do justice to horses. This important realisation convinced him to pursue the direction which his work had instinctively taken from the start, and concentrate on painting animals in general, and horses in particular, as accurately and truthfully as possible.

During the time he studied under David Agasse never lost sight of his main purpose, and applied himself with equal diligence to the study of the 'Skull of a Horse' (Cat.no.80) and the head of a hero ('Head of a Bearded Man', Cat.no.78), unswayed by the trumpeted glories of history painting. At the same time he attended classes in veterinary medicine, dissection and osteology. He was to build on these at a later date when he went to draw the flayed figure and skeletons in the Musée d'Histoire Naturelle.

In wanting to ground his work as firmly as possible in objective fact, Agasse was following what was a rich scientific tradition in Geneva. He was to be first and foremost a 'painter of animals', giving as faithful a rendering of his chosen subject as that earlier Genevese 'painter and chronicler of the Alps', Marc-Théodore Bourrit[3], had given of his shortly before.

The scientific community was in no doubt about Agasse's abilities. Not surprisingly, therefore, it was to Agasse that the Genevese diplomat and well-known agronomist Charles Pictet, known as Pictet de Rochemont[4], turned when he wanted two engravings to illustrate an article on the breeding of merino sheep. Agasse accepted the commission and went to draw the sheep on the model farm built on Pictet's estate at Lancy.[5] The article appeared in July of August 1800 in the journal *La Bibliothèque Britannique* which Charles Pictet had helped found. These two etchings, 'the attached engravings' described in the caption as 'genuine portraits drawn a few days before shearing', are the only engravings for which Agasse was solely responsible, from preliminary drawing to finished print (fig. p.195)[6].

The most important commission in Agasse's career was also to come, some time later, from the world of science, from the Royal College of Surgeons of England (Cat.nos.47–52).

In 1824 Agasse received via Edward Cross a letter from the famous naturalist Frédéric Cuvier, brother of Georges Cuvier, who had been Director of the King's menagerie in Paris since 1804: 'I should like to know, Sir, what price you would ask for wash drawings such as the ones I attach here for reference, in the event of my requiring you to draw for me such animals as are possibly to be found in London? ...I should be very pleased if my proposals were to suit you, Natural Science would surely benefit doubly from such a project...'[7] Frédéric Cuvier saw several of Agasse's drawings in Paris and was particularly struck by his representations of wild animals. This led him, at the end of a letter written soon after the first, to declare of an unknown painting of a chimpanzee 'this animal, and all the others you send me, will be included in the work on Mammals which I am to publish...'[8]

What happened then remains a mystery, because there are no drawings by Agasse reproduced in *L'Histoire Naturelle des Mammifères* published by Cuvier between 1824 and 1842 in conjunction with Geoffroy de Saint-Hilaire. Nevertheless, this episode

clearly shows the degree to which Agasse's work was respected by the scientific community, since Cuvier seems to have preferred his drawings to the more orthodox records which he would have had readily to hand.

Scientists are as interested as ever in Agasse's art and clearly still prize the contribution he made to our understanding of the horse. The legacy of his work is obvious in the way horses are portrayed today, especially in the field of veterinary medicine. Agasse's drawings achieve a high degree of anatomical accuracy, and at the same time capture precisely the way in which horses move,[9] and it is this exceptional combination of qualities that places his work in a class of its own.

Agasse was driven out of France by the Revolution in 1789 and on his return to Geneva he met George Pitt, a wealthy English aristocrat and great horse enthusiast. Their friendship sprang from their common interest in all things animal. On his succession to his title, George Pitt, now Lord Rivers, rescued Agasse from the threat of penury to which the loss of his fortune had exposed him by offering him his patronage, and a new dimension was added henceforward to their relationship. This remained unchanged until Lord Rivers' death in 1828, which heralded Agasse's retirement from his artistic career.

It was in the company of his new English friend that Agasse undertook his first journey to England in 1790. A great many Genevese had then fled to England, in terror of the Revolution, among them a friend of Agasse's father, Jean-Jacques Chalon, whose two sons, both watercolourists and future members of the Royal Academy, were to become firm friends with Agasse. Fresh from the severe neoclassical school, Agasse was confronted in the museums and galleries of London by the brilliant diversity of English painting. His feelings must have been very like those so vividly expressed by Töpffer on his arrival in England: '...In Paris, they all copy one another, here each painter is happy to be himself, and is as much master of his own brush as

his fellow countrymen are of their thoughts and opinions...'[10]

Vitally important though it was to Agasse's development as an artist, this trip was prematurely cut short by the ruin of his family, stripped of its assets in the revolutionary unrest which had gained Geneva in the interim. Agasse was faced with having to make a living from his art, and in difficult times.

It was not safe to be an aristocrat, even a fallen one, in Geneva in the last decade of the eighteenth century. This is what prompted Agasse to settle for a while in Lausanne. He was joined by Massot, and the two sent off their first canvases to the Geneva exhibition of Fructidor Year IV (1796) from there. The same year, Agasse took part, together with Töpffer, in a drawing tour of the countryside around Evian and Thonon.

Agasse's drawings from this tour are mainly of farmyard (Cat.no. 86 and back of Cat.no.93) or country houses, with Töpffer seen opposite Agasse drawing the same subject from a different angle. There is a whole series of these pencil drawings on white paper, each inscribed on the back with the date and place of execution.

Some of Töpffer's drawings from the tour have also survived. Unlike Agasse's, they are inscribed on the front, and give details of the colours to be used in future painted versions.

Töpffer was an old hand at this kind of venture, having been introduced by Pierre-Louis De la Rive in about 1792 to the small group of Genevese artists who used to go off landscape painting in the summer months in the Chablais region and in the countryside around Geneva. In 1798 Agasse took part, again with Töpffer, in one of De la Rive's expeditions. Sadly, no drawn record of this survives. During this period Agasse was also involved, along with Töpffer, Massot and Nicolas Schenker[11], with the Drawing Committee of the Société des Arts de Genève[12]. The Committee was responsible for the smooth running of the Ecole du Calabri, which the Société des Arts had taken over again in 1786, and

Jacques-Laurent Agasse: 'Merino Sheep', 1800. Engraving to illustrate the article by Charles Pictet de Rochemont published in *La Bibliothèque Britannique*

kept a watchful eye over everything from the appointment of drawing masters to the choice of models or materials.

Working with two friends who were both landscape artists had a notable effect on Agasse's drawing. The advantage was mutual, however, and for a long time Töpffer's compositions were to include animals taken directly from originals by Agasse[13]. There is definitely a marked improvement in the quality of draughtsmanship in Agasse's work between 1796, when he produced his 'Farm at Evian' (Cat. no. 86) during what was probably the first of the landscape drawing expeditions, and 1803, when 'A Hertfordshire Farm' (Cat. no. 106) was drawn.

The large wash compositions which De la Rive produced on these tours - his 'painted drawings'[14] - were to revive in Agasse a taste for wash and for the subtle effects which could be achieved from the graduated use of ink. De la Rive had been encouraged by Jean-Pierre Saint-Ours to adopt this technique, and his highly successful use of it must thoroughly have convinced his painter friends of its virtues. Both De la Rive and Töpffer used ink wash primarily to tint areas first outlined in pencil. Although Agasse was to do this in 'Man Leaning against a Cart' (Cat. no. 85), he generally made much bolder and more expressive use of the medium, as in 'The Gate' (Cat. no. 98), where each stroke of the brush tells even though no impasto is applied.

England for Agasse was a place of happy memories where horse painting was always in vogue, and encouraged by Lord Rivers he returned here in October 1800. In 1801, less than a year after his arrival in England, Agasse made a spectacular debut at the Royal Academy with a large composition entitled 'A Disagreeable Situation' (Cat. no. 7). There were endless preparatory drawings for this picture, ranging from small, broadly roughed-out composition sketches, to large technical studies of the carriage at the same scale as the final painted version (Cat. no. 18). Although there are a great many line drawings dealing with the formal aspects of this pic-

ture, no 'plastic' studies of volume are known to survive. Two such 'plastic' studies for another painting are included in this exhibition, however - two preliminary sketches for the horsemen in the foreground of 'Departure for the Hunt' (Cat. no. 99).

We know little or nothing about the drawings Agasse produced while in England, other than the odd fact or two about isolated events like his visit to Brocket Hall which help to date a handful of pictures. Missing in particular are the preparatory studies for his paintings of wild animals which must have figured large in his graphic work, if the very beautiful 'Head of a Fox' (Cat. no. 84)[15] is anything to go by. Equally conspicuous by their absence are any preliminary sketches for the horse portraits which were the core of Agasse's work. 'A Small Horse' (Cat. no. 104) and 'An English Thoroughbred' (Cat. no. 105), which date from the same period as 'Grey Horse in a Field' (Cat. no. 25), give us a hint of Agasse's prowess as a draughtsman in this field.

According to Töpffer, the fact that so few of Agasse's drawings survive is attributable to the contempt the English then had for 'black and white drawings'. Indeed, as Töpffer asserts in the letter quoted above, '...no account is taken here of black and white or other similar drawings. They do portraits in aquarelle that are as vigorous as oils, and they have an exhibition of what they call "watercolours", or paintings in watercolour, where every picture has the strength of oils. You have to know how the effects are achieved before you can really believe that these are works painted only with watercolour...'

Agasse, for his part, knew how 'these ... works' were created. The two landscapes in watercolour exhibited here (Cat. nos. 113 and 114) illustrate the soundness of his grasp of this peculiarly English of arts. These two topographical views are the only known examples[16] of what must have been an important area of Agasse's work. From the care taken to finish them, it seems likely that they were intended for sale.

The cityscape which features in the two watercolours of 1823 had already attracted Agasse some time before, notably in 1818 for which his *MS. Record Book* lists several views of bridges over the river Thames (Cat. nos. 38, 39 and 40). It is possible that Agasse was inspired to take up this theme once more[17] by the arrival in Newman Street[18] that year of the landscape artist Thomas Christopher Hofland[19], one of Agasse's few English friends. Although Hofland had by this stage painted some of his most famous landscapes, all set, like those of John James Chalon[20], near the Thames, he was known also to paint in watercolour occasionally.

Agasse must have had numerous opportunities to learn how to use watercolour either from the Chalon brothers or other painter friends who had gradually specialised in this medium after trying their hand at oils, or as a result of the 'watercolour mania' which was then sweeping the country. The craze spawned a mass of handbooks offering to make the rudiments of the subject simple for all to grasp.

In 1808 the Chalon brothers founded *The Sketching Society,* together with several other English artists. This association of watercolourists met once a week from October to April for a joint drawing session always attended by a guest artist of the President's choice[21]. Because of his friendship with various of the Society's members, it seems likely that Agasse would often have been chosen as the guest artist. This would have given him the chance to meet the famous watercolourists of the day, like William Turner of Oxford and Cornelius Varley[22].

Agasse's last known drawings are dated 1823 and although nothing apparently survives from the period from then until his death in 1849, we know from his *MS. Record Book* that he went on painting until the end of his life, and we can be fairly sure, therefore, that he must also have carried on drawing.

In the memorial address he gave in 1850 the President of the Société des Arts de Genève declared that 'Agasse was born an artist. From his earliest

years he was making cut-outs which could not have been bettered for their purity of outline. He can properly be considered one of the leading draughtsmen of his day, especially for his affectionate studies of animals, whose instincts, movements and anatomy he knew through and through. His drawings from nature are masterpieces every one. His only weakness lay in his use of colour, which, though always accurate, was never outstanding...'[23]

The truth of this closing statement is very much open to question, especially if we consider Agasse's watercolours where the freshness and immediacy of the colouring have been preserved.

Translated by Fabia Claris

[1] A. Bovy, *La Peinture Suisse de 1600 à 1900, Basle, 1948, p. 89.*

[2] Letter of 18 August 1801, quoted by Daniel Baud-Bovy in *Peintres Genevois,* II, p. 106.

[3] M. T. Bourrit (1739-1819), known for his pictures of glaciers. He accompanied de Saussure on his expeditions into the Alps, and represented the principal peaks first in enamel and watercolour, then in engraved form and oils. Louis XVI awarded him an annual allowance, renewed by Louis XVIII, for his pioneering work.

[4] Charles Pictet was a man of letters in his spare time and translated Byron, Thomas Moore and Walter Scott. He was a keen literary critic and edited 'Pieces of Literature' for *La Bibliothèque Britannique.*

[5] There was a "Novoí-Lancy" near Odessa a vast estate which Pictet had received from Alexander I in acknowledgement of services rendered to Russia in matters dealing with agriculture. Merino sheep breeding was flourishing in the days of Pictet, not only in Russia and Switzerland but also in France and Hungary.

[6] Agasse probably learnt engraving from Töpffer who started out as a professional engraver.

[7] B.P.U. Ms. fr 5668, fol. 12-13.

[8] B.P.U. Ms. fr 2628, fol. 105-7.

[9] Agasse is thought to be more successful from a scientific point of view in his dynamic depiction of movement combined with the static analysis of anatomy, so well balanced in his work, than other animal painters, George Stubbs included.

[10] Letter to his wife, Bystock, 21 June 1816. B.P.U. Ms. suppl. 1638.

[11] Nicolas Schenker (1760-1848), a Genevese by origin, settled first in Paris, then in Geneva where he engraved half a dozen of Agasse's drawings for publication in a small anthology (Cat. no. 91). He married Massot's sister in 1794.

[12] Agasse was to be made an honorary associate of the Société des Arts twenty-five years later.

[13] Notably 'Ulm Mastiff' which figures in a wonderful drawing whose present whereabouts are unknown and was incorporated by Töpffer in a watercolour of 1804 entitled 'On Exercise'. The dog reappears in the foreground of Agasse's 'A Disagreeable Situation' (Cat. no. 7).

[14] These 'painted drawings' were large wash drawings, minutely worked over their entire area. They were intended for sale from the outset, and were mounted with coloured surrounds edged with fine lines. Their subject matter was mainly made up of set elements laid down in the Encyclopaedia.

[15] The date suggested for this drawing is c. 1794 because this is when the oils of the same subject are known to have been painted (Fondation Oskar Reinhart and Private Collection). If this date is correct, then this drawing represents an early example of Agasse's work on wild animals.

[16] These watercolours show us an unfamiliar side to Agasse. The two exhibited here are the only ones known in Switzerland.

[17] We know little of Agasse's achievement as a landscape painter. *Bryan's Dictionary of Painters & Engravers* mentions six engravings of landscapes after Agasse, the original drawings for which are now lost.

[18] This was Agasse's home for twenty years. It was nicknamed 'Painters' Street' because of the enormous number of artists who lived there.

[19] T.C. Hofland (1777-1843) lost his fortune as Agasse did and from then had to make a living from his painting.

[20] J.-J. Chalon and Agasse often worked together. J.-J. Chalon was represented in the Royal Academy in 1850, a year after Agasse's death, by a picture called in his dead friend's honour 'A Hollow Road Through a Wood, the figures by the late J.L. Agasse'.

[21] The members took it in turns to preside over these evenings. Supper was provided after the drawing session and rounded off the evening.

[22] C. Varley was the younger brother of John Varley, who was then considered to be one of the leading watercolourists in London, and whose teaching had a profound influence on the development of watercolour as a medium.

[23] 32nd annual meeting of the Société pour l'Avancement des Arts; address by M. De la Rive, President of the Société des Arts, on 1 August 1850.

Catalogue of Drawings

*76 Full-length Portrait of a Young Man Writing *before* 1786

This is an early work, drawn before Agasse went to Paris, and it offers clear evidence of his aptitude for painting. At this stage he could enjoy art as an amateur; pressure of circumstance was later to compel it to become his livelihood.

The portrait is of a young 'bourgeois de la haute ville', a term then in vogue for Genevese aristocrats. The Agasse family had belonged to the latter since 1739, when Jacques-Laurent's grandparents were made freemen of Geneva.

This drawing has traditionally been thought to be a self-portrait, but it is more likely to be a portrait of one of Agasse's friends. The young man is shown writing with his right hand. Agasse was himself right-handed, and if he had drawn his own reflection in a mirror he would have appeared in the picture as writing with his left, rather than his right, hand.

Charcoal and stump on cream paper, yellowed, fully laid down on card 17⅛ × 10⅛ (43.5 × 25.7)

Provenance
Louise-Etiennette Agasse, the artist's sister, Geneva; Louis Glatt, Geneva

Exhibitions
Maison Tavel, Geneva, 1968 (18); Musée Rath, Geneva and Musée des Beaux-Arts, Dijon, 1984 (78)

Literature
Hugelshofer, 1969, pp. 218-9, no. 88

Cabinet des Dessins, Musée d'Art et d'Histoire, Geneva (Acc. no. 1968-34)

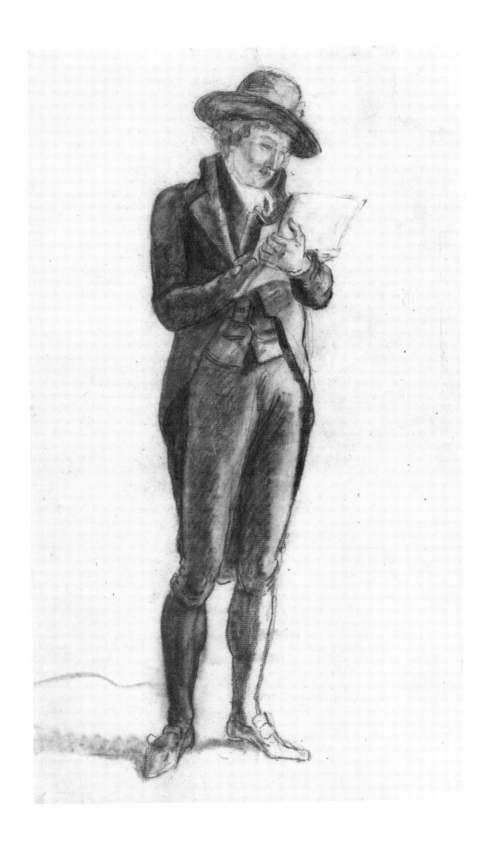

77　An Old Horse *before* **1786**

Ageing horses were a popular subject with Agasse. His large compositions (notably 'The Horse Market at Smithfield') sometimes include an old horse in the midst of a group of younger ones, as if to remind us that at the end of its 'useful' life a horse can look forward to a lengthy old age, unless of course, as happens all too often, this prospect is brutally snatched away from it in the abattoir.

A rather more peaceful fate seems however to await the elderly horse in this charming early work from Agasse's Genevese days. (See also 'The Colt', repr. p.192)

Black chalk, charcoal and stump, and red chalk, heightened with white, on buff medium weight laid paper, fully laid down on card
8¼ × 11¼ (20.7 × 28.3)

Provenance
Louise-Etiennette Agasse, Geneva; Louis Glatt, Geneva

Exhibition
Maison Tavel, Geneva, 1968 (10)

Cabinet des Dessins, Musée d'Art et d'Histoire, Geneva
(Acc. no. 1968-43)

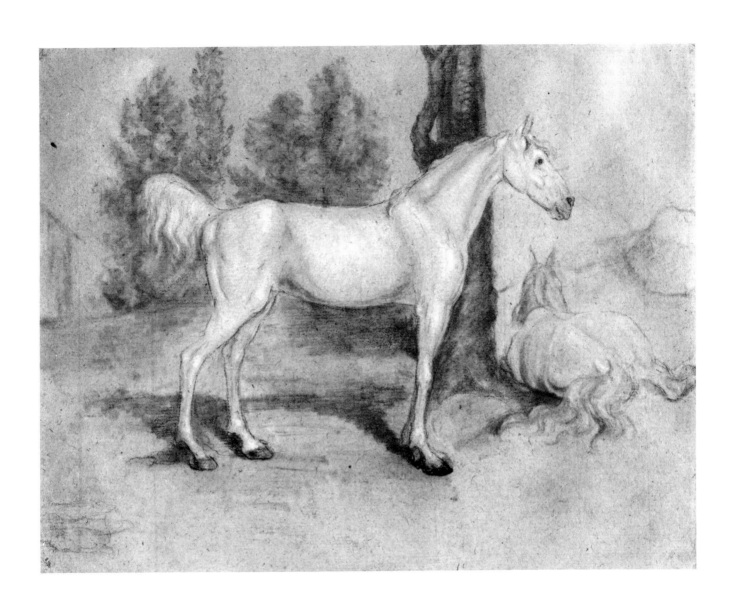

*78 Head of a Bearded Man Three Quarters Turned
to the Right *between* **1786** *and* **1789**

This life drawing almost certainly dates from the period Agasse spent in Paris, and probably from his time with Jacques-Louis David.

In the three years he spent in David's studio Agasse was to remain impervious to the grandiose charms of historical painting, and learned first and foremost about the importance of strong analytic line drawing and the need for great clarity in all artistic expression. This study conveys very forcefully the strong personality of the model.

Charcoal and stump heightened with white chalk on buff heavy weight laid paper, upper edge irregularly torn 15 × 11½ (38 × 29)

Provenance
Hippolyte Gosse, Geneva; Elisabeth Maillart-Gosse, Geneva

Private Collection

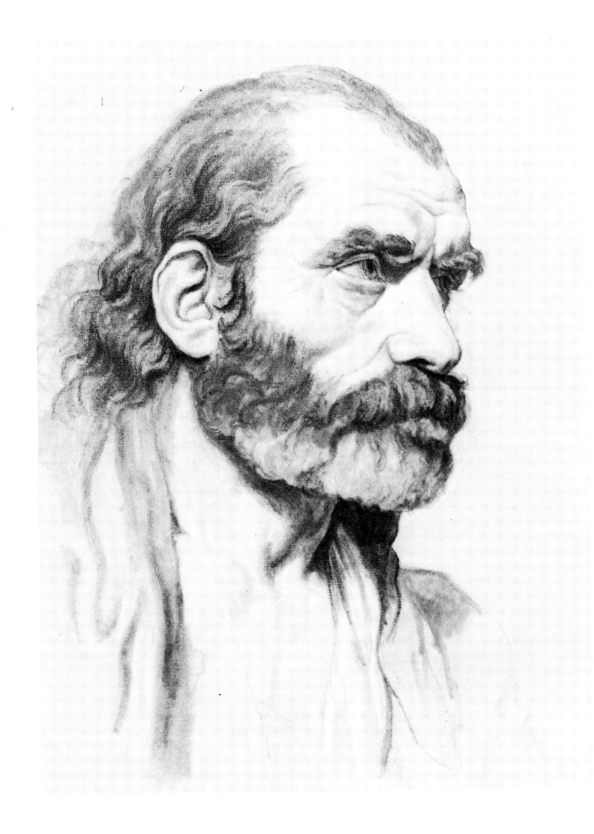

*79 Wrestlers after the Antique *between* **1786** *and* **1789**

This drawing, typically neo-classical in its choice of subject, also dates from the time Agasse spent in David's studio. It is of a sculpture in the Uffizi Gallery (where it has been since 1677) which was widely known in Agasse's day. With its clever arrangement of semi-spheres it must have been a perfect illustration of David's opinion that in order to succeed a composition had to be based on strict geometric principles.

Agasse has chosen to depict the scene in such a way that the weaker wrestler's features are hidden from view. By turning him into a mere faceless loser like this, Agasse has made the contest seem all the more inexorable.

Great importance was attached in David's day to the study of the Antique. The great virtue of this drawing, which must have taken at least two days to complete, lies in the way Agasse has managed to convey the sense of movement peculiar to classical sculpture while avoiding the rigidity so often apparent in drawings made from sculpture.

Charcoal and stump heightened with white chalk and brush, over a black chalk sketch, on buff heavy weight laid paper
Watermark, 'DLG...?' 16¾ × 18⅞ (42.5 × 48)

Provenance
Gosse Collection, Geneva

Private Collection

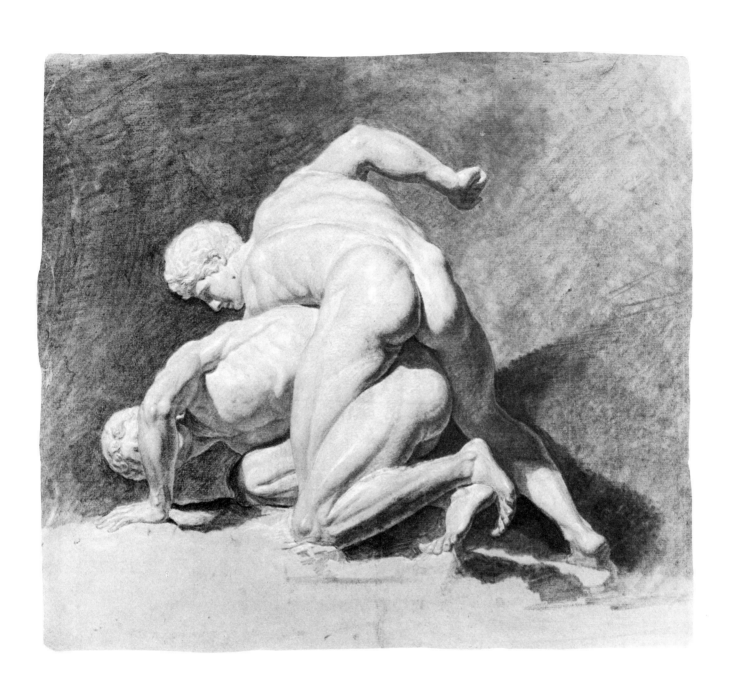

Agasse also studied animal anatomy in Paris and showed the same degree of application here as he did in his work in David's studio from life and the Antique. During the same period he was also a keen attendant of classes in dissection, osteology and veterinary medicine.

This study was probably made in the Skeleton Hall of the Musée d'Histoire Naturelle where Agasse often went to draw. There he made detailed transcriptions of the interlocking system of joints in the horse and studies of the anatomy of a number of wild animals, including the deer and the rhinoceros, as well as of the other articulated skeletons in the Museum's collection.

Agasse makes more of this particular skull (a gelding's or a stallion's to judge from the teeth) than a mere anatomical study: he takes the same amount of care over it as he does over 'noble' subjects (Cat.nos.78 and 79), and tackles it in the same way and at the same scale. In fact he treats this humble skull as if it were nothing short of a real Academy piece.

Charcoal and stump heightened with white chalk on buff heavy weight laid paper $17\frac{7}{8} \times 12\frac{3}{8}$ (45.5 × 31.5)
On the back 'Study of a Flayed Foot'

Provenance
Hippolyte Gosse, Geneva; Elisabeth Maillart-Gosse, Geneva

Private Collection

*81 Setting off for the Ride 1791

Three riders already in their saddles - two ladies and a gentleman - await a fourth who has just finished tightening up his horse's girth and is preparing to mount. Agasse has managed to imbue this ordinary everyday scene with a great dramatic tension obvious in even the smallest detail: the rider in the foreground kicks off his stirrups as he turns impatiently in his saddle, the horses paw the ground restlessly, and even the mongrel in the front of the picture seems irritated by the delay.

Pen and grey-brown ink on white medium weight wove paper, yellowed 7¼ × 9 (18.4 × 23)

Provenance
Adam-Wolfgang Töpffer, Geneva; bequeathed by his descendents to the Musée d'Art et d'Histoire, 1910

Exhibitions
Winterthur, Coire, Lucerne, Basle, Lugano, Lausanne and Berne, 1968 (1); Schloss Jegenstorf, 1970 (19)

Literature
Baud-Bovy, 1904, p.104; Crosnier, 1917, p.47

Cabinet des Dessins, Musée d'Art et d'Histoire, Geneva (Acc. no. 1910-469)

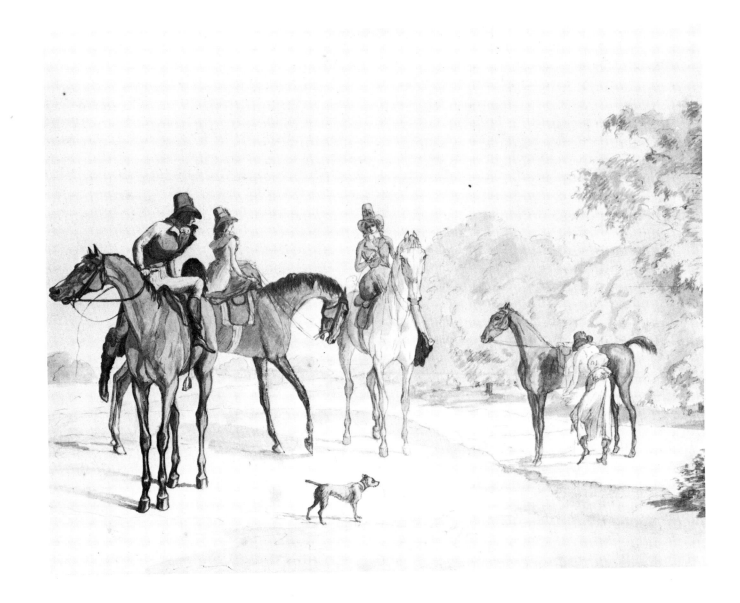

*82 **The Fall** *before* **1800**

Only its large size - one which Agasse was later to abandon - gives this drawing away as an early work. In all other respects it is a mature piece in which Agasse's extensive knowledge of horses and his great pictorial skill are already working together to the full.

While out for a ride, a horseman has had a fall after jumping a hedge. The horse has landed badly, fallen onto its knee, and rolled over onto its side, trapping the leg of its rider who breaks his fall with his right fore-arm. The scene unfurls in front of a second rider who is waiting for his companion beyond the hedge. We are drawn into the picture by this man who like us witnesses its events as a helpless onlooker and we stiffen with anxiety as he does, utterly caught up in the action.

According to the note on the cartouche, the picture is of an accident which really did befall Agasse. If this is true, he does not seem to have found his sprained arm much of a hindrance when it came to executing this drawing the very next day.

Pen, brush and grey ink wash over a pencil sketch on white fine laid paper Watermark, 'J. Honig & Zoonen' 14⅛ × 21¼ (36 × 54) The back of the original mount is inscribed in an unknown hand 'The cartouche reads/'Picture of an accident which befell Agasse/ as he was jumping a hedge at Troinex/ painted by himself the day after/ the accident in which he sprained his left arm 1783/ [the date is later than the inscription].

Provenance
Michel David Audeoud, Geneva, 1783; Frédéric Audeoud, Geneva, 1862; Emma Audeoud, Geneva, 1888; Jacques Ormond, Geneva

Exhibitions
Musée d'Art et d'Histoire, Geneva, 1930 (1); Maison Tavel, Geneva, 1968 (1)

Literature
Gordon Roe, *The British Racehorse,* September 1959

Private Collection

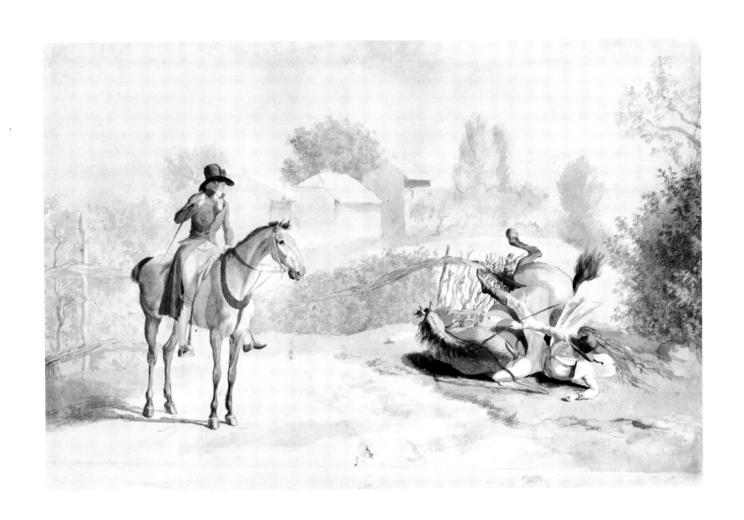

*83 Head of a Sleeping Mastiff *before* 1800

Buffon, whose *L'Histoire Naturelle* Agasse read as a child, maintains that the horse is 'the noblest of all man's conquests'. If he is right, then a dog is without doubt his most faithful companion. To judge from the number of portraits of dogs, alone or with horses which figure in his work, it is clear that Agasse was far from disagreeing with either contention.

Mastiffs in particular seem to have caught Agasse's imagination, at a time when England itself was still a closed book to him. They provide the subject for numerous drawings and for two oils which Agasse painted in collaboration with Massot. Throughout it seems as if the bulldog is the very symbol of England – a country to which the young Agasse was already beginning to feel himself very much attracted (cf. Hardy, ms MAH).

Black chalk and stump on grey-buff medium weight wove paper 10 × 8 (25.4 × 20.3)

Provenance
Louise-Etiennette Agasse, the artist's sister, Geneva;
Gosse Collection, Geneva

Private Collection

*84 Fox Lying Seen Head On *c.* 1794?

This is another head on view of an animal, wild this time. Although Agasse shows it lying down like the sleeping mastiff (Cat. no. 83), this fox is visibly on its guard, and it is this constant watchfulness which probably distinguishes it most clearly from its domestic counterparts. In this masterful portrait Agasse has captured all the fretful tension of the animal's natural instinct. Agasse painted and drew his crafty old friend the fox over and over again in works ranging in scale from a genuine miniature of a fox caught in a trap (Musée d'Art et d'Histoire, Geneva) to a life size picture of which Lord Rivers had a replica.

Black chalk and stump heightened with white chalk on white medium weight laid paper
Watermark, 'DEO...;' $9\frac{3}{8} \times 10\frac{3}{4}$ (23.7 × 26)

Provenance
Hippolyte Gosse, Geneva

Literature
Reproductions of the old school of painting, miscellany [n.d.]; Hardy, 1916, p.194

Private Collection

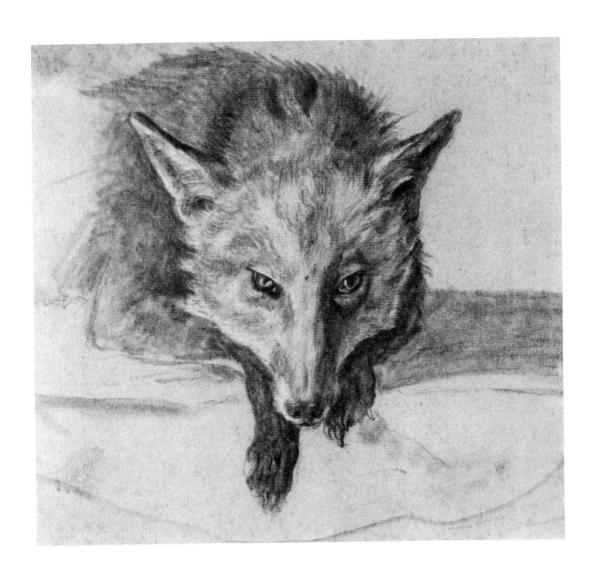

*85 Man Leaning against a Cart *c.*1795

If we compare this portrait of a man with the one painted some ten years earlier (Cat.no.76), we find that a great many changes have taken place in the interim, both in Agasse himself and in society at large.

Agasse's work in general has become more polished, his line more controlled and his technique more accomplished. This drawing in particular shows his ability to apply a sketchy or highly finished treatment as appropriate in one and the same picture.

The changes in society, meanwhile, had blurred the old social distinctions, and it is difficult to be sure in what precise social niche most end-of-the-century sitters fit. In the past it was easy to recognise someone as belonging to 'good society' by the way they dressed – their knee breeches or the buckles on their shoes said it all. But who is to say whether the elegant man leaning so proudly against this cart is in fact its owner? Having lost his fortune in the turbulent days of the Revolution, Agasse for his part would have felt the impact of these social upheavals keenly.

Pencil, brush and brown ink wash on white paper, yellowed
Watermark, 'J. Honig and Zoonen' Stuck down onto a backing
sheet $15 \times 10\frac{7}{8}$ (38.3 \times 27.5)

Provenance
Mme Théodore de Saussure, Geneva; given by her to the Société des Arts, 1907

Exhibitions
Musée Rath, Geneva, 1944 (44); Maison Tavel, Geneva, 1968 (35); Musée Rath, Geneva and Musée des Beaux-Arts, Dijon, 1984 (81)

Literature
Crosnier, 1910, p.169, repr.; Athénée 1863-1963, 1963, no.76; Herdt, February 1968, no.82, p.2; Herdt, 1981, repr.p.41

*Société des Arts Collection, Musée d'Art et d'Histoire, Geneva
(Acc.no.Aga.2.)*

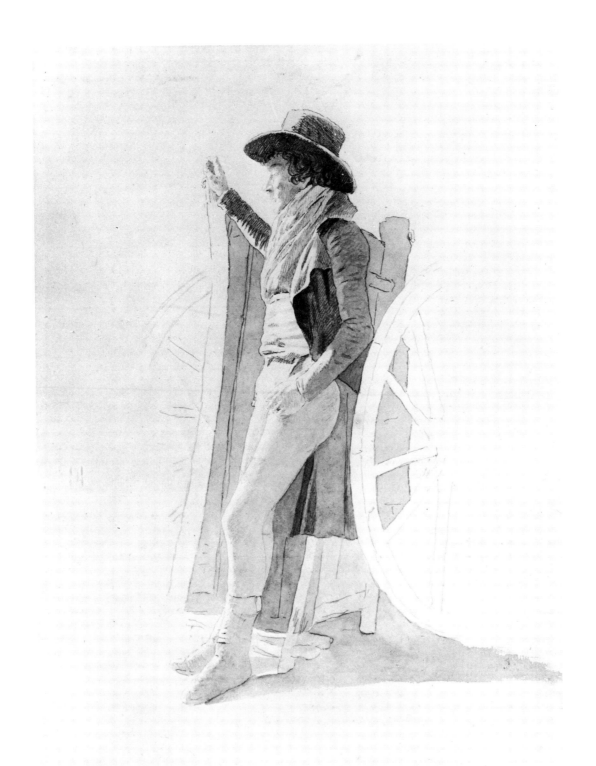

*86 Farm at Evian 1796

This drawing of a farmyard dates from a drawing tour of the Chablais region which Agasse undertook with his friend A.-W. Töpffer. They went looking for landscape subjects on a similar tour two years later of the area around Geneva, in the company of their older friend Pierre-Louis De la Rive. Agasse made a great many sketches of this farm at Evian, and Töpffer, who can be seen here drawing, was also to include the buildings in later works.

Both artists have taken up position under an arch, which gives them a ready-made frame for their composition. This was a device Agasse often used (see the back of Cat. no. 93).

Inscribed on the back, 'Evian 1796' Pencil on white fine laid paper Watermark, 'C. & D. Blauw' 12⅜ × 15¼ (31.5 × 39.3)

Provenance
Louise-Etiennette Agasse, Geneva; Hippolyte Gosse, Geneva; Elisabeth Maillart-Gosse, Geneva

Private Collection

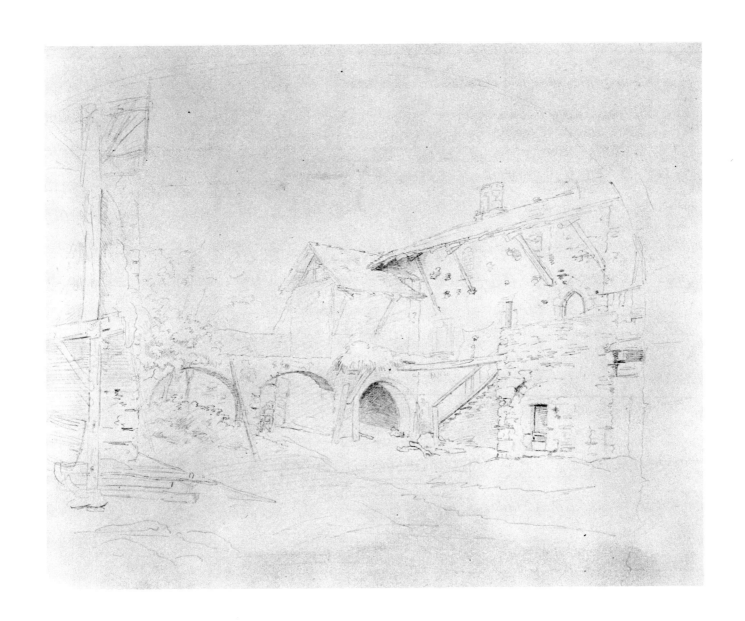

*87 Portrait of Louis-André Gosse *c.* 1798

This is the first of the half-length portraits Agasse did of his cousin, and he has cleverly chosen to make it an oval, which perfectly sets off the boy's adolescent features. Three quarters turned to the left, this elegantly dressed young bourgeois (whose clothes are reminiscent of the 'Young Man Writing', Cat. no. 76) looks us straight in the eye, the hint of a smile playing on his lips.

Agasse has made the boy's eyes sparkle by adding a few touches of black ink just to the pupils and so giving them the greatest tonal depth of anything in the picture. The grey background, too, has a contribution to make to the shading in the drawing by extending the tonal range Agasse has to work in.

Inscribed in an unidentified hand bottom right 'L. A. Gosse by Agasse'
Black chalk and stump, heightened with white gouache and with black ink in the pupils, on grey prepared paper 7⅛ × 5¾ (18 × 14. 5) (Oval)

Provenance
Hippolyte Gosse, Geneva; Mme E. Maillart-Gosse, Geneva; Mme P. Boissonnas-Maillart, Geneva

Exhibition
Musée d'Art et d'Histoire, Geneva, 1930 (35); Maison Tavel, Geneva, 1968 (25)

Literature
Baud-Bovy, 1904, p. 102; Danielle Plan, *Henri-Albert Gosse, un Genevois d'autrefois,* Genève, 1909, p. 420; Hardy, 1916, p. 192

Private Collection

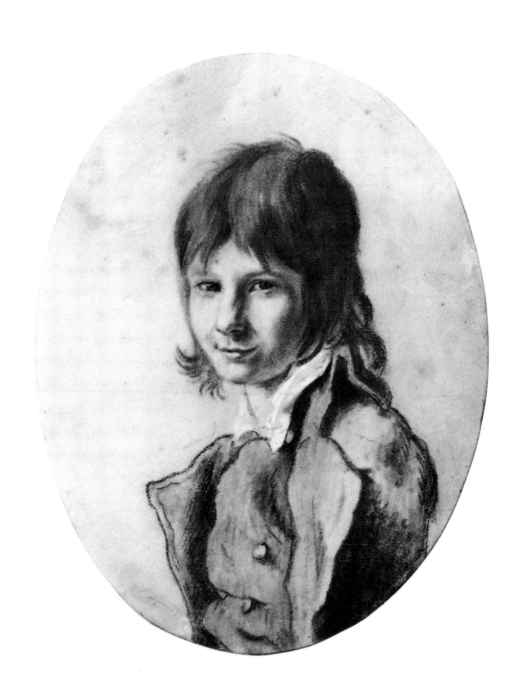

*88 Portrait of Louise-Etiennette Agasse, the Artist's Sister *c.* 1800

Agasse's skill as a portraitist is clearly visible in this very spontaneous drawing of his sister Louise-Etiennette. He was keenly aware of his own ability and considered his 'human' portraits every bit as good as his animal ones. He was equally sure of the quality and lasting worth of his work and remained convinced of these until the end of his life, when in reality he had faded into obscurity and his work no longer sold. Agasse's younger sister, drawn here just before his departure for England, acted for several years as his 'dealer' in Geneva. Agasse considered the English market unworthy of him, especially in his later years, and rightly so, it would seem: at the studio sale held to cover the costs of his funeral, his best works fetched less than £1.

We sense in this portrait of Louise-Etiennette the bond which existed between brother and sister. Louise's expression seems to draw her brother's pencil inexorably to it, and as he moves away to tackle the rest of the figure, Agasse is pulled back by her mischievous but affectionate face, his pencil marks gaining in urgency as they return to it.

Black chalk and stump heightened with white wash on grey prepared fine wove paper 10¼ × 19⅜ (26.2 × 20.7)

Provenance
Louise-Etiennette Agasse, Geneva; Louis Glatt, Geneva

Exhibitions
Maison Tavel, Geneva, 1968 (55); Musée Rath, Geneva and Musée des Beaux-Arts, Dijon, 1984 (79)

Literature
Herdt, 1981, p. 40, repr. 36

Cabinet des Dessins, Musée d'Art et d'Histoire, Geneva (Acc. no. 1968-41)

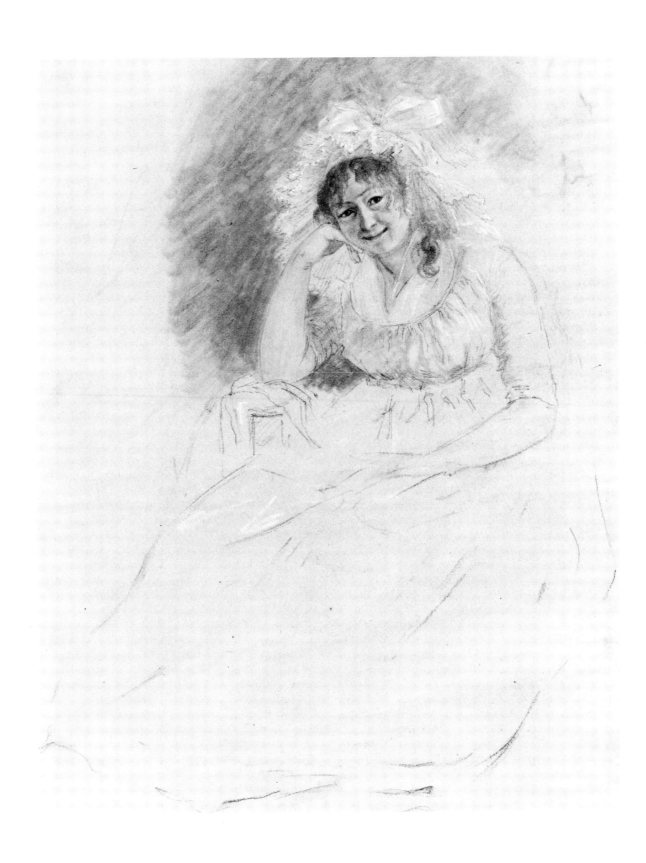

*89 Young Woman Seen from Behind *c.* 1800

In this delightful, softly stumped drawing we get a strong sense of the presence of the woman whose back is almost all we see. She sets her hat at a dashing angle and carries it off with aplomb. It is the kind of hat which was in fashion in France at the beginning of the Directoire, and identifies her as French or Genevese.

This drawing is very close in style to the portrait of Agasse's sister (Cat. no. 88), and in it Agasse proves himself capable of observing people with the same precision as he does animals, as long as the subject inspires him.

Black chalk and stump heightened with white wash on grey prepared medium weight wove paper 8¼ × 5⅜ (21 × 13.5)

Provenance
Louise-Etiennette Agasse, Geneva; Louis Glatt, Geneva

Exhibition
Maison Tavel, Geneva, 1968 (57)

Cabinet des Dessins, Musée d'Art et d'Histoire, Geneva (Acc. no. 1968-35)

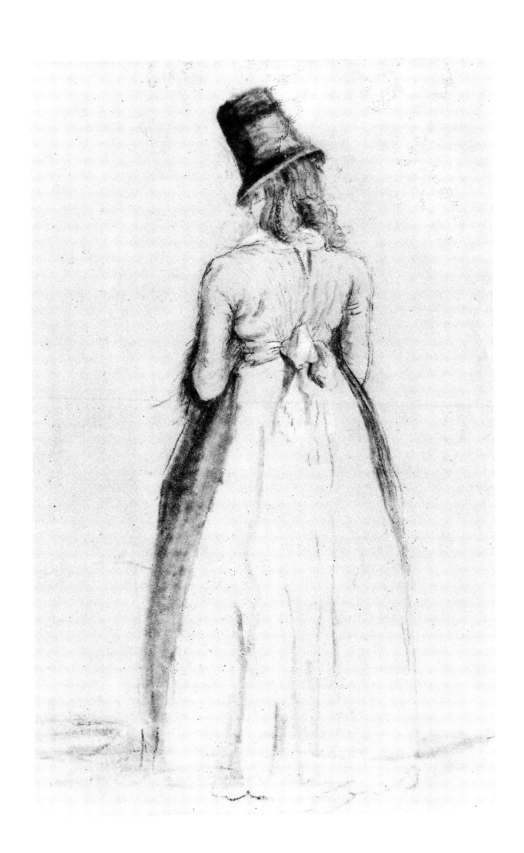

*90 Study of Two Young Girls Seated *c.*1800

Agasse prepared the paper he used for this study and for the three previous drawings by priming it which altered its colour and structure. As it was in the case of the other drawings, the effect here was to tint the paper. This made it possible to use highlights and these are painted on here in thin layers which stand out well against the grey ground. The treatment also had an effect on the surface of the paper: it became much rougher and gave the pencil something to grip onto, while also making it much easier to use a stump.

Black chalk and stump heightened with white chalk and wash on grey prepared medium weight wove paper 8⅜ × 10⅛ (21.4 × 25.9) Inscribed in pen in an unidentified hand bottom left 'From Agasse's portfolio/given by Mlle Agasse'

Provenance
Madeleine Humbert, Geneva; Elisabeth Senn-Humbert, Geneva; Valentine Rieder-Senn, Geneva; Andrée Rieder Picot, Geneva

Private Collection

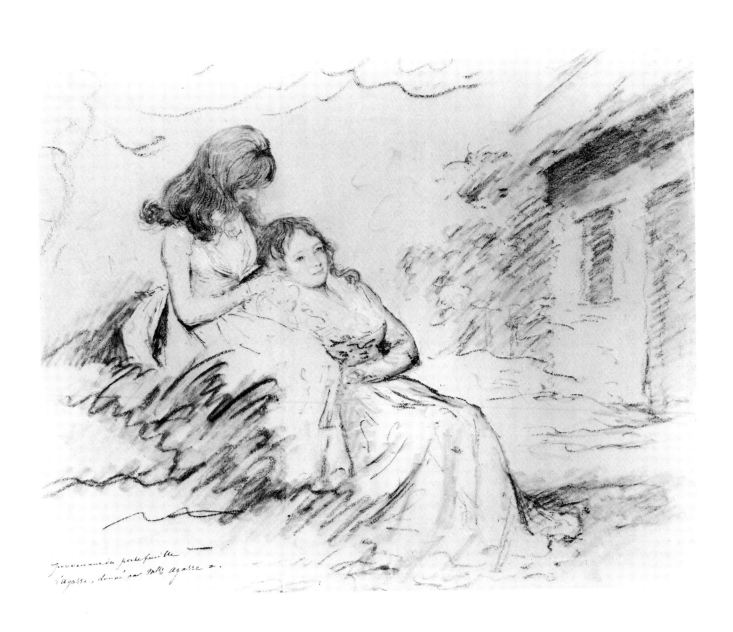

Souvenir du portefeuille
d'Agasse, donné par Mlle Agasse à.

91 Two Horses *c.* 1800

In this drawing Agasse depicts two horses greeting each other in a typical preliminary to mating: the dark-coated stallion holds his head high, points his ears and bends his knee gently. The mare wears a sleepy look and keeps her head low, her ears apart and her eyes half closed.

In the simplicity of its setting, the treatment of the background and its didactic quality, this wash drawing has much in common with Agasse's designs for engravings.

Nicolas Schenker was the principal engraver of Agasse's works and in about 1800 he published an *Anthology of Animal Engravings* for which Agasse provided the drawings. The drawing exhibited here shows such marked similarities to some of the etchings in Schenker's ethnology that it seems quite possible that this too was a study for an engraving.

Brown ink wash over a light pencil sketch on white wove paper, fully laid down on unbleached paper; border of three black lines
$7\frac{7}{8} \times 8\frac{3}{4}$ (20 × 22.2)

Provenance
Charles Bastard, Geneva

Exhibitions
Geneva, 1955 (not in Cat.); Maison Tavel, Geneva, 1968 (42)

Related Works
?Watercolour version, Private Collection, Sweden

Cabinet des Dessins, Musée d'Art et d'Histoire, Geneva (Acc. no. 1911-20)

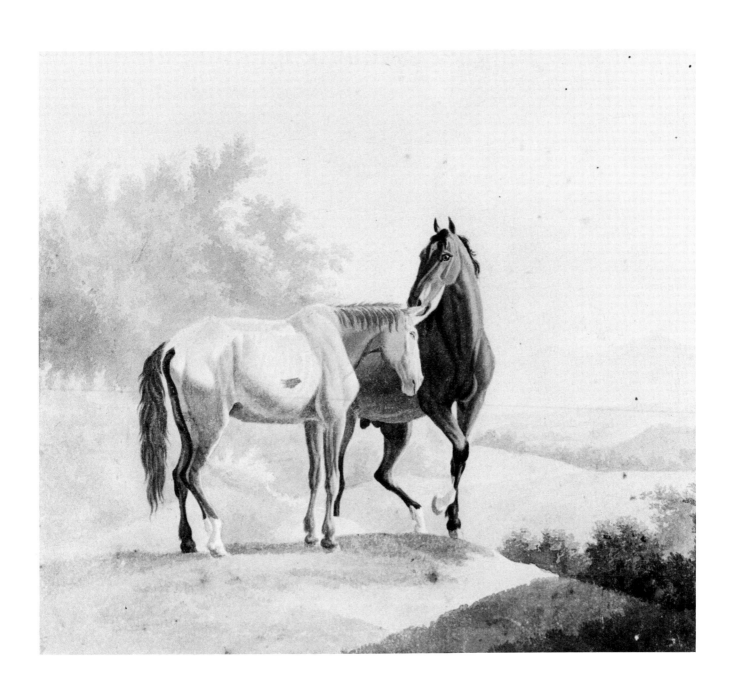

*92 Portrait of Frédéric-Samuel Audeoud-Fazy *c.* 1800

This wash drawing is the preliminary version of a painting the same size, also in the Musée d'Art et d'Histoire in Geneva. Although the painting shares the same basic composition, the relationship between the man and the horse was to undergo a subtle change. Agasse's main concern in the drawing was to give us a picture of a horse and its owner rather than a portrait of a man with a horse as a mere accessory at his side.

The work was commissioned by one of Agasse's relatives who must have noticed how the picture was tending and asked him to give more prominence to the man than to the horse in the painted version. Agasse achieved the desired effect by making alterations both to scale and colour.

Brought together in this drawing are several elements characteristic of Agasse's work which might be summed up as a sort of serene calm, born of the understanding created, with the artist's help, between animal and man. This special relationship is crystallised in the two sets of eye contact in the picture: as soon as we look at the picture, we come under the spell of the horse's gaze; then, as we look further, we see a similar communion taking place in the inquiring look the man seems to offer his dog.

Brush, grey and brown ink wash over a pencil sketch on white medium weight laid paper 9¼ × 11⅜ (23.4 × 29)

Provenance
Georges de Seigneux, Geneva; Aloys de Seineux, Geneva

Exhibitions
Musée Rath, Geneva, 1944 (46); Winterthur, Coire, Lucerne, Basle, Lugano, Lausanne and Berne, 1968 (2); Schloss Jegenstorf, 1970 (21): Musée Rath, Geneva and Musée des Beaux Arts, Dijon, 1984 (80)

Literature
Hugelshofer, 1969, no. 87, p. 216, repr.

Related Works
Painting in the Musée d'Art et d'Histoire, Geneva, Acc. no. 1913-68 (Cat. no. 4)

Cabinet des Dessins, Musée d'Art et d'Histoire, Geneva (Acc. no. 1913-69)

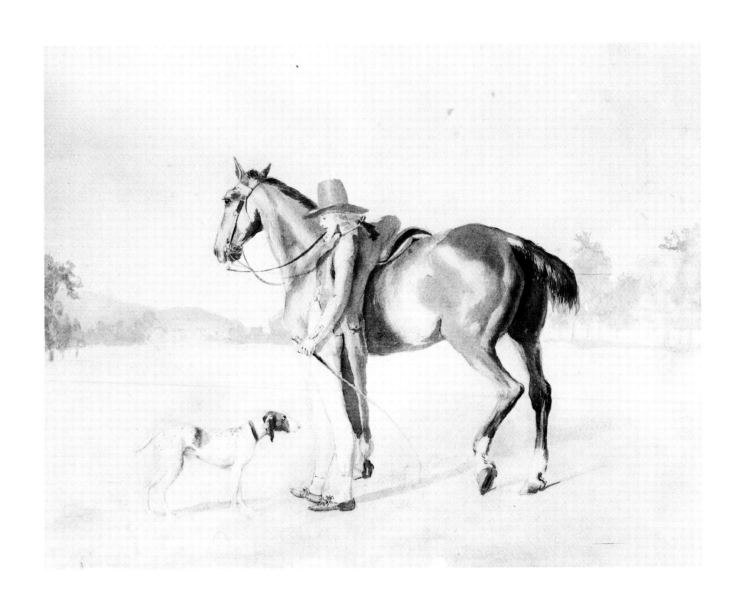

93 Study for 'A Disagreeable Situation': A Young Couple in a Barouche which is Threatening to Overturn c.1800

The barouche, which Agasse has drawn here on a large sheet of paper without its frisky pair, was to be the focal point of the first of his paintings to be exhibited in England (Cat.no.7). The drawing was large enough for his study of the vehicle as it threatened to overturn to be at the same scale as the final painted version.

It is worth pointing out the care Agasse has put into painting a humble barouche: he has studied its mechanical 'skeleton' as painstakingly as he would the anatomy of an animal. This preoccupation with accuracy is reflected in other studies of the same barouche in which it is drawn 'dissected' into separate components.

A great many preparatory drawings are known to exist for 'A Disagreeable Situation', ranging from small composition sketches to large technical studies like this one.

On the back is a rough sketch of an ornate landscape still very much in keeping with Agasse's Genevese period. This piece comes therefore at a turning point in Agasse's career, when he was about to leave Geneva for good and settle in London.

Pen and grey-brown ink, with black chalk and stump, and red chalk over a pencil sketch on white heavy weight laid paper Watermark, 'C & I Honig', with a fleur de lys $16\frac{1}{2} \times 19\frac{7}{8}$ (42×50.5). On the back, 'Farmyard Entrance with a Man Seen from Behind', grey-brown ink wash over a pencil sketch

Provenance
Jeanne Soldano, Geneva

Private Collection

*94 Double Page of Sketches *c.* 1800

These are pages from one of Agasse's sketchbooks and are covered in quick figure studies, almost certainly of people he observed in the street. Because of their size, it seems likely that the object of these studies was to provide a stock of people to fill in the backgrounds of future pictures. The fact that they were so small meant they could be dashed off with the speed and discretion for which the subject could sometimes call, if the position of the man seen from behind on the left hand page is anything to go by.

In the fine pencil drawings on these sheets we glimpse the hint of humour which runs through so many of Agasse's drawings, the instinct he has for bringing nature delightfully and fittingly to life.

Pencil on white fine laid paper, each 7¼ × 4½ (18.3 × 11.3)

Provenance
Louise-Etiennette Agasse, the artist's sister, Geneva;
Noémi Boissonnas-Maillart, Geneva

Private Collection

*95 Doe in Hyde Park 1801

Like nos. 94 and 96, this drawing almost certainly comes from one of the sketchbooks Agasse used to carry about with him so that he could jot down anything which caught his eye while he was out in the open. He produced a great many of these sketches, particularly in his early days in London, and some of them were to find their way into his finished works.

As shown by the inscriptions on sheet after sheet, Agasse often went to Hyde Park to draw the animals or the surrounding landscape. He also enjoyed drawing in Kensington, which was then a small country town quite separate from London. Agasse lived there from the day he arrived until 1803, with his friends the Chalons, painters from Geneva who like him had found refuge in England.

Pencil on white fine laid paper irregularly cut at the top 4⅜ × 8⅛
(11 × 20.7)
Inscribed upper left 'Hyde Park 1801'
On the back, studies of a haycock, the head of a bulldog and the hindquarters of two animals

Provenance
Louise-Etiennette Agasse, Geneva; Louis Glatt, Geneva

Exhibition
Maison Tavel, Geneva, 1968 (45)

Cabinet des Dessins, Musée d'Art et d'Histoire, Geneva (Acc. no. 1968-60)

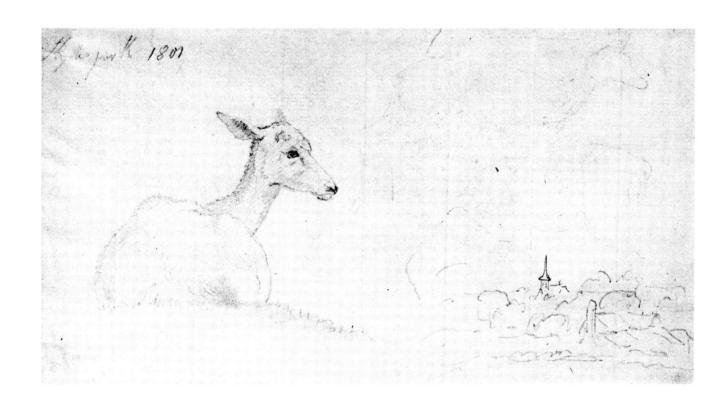

96 Swan and Sleeping Sow *c.* 1801

Agasse's talents as an animal painter are clearly manifest in these two drawings from the life. His pencil has caught perfectly all that is purely animal in the dozing sow and the swan preening its feathers, without adding a single anthropomorphic touch.

Agasse's sketchbooks are full of drawings of domestic animals of all kinds, which he captures in their most characteristic attitudes. He gives each creature his undivided attention, thoroughbred horse and sleeping sow alike, irrespective of pedigree.

In about 1803 Agasse's repertoire broadened as he began to visit the menagerie at Exeter Change and draw the wild animals there. Sadly, few of the drawings from this period have as yet come to light.

Two pencil drawings on white medium weight laid paper
Watermark 'HOOK...?' Sow, $4\frac{1}{4} \times 4\frac{1}{8}$ (10.7 × 10.5);
Swan, $4\frac{1}{8} \times 8$ (10.4 × 20.5)

Provenance
Louise-Etiennette Agasse, the artist's sister, Geneva;
Gosse Collection, Geneva

Private Collection

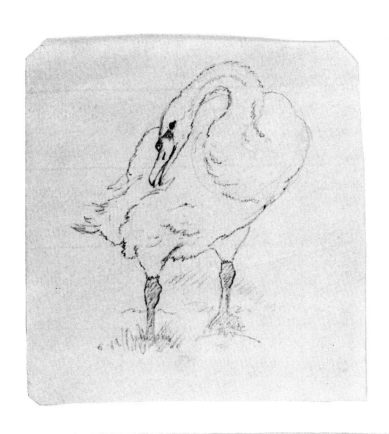

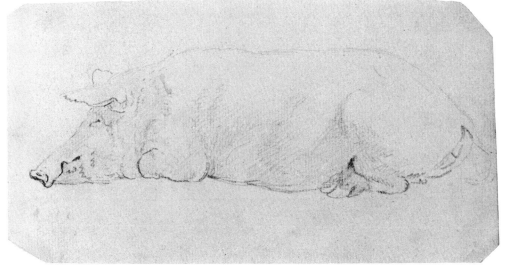

*97 A Hertfordshire Farm 1803

These outbuildings were probably part of the estate belonging to Lord Melbourne, father of the famous Prime Minister, near Hatfield in Hertfordshire. The horse shows held at Brocket Hall at this period were enormously popular and Agasse was to find them a rich source of subject-matter (Cat.nos.23 and 24). Similar drawings survive of other farm buildings identified as belonging to Lord Melbourne's estate.

Agasse demonstrates his powers of observation here to great effect, and manages to record the place in all its detail while successfully avoiding the monotony of a topographical survey. Two things in particular help create the variety which 'makes' the drawing: the subtlety of the treatment of detail (foreground and far distance are blurred, while the middle ground is sharply defined), and the diagonal composition, which draws the eye smoothly down the line of roofs to the little cottage beyond. As we let our eye travel over the page we have the security of a fixed point of reference where the oblique line of the roofs meets the detail of the middle ground.

Inscribed twice on the back: not very legibly in pencil 'Herts I—1803', in black crayon 'Herts'
Pencil on white light weight paper, the outlines of the drawing fixed with ?egg white Watermark, 'C PIKE' 8 × 13 ¾ (20.5 × 34.9)

Provenance
Louise-Etiennette Agasse, the artist's sister, Geneva;
Gosse Collection, Geneva

Private Collection

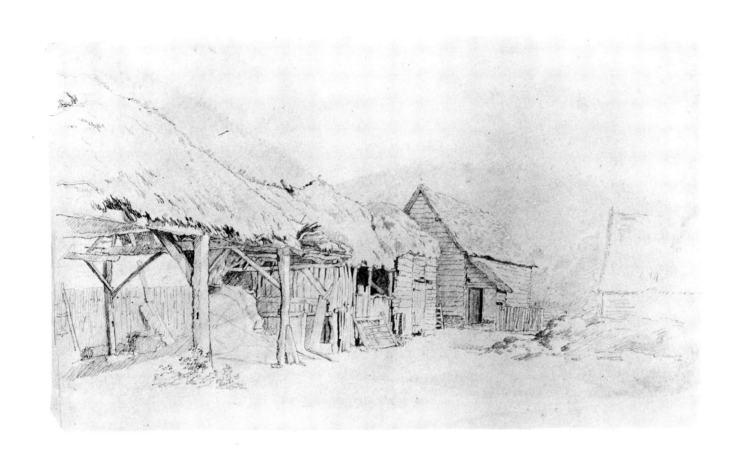

*98 The Gate 1803

In this spirited drawing we meet again the two riders (one in hunting pink, the other in a top hat) from the foreground of 'Departure for the Hunt' (Cat.no.11). We find them in mid-crisis: the chestnut with the white hind foot has taken the gate badly and fallen; it rolls onto its side to get out of the way of the grey horse as it jumps the hurdle, hot on its heels.

The drawing is a preparatory study for a small painting called 'A Man Leaping' which was conceived as a companion to another oil of the same size probably entitled 'Foxhunting' (whereabouts unknown). According to Agasse's *MS. Record Book* both canvases were painted immediately before 'Departure for the Hunt' (Cat.no.11): '1803/ May 26th Fox hunting (very small sketch)/ June 3rd Companion to the little hunting, a man leaping./ June 15th A hunting going out in the morning.' (see Cat.no.11)

Brush and brown ink wash on white fine laid paper, yellowed Watermark, 'LASE...IAZ?' $7\frac{7}{8} \times 10\frac{1}{8}$ (19.8 × 25.7)

Provenance
Ninette Duval-Töpffer, Geneva; Etienne Duval, Geneva; given by him to the Société des Arts, Geneva

Literature
Baud-Bovy, 1904, p.90, repr.; Hardy, 1, 1916, p.193; *Athénée 1863-1963*, 1963, no.109; Herdt, no.82, February 1968, p.4

Related Works
Unknown painting entitled 'A Man Leaping', 1803, referred to in the *MS. Record Book*

Collection of the Société des Arts, Musée d'Art et d'Histoire, Geneva (Acc.no.Aga. 3)

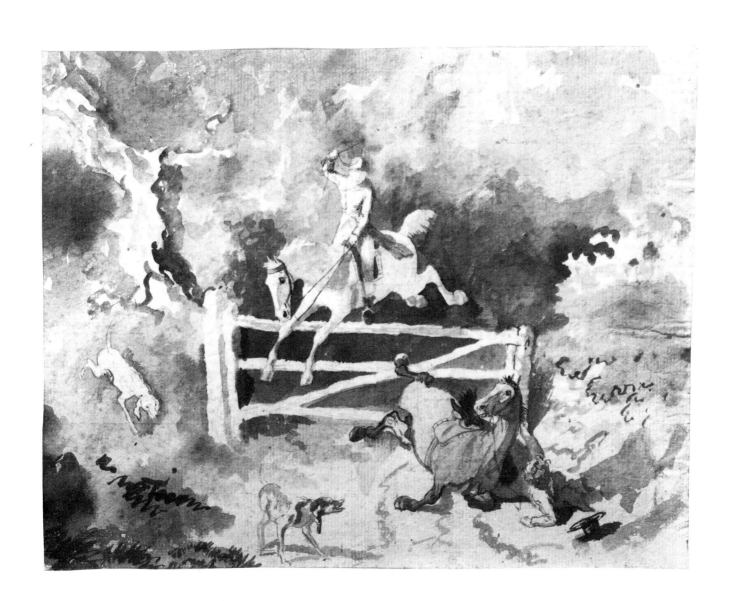

*99 Two Studies of Riders for 'Departure for the Hunt' 1803

These are both preparatory sketches for 'Departure for the Hunt', which was the largest of the works Agasse produced in May and June 1803 during the course of what the preceding drawings in this exhibition have already shown to be a very fruitful stay in Hertfordshire.

In the left-hand drawing, which Daniel Baud-Bovy considers to be a self-portrait of Agasse, the rider is still shown in a somewhat passive attitude at this stage, although his dress and seat are just as they appear in the finished painting. The whipper-in in the right-hand drawing is shown in his final pose,

alone at this stage; in the painting we will see him accompanied by his hounds. Otherwise, only his dress will change, and the modification there will only be slight: his frock coat will be buttoned up and his top hat exchanged for a jockey's cap more suited to the occasion.

Agasse was sometimes approached by other artists who wanted his help in making their paintings of horses more believable, and he was wont to observe that they did not know how to 'put the man on the horse'. These sketches show clearly how the job ought to be done (cf. Gordon Roe).

Inscribed in an unidentified hand at the bottom of each sheet
'Agasse, given by Mlle Agasse'
Black chalk heightened with white wash on grey prepared medium weight wove paper $8\frac{5}{8} \times 6\frac{3}{8}$ (21.8 × 16.2) and $7\frac{1}{8} \times 8\frac{3}{8}$ (18 × 21.2)

Provenance
Louise-Etiennette Agasse, Geneva; Madeleine Humbert, Geneva; Elisabeth Senn-Humbert, Geneva; Valentine Rieder-Senn, Geneva; Andrée Picot-Rieder, Geneva

Private Collection

Agasse, donné par
Mlle Agasse.

Agasse, donné par

*100 Sportsman, Horse and Dog *c.* 1803

This finely balanced little sketch clearly illustrates Agasse's ability to tackle conventional subjects in an original way.

The immediacy of drawing allows an artist to capture quickly and succinctly whatever he wants, and it is by looking at his drawings that we can see what it is that obsesses Agasse most as an artist rendering faithfully each different animal's particular physical character. In the first decisive moments of this drawing Agasse has given only the barest indication of the man's features, while both dog and horse are already distinct individuals.

Brush and brown ink wash over a pencil sketch on white fine laid paper
Watermark, 'JH' in monogram 5⅝ × 8 (14.2 × 20.2)

Provenance
Adam-Wolfgang Töpffer, Geneva; bequeathed by his descendents to the Musée d'Art et d'Histoire in 1910

Exhibition
Maison Tavel, Geneva, 1968 (33)

Cabinet des Dessins, Musée d'Art et d'Histoire, Geneva (Acc. no. 1910-576)

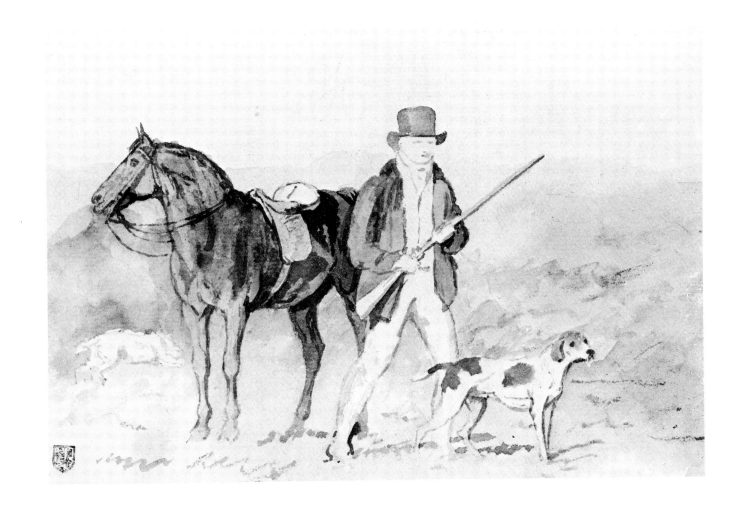

*101 The Hunt *c.* 1803

If 'Huber-Voltaire', as Jean Huber was popularly known, was the founding father of the art of the cut-out in Geneva, Jacques-Laurent Agasse was without a doubt one of its most brilliant exponents.

In a letter to Louis-André Gosse in 1810 Agasse's aunt remembers her nephew developing this gift from an early age: '... he revealed a taste and talent for animals as early as two and a half, when he used to make wonderful cut outs of animals based on Buffon...' (1904, *Baud-Bovy,* vol. II, p. 106).

This dramatic composition is a real 'painting in cut-out' - a term applied by Daniel Baud-Bovy to similar works by Jean Huber. In all probability what we see here is a fox hunt. The choice of subject, together with the way the riders are mounted, suggests that this cut-out dates from Agasse's English period. There are unexpected tricks of perspective to be found here, and an abundance of finely drawn detail. If you look hard enough, you can spot as many as ten hounds in the picture!

Cut out of white paper on white fine wove paper tinted grey, with a light pencil sketch under the grey $14\frac{1}{2} \times 13\frac{1}{2}$ (37×34.5)

Provenance
Hippolyte Gosse, Geneva; Claire Maillart-Gosse, Geneva

Exhibition
Musée d'Art et d'Histoire, Geneva, 1985 (29)

Literature
Herdt, no. 82, February 1968, p. 2 and cover

Cabinet des Dessins, Musée d'Art et d'Histoire, Geneva (Acc. no. 1985-12)

*102 Riders Arriving at an Inn c. 1803

This second, smaller cut-out shows two riders arriving at an inn. The first has already dismounted and is talking to the innkeeper. The other has only just arrived and is having to restrain his horse which is frightened of the barking dogs.

The episode bristles with life and is recounted with great skill. It gradually takes shape as perfect outline follows perfect outline in a succession of evocative silhouettes, and comes together at last out of the harsh contrast of light and dark created by the white of the paper and the black of the background.

Cut-out of white fine laid paper $4\frac{1}{2} \times 7\frac{1}{2}$ (11.5 × 19)

Provenance
Hippolyte Gosse, Geneva; Elisabeth Maillart-Gosse, Geneva; Noémi Maillart-Boissonnas, Geneva

Literature
Reproductions of the old Genevese school of painting, miscellany [n. d.]

Related Works
Curved version reproduced in Baud- Bovy, 1904, p. 150

Private Collection

*103 The Riding School 1806?

This composition is reminiscent of Cat. no. 81, 'Setting off for the Ride', drawn before Agasse left for England. Agasse was alive to the differences between his new English environment and his native Switzerland, and this is reflected in the way he has changed particular details: the mongrel has been replaced by setters and greyhounds, the ladies' tall hats and elegant frock coats have given way to bonnets and quieter shawls, and the horses, by contrast, now sport the most magnificent coats.

These three drawings originally formed a single panoramic view, and they conjure up the atmosphere of a race meeting of the kind Lord Rivers and Lord Heathfield used to organise in those days. Agasse takes a wry and gently ironic look at the scene, very much in keeping with the trend among English artists of the time.

The original composition has been cut up and divided into three distinct moments. A skilful hand has been at work here and has succeeded in giving each fragment a unity of its own.

The left hand drawing shows horses caught in mid motion at various stages in their training. Their 'frozen' attitudes call to mind - albeit anachronistically - the experiments of Marey and Muybridge.

In the central drawing, a knot of people is watching the preparations for a race from a knoll. Agasse gives us a sense of the highness of the ground by showing us how the wind forces the man on the left to hold on to his hat and prompts the ladies to draw their shawls more tightly around them.

In the last picture in this continuous sequence, the one on the right, Agasse has retained the line of the horizon, absent from the other two, in order to focus attention on the main scene. The horses are now ready to be off and are going onto the racecourse which opens out beyond the palisade on the far right of the picture.

Pen, brush and grey/beige ink wash over a pencil sketch on buff medium weight wove paper. (i) 5 7/8 × 10 (15 × 25.5); (ii) 5 5/8 × 6 3/8 (14.4 × 16.3); (iii) 6 3/4 × 6 3/4 (17.2 × 17.2)

Provenance
(i) Adam-Wolfgang Töpffer, Geneva; bequeathed by him to the Musée d'Art et d'Histoire, Geneva, 1910 (ii) Louise Töpffer, Geneva; Mme Gustave Nepveu, Paris, François Nepveu, Paris (iii) Mme Gustave Nepveu, Paris, François Nepveu, Paris

Exhibitions
(i) Maison Tavel, Geneva, 1968 (32); Schloss Jegenstorf, 1970 (18)

Literature
(i) Baud-Bovy, 1904, p.105

Related Works
'The Riding School', oil, Musée d'Art et d'Histoire, Geneva (Acc. no. 1928-4)

Cabinet des Dessins, Musée d'Art et d'Histoire, Geneva (Acc. nos. (i) 1910-270 (ii) 1987-31/19 (iii) 1987-32/47)

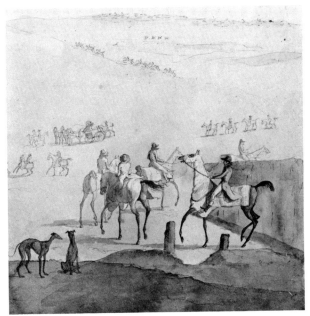

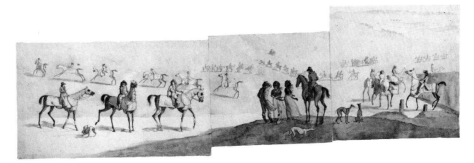

This drawing epitomises horse portraiture in the strictest sense of the word: the subject of the picture is nothing more nor less than 'the horse', and the background has therefore been left deliberately neutral. Neutral backgrounds were often used in 'human' portraiture of the same period to focus attention on the sitter's face, and a similar technique is applied here to make the character of the animal stand out more effectively.

In this drawing we see too the culmination of a major strand of Agasse's work in the exceptional sensitivity with which he captures the essential 'horse-ness' of the beast. It was very probably on seeing works like this that Agasse's young contemporary Landseer - not a man given to eulogy - was prompted to exclaim, 'He paints animals like nobody else'.

The English thoroughbred depicted here is in all probability a stallion, and is despite its small appearance a full-grown horse. Its long tail, heavy halter and shaggy pasterns make it unlikely that it was being bred for a life of racing.

Brush and brown ink wash over a pencil sketch, with traces of red chalk and heightened with white gouache on buff heavy weight wove paper, fully laid down
Pasted down sheet edged with blue paper with three black border lines $10\frac{3}{8} \times 7\frac{5}{8}$ (26.2 × 19.3)

Provenance
Charles Bastard, Geneva

Exhibitions
Winterthur, Coire, Basle, Lugano, Lausanne and Berne, 1968 (3); Musée Cantonal des Beaux Arts, Lausanne, 1982 (19)

Literature
Hardy, 1, 1916; Hardy, 1921

Related Works
Two paintings, both in private collections, 'The Little Horse' and 'Two Horses and a Dog in a Stable'

Cabinet des Dessins, Musée d'Art et d'Histoire, Geneva (Acc. no. 1911-19)

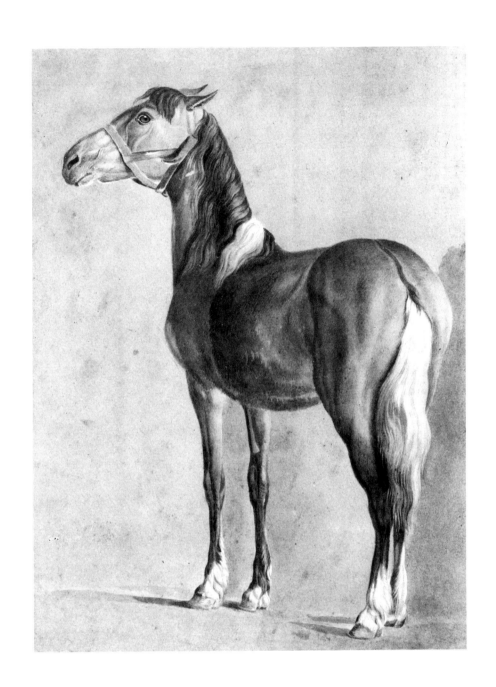

*105 English Thoroughbred Accompanied by a Groom on a Saddle Horse 1807?

The horse portrayed in this marvellous drawing may be the stallion Worthy, brother of the famous race-horse Waxy. The *General Stud Book* of 1820 gives several horses got by Worthy, one of them out of Lord Grosvenor's mare Marcella in 1804.

Agasse painted the horse in oils in 1807 and produced a second picture of him six months later, doubtless as a commission, even though this flatly contradicts the evidence of his *MS. Record Book*

which gives 1821 as the date of his first commission. Hardy interprets the reference to 1821 - quite rightly it would seem - as meaning 'first picture of an imposed subject (other than a portrait) executed as a commission'.

This wash drawing very probably represents Agasse's first ideas for a portrait of Worthy. In this looser form he tries to free himself from the constraints of conventional horse painting.

Brush and brown ink wash over a pencil sketch on white medium weight laid paper 10¼ × 15 (26 × 38)

Provenance
Goudet Collection, Geneva

Private Collection

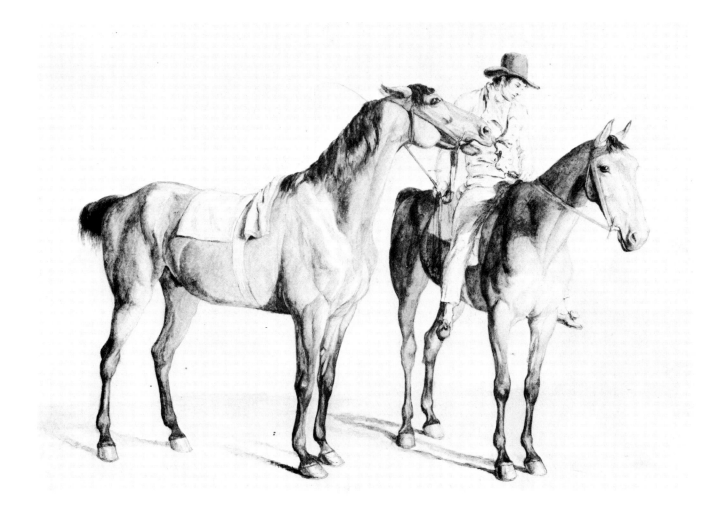

*106 Study of Trees, Dorset 1808

The entry for November 1808 in Agasse's *MS. Record Book* reads, 'Nov. 10th From a study in Dorset, trees (small picture)'. According to Hardy, 'Small Picture' means a standard 'Small Head Size', 20 × 16 (50 × 40).

The note probably refers to the stay he made at one of Lord Rivers' houses called Rushmore Lodge which was on his extensive estate on the Wiltshire/Dorset border.

The subject of this drawing (which may well be the 'study' mentioned in the *MS. Record Book*) must have made Agasse think back to the tours he made of the countryside with his Genevese friends A.-W. Töpffer and P.-L. De la Rive before his departure for England.

This composition goes far beyond a simple sketch, and is one of the rare examples of pure landscape Agasse is known to have produced.

Black chalk on white medium weight laid paper
Watermark, 'J WHATMAN 1805' 17 × 13⅜ (43.3 × 34)

Provenance
Louise-Etiennette Agasse, the artist's sister, Geneva;
Gosse Collection, Geneva

Private Collection

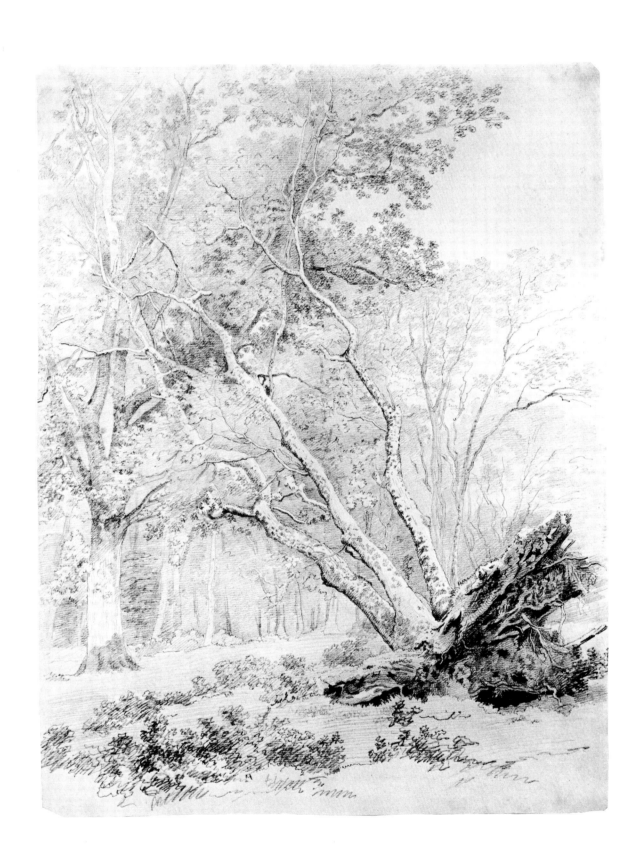

*107 Portrait of the Artist Painting at an Easel *c.* 1810?

Agasse is seen standing, working on the upper part of a large canvas which already appears to be well advanced. He is holding his brush by its end and is using a rectangular palette of unusual design. He is shown looking pretty dishevelled in indoor clothes, very much the fallen aristocrat turned bohemian.

The watercolour version of this drawing has been attributed variously both to John James Chalon and to Agasse. It was undoubtedly based on this drawing, however, and since both versions are by the same hand, it does look very much as if this frank, uncompromising portrait is the work of Agasse himself.

Pencil on white fine laid paper
Watermark, 'JOHN HALL' 8⅝ × 6¼ (22 × 16)

Provenance
Hippolyte Gosse, Geneva; Elisabeth Maillart-Gosse, Geneva; Noémi Boissonnas-Maillart, Geneva

Literature
Plan, 1902, pl.

Related Works
A version heightened with watercolour is reproduced in the article by C. F. Hardy in *The Connoisseur,* August 1916, p. 198

Private Collection

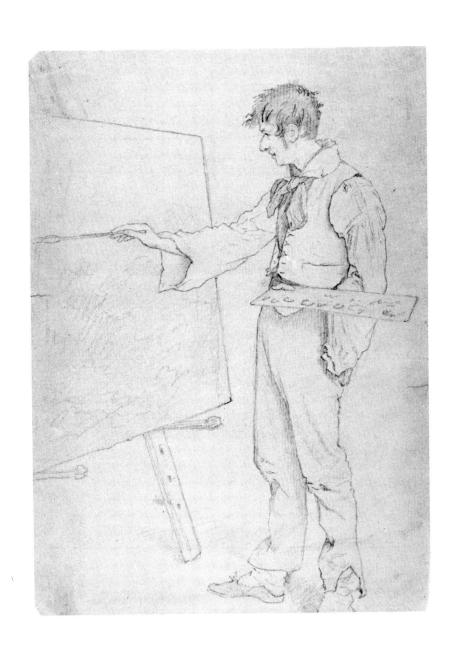

108 Stable-yard *c.*1810?

The scene takes place amongst coachmen and grooms. Agasse always felt at ease in this kind of environment, as A.-W. Töpffer confirms in a letter he wrote while on a visit to his friend in 1816, '...(Agasse) showed me around all the famous stables, took me everywhere the finest horses are to be seen...he is well in with all the grooms, horse dealers, horse fanciers and so on. Men who make a living out of showing animals to the public are among his closest friends. He is welcome everywhere, and all these people look upon him as a real expert'.

The sketchy quality of the drawing helps to capture the animation of the scene in front of the stable in which magnificent Clydesdale horses weighed down with heavy harness mingle with refined thoroughbreds whose tails have been docked. The technique itself has a contribution to make: the variety of tone in the drawing helps to evoke the enormous range of sounds to be heard outside the stable.

Brush and brown ink wash over a pencil sketch on white fine laid paper
Watermark, 'J. HONIG & ZOONEN' 7¼ × 11½ (18.3 × 29.3)

Provenance
Adam-Wolfgang Töpffer, Geneva; bequeathed by his descendents to the Musée d'Art et d'Histoire, Geneva, 1910

Exhibition
Maison Tavel, Geneva, 1968 (36)

Literature
Hardy, 1, 1916; Hardy, 2, 1921

Cabinet des Dessins, Musée d'Art et d'Histoire, Geneva (Acc. no. 1910-593)

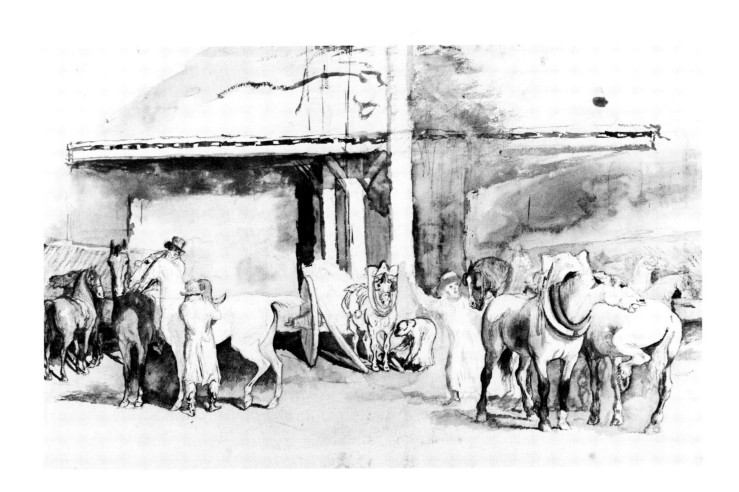

*109 Runaway Horse *c.* 1812

Its ears laid back, an English thoroughbred runs off whinnying and rolling its eyes. What has probably happened is that the horse has got the bit between its teeth, thrown its rider, and galloped off at full tilt with nothing but a saddle-cloth on its back.

This may be the drawing referred to in one of Agasse's entries for 1812 in his *MS. Record Book,* 'Feb. 10th Sketch of a horse in motion'.

In tackling a horse in so unusual a pose Agasse is anticipating the work of Edward Muybridge and his use of chronophotography as a means of analysing movement in the horse. Muybridge's experimental methods, devised some sixty years after this drawing was produced, were to revolutionize the way in which horses were represented in motion.

Pen, brush and grey and brown ink wash, heightened with a reddish wash, over a pencil sketch on white medium weight wove paper 7¾ × 9⅝ (19.6 × 24.5)

Provenance
Mme Gustave Nepveu, Paris; François Nepveu, Paris; Hermany Arnet, Geneva

Cabinet des Dessins, Musée d'Art et d'Histoire, Geneva (Acc. no. 1987-32/18)

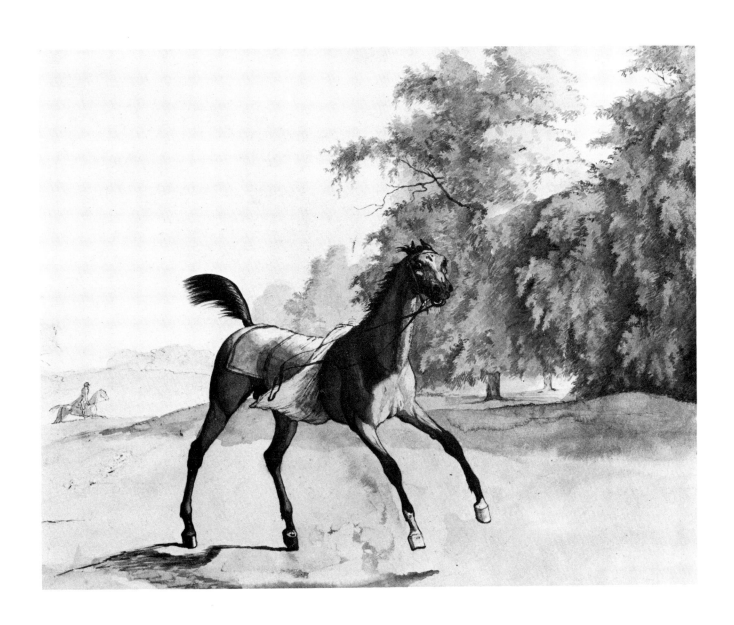

In this wash study Agasse was obviously trying to reach a wider public than the horse-oriented community to whom his work is normally addressed. Agasse always resented being called an animal painter and the variety of his output is a clear product of his determination to avoid being categorised in this way.

When he came to make a painting from this drawing, Agasse changed the composition slightly, by reducing the painted area and adding a dead tree on the right. He probably thought these changes were necessary to compensate for the greater prominence given to the grey horse in the new version.

Brush and brown ink wash over a pencil sketch on white wove paper
Pasted down sheet edged with green paper with three black border lines 8½ × 10⅝ (21.5 × 27)

Provenance
Charles Bastard, Geneva

Exhibitions
Maison Tavel, Geneva, 1968 (37); Schloss Jegenstorf, 1970 (22)

Related Works
Painting sold through Ackermann, London [n.d.]

Cabinet des Dessins, Musée d'Art et d'Histoire, Geneva (Acc. no. 1911-21)

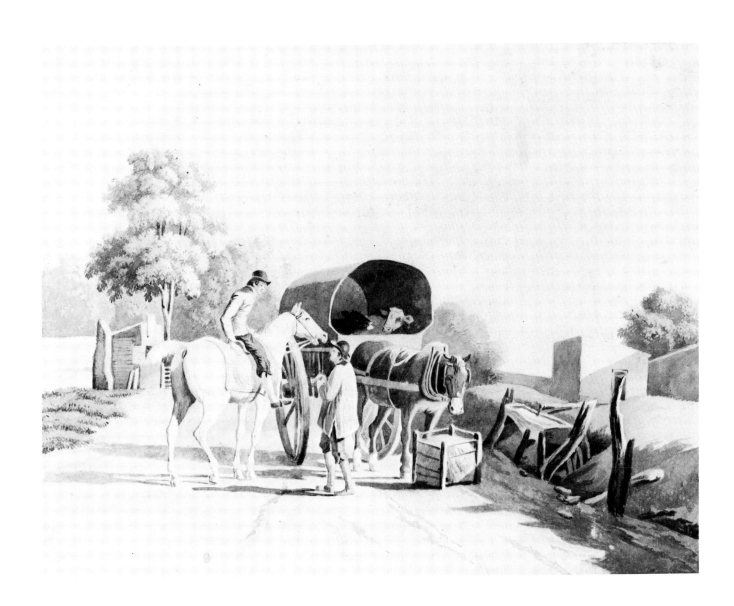

The colour aquatint after this drawing which was published in 1824 was to become probably the most talked about of all Agasse's works. Here was a cherished institution at the height of its popularity portrayed by an expert - it was a combination which could not fail. The drawing is of none other than the Royal Mail, and in the engraving these words are clearly visible emblazoned on the side of the coach.

The drawing was particularly admired for the foreshortening of the horses and for the accuracy of the picture it gave of the coachman's craft. The coachman has just changed horses and is carefully breaking in the fresh pair, slackening the bridles off slowly.

In the version published in 1824, the woman sitting next to the coachman has been replaced by a man. The reason generally adduced for this is that it was not thought ladylike to sit there. This explanation has been called into question, however: in one engraving of 'The Last Halt of the Portsmouth Stage-coach' (Cat.no.34) published in 1832 the figure at the coachman's side remains resolutely female.

We are led to the inevitable conclusion that the best of Agasse's work was never engraved.

Watercolour over a pencil sketch on white paper, yellowed
$12\frac{5}{8} \times 15\frac{3}{4}$ (32 × 40)

Engraving
(i) by F.C. Lewis in aquatint $11\frac{3}{4} \times 15\frac{1}{2}$ (29.8 × 39.4), published by J. Watson, London, 1820; (ii) by Dubourg in aquatint printed in colour $11\frac{3}{4} \times 14\frac{3}{4}$ (29.8 × 37.4), published by J. Watson, London, 1824. (In this engraving, the woman sitting next to the coachman has been replaced by a man.)

Provenance
Rehfous, Genevese dealer; Bernard Naef, Geneva

Exhibition
Maison Tavel, Geneva, 1968 (40)

Private Collection

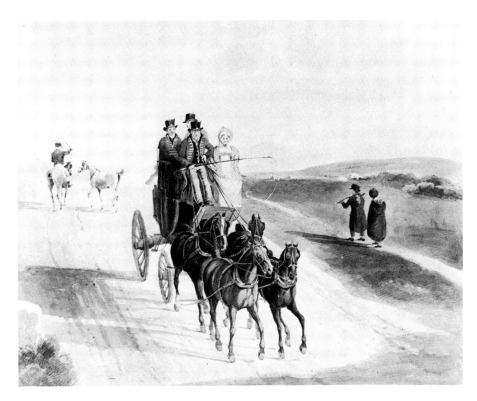

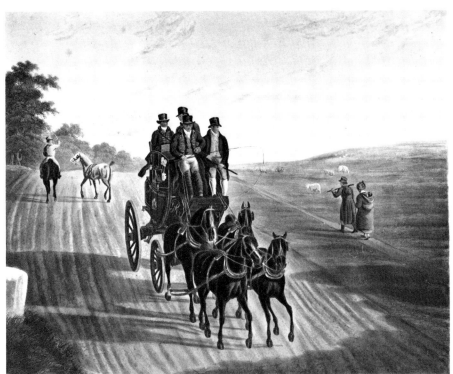

*112 Study for 'The Hard Word' 1820

The sitter is the young Lionel Booth, then aged six and a great friend of Agasse's. He was the eldest son of Agasse's friend and landlord George Booth whose family was to provide Agasse with the inspiration for so many portraits of this kind.

The drawing is carefully worked throughout and ranks as high as the painted version (Cat.no.46). Indeed, when the two are compared, it is the drawing which has the greater intimacy and is more of a real 'portrait'. In the painted version, the wider theme of the 'Hard Word' has taken over, and the portrait element has been relegated to second place.

Black chalk on white heavy weight wove paper
Watermark, 'J. WHATMAN' 17¾ × 11⅞ (45 × 30.2)

Provenance
Odette Gosse, Geneva

Exhibition
Maison Tavel, Geneva, 1968 (59)

Literature
Baud-Bovy, 1904, p.117; Hardy, 2, 1921

Engraving
by R. Syer in mezzotint, published by Agasse [n.d.]

Related Works
Picture painted in 1820, Private Collection (Cat.no.46)

Cabinet des Dessins, Musée d'Art et d'Histoire, Geneva (Acc.no.1921-1)

*113 St Paul's Cathedral Seen from Southwark Bridge 1823

Watercolours are a little known part of Agasse's work, but Agasse displays great virtuosity in this medium, and is certainly well up to the standard of the renowned English watercolour school.

The fact that Agasse signed his watercolours is proof that he rated them highly, all the more so because he rarely signed any of his work. This watercolour, like the one that follows it (Cat. no. 114), is not listed in Agasse's *MS. Record Book*. There is however a gap of a few months in 1823 when nothing is listed, so this is perhaps when they were painted.

That Agasse should have tried his hand at this medium should come as no surprise considering the environment in which he was living - Newman Street was then bursting with watercolourists, notably A.V. Copley Fielding who settled there that very year, 1823. Moreover, Agasse was often invited to the evenings organised by the *Sketching Society* whose members were predominantly watercolourists (like Cornelius Varley and W. Turner of Oxford), and whose founder members, the Chalon brothers, were old friends of Agasse's.

Inscribed bottom left, 'J. L. A. 1823'
Watercolour, brush and pen, heightened with gouache over a light pencil sketch on white medium weight wove paper, stuck down at six points, with a straight tear down the lower half of the right hand side 8 × 12 (20.3 × 32)

Provenance
Ellis and Smith, London; G. and L. Bollag Gallery, Zurich, 1937

Exhibition
Maison Tavel, Geneva, 1968 (58)

Cabinet des Dessins, Musée d'Art et d'Histoire, Geneva (Acc. no. 1937-38)

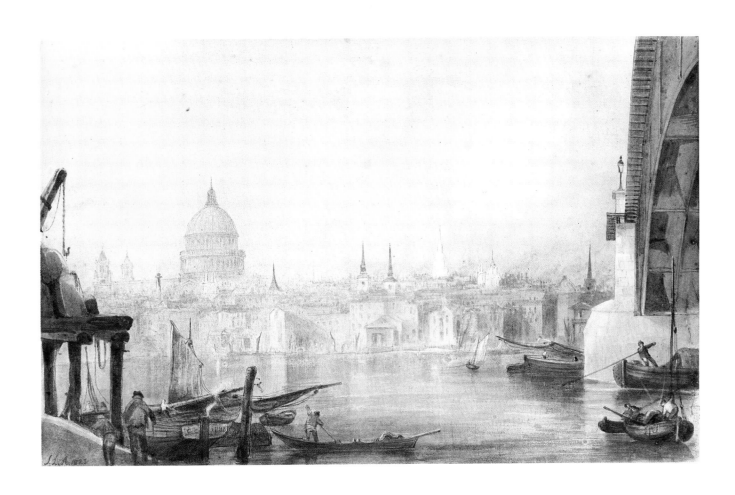

*114 View of Greenwich Hospital 1823

In this topographical drawing, Agasse has chosen an unusual angle from which to depict Greenwich and its famous Naval Hospital (now the Royal Naval College). This is so that he can include the west side of the building painted a generation earlier by Canaletto on his visit to England.

Agasse has taken up position at the top of Croome Hill, and not, as is usual when drawing the building, in the Royal Park designed by André le Nôtre which can be seen spreading out to the left of the picture.

Agasse leads us into the picture along a zig-zag path and this skilful manipulation of depth allows him to create that sense of distant haze so perfectly attuned to watercolour. We leave the charming little group at the bottom right of the picture and skirt the park as we follow the road across the picture until we reach the façade of the Hospital. Here we stop briefly before carrying on to the church where we stop once more and gaze out over the masts as they disappear down the Thames.

Inscribed bottom right, 'J.L.A.1823'
Watercolour on paper $9\frac{1}{8} \times 12\frac{5}{8}$ (23.1 × 32)

Provenance
Ellis and Smith, London; G. and L. Bollag Gallery, Zurich

Museum Stiftung Oskar Reinhart, Winterthur

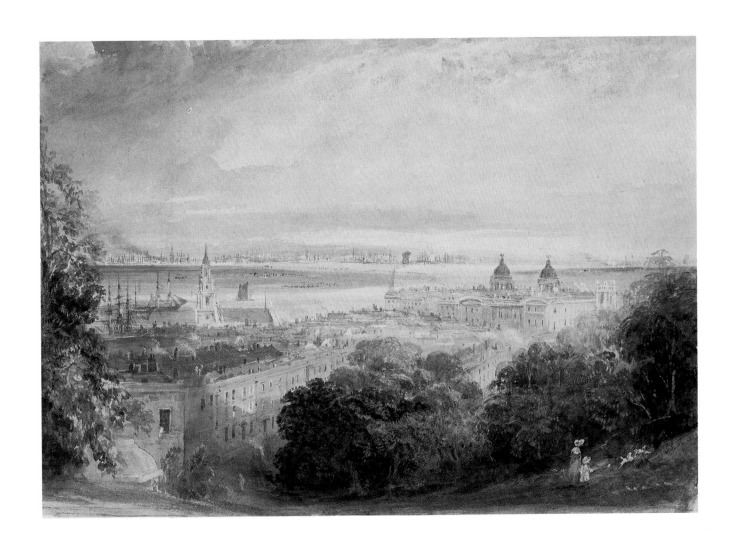

*115 Stable Boy with Two Grey Horses and a Dog *c.*1837

Two carriage horses are being taken to their stable by a groom and his dog. Freed from the restraint of harness and bridle they walk with great calm and majesty, although the sky is darkening and the dog is frightened by the impending storm.

This drawing seems very different in spirit from the rest of Agasse's work because of the unusual treatment of the horses. Placed absolutely side by side, they assume almost hieratic proportions. Such monumentality is not normally a feature of Agasse's work, nor is the theatrical use of light which takes the picture out of the realm of everyday experience. All this makes us think that this drawing dates from Agasse's 'Romantic' period, which gave rise to works like 'The Fountain Personified' (Cat. no. 70).

Brush and grey and brown ink wash on heavy white wove paper
6⅞×9⅝ (17.3×24.5)
The paper has been re-used: when it is held up to the light an upside down drawing heightened with wash is revealed. This is the only known instance of Agasse re-using drawing material. The underneath drawing is partly unfinished and depicts two horses (one ridden by a groom) at a watering place.

Provenance
Gustave Maunoir, Geneva

Exhibitions
Musée Rath, Geneva, 1955 (not in Cat.); Maison Tavel, Geneva, 1968 (38); Schloss Jegenstorf, 1970 (14); Musée Rath, Geneva and Musée des Beaux-Arts, Dijon, 1984 (82)

Literature
Herdt, 1968, No. 82, February 1968, p. 3; Deuchler, Röthlisberger, Lüthy, 1975, p. 150; Herdt, 1981, p. 41, repr. 37

Cabinet des Dessins, Musée d'Art et d'Histoire, Geneva (Acc. no. 1930-24)

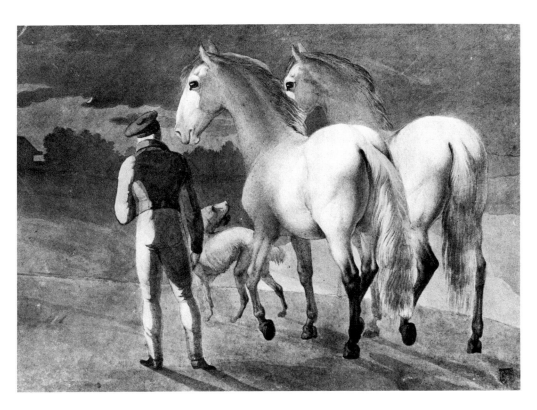

Index

This index comprises all proper names, apart from Agasse. It also includes the titles, in inverted commas, of all Agasse's works mentioned in the catalogue. The references are to page numbers.

Photographic Credits

Maurice Aeschimann, Geneva
1, 2, 4, 5, 7, 8, 9, 12, 13, 16, 27, 28, 33, 35, 37, 42, 45, 53, 54, 55, 65, 67, 73, 82, 91, 100

George Bodmer, Zurich
79, 83, 84, 86, 96, 97, 106, 107

Gad Borel-Boissonnas, Geneva
repr. p. 8

Richard Caspole, Yale Center for British Art
14, 23, 57, 58, 63, 64, 75

Christie's, London
29, 74

Geoffroy Clements, New York
69

Colorphoto Hinz, Allschwil-Basle
10, 30

Hildegard Fritz-Denneville Fine Arts, London
31, 68

Fondazione Thyssen-Bornemisza, Lugano
39

Foto-Studio H. Humm, Zurich
21, 22, 66

Galerie Römer, Zurich
44

Harari and Johns, London
20

Institut Suisse pour l'étude de l'art, Zurich
46

Kunstmuseum, Aarau
24

Kunstmuseum, Berne
61

Musée d'Art et d'Histoire (Yves Siza), Geneva
3, 6, 11, 18, 32, 36, 41, 43, 56, 62, 70, 78, 80, 81, 85, 87, 88, 89, 90, 93, 95, 98, 99, 101, 102, 103, 104, 108, 110, 111, 112, 113

Musée d'Art et d'Histoire (Jean-Marc Yersin), Geneva
17, 76, 77, 92, 94, 105, 109, 115

Museum Stiftung Oskar Reinhart, Winterthur
25, 34, 38, 114

Royal Collection, London
59, 60

Royal College of Surgeons of England, London
47—52

Tate Gallery, London
19, 26

John Webb, London
40, 71, 72

Private Collection
15